MICHELANGELO'S FLORENCE *PIETÀ*

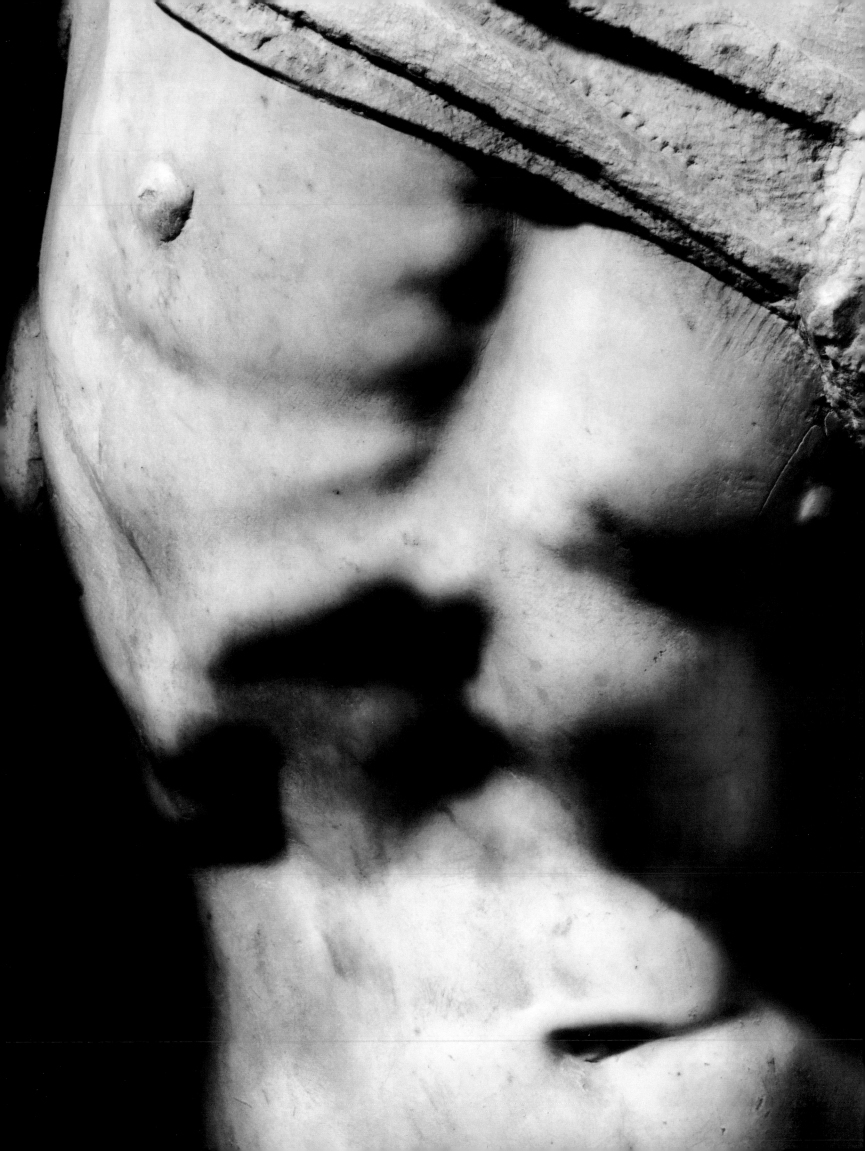

MICHELANGELO'S FLORENCE *PIETÀ*

JACK WASSERMAN

With contributions by
Franca Trinchieri Camiz, Timothy Verdon, and Peter Rockwell
Technical studies by ENEA, Opificio delle Pietre Dure, and IBM

NEW PHOTOGRAPHY BY
AURELIO AMENDOLA

PRINCETON UNIVERSITY PRESS
PRINCETON AND OXFORD

FRONT COVER: Heads of Christ, the Virgin, and the bearded figure (plate 83)
BACK COVER: Three-quarter view from the right (plate 31)
FRONTISPIECE: Christ, torso
DETAILS USED ON DIVIDER PAGES: *part I* (pages 22–23): Heads of Christ and the Virgin (plate 47);
part II (pages 170–71): Christ, band at chest and neck (plate 68)

Published by Princeton University Press, 41 William Street, Princeton, New Jersey 08540
In the United Kingdom: Princeton University Press, 3 Market Place, Woodstock, Oxfordshire OX20 1SY
www.pupress.princeton.edu

Publication of this volume has been made possible in part
by a generous grant from the Adam Sender Charitable Trust.

Printed and bound in Italy
1 3 5 7 9 10 8 6 4 2

Library of Congress Cataloging-in-Publication Data
Wasserman, Jack, 1921–
 Michelangelo's Florence Pietà / Jack Wasserman ; with contributions by Franca
Trinchieri Camiz, Timothy Verdon, and Peter Rockwell ; technical studies by
ENEA, Opificio delle Pietre Dure, and IBM ; new photography by Aurelio
Amendola.
 p. cm.
 Includes bibliographical references and index.
 ISBN 0-691-01621-6 (cloth : alk. paper)
 1. Michelangelo Buonarroti, 1475–1564. Florentine Pietà. 2. Michelangelo
Buonarroti, 1475–1564—Criticism and interpretation. 3. Jesus Christ—Art.
4. Mary, Blessed Virgin, Saint—Art. I. Camiz, Franca Trinchieri. II. Verdon,
Timothy. III. Rockwell, Peter. IV. Amendola, Aurelio. V. Title.
NB623.B9 A645 2003
730'.92—dc21 2002022746

To the women in my life, in chronological order:
Pearl, Ambra, Shara, Talya, Alexa, Layla,
Emily, Sophie, and Maya

CONTENTS

II RESOURCES

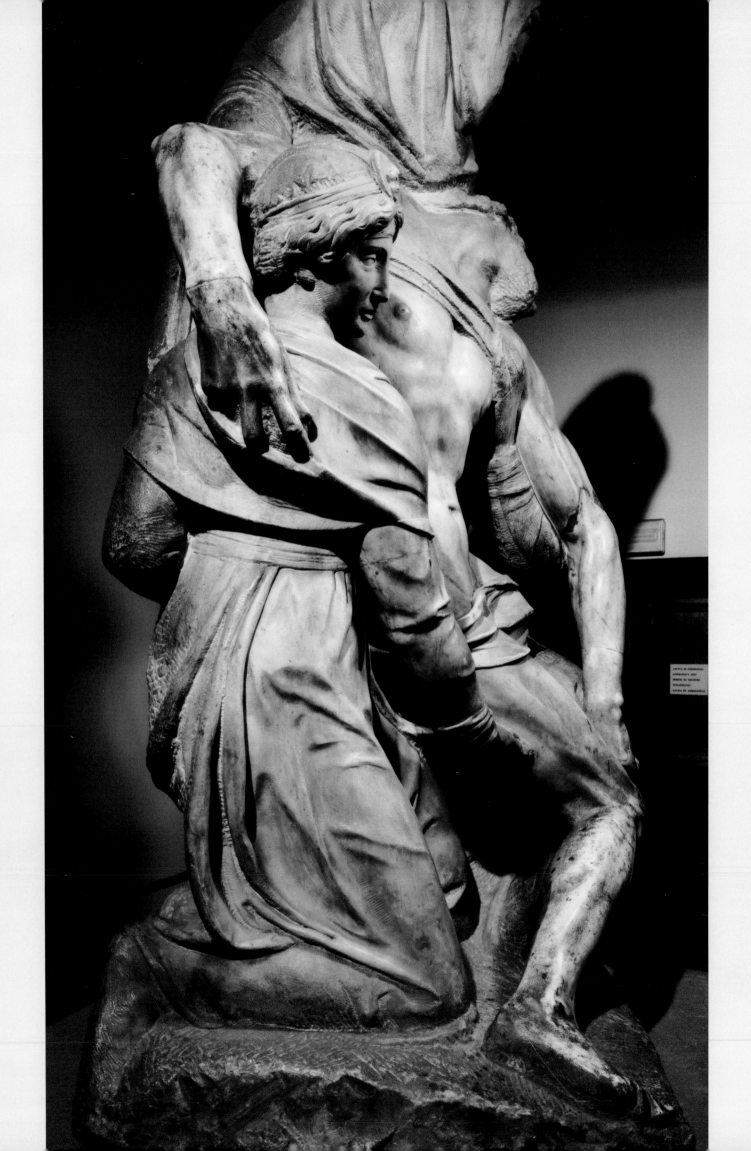

PREFACE

MICHELANGELO's PIETÀ (plate 2), today in the Museo dell'Opera di Santa Maria del Fiore in Florence, communicates a stunning emotional power through its grand scale; the powerful pose of the helpless, twisting body of the dead Christ (plate 6); and the eloquent expressions on the faces of Christ, the Virgin, and the older bearded male figure in the group (plate 83). These compelling features stimulated me to study the statue, initially as an article in which I intended to examine its subject and the reason for its tragic, mutilated condition. It soon became apparent to me that neither topic could be properly addressed without bringing it into relation to other problems that beset the statue. The idea for a comprehensive monograph on the Florence *Pietà* grew from this.

The monograph is guided by two principles. One is that a fresh, systematic, and thorough investigation of the *Pietà* (indeed of each of Michelangelo's works) should precede studies of his entire oeuvre. The obstacles to achieving a reasonably thorough, accurate history and understanding of the statue have been the paucity of primary and secondary sources as well as incomplete information about its physical characteristics. Historians have had to rely predominantly on speculation, proliferating hypotheses often formulated without considering ideas expressed by other historians. Such overlapping but isolated scholarship has inevitably created redundancies and has scattered through the literature important ideas that should be considered together in order to answer the many questions that the *Pietà* and its history generate. In preparing this monograph, I sought to retrieve documents, examine them carefully, and lay out the major hypotheses relating to each of the important issues. I have also gathered as much state-of-the-art information on the statue's physical characteristics as possible.

PLATE I

Michelangelo (Italian, 1475–1564), Pietà, *c. 1550. Marble, 7 ft. 5 in. (2.3 m). Museo dell'Opera di Santa Maria del Fiore, Florence. Detail: The Magdalene, full figure from the left*

9

A second guiding principle for this monograph has been that since this *Pietà* has so many ramifications, its issues would best be treated through the collaboration of specialists whose expertise can properly analyze and address specific problems that have never been adequately considered. I worked closely with several individuals and three institutions in the research and preparation of this book, and each made specialized contributions toward solving the new and old problems of the *Pietà*. As my text points out, in places I come to a different conclusion than do individual contributors, but this is a natural, and not unwelcome, result of such a cooperative venture.

The distinguished contributors help to make this a more complete study of Michelangelo's statue than any one author could write. Franca Trinchieri Camiz, art historian and archivist, was in the process of exhaustive archival research on the history of the statue in Rome when she became terminally ill, and I completed her important contribution to this volume. Monsignor Timothy Verdon, canon of the Florence Cathedral and professor of art history, has written an essay discussing the numerous theological references to the doctrine of the Eucharist in the Catholic Church and its multiple and subtle manifestations in the statue. Peter Rockwell lends his skills as a marble sculptor to an important essay on the various carving procedures used in the statue and its mutilation.

Of the three institutions that participated in this study, the first, the Opificio delle Pietre Dure (OPD), a state agency in Florence responsible for the restoration of stone sculpture, conducted important tests on the statue's surfaces and stucco in-fills. The second, the Ente per le Nuove Tecnologie, l'Energia e l'Ambiente Unità Salvaguardia Patrimonio Artistico (ENEA), a state agency in Rome responsible for the protection of Italian artistic patrimony, performed a gamma-ray examination of the restored areas of the statue in order to determine the nature, placement, and condition of the pins that had been used to reassemble the parts and how they had been inserted. They cautioned me that the process was not easily accomplished, because in order to penetrate the marble of the *Pietà*, the gamma radiation would have to proceed for a half-hour or an hour and could be dangerous to the health of anyone within its reach. The ENEA scientists investigated the area where the statue was located in the museum and its relation to the street and to a neighboring building. We were very fortunate that the building was unused and that the statue was well distanced from the street, so the gamma-ray photography could proceed.

The International Business Machine Corporation (IBM) was the third institution to participate in this study. The IBM Corporation became an inestimable collaborator in this endeavor and presented me with the unique ability to analyze alternate views of the Florence *Pietà* through a virtual computerized model it made of the statue, a research tool that offers numerous advantages over traditional methods, such as photography. For example, it allows one to view the statue in visually manageable size and from various angles—from below, from above, in the round—and to reduce the view of the statue down to its core block, to what remained after Michelangelo's destruction of it. I had heard of the new technology of making virtual models some years back, and it occurred to me that such

an image would be essential for my study of Michelangelo's *Pietà*. The problem, of course, was how to make contact with a technology firm such as IBM and convince them to undertake my project. In a happy coincidence, it turned out that a friend and former undergraduate student of mine from many decades ago, David Lenefsky, was also a friend of the president of the IBM International Foundation, Stanley Litow, to whom he introduced the idea of my wish to have a virtual image of the *Pietà*. In 1997 I submitted a detailed proposal to the foundation, and two months later I received a call from the vice president of the IBM International Foundation, Paula Baker. She warned me that although the IBM research scientists were enthusiastic about the project, its costs had yet to be determined and she felt that it might exceed the foundation's budget. Several months later, she called again to inform me that no less than the chief executive officer of IBM had approved the project and that the scanning of the statue would soon begin! The work was slow and painstaking, and on several occasions the specially manufactured digital camera failed to function. At each failure my heart skipped a beat. The experience was exhilarating, as was the image, when I witnessed the virtual model gradually emerge on the computer screen. For the first time, I have been using a digitized virtual model as a tool in art-historical research.[1]

One of the most important tools for the study of any work of art is excellent photographic material, and I have sought to procure the very best for this publication. Although there is a fine tradition of late-nineteenth-century photographers who have documented the *Pietà* with great skill—such as Giacomo Brogi; James and Domenico Anderson; and Leopoldo, Giuseppe, and Romualdo Alinari[2]—I felt that a new and complete set of photographs would need to be taken because the existing images did not capture the variety and details of the anatomy of the figures and the surfaces of the marble. After interviewing several photographers, I was able to settle quite confidently on Aurelio Amendola for the task. He has created many breathtaking and artistic photographs of Renaissance sculpture and quickly grasped that in this case, we also needed tools for modern research.[3] We worked very closely together, and I can attest that he was able to adjust the lamps and take photographs that make Michelangelo's surface details come alive, even when faced with areas of the marble that are the most difficult to light and view clearly.

In addition to the valuable visual aids the IBM Corporation and Aurelio Amendola produced, I also commissioned for this monograph diagrams that identify findings of the various technical analyses: chisel use and recarvings, connecting pins, the severed pieces, and locations and nature of the diverse stucco in-fill compositions. The virtual model and supplementary visual and textual documentation is also provided in the accompanying CD-ROM, produced by IBM.

Coordinating such a team of collaborators was often an anxiety-producing experience. What if one of the Italian state organizations found it impossible to carry out a procedure? What if the great technological giant IBM would not agree to scan the statue, or if the result of the scanning did not meet our expectations? The answer to such questions is that the book still might have been a useful one as a traditional monographic study. Success in all these endeavors, however, has given the book a significant dimension, making it unlike any other study of Renaissance sculpture.

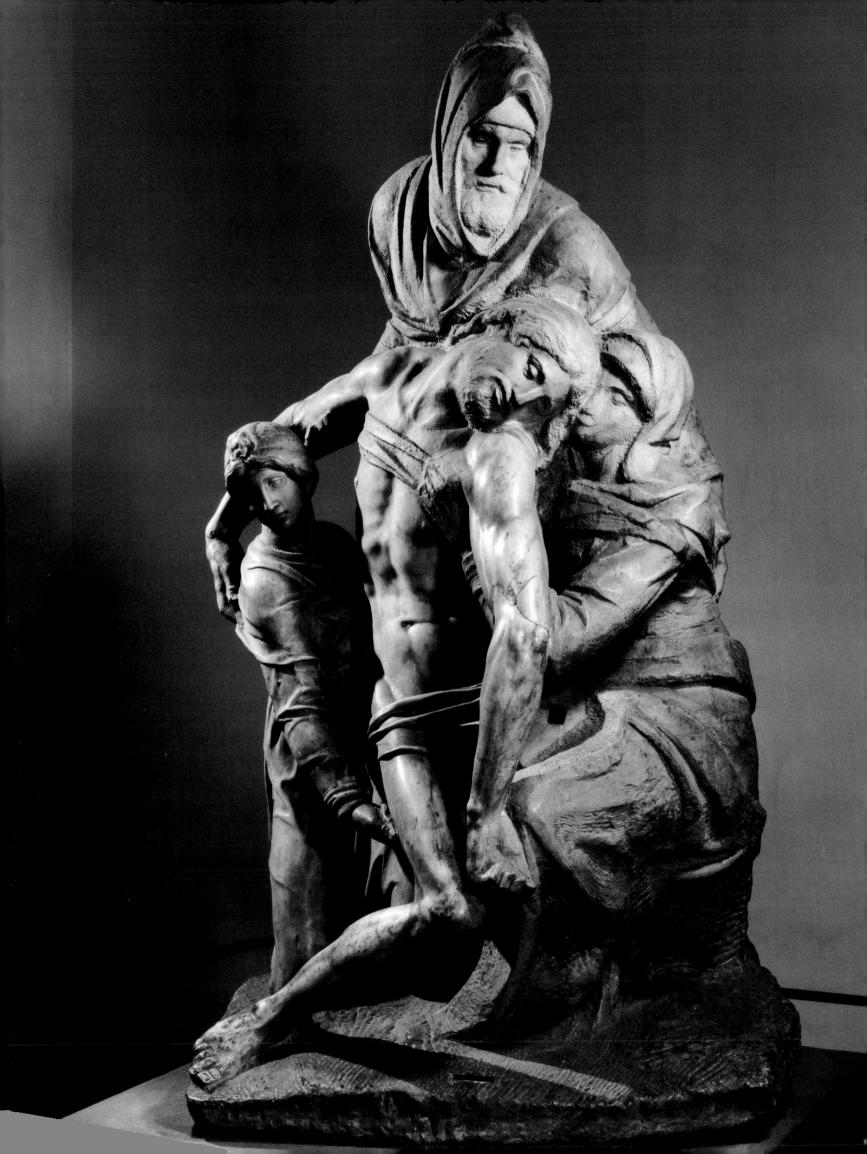

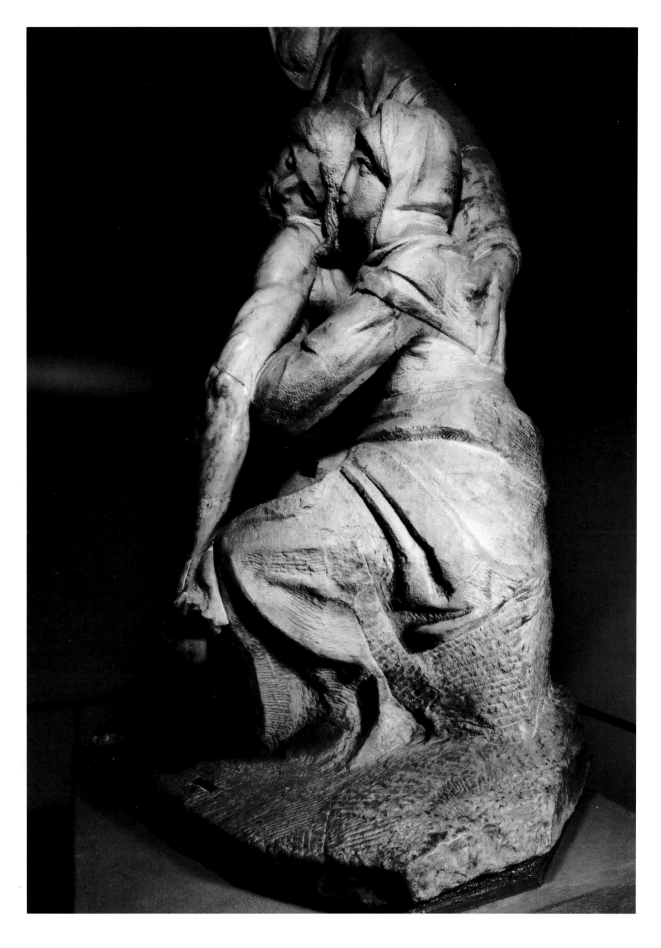

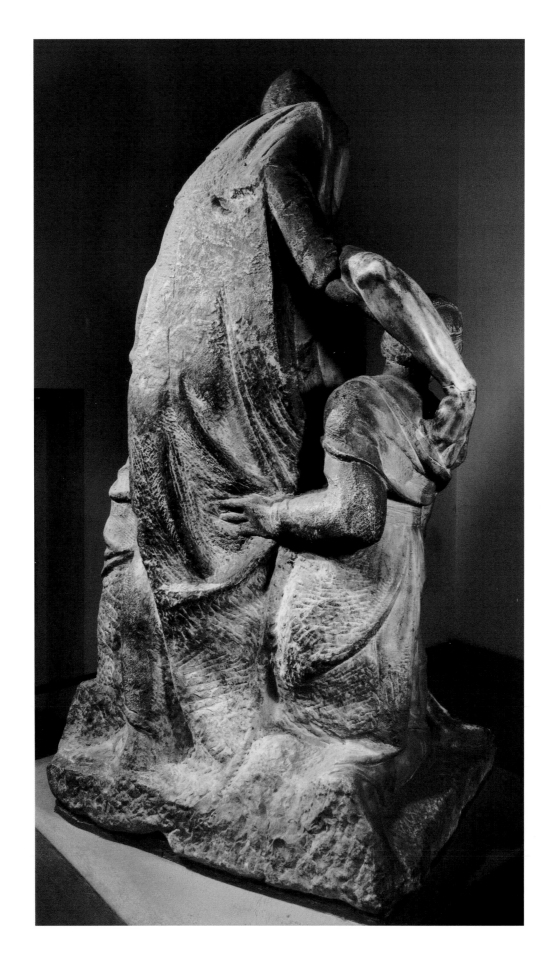

PLATE 4
View of the back, from the right

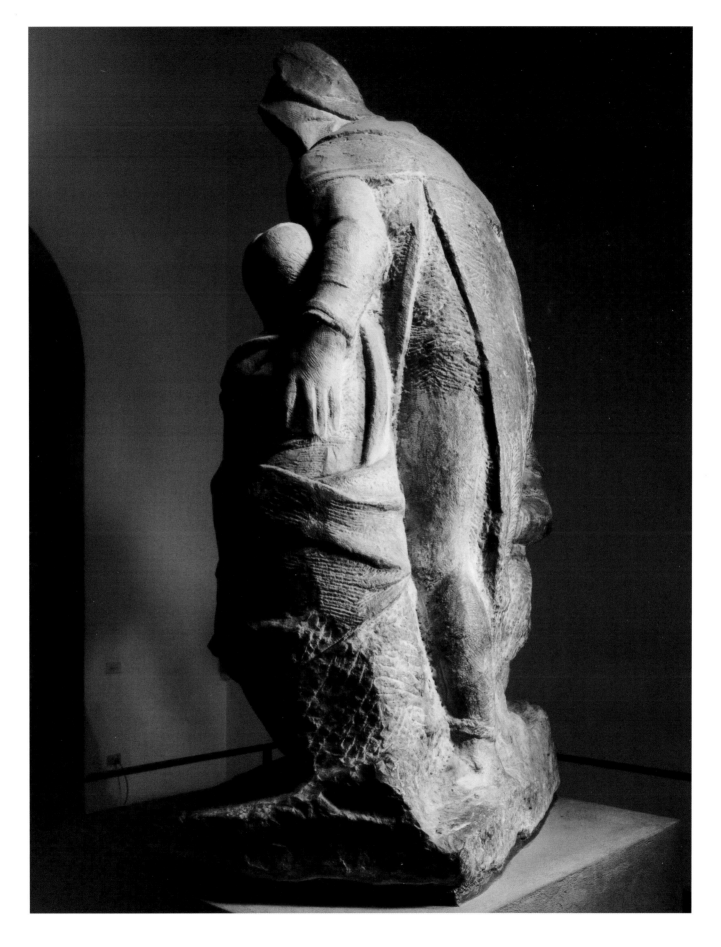

PLATE 5
View of the back, from the left

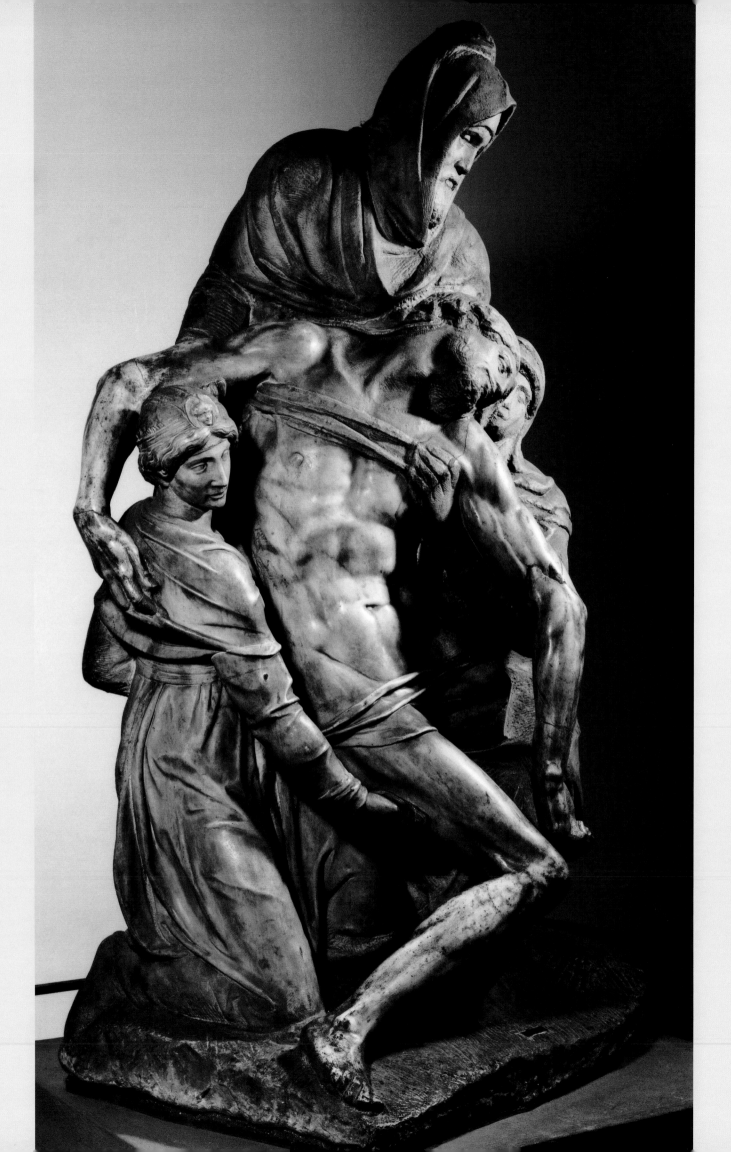

INTRODUCTION

MICHELANGELO WAS IN HIS MID-SEVENTIES when, around 1550, he began to carve a huge block of white Carrara marble, measuring 7 feet 5 inches high (2.3 m).[1] Ascanio Condivi, in 1553, and Giorgio Vasari, in 1568,[2] both friends and biographers of the master, described the statue as composed of four figures: Christ, deposed from the cross, is sustained by the Virgin Mary as he descends into her arms. Because the mother, in her extreme sorrow, is incapable of supporting the body of her son alone, the Virgin is helped in her effort by a bearded man the biographers call Nicodemus and by a female figure they identify as "another Mary."

Vasari's *Lives of the Painters, Sculptors, and Architects* of 1568 is the major source for what we know of the *Pietà*'s history during Michelangelo's lifetime. We read there that the Florence statue is the last of three marble *Pietà*s that the artist created over a lifetime of activity (plate 2).[3] The earliest, Michelangelo's renowned *Pietà* in St. Peter's, Rome (plate 7), was carved when he was a young man of twenty-three. The general motif of that work, the seated Virgin with the dead Christ recumbent in her lap, was a traditional form that had been established during the Middle Ages and continued to dominate the representation of the subject in the sixteenth century and after. The style of the St. Peter's *Pietà* is typical of the High Renaissance in its classical perfection and beauty of form and in its highly finished and lustrous surfaces. It portrays the quiet, tender reserve of the mother resigned to her son's martyrdom. The Virgin eloquently communicates

PLATE 6

View from oblique left

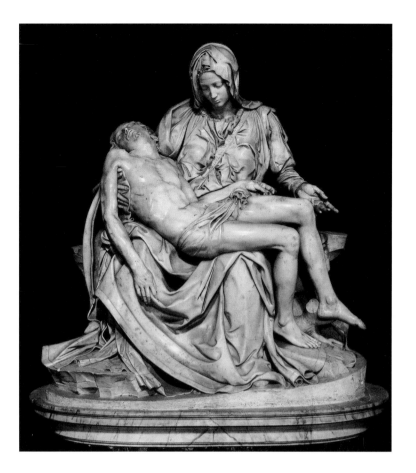 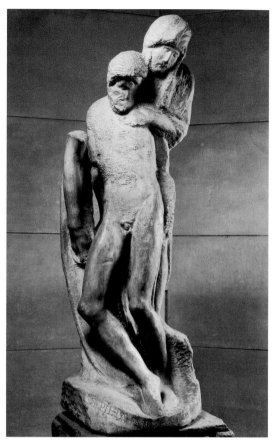

her acquiescence to her son's destiny with her inclined head and the listless, sideward gesture of her open-palmed left hand.[4]

The Rondanini *Pietà*, in the Museo Civico in Milan (plate 8), is the second of Michelangelo's versions of the Pietà subject.[5] Like the St. Peter's *Pietà*, the composition consists of two figures, Christ and the Virgin, but the relationship between them is very different. Now a standing Virgin holds her lifeless son upright.[6] This statue imparts a spiritual intensity in the unnatural demands it makes on the Virgin to support the corpse, but the event is frozen in time.

The Florence *Pietà* is Michelangelo's last treatment of the subject, and it is unique among the three.[7] The artist conceived the statue on a monumental scale and gave it a more personal imprint by representing his own features on the face of the bearded man who holds Christ's body in its descent from the cross.[8] He also departed from both the iconic composition of the St. Peter's *Pietà* and the implicit and static narrative of the Rondanini *Pietà*, in which the Virgin may be interpreted as lowering Christ toward an invisible tomb or Stone of Unction, the slab on which the body would be anointed before burial. As I discuss in detail in chapter 2, in the Florence *Pietà*, Michelangelo has combined the four figures into an unambiguous narrative of the crucified Christ being returned to his mother. Thus, the artist made Christ's mystical death vivid and palpable.

Vasari tells us that Michelangelo carved the monumental statue with its larger-than-life figures (plate 2) "to amuse himself, to pass the time of day, and . . . to keep his body healthy."[9] Michelangelo complained constantly in his letters of being

old and in poor health,[10] so are we to believe he actually wanted to engage in such strenuous labor for these reasons alone? In fact, Vasari added a more compelling explanation: that Michelangelo was making the statue as a marker for his own tomb. Together, these reasons imply that the artist was carving this Christian monument for its redemptive powers, without a commission from a patron.[11] But Vasari reports that after laboring on the statue for several years, Michelangelo suddenly began to attack it and would have destroyed it entirely but for the timely intervention of his servant, whom Vasari identifies only as Antonio.[12] After this, the statue changed hands several times. Michelangelo gave the *Pietà* to his servant in its ruined condition. Then a Florentine banker, Francesco Bandini, purchased it and commissioned Tiberio Calcagni, Michelangelo's assistant, to repair and complete the statue. However, it remained incomplete and later in the century became a garden ornament in a suburban villa on the Quirinal Hill in Rome owned by Francesco's son, Pierantonio Bandini.

The most contentious aspect of Vasari's account is the variety of conflicting reasons he gave to explain Michelangelo's attempt to destroy the *Pietà*. First he claimed that Michelangelo found the stone difficult to carve because it was hard and had many cracks. He then asserted that Michelangelo's artistic concepts were too great to be translated into statuary, leaving the master dissatisfied with anything he did. Vasari finally maintained that Michelangelo's anger against his statue was aroused by another servant, Urbino, who had nagged him to complete the work, which the artist had already grown to hate. Historians have not reached any consensus over the claims. A number recite Vasari's arguments verbatim, some have selected one or another of them as being factual, and still others have implicitly rejected all three of Vasari's arguments by proposing alternatives of their own. I find none of the existing explanations persuasive and will, in the course of the book, offer another reason to account for Michelangelo's aggressive behavior toward his creation.

There are still many more unresolved problems connected with the early history of the *Pietà*. With good reason, no one doubts Vasari when he states that Michelangelo began the *Pietà* as a monument for his own tomb; that Antonio halted the artist's attack on the statue and received it as a gift from the master; that Calcagni repaired and recarved the statue; and that it was installed in the Bandini garden on the Quirinal Hill. I do take issue, however, with the historians who accept Vasari's assertions that Michelangelo chose Santa Maria Maggiore—which they identify with the basilica in Rome—as his burial church, and, more important, that he intended to destroy the statue outright.

Scholars have debated additional questions raised by Vasari's account. Is the statue properly entitled a *Pietà* and does it represent Christ descending from the cross into the lap of the Virgin? Is the bearded male who holds Christ from behind really Nicodemus, or is he Joseph of Arimathea? What was his servant Urbino's actual role, if any, in causing Michelangelo to break up the *Pietà*?

And then there are the questions that Vasari leaves unresolved. Most of these problems are not satisfactorily explored in the Michelangelo literature. When did Michelangelo begin working on the statue? Who was responsible for the

Magdalene's diminutive size in comparison to the other three figures? What was the relationship between the *Pietà* and the altar in Michelangelo's proposed funerary chapel? When, exactly, did he mutilate the statue and when did Antonio and later Francesco Bandini acquire it? How many and what fragments did Calcagni use in his restoration of the statue and how did he reassemble them? What parts of the statue did Calcagni himself carve? When was the statue placed in the Bandini garden? Where and how was it displayed and what role did it have as a Christian statue in a secular context? What is the religious message that Michelangelo sought to convey? These and other problems from the early history of the *Pietà* will be examined in the chapters that follow.

The main body of this text analyzes questions and problems connected with Michelangelo's Florence *Pietà* in eight chapters, six of which I wrote. In the first and second chapters I discuss the origins and function of the statue, its chronology, and the reasons for its inception. These chapters also address the problems of its title and subject matter, its visual and iconographic sources, the formal significance of its composition, and aspects of its religious content. In chapter 3 I analyze the attempts of Vasari and modern scholars to solve, with conflicting conclusions, the problem of Michelangelo's attack on the statue. I propose my own hypothesis, based on an essential question that, to my knowledge, has not been raised before: Did Michelangelo really set out to destroy the statue? In the fourth chapter I examine the evidence for the date of Francesco Bandini's acquisition of the *Pietà* and Tiberio Calcagni's restoration. In the course of this analysis I attempt to identify the pieces Michelangelo had broken away, to reconstruct Calcagni's method of reassembling them, and to explore the extent of his responsibility for making new pieces and recarving the statue's surfaces.

Franca Trinchieri Camiz, an art historian and archivist, wrote the fifth chapter. Using the extensive documents she unearthed in the archives in Rome and Florence, she located the site that the *Pietà* occupied in the Bandini garden on the Quirinal Hill, determined the role of the statue in such a secular setting, and established most of the changes of ownership it underwent until 1660. As she had become terminally ill and was unable to complete her contribution to this volume, I continued Ms. Camiz's archival researches after her death and, guided by the direction they were taking, I uncovered additional documents for the history of the statue in Rome. I wrote the small portion of her essay that extends the statue's provenance from 1660 to its purchase by Cosimo III in 1671. This chapter is the most complete record since Vasari's of the fortunes of the *Pietà* during its sojourn in Rome.

In chapter 6, with the aid of newly discovered documents, I trace the movements of the *Pietà* from its arrival in Florence until its entry in the Museo dell'Opera di Santa Maria del Fiore. In the process, I reassess old questions, such as the statue's presumed initial placement in the crypt of San Lorenzo and the conditions under which it was relocated in the Duomo prior to entering the Opera Museum. I also deal with new questions, among them the relationship between the *Pietà* and the Duomo, the efforts to find an appropriate site for the statue, and the circumstances leading to its installation in the Opera Museum.[13] In chapter 7

I trace the not-always-favorable response to the statue by artists and others from the sixteenth to the beginning of the twentieth century. Chapter 8 is an iconographical study of the *Pietà* by Monsignor Timothy Verdon, who analyzes specific references to the figure of Christ and its connection to a Eucharistic setting above an altar. Verdon fills out this interpretation with numerous theological references to the multiple and subtle doctrinal manifestations in the statue.

The second part of the volume consists of a rich and multidisciplinary set of resources including technical and scientific studies that aim at clarifying and revising the history of the *Pietà* from its inception to its reception through the centuries. This part of the volume begins with an essay by Peter Rockwell, a sculptor in stone and consultant to restorers, who has studied Michelangelo's carving technique. He has examined the surfaces and the damaged areas of the *Pietà* more extensively than anyone ever before, identifying Michelangelo's carving tools, the order in which he used them on the statue, and the nature of the surfaces they produced.[14] He also develops a hypothesis of how Michelangelo broke up the statue and determines the extent and character of Calcagni's restoration of the work.

Three technical reports follow Rockwell's essay. The first is the report of the Ente per le Nuove Tecnologie, l'Energia e l'Ambiente Unità Salvaguardia Patrimonio Artistico (ENEA) on the gamma-ray examination of the statue. Pietro Moioli, the ENEA scientist responsible for the examination, explains the technical details of the operation, describing the type and length of pins and their method of insertion.[15] This is followed by the results of the analysis undertaken by scientists from the Opificio delle Pietre Dure (OPD), led by the director of the scientific laboratories, Mauro Matteini, of the various deposits, drip marks, patinations, and stucco compositions on the *Pietà*.[16] The IBM virtual model of the statue (plate 9) is discussed in the next essay by Holly Rushmeier, Fausto Bernardini, and others of the team that devised the program and scanned the *Pietà* directly. They report the story of their endeavor in the next essay in the resources. A further appendix assembles all the known documents—published and unpublished—that mention the sculpture. Finally, there is an analytic catalogue of works of art, which I compiled, that derive from this venerated statue.

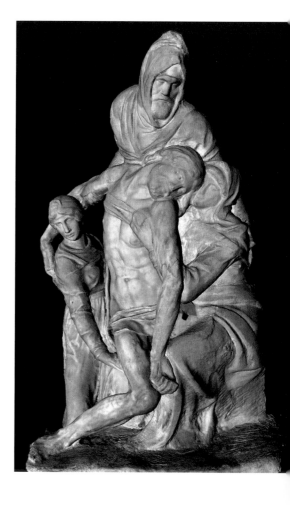

PLATE 9
Virtual model, eye-level view

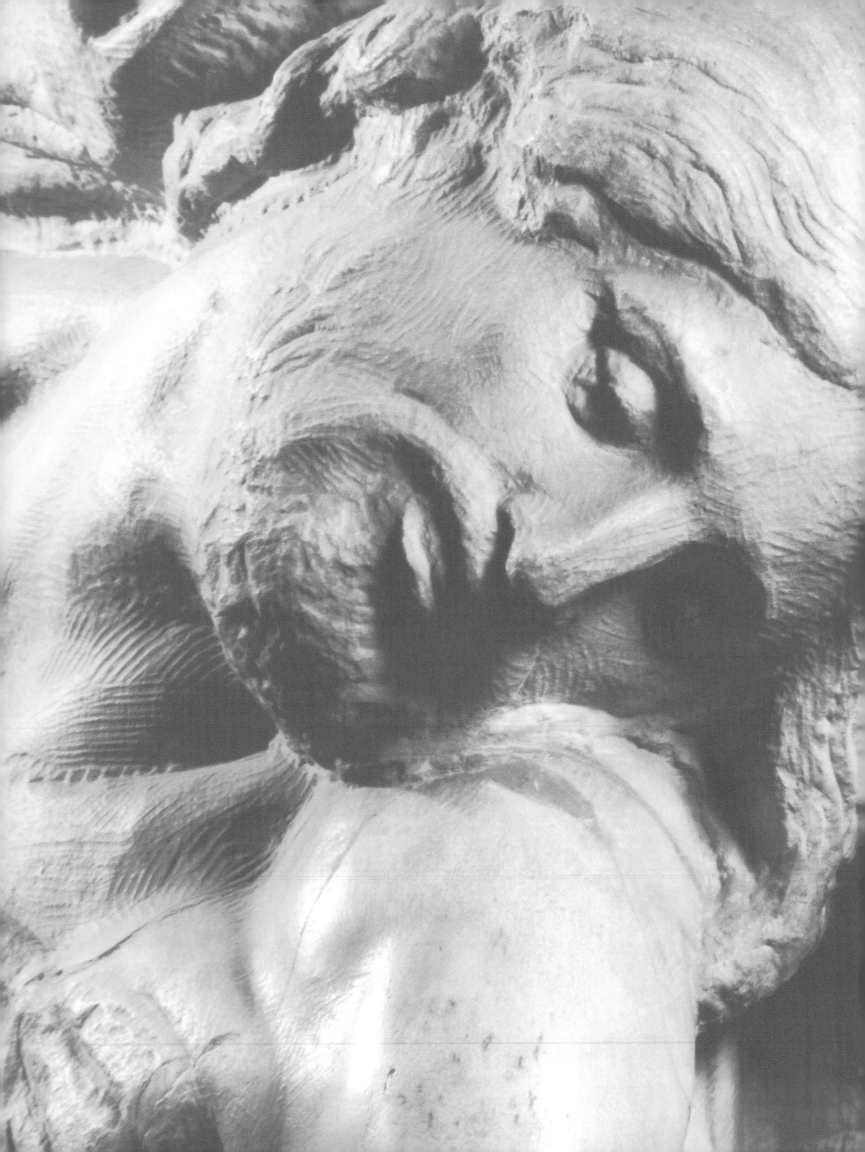

I

CREATION
AND HISTORY

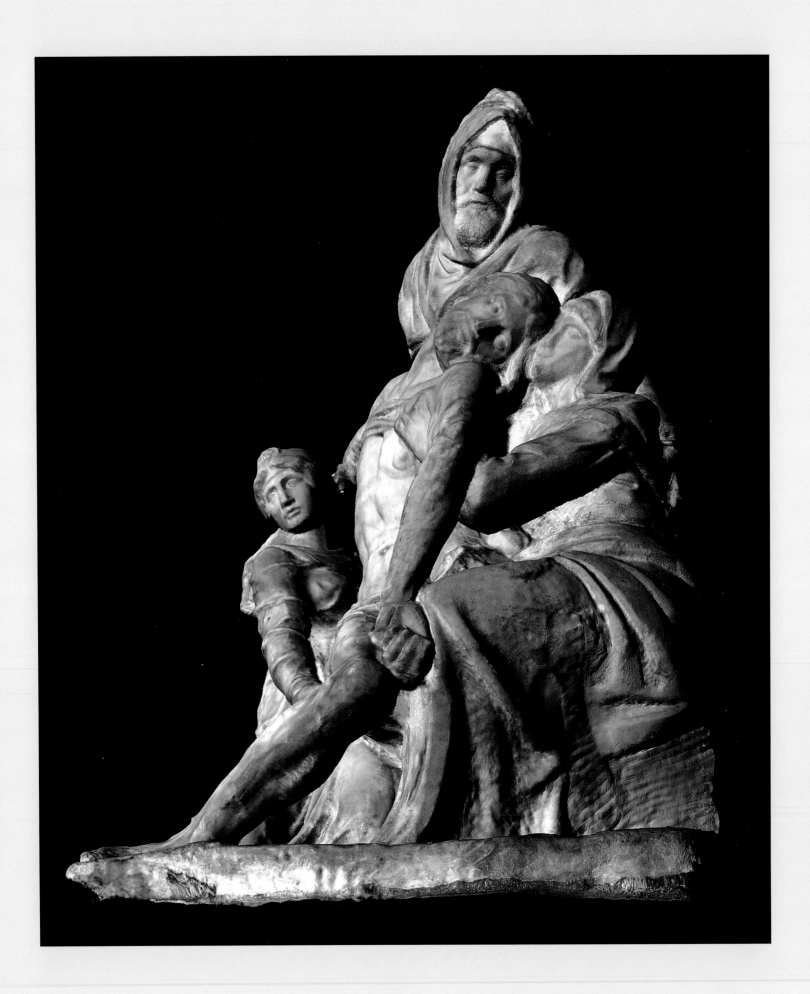

I

ORIGIN
AND FUNCTION

THE FUNERARY CHAPEL THAT MICHELANGELO contemplated for himself was utterly simple. Giorgio Vasari tells us that Michelangelo "had wanted [the *Pietà*] to serve at his own tomb, which was to be at the foot of the altar where he thought to place [the statue]."[1] Although his sentence in the original Italian is ambiguous, it is clear enough to indicate that the chapel was to consist of the *Pietà*, an altar, and the artist's tomb. This contrasts sharply with the little-known funeral chapel that Michelangelo had in mind as a younger man in Florence, which, according to sixteenth-century humanist and historian Benedetto Varchi, was to have been grand in scale and enclosed in a separate room. In his eulogy at the Michelangelo commemorative services in the church of San Lorenzo in Florence in 1564, Varchi announced that the artist—at an unspecified date, but possibly in the early 1530s, at the age of about fifty-five—had negotiated with the friars of Santa Croce in Florence "to grant him a place in their very spacious church so that he could build a chapel in which to place his tomb; promising them . . . that, in addition to the architecture, he would make with his own hands many paintings, sculptures, and ornaments so that foreigners who passed through Florence would go first to Santa Croce, to see that chapel."[2] Nearly twenty years later, however, Michelangelo was planning not an enclosed chapel, but one—if we interpret Vasari correctly—that was to consist of the statue and an altar placed against the wall of a nave or side aisle, with the artist's tomb in the pavement in front of or under the altar.

PLATE 10
Virtual model, view from below

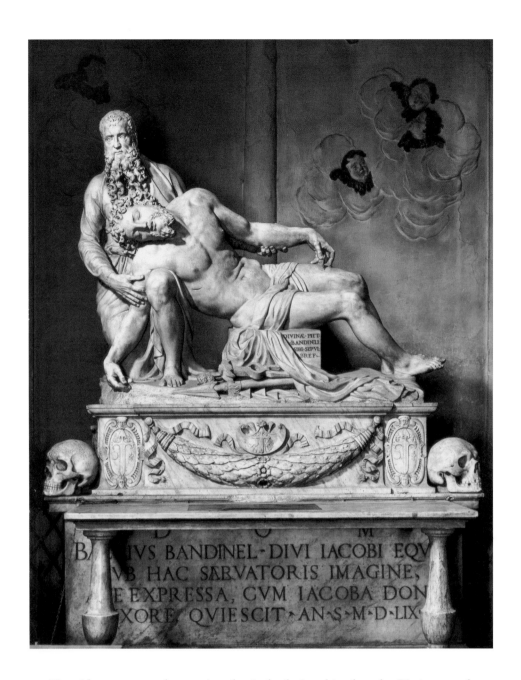

Vasari leaves vague the precise physical relationship that the *Pietà* was to have
to the altar. Historians tend to place the statue directly on the altar table, citing
as an example the *Pietà* that the sixteenth-century Florentine sculptor Baccio
Bandinelli made for his own funerary chapel in Santissima Annunziata, which,
according to Vasari, was conceived in imitation of Michelangelo's intentions (plate
11).[3] But the two situations are different. Bandinelli's group is not on the altar itself,
instead it rests on a solid structure attached to the rear of the altar. This arrange-
ment was probably compulsory, since the altar table does not seem strong enough
to support the weighty two-figure statue. In any case, it would have been neces-
sary because the altar is not located against a wall, but freestanding in the open
space of the chapel.[4] Had the altar been adjacent to a wall, Bandinelli most likely
would have displayed his statue above it, as Renaissance tradition dictates. Anto-
nio da Sangallo, for example, in 1525 arranged his statue of St. James above an

altar that is set against a wall in the Serra Chapel in San Giacomo degli Spagnoli in Rome.[5]

If it is true that Michelangelo had planned a wall arrangement for his funerary ensemble, did he, like Sangallo, consider placing his statue above the altar? The IBM virtual model of the *Pietà*, a potent new research tool, yields striking results to this question. As seen in its present installation at eye level on a low base, the proportions and composition of the statue appear to be distorted (plates 2, 6, and 9). Christ's arms, which are approximately equal in their dimensions, appear unequal in the museum's display of the statue: the left limb seems considerably longer than the right one.[6] The four figures, moreover, appear excessively compressed into an almost two-dimensional configuration, while Christ seems semi-detached from his mourners and his torso is sharply vertical, eccentricities that are emphasized by the steep fall of the left arm. Finally, Mary Magdalene's body is not entirely visible, her left leg hidden behind the right leg of Christ.

But an experiment made with the model so that it is raised and seen from below (plate 10)—an operation that is impossible to perform with the statue itself, because of its great weight (possibly several tons)[7]—demonstrates that Michelangelo would indeed have raised the *Pietà* to the approximate height of Sangallo's Serra Chapel statue, whose base is at about head level of an average person, that is, 5 feet 8 inches (1.7 m) above the pavement and 20 inches (51 cm) above the altar table.[8] With the virtual model raised to this height, all the apparent discrepancies we noted prove to be the result of Michelangelo's adjustment for optical distortions of distance and angle. The arms now appear approximately equal and the statue acquires a three-dimensionality, which is especially noticeable in Christ's body; it inclines inward from his forward projecting right knee to the inner right shoulder and arm. Consequently, Christ settles back into the group in an intimate physical relationship with the Virgin and the bearded figure behind him. His position is comparable to that in the figure of Christ in a woodcut by Albrecht Dürer of a *Trinity* (plate 12) and a painted *Pietà* by Andrea del Sarto,[9] both works considered to be Michelangelo's compositional sources. As for the Magdalene, her left knee becomes visible and spatially separated from Christ's leg, and her figure acquires a distinctly triangular shape.

Renaissance practice—exemplified by Sangallo's statue—may serve also as a guide for positioning Michelangelo's *Pietà* in a niche above an altar,[10] the structural setting that would be required to accommodate the statue's great weight. I demonstrate this concept with another important contribution of IBM: a virtual construction of the setting as Michelangelo may have planned it (plate 13). Also in accordance with Renaissance tradition—and, incidentally, with Michelangelo's own practice—the *Pietà* would have been sited with its base parallel to the front platform of the niche (plate 2).[11] In this position the statue achieves reasonable symmetry, the two sides bisected by a vertical axis formed by the head of the bearded figure and Christ's left arm. The niche would probably have been rectangular in shape, which is the form Michelangelo favored beginning with the Medici Chapel in Florence of 1523.[12]

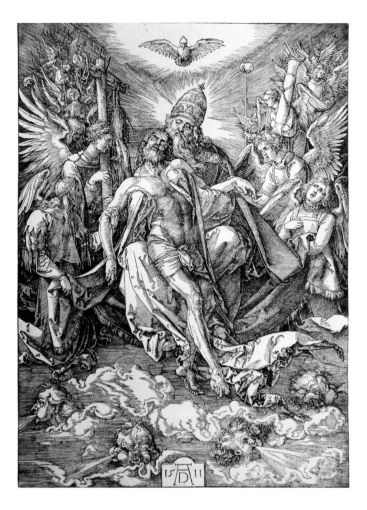

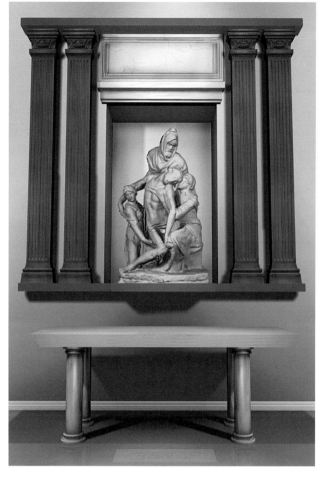

• • •

Michelangelo's intention to use the *Pietà* as his funerary monument raises the question of the identity of the church in which he hoped to be buried. Condivi, in 1553, referred to it as "some church."[13] Years later, in 1568, Vasari gave the name of Santa Maria Maggiore to the sanctuary, without, however, specifying the city in which it was located. The site is universally identified today with the basilica of Santa Maria Maggiore on the Esquiline Hill in Rome.[14] Yet the accuracy of Vasari's claim is open to question, since Michelangelo had no formal connection with this building in the years when he carved the statue.[15] Only about a decade after he began the *Pietà*, in 1560, did Michelangelo design the Sforza Chapel in this church.[16] If Rome was to be his intended city of burial, he had personal associations with three other churches. Two were situated in his own neighborhood: Santissimi Apostoli, where, according to Vasari, his corpse lay temporarily in state before being transported to Florence,[17] and San Silvestro al Quirinale, where on several occasions in 1538 or 1539 he discussed questions of art with Vittoria Colonna, his intimate spiritual friend.[18] San Giovanni Decollato, the third church, was the headquarters of a charitable organization, the Confraternita della Pietà, in which Michelangelo was inscribed as early as 1514.[19] But if, indeed, personal association was a factor in Michelangelo's choice of a burial place, as one might expect, then

we should more correctly look to Florence as the location of the church, and Santa Croce would be the logical church.

Let us pursue this idea in an orderly fashion. When Vasari cites Santa Maria Maggiore as Michelangelo's choice for a tomb chapel, he entraps himself in an apparent contradiction. He mentions the Roman basilica only once in this connection, in his chapter on Baccio Bandinelli in the *Lives* of 1568.[20] But several chapters later, in his life of Michelangelo, Vasari publishes a letter Michelangelo wrote to him in 1554 that declares, "Know for certain that I would be happy to lay my feeble bones beside those of my father, as you ask me to do."[21] His father is buried in the cloister of Santa Croce in Florence.[22] What prevented him from fulfilling this desire, Michelangelo added, was an urgent need to complete the construction of St. Peter's.[23] Vasari also notes Michelangelo's plea to those who were present at his deathbed in February 1564, that upon his demise they attend to the return of his body to Florence.[24] From one of those friends, the sculptor and painter Daniele da Volterra, Vasari learned on 17 March 1564 that "Michelangelo's nephew. . . ordered the body transported to Florence, as Michelangelo commanded us to do many times when he was well, and even two days before his death."[25]

We may account for the discrepancy in Vasari's text in several ways. Since Vasari does not mention in what city Santa Maria Maggiore is located, he actually may have had in mind the Florentine church that bears the same name. This building is near the Duomo and among that city's oldest and most venerable sanctuaries. Alternatively, Vasari may have been guilty of a slip of the pen, intending to write, say, Santa Maria dei Martiri (the Pantheon), where Raphael is entombed and where Michelangelo may have felt himself worthy of such an honorable burial.[26] Finally, Vasari may unconsciously have conflated the names of two Florentine churches that are associated with Michelangelo's funeral in Florence in 1564: Santa Maria del Fiore (the Duomo)—in which, he notes, Cosimo I suggested that Michelangelo be interred[27]—and San Piero Maggiore—in which, he writes, Michelangelo's corpse was placed upon its arrival in Florence while awaiting entombment in Santa Croce.[28]

Vasari was, after all, not immune to error when discussing the *Pietà*. For example, in the chapter where he mentions Santa Maria Maggiore, he describes the statue as already finished and as comprising five figures, rather than the actual four.[29] He certainly knew better, since in the earlier edition of the *Lives* published in 1550 he had noted its unfinished character and the fact that there were four figures.[30] Moreover, by the time he wrote his 1568 version of the life of Michelangelo he was able to refer to the unfinished condition of the *Pietà*, its composition of four figures, and Michelangelo's plans for burial in the Florentine church of Santa Croce.

Michelangelo had begun the *Pietà* by 1550, when Vasari mentioned it in the first edition of the *Lives*. We cannot be more specific than 1550 with any certainty because we have no documents to date its inception. Several alternative dates have been proposed, the most reasonable being 1547 and 1549–50.[31] Two arguments are used to support the 1547 date. One is that the artist was motivated to

begin the *Pietà* out of despair over the death of his friend Vittoria Colonna on 25 February 1547.[32] Colonna's profound spiritual influence on Michelangelo is well known, so the theory that Michelangelo may have considered the Florence *Pietà* a tribute to her memory is difficult to dispute.[33]

A more pragmatic argument in favor of the 1547 dating is that Paolo Giovio, a bishop and historian on friendly terms with Michelangelo, informed Vasari of the existence of the statue in time for the latter to insert a reference to it into the text of the 1550 edition of the *Lives*.[34] According to this line of reasoning, Vasari, who had sent the manuscript to Giovio in 1547 for his comments and criticism, would have been alerted of the existence of the *Pietà*.[35] The difficulty of this argument is that Giovio does not mention the statue in any of the letters he wrote to Vasari that refer to the manuscript. For example, in one dated 10 December 1547, he wrote only that "I noted little that struck me and I encourage you to publish the book in any case."[36] A brief and non-substantive comment such as this cannot sustain anything as significant as news of a monumental statue by the greatly admired artist. There is always the possibility, of course, that Giovio had mentioned the statue in an annotation in the draft copy, which has not survived.

The alternative date of 1549–50 is also dogged by uncertainty. It is mainly filtered through the 1568 edition of Vasari's *Lives*.[37] Vasari seems to suggest 1549–50 when he discusses the *Pietà* after concluding that Michelangelo's frescoes in the Pauline Chapel in the Vatican "were the last paintings he made, at the age of seventy-five."[38] Michelangelo celebrated his seventy-fifth birthday in 1550. Vasari also associated the making of the *Pietà* with the completion of the Pauline frescoes in 1550, writing that "according to what [Michelangelo] told me, he made them with great effort, because painting, after a certain age, especially work in fresco, is not an art for the old."[39] A short paragraph later, he writes: "Michelangelo could not mentally or by nature exist without doing something; and, since he could no longer paint, he concerned himself with a piece of marble with which to carve four round and larger than life figures, producing therein a dead Christ."[40] This comment makes it distinctly possible that Michelangelo began work on the *Pietà* in 1549–50.

The printing of the first edition of Vasari's *Lives* began in the summer of 1549 and was completed on 17 March 1550.[41] Thus, if the 1549–50 dating has credence, a reference to the statue would have to have been a last-minute addition to the text. That may well have happened, as a persuasive concatenation of circumstances would suggest. In early 1550, while the *Lives* were still being printed, Vasari left Florence for Rome to attend the coronation of his patron, Cardinal del Monte as Pope Julius III (r. 1550–55) on 22 February.[42] He gave friends the responsibility of seeing the manuscript through the press. But then, within a fortnight of his arrival in Rome, Vasari abruptly ordered the printing stopped. His letter to the press is lost, together with the exact nature of his concern.[43] However, when the book was finally published, in late March of 1550, it was "with the short addition you wanted," as one of his correspondents wrote to Vasari.[44] None of the correspondence identifies the item in question. It may, of course, refer to the dedication of the book to Julius III, which, it has been pointed out, "was among the last things

to be printed."[45] But can we not assume that Vasari would have included the dedication in the manuscript before leaving for Rome, since he went there specifically to attend the pope's coronation? The "short addition," in that case, may have referred to the *Pietà*. Indeed, Vasari certainly would have felt the statue to be important enough to require his sudden, inconvenient, and costly interruption of the book's printing. Moreover, Vasari's correspondent did note that the interruption he ordered occurred "mid-way into . . . Michelangelo's biography"; this is, in fact, precisely where the reference to the *Pietà* appears.[46]

Which of the dates is correct may not be of vital importance, since they are at most only three years apart. What does matter is that these few years in question encompass a critical moment in the religious history of the sixteenth century. The Council of Trent had been convened in 1545 to discuss and resolve the many questions of dogma and doctrine that were being raised by transalpine Protestants, who were defecting from the church, and by groups and individuals in Italy seeking reforms within the church. When Michelangelo began the *Pietà* he must have been aware of this religious divisiveness and of the Council's efforts to clarify and defend traditional institutional and spiritual values.

Yet, how can we judge, from looking at the statue, what Michelangelo thought and felt about these matters? We know at least that he was a deeply committed Catholic and probably encouraged in his faith by the emerging Counter Reformation.[47] In 1545 he had planned a pilgrimage to Santiago de Campostella, and in 1550 he did make a pilgrimage to the seven churches of Rome. In the same year he was, according to the papal historian Ludwig Pastor, "among those who endeavored to gain the Jubilee indulgence."[48] When his two brothers died, in 1548 and 1555, he was relieved to learn that one had died "confesso" (having confessed his sins), and the other with "all the sacraments that the Church ordains."[49] In 1556 he visited the sanctuary of Loreto as an act of devotion.[50] It is obvious that in the *Pietà* Michelangelo was creating a statue whose subject had been prevalent in Catholic Italy long before the advent of Protestantism and the ensuing Italian reform movement.

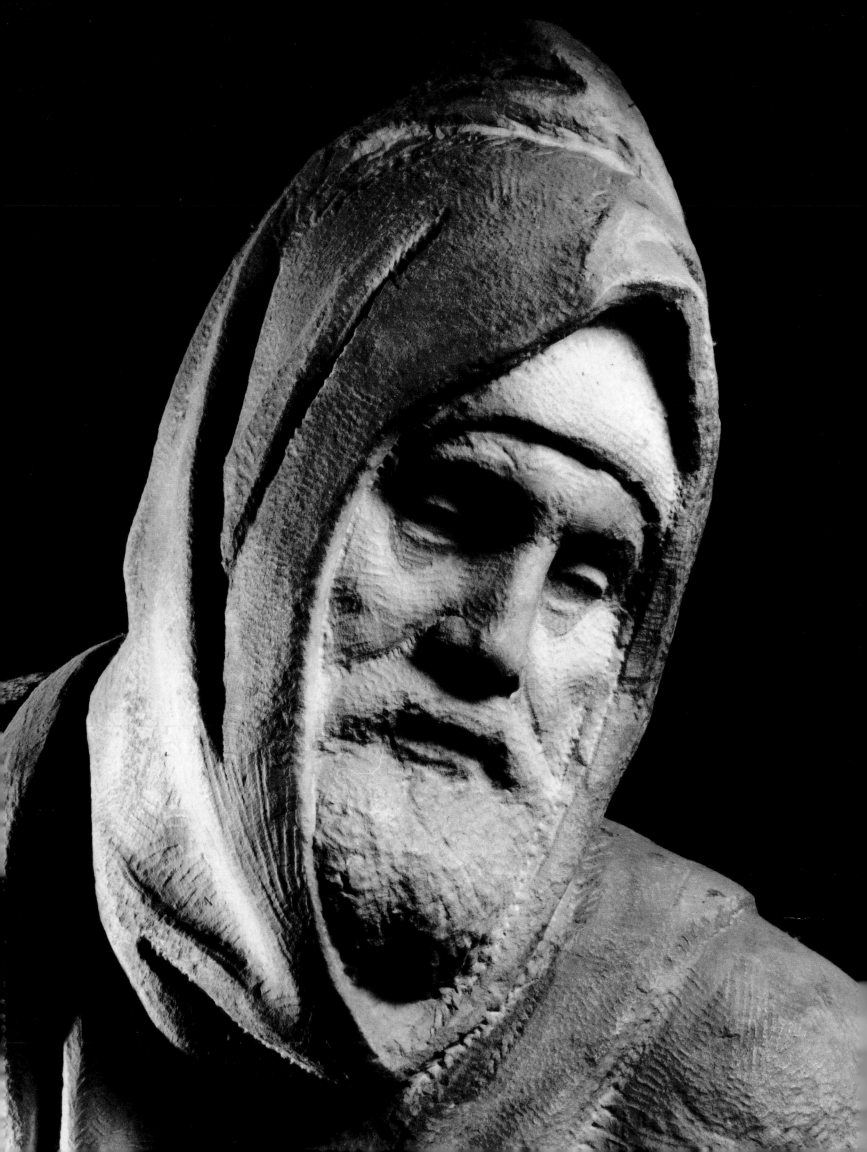

2

SUBJECT, CONTENT, AND FORM

WE HAVE REFERRED IN THIS STUDY to Michelangelo's Florence statue as a Pietà. So had Condivi and Vasari in the sixteenth century.[1] Condivi called it a Pietà once, and Vasari as many as six times,[2] both citing the composition of the Virgin mourning the body of Christ, who has been deposed from the cross and is embraced by his mother. Condivi's and Vasari's descriptions also identify Michelangelo's statue as a Pietà, as the scene was defined in the Renaissance: Luca Landucci, a Florentine apothecary and diarist, wrote in 1482 that the "Virgin seated and holding the dead Christ in her arms after he had been taken down from the cross . . . is called by some a Pietà."[3] The statue was referred to as a Pietà well into the nineteenth century.[4]

In 1873 Gaetano Milanesi interrupted the tradition. Disputing the fact that Giorgio Vasari called the statue a Pietà, Milanesi focused on the way Michelangelo's biographer happened to begin his description of the composition as "Christ deposed from the cross" and declared that the work "is not a Pietà, but a Descent of Christ from the cross."[5] Most historians call the statue a Pietà out of custom, but many of these attribute to the composition a variety of mostly incompatible themes.[6] In 1940 Herbert von Einem claimed that the statue represents a Lamentation.[7] He, at least, made a distinction between a traditional Pietà—which, like Michelangelo's *Pietà* in St. Peter's, is composed exclusively of Christ and the Virgin—and narrative compositions, which include other figures.[8] Nearly twenty

PLATE 14
The bearded figure's head from the front, slightly oblique view

33

years later, von Einem interpreted Christ in the Florence *Pietà* as the *imago pietatis*, the Man of Sorrows, a late medieval type in which the crucified Christ is represented as the eternal and redemptive sufferer.[9] In these symbolic images, Christ is unclothed, in an upright and frontal position; partially within a coffin or a full-length standing figure on the ground; alone or accompanied by the Virgin and other mourners; with his hands, marked by the nail wounds, turned in the direction of the observer. But to portray Christ as a Man of Sorrows, Michelangelo would have to isolate him partially from the three mourners and represent him in a strictly frontal and vertical position. Such a disciplined disposition of Christ assumes, moreover, that Michelangelo intended the statue to be seen at eye level, as it is currently installed in the Museo dell'Opera di Santa Maria del Fiore (plates 2 and 6). It allows the statue to be interpreted as the kind of abstract, timeless grouping of figures that gives the Man of Sorrows imagery its symbolic status. But the raised virtual model, as we have seen, quite convincingly shows this not to be the intended viewpoint (plate 10). At most, the traditional Man of Sorrows imagery had a compositional influence on the Florence *Pietà*, but not a conceptual or thematic one.

The art historian Frederick Hartt also created an incompatible relationship between the *Pietà* title and the composition as he saw it. "The time-honored Italian name 'Pietà' still seems the best," he writes, but he describes the statue as an Entombment.[10] According to Hartt, the bearded figure that supports Christ is not Nicodemus, as Condivi and Vasari identify him, but Joseph of Arimathea, who, in the Gospels, donated his own tomb as a sepulchre for Christ.[11] Thus Michelangelo, by giving the pious man his own features, makes his tomb under the altar hypothetically available to Christ, "who sinks toward it with a downward motion."[12] A major flaw with Hartt's interpretation, however, is that it does not take into account the missing left leg, which once fell over the thigh of the Virgin. In that position, the leg would in fact halt Christ's descent at her supporting lap.

Reinterpretation of the statue took a curious and sometimes untenable turn when various scholars began to conflate several subjects into single iconographies. In retrospect, Charles de Tolnay seems restrained in his claim that "The 'Pietà'... is in fact a fusion of a Deposition and a Lamentation," since the two scenes actually follow each other in uninterrupted succession.[13] De Tolnay verges on, but does not quite achieve, an accurate understanding of the statue's subject matter. The inadequacy of his interpretation, as we will see below, is that it implies a static, rather than dynamic, narrative composition. Howard Hibbard, on the other hand, flouted plausibility when he wrote that in Michelangelo's statue a "Deposition, a Pietà, and Entombment are fused into one iconic image,"[14] as did Glenn Andres and his coauthors, who maintain that "strictly speaking [the statue] is not a *Pietà*, but a composite *Deposition-Lamentation-Entombment*."[15] Only by projecting onto the statue a scene from the Passion we know will eventually take place, but which it does not specifically represent, can we interpret the composition as an Entombment. Finally, straining probability, Harald Keller described the statue as "more like the late medieval concept of *Deposition, Mourning,* and *Ecce homo*."[16]

In fact, it bears no relation to the imagery of Ecce homo, the event described by the evangelist John (19:4–15) in which the beaten and mocked Christ, wearing the crown of thorns on his head, stands before Pilate, the Roman procurator of Judea, who declares "Behold the man" (Ecce homo).[17]

Such conflations are troublesome because they rupture the unity of Michelangelo's conception of his *Pietà* as a dynamic ensemble, a composition in transition, with one episode evolving gradually into another—a Deposition at the point of becoming a Pietà. For this interpretation, we may invoke Condivi's early description of the statue, which seems to indicate that Michelangelo staged the four figures in a synchronized action that is still in progress and dictated by historical time and place.[18] Dominating the action, the bearded figure helps Christ in his descent from the cross. He holds up Christ's right arm with one hand (plates 35 and 63), the other he places on the back of the Virgin (plate 5), as if he were bringing mother and son together. The Virgin receives Christ in her embrace. She places her head against his and encircles his body with both arms. With her left hand she reaches under Christ's arm, settling it on his chest (plates 15 and 32); with her right hand she reaches behind Christ and grasps his right side at the level of the cloth that lies across his chest (plate 27).[19] Even Michelangelo's treatment of Mary Magdalene is part of a dynamic narrative that breaks radically with traditional representations of her mourning the dead body of Christ.[20] Normally, the Magdalene is seen as emotionally distraught, kissing or embracing his feet or one of his hands. In the Florence *Pietà*, instead, she actively assists in Christ's descent: her right arm extended with the hand placed on his thigh, she seemingly prepares to shift his leg in its involuntary fall onto the Virgin's lap (plate 6). Her physical exertion is such that her pressure against Christ's thigh causes its muscles to bulge out where she takes hold (plate 32). Simultaneously, in order to gain the leverage necessary to guide Christ onto the Virgin's lap (plate 62), she presses her hidden left hand so deeply into the garment covering the leg of the bearded figure as to pull it and inadvertently expose his other trousered leg (plates 16 and 17).[21] These are not symbolic personages, but realistic figures interacting in a resolutely physical way. Even the base is treated as if it were a natural site: it dips in the direction of Christ's right foot and rises again under the kneeling Magdalene (plates 1 and 6).

Christ's body and the disposition of his limbs summarize the entire sequence of his descent from the instrument of his martyrdom into his mother's embrace. His right arm, supported by the bearded figure, retains in modified form the horizontal extension it had on the cross.[22] His left arm, hanging inertly, evokes his precipitous fall. The arrangement of Christ's legs suggests a late moment in his descent. His left leg, were it present, would come to a rest over the Virgin's thigh; his right leg falls aimlessly to the ground between her knees. Lastly, the cloth at Christ's chest, which had been drawn down with him from the cross, falls into the Magdalene's hand and down across his loins and will become the shroud that will cover his body when it is prepared for burial.[23] Thus, Christ, recently removed from the cross, is settling onto the Virgin's lap—with which he has already made contact—to create a traditional, if more dramatic, Pietà.

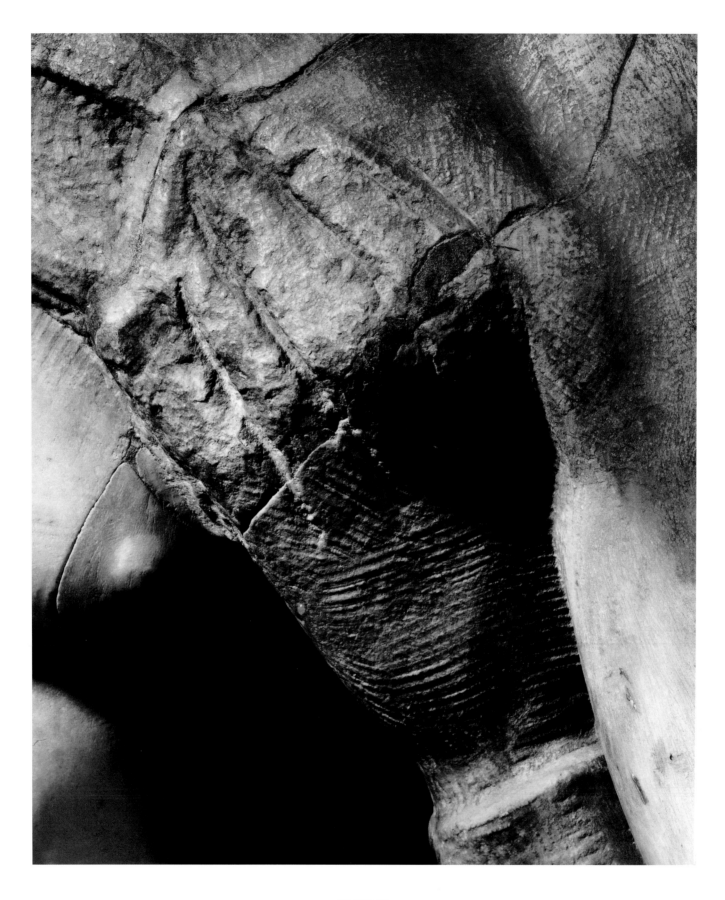

PLATE 15
Virgin, left hand, above Christ's left nipple

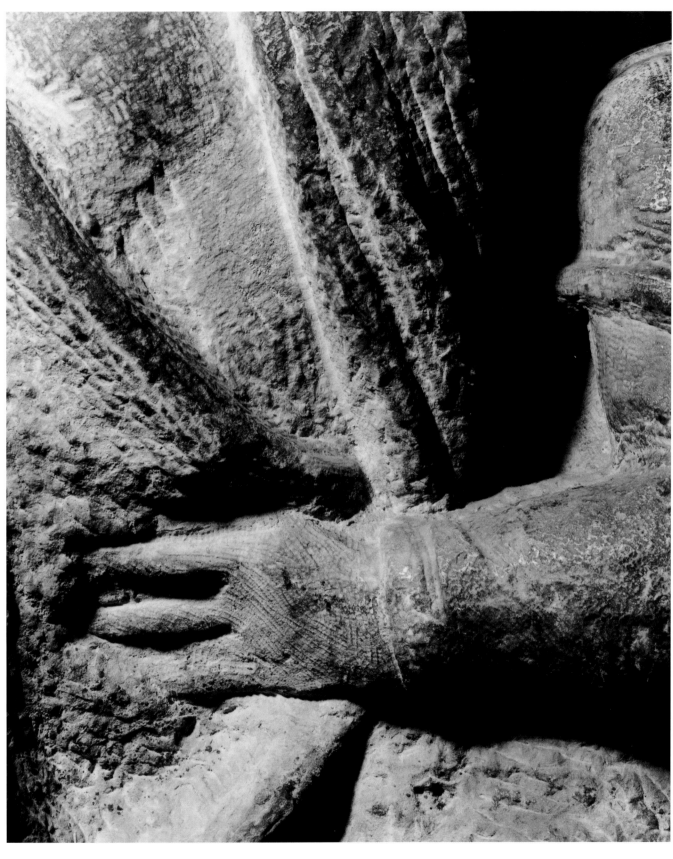

PLATE 17
*The Magdalene, left hand on leg
of the bearded figure*

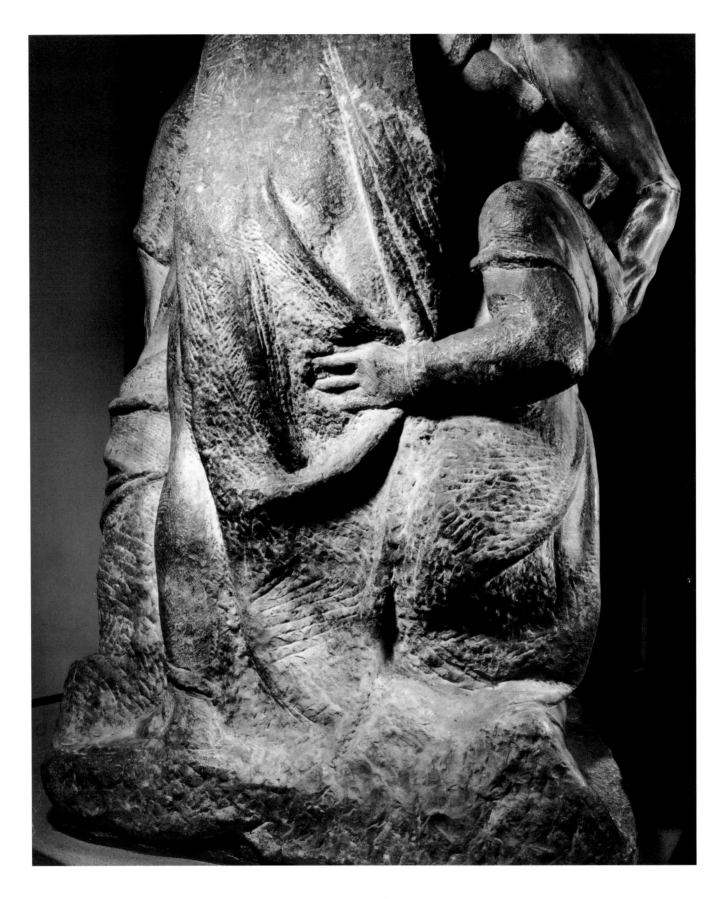

PLATE 16
View of lower back

Michelangelo, it is frequently said, was influenced by numerous sculptures, paintings, drawings, and prints as he was preparing the Florence *Pietà*.[24] The *Laocoön* and *Farnese Bull* are cited as ancient prototypes for his idea of creating a multi-figure composition from a single block of stone, although, as it has been pointed out, these classical statues are composed of figures individually carved from multiple blocks.[25] Scholars have suggested more recent paintings to explain Michelangelo's composition, in which Christ is surrounded by three figures, one a bearded male supporting him from behind. They include a fourteenth-century Lamentation by Giovanni da Milano[26] and fifteenth-century Entombments by Fra Angelico (plate 18) and Filippino Lippi.[27] At times specific sources have been cited for individual motifs. The junction of Christ and the bearded figure behind him is said to derive from an ancient relief representing the transport of the dead body of Patroclus, as well as the *Trinity* woodcut by Dürer of 1511 (plate 12).[28] Christ's general posture is related to Andrea del Sarto's Puccini *Pietà*.[29] Michelangelo may have consciously incorporated in his statue the motif of Christ supported from behind by a second figure from a comparable arrangement he had recently included in the Rondanini *Pietà* (plate 8). On the other hand, he rejected entirely the approach he had taken to the theme of the *Pietà* in a drawing he had made for Vittoria Colonna in about 1545 (plate 19).[30] Possibly he felt that its rigidly symmetrical composition and its didactic, prayerful message—"No one thinks how much blood it costs"—in the inscription above the orant Virgin's upturned head were singularly appropriate to the private character of the drawing.[31] The *Pietà* Michelangelo

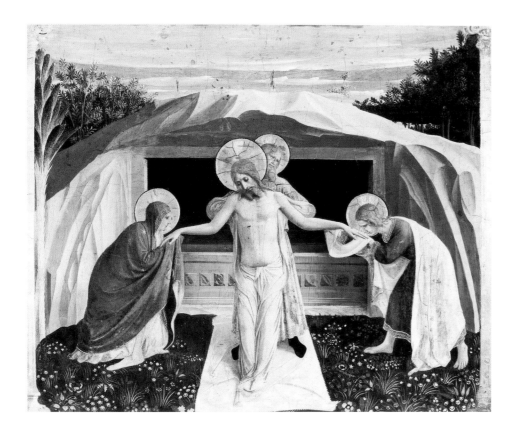

PLATE 18
*Fra Angelico (Italian,
c. 1387–1455),* Entombment,
*1438–40. Panel, 15 x 18⅛ in.
(38 x 46 cm). Alte
Pinakothek, Munich*

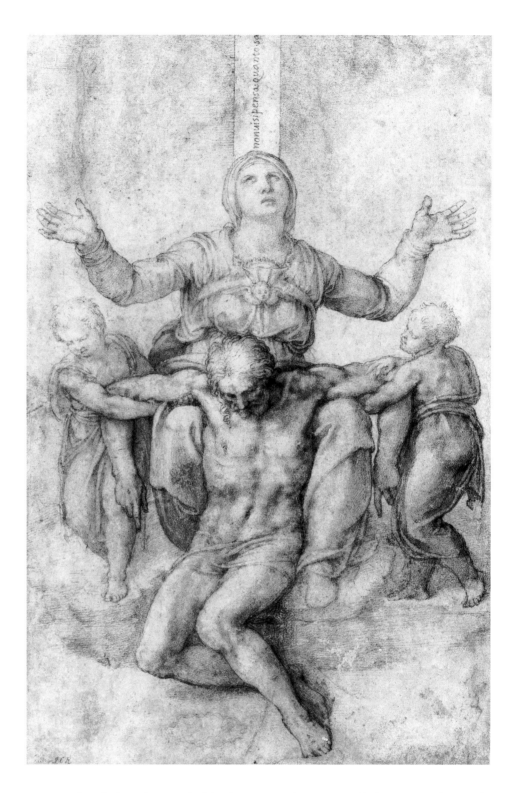

contemplated, though intended for his personal use, nevertheless was to be a public monument in a church.

With the possible exceptions of the *Laocoön,* the *Farnese Bull* (both very much admired in the sixteenth century), and the Rondanini *Pietà,* it is unlikely that Michelangelo referred directly to these works when he began to contemplate the Florence *Pietà.* Rather, he probably absorbed their compositions and motifs into the large artistic memory bank he had developed over a lifetime of observation

and from which he drew his ideas. Vasari had this method in mind when he made his famous remark that Michelangelo had so tenacious and profound a memory that the artist forgot nothing he saw, even if only once, and used this store of information in such a manner as to disguise its origins.[32] However, Michelangelo filtered the images from the artistic memory bank that became sources for his *Pietà* through two drawings of the Pietà subject, in the Louvre and in the Albertina, Vienna, that have been dated to 1530–34.[33] They each have strong links to his Florentine past in conception and details. Their subject and dating suggest that Michelangelo may have conceived them as preparatory works for the aborted tomb chapel he had hoped to erect for himself in the Florentine church of Santa Croce in those years. This would be reason enough for his returning to them when he began to plan his new tomb monument.

The Louvre sketch is the more traditional of the two drawings (plate 20). The representation of Mary Magdalene kneeling and kissing Christ's hand and the seated Virgin embracing Christ are familiar from medieval and Renaissance

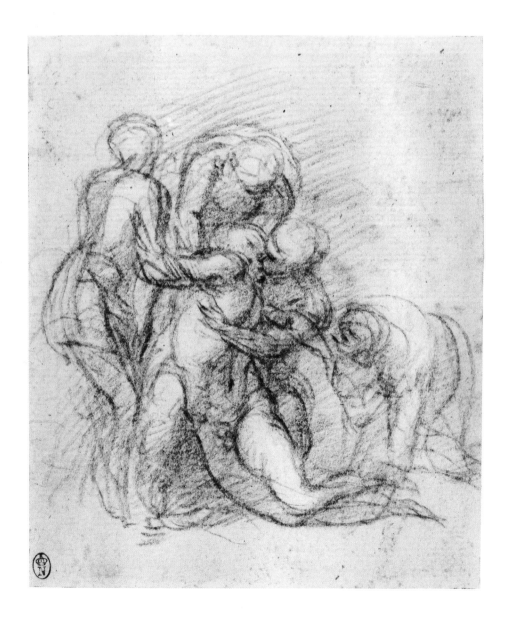

PLATE 20
Michelangelo, Pietà, *c. 1530–34.*
Red chalk, 4⅜ x 3⅝ in. (11 x 9.3 cm).
Musée du Louvre, Département des
Arts Graphiques, Paris

paintings of the Pietà or Lamentation, while Christ settling between the legs of his mother and the presence of a male figure who holds him from behind are reminiscent of compositions of the Trinity (e.g., plate 12). Yet in its motif of the multiple-figure group and in the willowy and twisting posture of Christ the sketch foreshadows the statue. In the drawing, Christ slips between the knees of the Virgin in an elegantly spiraling curve that causes the heads of the two figures to meet and makes possible the mother's sorrowful and passionate kiss. In the statue (plate 6), Christ sits on the Virgin's lap and his body is more rigorously and systematically patterned in the intersection of arms and torso.

The Albertina drawing (plate 21) also inherits the time-honored Trinity composition echoed in the *Pietà*.[34] But its importance lies in transmitting to the statue a novel treatment of Mary Magdalene and Christ. The Magdalene places one hand

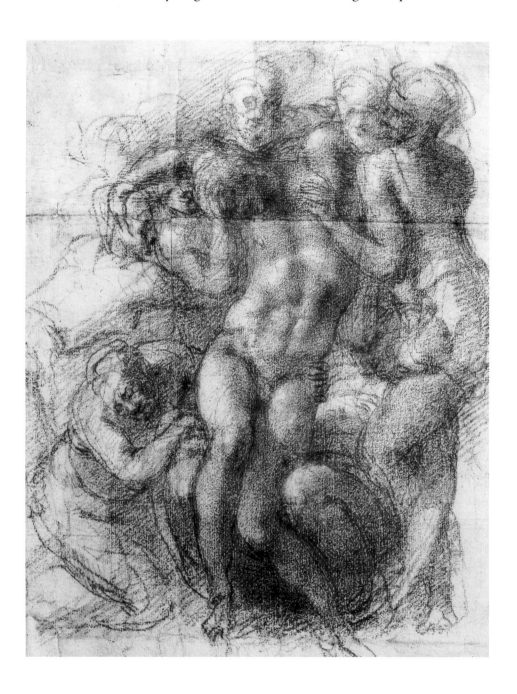

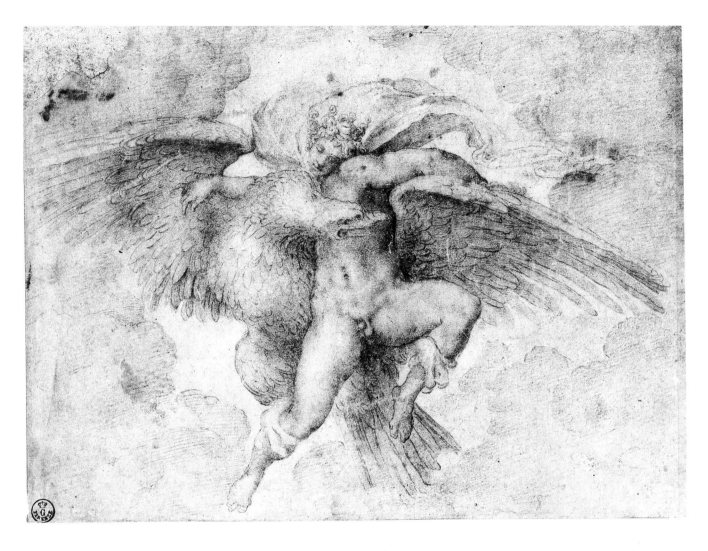

on Christ's thigh in a gesture reminiscent of certain sixteenth-century Depositions (and similar to her leveraging hand in the statue) and reaches with the other hand behind Christ's back to take hold of his left hip, her fingers barely visible.[35] In the Albertina drawing Christ sinks downward, as in the Louvre sketch, but now he is in upright position and his body undulates from bent head to bent left leg. Indeed, reversed, the shape of Christ's torso and the bent position of his head directly anticipate the statue. With outstretched arms, we see he is recently descended from the cross; with his hip shifted sideward, he is about to be eased onto the lap of the Virgin by Mary Magdalene. Michelangelo instilled this concept into the statue, where Christ's body has sunk more deeply into the Virgin's lap.

Michelangelo harked back to two additional drawings of different subjects in planning the *Pietà*. One, dated to 1532, is his *Rape of Ganymede*, which we know through copies (plate 22).[36] With small alterations, the pose of Ganymede is a reasonable prototype for that of Christ, in his extended right arm, his head inclined toward the pronated left arm, and his splayed legs.[37] The connection appears particularly strong when Ganymede is compared with a wax replica of the *Pietà* in which Christ's left leg is restored (plate 41).

The second drawing is his *Deposition* of about 1540, now in the Teylers Museum in Haarlem (plate 23). Seeing it, we can visualize how Michelangelo may have

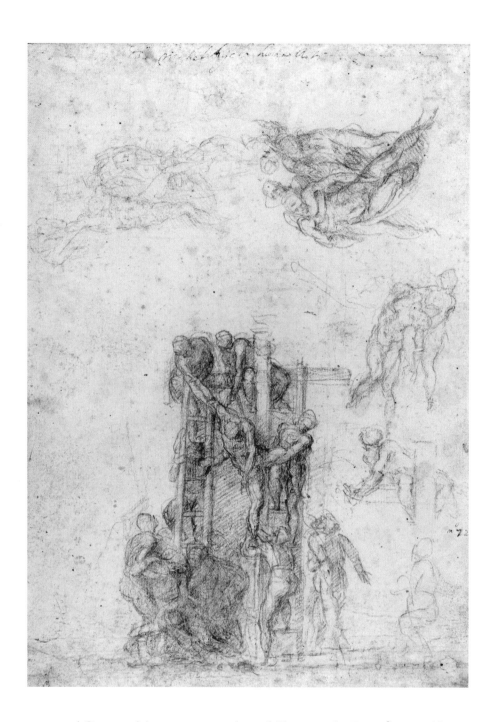

transposed Ganymede's posture into that of Christ in the *Pietà*.[38] Were Christ in the drawing to continue his descent onto the lap of the Virgin in the statue, we can imagine his left leg retaining its bent position as it falls over the leg of the Virgin. The extended right leg would be displaced by the resistance it meets as the foot touches the ground, as the left arm is twisted into a spiral and pressed forward by the Virgin's embracing left arm.

Michelangelo may have also recalled the four drawings when contemplating the Florence *Pietà* because of their pictorial nature—the representations of the *Pietà* and the *Deposition* are multi-figure narratives; the *Rape of Ganymede* is set in the midst of clouds.[39] He had just emerged from having dedicated more than a decade

to painting, from initiating the *Last Judgment* to completing the two frescoes in the Pauline Chapel. This experience may have stimulated the artist not only to conceive a multi-figure marble *Pietà* as a narrative, but especially to solve a critical compositional problem when carving it.[40]

Condivi is the starting point for this conjecture. He admired the statue "mostly because all the figures are seen distinctly; the draperies of one figure are not confused with draperies of the others."[41] In other words, he is saying that Michelangelo individualized the protagonists and clearly differentiated their garments, enunciating a principle of statuary that the Renaissance had inherited from antiquity: regardless of the number of figures, clarity and precision must prevail and bodies and their limbs must be distinct and apparent. This is as true of the ancient *Laocoön* as it is of Jacopo Sansovino's sixteenth-century *Virgin and Child with St. Anne*.[42] The same principle holds true for the four-figure marble *Pietà* by Ippolito Scalza in the Cathedral of Orvieto of 1574,[43] and of the marble *Deposition* of 1586–96 (plate 24), which Tommaso della Porta made in competition with the Florence *Pietà* by increasing to five the number of figures represented. However, Condivi's view of the *Pietà* is inaccurate.

When Condivi wrote those lines, Michelangelo was, in fact, engaged in creating four figures from a marble block that is too narrow in width and shallow in depth to accommodate them.[44] Because the block lacks the elasticity it might have had were it excavated expressly for a statue Michelangelo had already planned, we may comfortably assume, as have others, that the block had been already lying about in Michelangelo's workshop.[45] (He had used a spare block decades earlier for the allegorical figure of *Day* in the Medici Chapel.)[46] Condivi and Vasari seemed to imply such a fortuitous circumstance when they observed that among the reasons Michelangelo took up the marble were to keep fit and to pass the time of day.[47]

It is a fact that the Florence *Pietà* is a four-figure group compressed into a narrowly contracted and vertical composition in which a number of forms and details are obscure. The marble block was not entirely suitable, so Michelangelo had to resort to illusion, distortion, and abbreviation when carving the statue—devices typical of pictorial art, but uncommon in statuary. Michelangelo had already employed such devices in his paintings. For example, in the *Doni Tondo* (plate 25), the arms of St. Joseph disappear behind the Virgin, his left leg is spatially and anatomically abridged, and his right leg is so far extended to the foreground as to seem detached from the body. Michelangelo took these pictorial liberties with the *Pietà*: some of the limbs he represented as whole, but others he abridged, and still others he merely alluded to, leaving them for the observer to sort out—although the statue being arranged in a niche would make this difficult to do. For example, the left hands of the bearded figure (plates 5 and 26) and of Mary Magdalene (plate 16) are visible only from behind the statue, although, as we have seen, they are essential to the narrative. We do not grasp the full meaning of the *Pietà* unless we recognize that the bearded figure places his left hand on the back of the Virgin to bring her closer to Christ, and that the Magdalene's left hand presses against the bearded figure's right leg to gain leverage in her effort

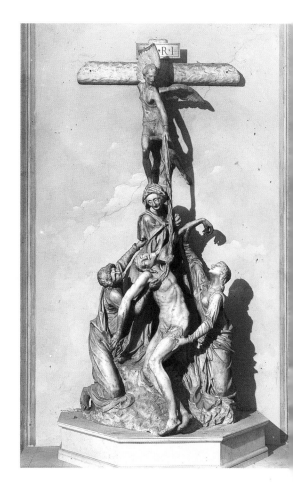

PLATE 24
Tommaso della Porta (Italian, c. 1546–1606), Deposition, *1586–96. Marble. Chapel of Sant'Ambrogio, San Carlo al Corso, Rome*

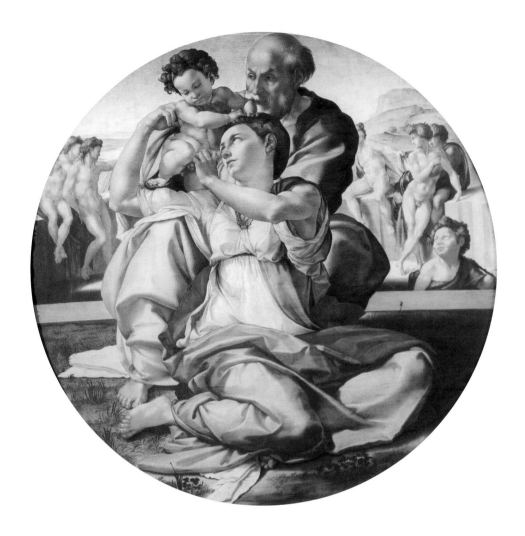

RIGHT **PLATE 25**
Michelangelo, Doni Tondo,
c. 1503. Panel, diam. 47¼ in.
(120 cm). Uffizi, Florence

OPPOSITE **PLATE 26**
*The bearded figure's left hand
on back of the Virgin*

to support Christ. A few scholars, failing to take into account the Magdalene's hidden gesture, have interpreted her as presenter of Christ's body and related to Leon Battista Alberti's "person who admonishes and points out to us what is happening" in a painting.[48] Such a role is traditionally played by St. John, who points to the Holy Family in representations of the Sacra Conversazione.

The Virgin is a more extreme example of this hide-and-seek approach. Her right arm simply does not exist in the piece. Owing to the shallowness of the marble block, that arm implicitly extends between the bodies of Christ and the bearded figure, her hand ending up at Christ's side to establish the motif of an embrace (plate 27), but her hand, of course, is not visible from the front of the statue.[49] Then there is the question of the Virgin's right leg: it is not materially present (plates 2 and 10).[50] Instead, it is replaced by the Magdalene's left thigh. This is strikingly evident in the worm's-eye view of the virtual model (plate 10).

To sum up, Michelangelo had the option of carving the statue in full detail by selecting a subject and composition appropriate to the block's shape and dimensions. He chose not to. Alternatively, he might have procured a block whose dimensions were appropriate to the composition he had in mind. That he did not do so must have been a willful decision to fulfill a personal and deep-seated compulsion to compose a grandiose statue at any cost, even to the extent of employing the painter's method of illusionism.[51]

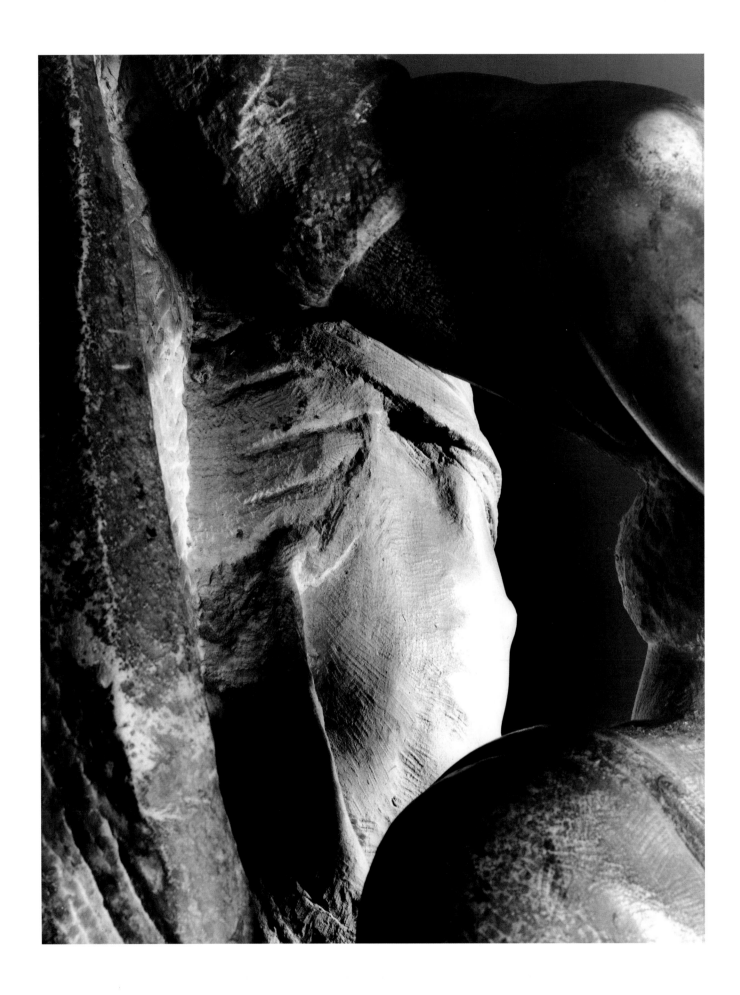

Michelangelo surely foresaw that the abridgments and truncations he used in carving the *Pietà* would barely rise to the level of the viewer's consciousness, with the statue being seen from the distance of a niche above an altar. But he may have thought of the niche site as a stimulus for another aspect of the statue—that is, as a sequence of integral and interdependent compositions that would be revealed as one passed by the statue in an arc-like progression from diagonal left to diagonal right. Pausing to participate in religious services, one would see it from the front. Michelangelo had cultivated this treatment of statuary in his *Resurrected Christ* in Santa Maria sopra Minerva, Rome (plate 28).[52] The *contrapposto* turn of Christ prompts the beholder to follow a continuous arc-like motion from one side to the other.[53] In the *Pietà*, Michelangelo reinvented the multiple-view concept by transposing it from a single-figure statue into a group composition within the context of a niche.[54]

With remarkable inventiveness, Michelangelo adapted the multiple-view feature of the *Pietà* to the closely paced sequential scenes of the narrative. The bearded figure is the axial center of the composition and, through the contrasting turns of his body and head, the driving force of the narrative's progress (and its apprehension by the ambulating observer). Thus, the three-quarter view from the left (plate 30), the one favored by most photographers and imitators of the statue, obtains its self-contained composition from the intersection of the majestically spread-out arms and curved torso of Christ, and the rhythmic adaptation of the Magdalene's body to his. From this vantage point, Christ is singled out as deposed and supported by the bearded figure and the Magdalene; the Virgin is relegated to second place. In the frontal view—the main one—(plate 29) Christ is represented in full descent into the Virgin's lap, and the four figures comprising the composition verge on symmetry. Finally, in the three-quarter view from the right (plate 31), the three principal figures converge in a triangle, the head of the bearded man at its apex. Now the narrative reaches a culminating moment in which the mother sorrowfully mourns her son, overseen by the artist himself as the bearded figure. The Magdalene—from this view—is the remote figure.

Historians have attached several meanings to the *Pietà*, as befits a great and complicated statue. These may be subjective theories or insights into Michelangelo's true intentions, and one cannot always distinguish between them. What is certain is that Michelangelo's message is many-faceted and implicit in the general iconography of the *Pietà* and in each of its four figures. The Virgin Mary is central in traditional representations of the Pietà.[55] On a first level, the Virgin is the tormented mother who embraces her son's lifeless body before it is carried away for burial, as described in the twelfth-century *Meditations on the Life of Christ* of St. Bonaventura.[56] On a higher level, she communicates a spiritual doctrine: by her grief and compassion she shares in Christ's redemptive martyrdom, and earns, thereby, the role of mediator in humankind's deliverance.[57] That is how the medieval mystics St. Brigit and Jean de Gerson defined her role in this Passion scene.[58]

The Virgin's dual role of mourning mother and mediator in atonement, though familiar enough to adherents of church doctrine in Michelangelo's day, may

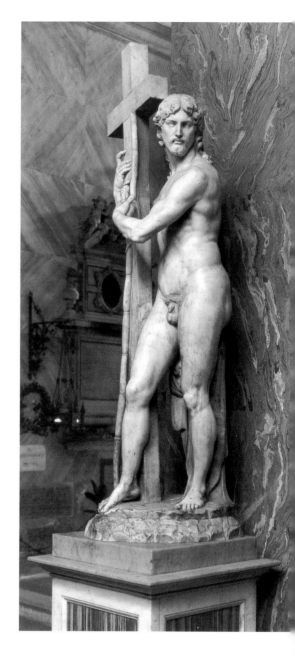

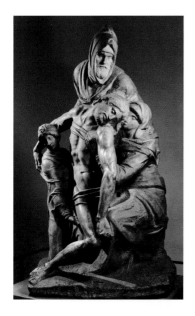

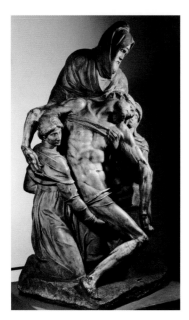

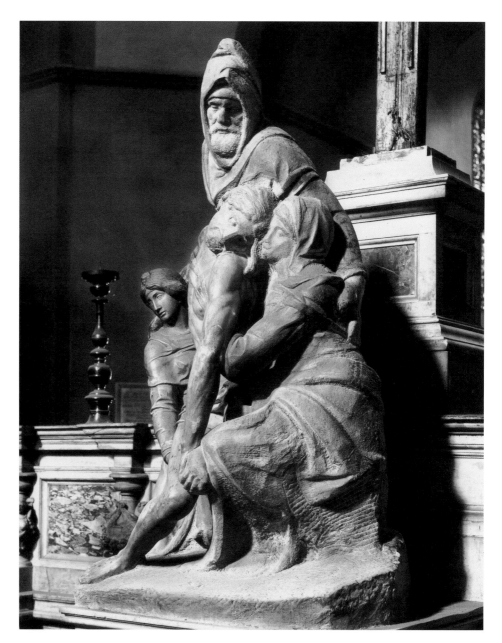

nevertheless have been transmitted to him directly by his friend Vittoria Colonna. She evoked the idea in her reflections on the Pietà in her *Meditation on Holy Friday*,[59] which she wrote in about 1542–44. Colonna began her spiritual musings with the human aspect of the Virgin's grief at Christ's death: "I see the sweet mother with her breast filled with the most ardent charity and tied with many chains of love to her son . . . [and] to ease the bitter weariness at her torment she decides to give herself as a bed for her dead son."[60] Later in the text, she bequeaths the redemptive significance to the Virgin's humanity: "I think . . . that the Queen of Heaven mourned him in many ways, first, as human, seeing the beautiful body formed of her own flesh entirely lacerated. . . . Then she considered, rather saw in the Divine face painted the vestiges of charity, obedience, humility, patience, and peace . . . [and] that her mourning was the reason for joy for many souls dear to her, which for so long had been awaiting that blessed day. But this did not

moderate her pain, rather it increased because it made still greater her obligation and the redemption which she generated."[61]

Such scholars as Charles de Tolnay and Leo Steinberg interpret the Virgin in Michelangelo's Florence *Pietà* as symbolizing the church.[62] She did, of course, attain this symbolic dimension in the liturgy and in patristic literature, where she is referred to as the bride of Christ, and Christ as the bridegroom of the church. No doubt Michelangelo was familiar with this concept, as were his contemporaries, but whether he intended to communicate it explicitly in his statue, as de Tolnay and Steinberg maintain, is another matter. Timothy Verdon, who accepts this interpretation in his essay in this volume, points out that the statue communicates the concept in two ways, both "erotic." One of these "eroticisms" is innocent enough. It concerns the kiss the Virgin plants on Christ's cheek. Verdon allies it to interpretations by the church fathers of the erotic parts of the Old Testament Song of Songs, in particular the verse that begins "Let him kiss me with the kisses of his mouth." But does a mother's farewell kiss to a dead son support this doctrinal interpretation?

Verdon's second argument has a more serious implication for understanding the meaning and history of the *Pietà*. For this, he invokes Steinberg's thesis concerning Christ's missing left leg. According to Steinberg, the left leg, by crossing over the lap of the Virgin, signifies Christ, the bridegroom, taking possession of his bride, the church. Verdon accepts this hypothesis with some reservation. For the present, it is enough for me to claim that the leg behaves as it does in any *Pietà*: it falls aimlessly over the Virgin's lap, the temporary resting place she offers the dead body for its repose.

The other object of veneration in Pietà representations is Christ. Vittoria Colonna recognized his centrality as she turned interlocutor in the middle section of her *Meditation* and beckoned the world to follow the Virgin's example and gaze upon the corpse and the wound on its side, from which "the sacraments of our grace flow." Those who do this, she was certain, will "enjoy immense grace."[63] It was unnecessary for Colonna to name the sacraments individually, but obvious among them is Communion, the celebration of the Eucharist. As Verdon demonstrates in his essay, the Eucharistic significance of Michelangelo's *Pietà* becomes explicit above an altar.[64]

The other two figures in the composition draw their sustenance from Christ. Mary Magdalene rarely appears prominently in formulations of the religious meaning of the Pietà, but Steinberg casts her as the counterpart of the Virgin— "as an object of [Christ's] love." He maintains that just as Christ revealed his love for the Virgin with the "possessive" left leg, so he conveys his love for the Magdalene with his embracing right arm and the shroud at his side, which, he claims, hangs between her breasts and caresses her body as it falls into her hand (plate 32).[65] Consequently, he concludes, the saint, like the Virgin, symbolizes the church; he cites medieval and Renaissance theologians to support this idea.[66] Yet if we look a little more closely at the shroud and Christ's right arm it becomes evident that Steinberg interprets both of them inaccurately. The shroud is attached to the Magdalene's unfinished left breast—being still part of the stone from which

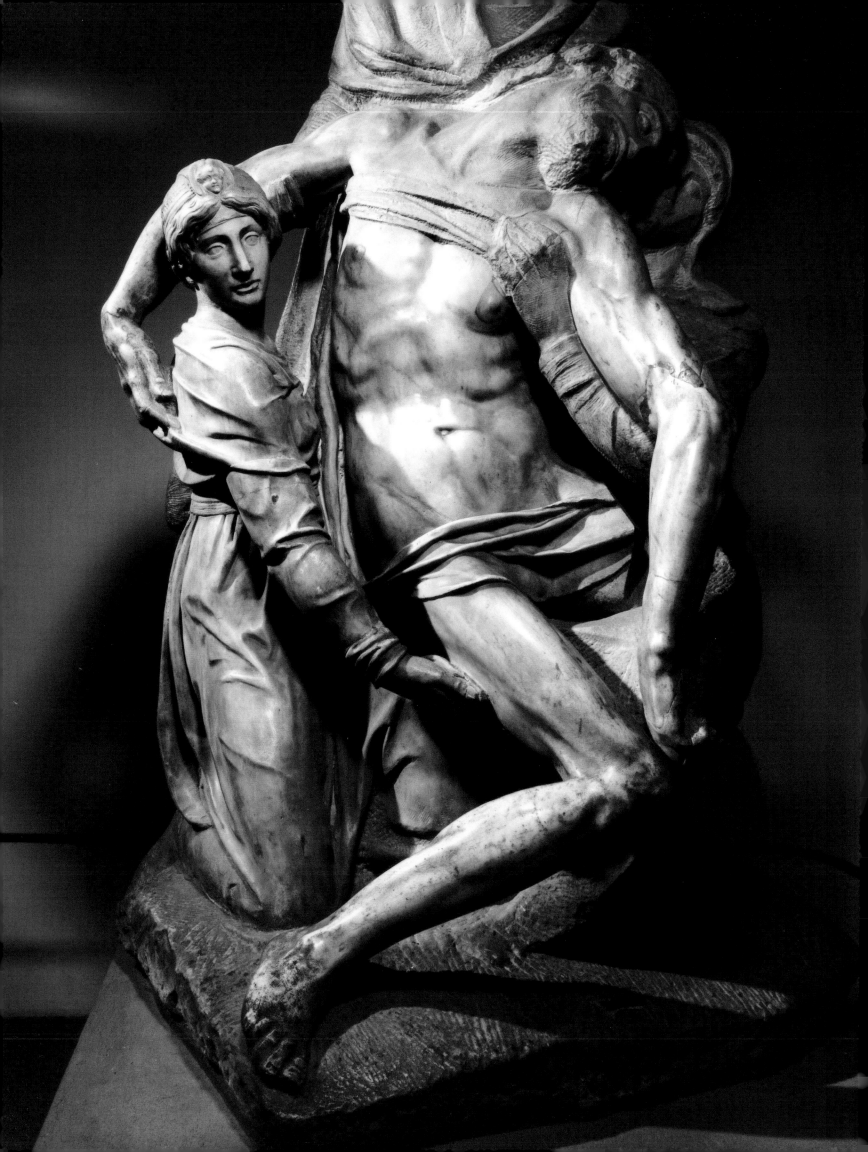

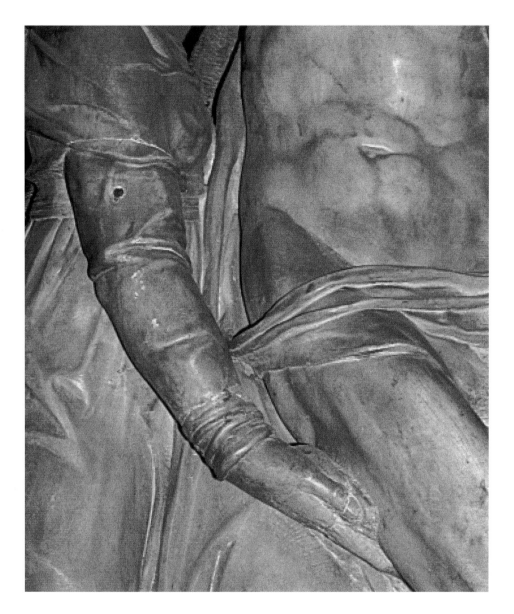

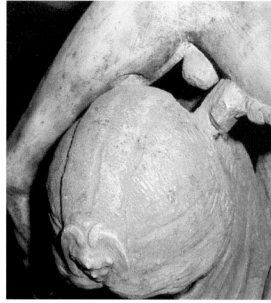

it is in the process of being carved—and continues in a freefall, away from her body (plates 32 and 33), until it enters her hand. As for Christ's arm, it circles the Magdalene at the level of her head, from which it is scrupulously separated by the forefinger of the bearded figure (plates 34 and 35) and by another bridge support, which had been chiseled away when the statue was restored by Calcagni, that had extended from his forearm (surviving as a concave area) to her head (plate 34). Moreover, Christ's arm does not touch any other part of her body, except lightly with the fingertips on her back, as a support (plate 36).[67] The position of Christ's arm, held up by the bearded figure, is not an embrace, rather it is still taking the form it had on the cross. This exact nature of Christ's arm and its relation to the Magdalene's body is evident in the IBM virtual model when it is viewed from above (plate 35).

There are other ways of defining the spiritual meaning of Mary Magdalene. The obvious one is as penitent and redeemed prostitute. Her presence in the statue as a well-dressed and carefully groomed woman may allude to her conversion

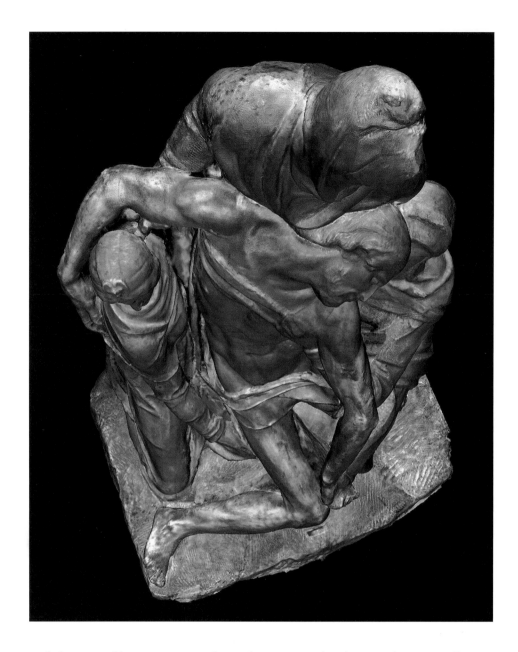

RIGHT PLATE 35
Virtual model, view from above

OPPOSITE PLATE 36
*The Magdalene, encircled by
Christ's right arm*

and the acts of bitter penance she underwent, as the thirteenth-century Jacopo
da Voragine, bishop of Ostia, describes it.[68] In another interpretation, Voragine
wrote that, with her conversion, "the Magdalene was magnified by the super-
abundance of grace, because where sin abounded, grace did more abound."[69] Vit-
toria Colonna in the *Meditation on Holy Friday* recalls this social condition of the
Magdalene and implores her to "come and wash yourself in the pure and precious
blood" of Christ.[70] Michelangelo may have considered the Magdalene's process
of transmutation from a state of sin to one of grace as exemplary of his own spiri-
tual condition.

The Magdalene's state of grace is possibly symbolized by a child's head in a
brooch that holds together the straps of her headpiece (plates 36 and 61). To be
sure, the head is ambiguous enough to be identified in contradictory terms as a
"winged *amorino*, symbol of Love,"[71] or as a cherub or seraph, which are symbols
of the heavenly sphere.[72] The latter would be close enough to symbolize the

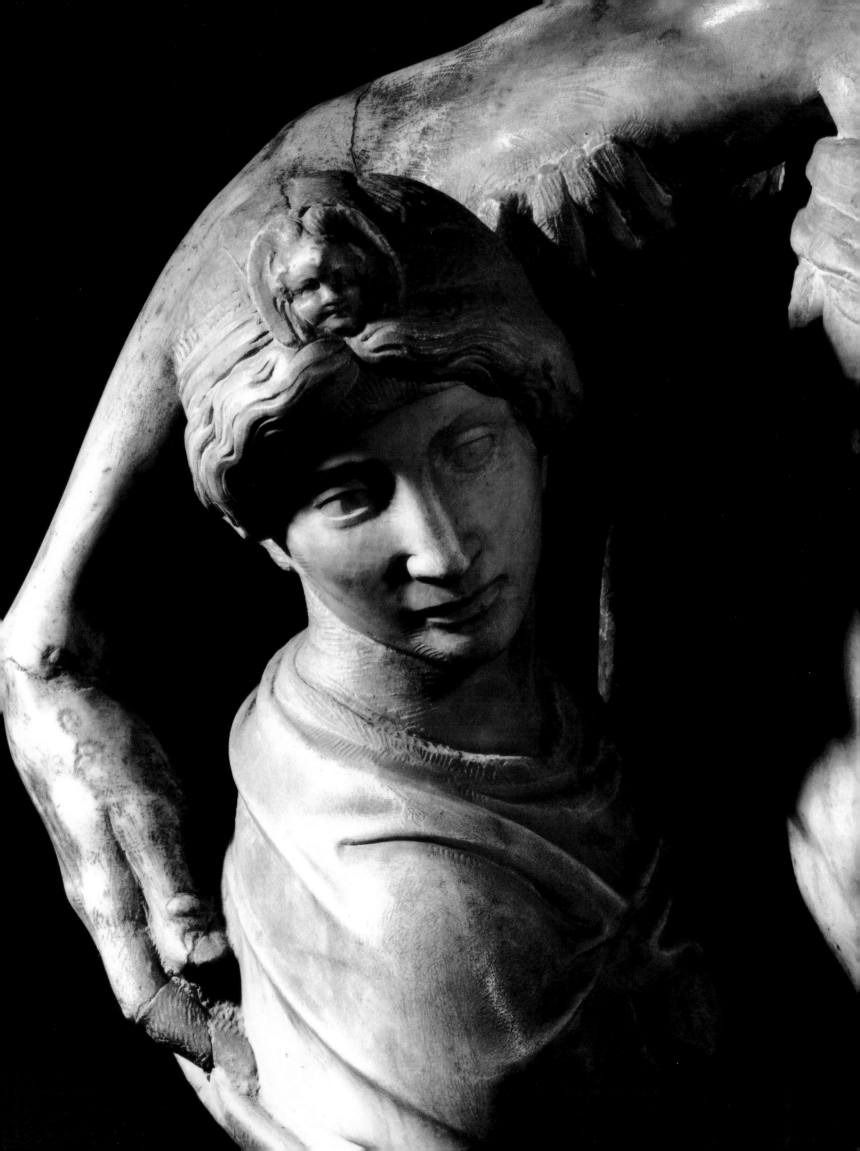

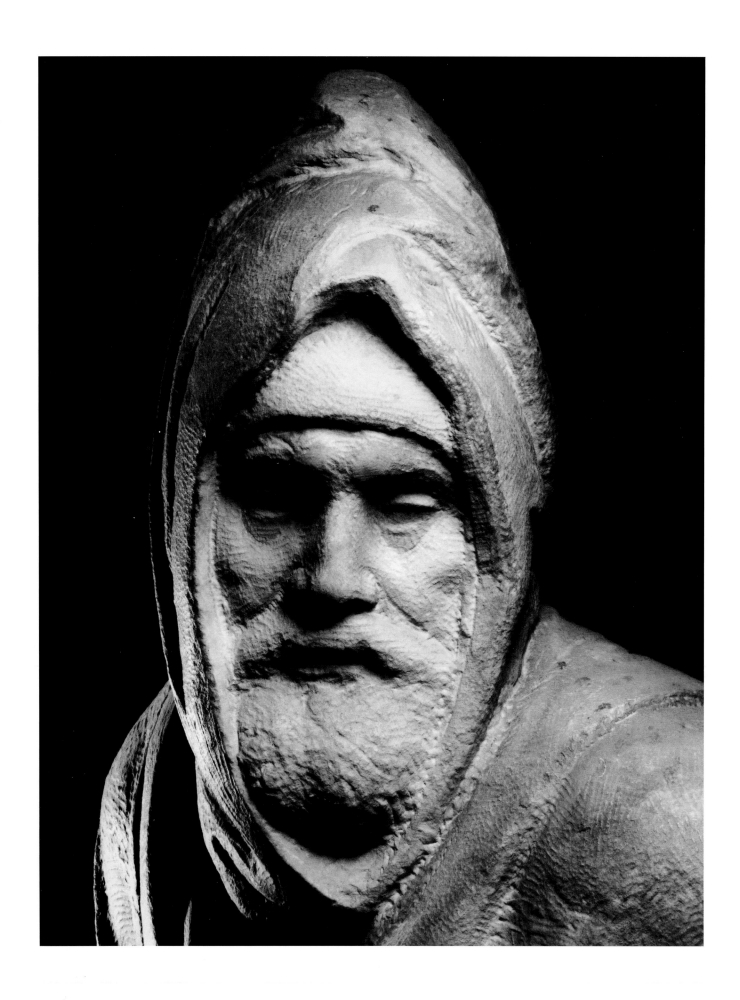

Magdalene's state of grace. But any of these would have wings, which are absent: The elements that might be read as wings are actually ornamental framing devices, like those on coats of arms of the period, that curl outward from above and turn downward to encircle the child's head.[73] Therefore, the child may be an abbreviated representation of an angel, which is commonly seen without wings in Renaissance art. From Voragine we learn the significance of an angel as a beatific attribute of the Magdalene. He writes that during her thirty-year retreat in a cave in Marseilles, angels lifted her to heaven seven times each day to hear celestial music, as a substitute for eating earthly food.[74] May this be why she appears distracted in the sculpture?

The identity of the bearded male (plate 37) has been perpetually argued. Although both Vasari and Condivi agree in naming him Nicodemus, the debate will, no doubt, continue ad infinitum, because there are no confirming attributes on the statue.[75] Perhaps the figure can be identified as both Nicodemus and Joseph of Arimathea. Such is the interpretation of Vittoria Colonna, who singles out the two pious men for special mention and—referring to the piety of their joint participation in removing Christ from the cross and burying him—attributes to both the "triumph" and the "glory" of "the most beautiful work that one can ever perform."[76] Perhaps also, then, Michelangelo desired to honor Nicodemus and Joseph of Arimathea in a collective image (plates 2, 14, and 37).[77] By imprinting his features on the bearded figure, he may have hoped to receive the honors that accrued equally to both by participating vicariously in Christ's Passion.

PLATE 37
Head of the bearded figure, full face

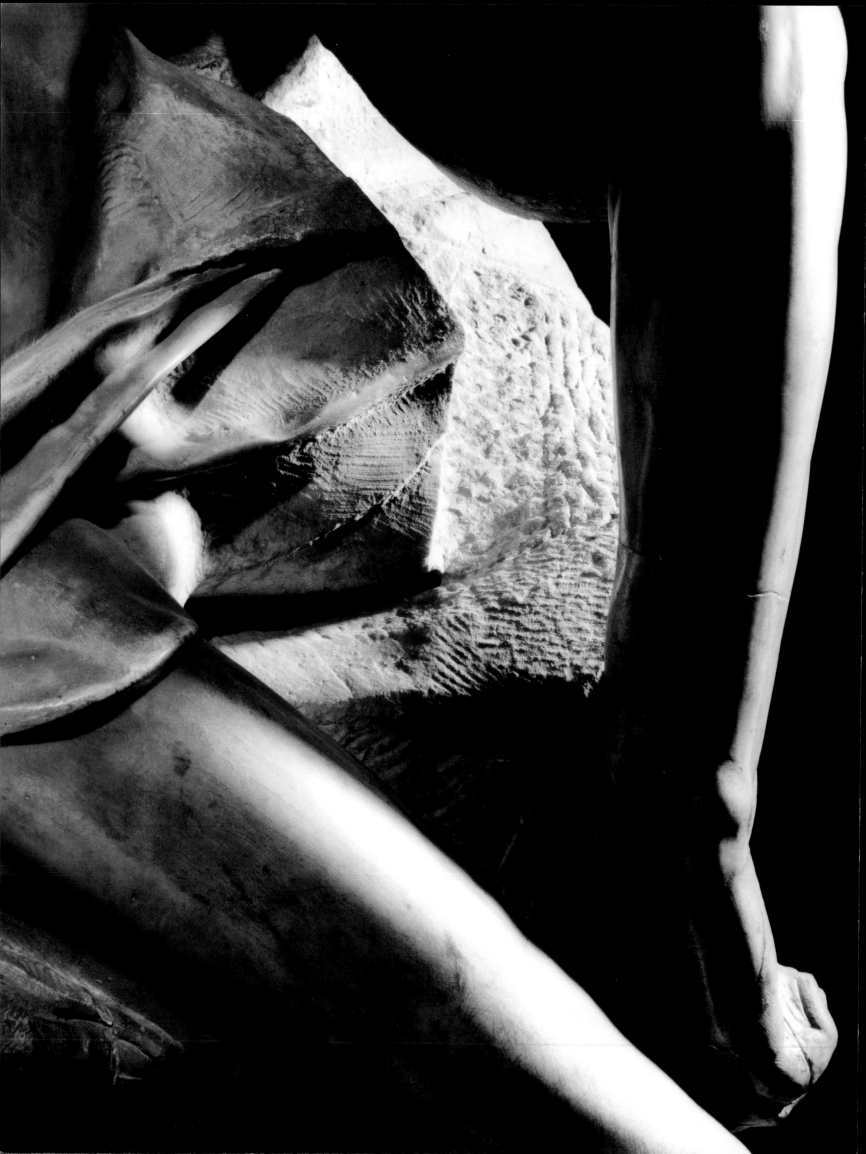

3

THE DESTRUCTION

Considering the spiritual and physical effort that Michelangelo devoted to creating the *Pietà*, it comes as a shock when Vasari tells us that the artist, after years of labor, attacked the statue with the intention of destroying it. Michelangelo, Vasari writes, "worked almost every day on this stone with four figures . . . which he broke,"[1] and, "losing his patience, he wanted to break it completely."[2] He then offers three contradictory explanations to account for Michelangelo's behavior.[3] He asserts, first, that the artist had encountered technical problems in carving the statue, noting that the "stone had many fissures, and was hard, and he frequently made smoke striking it with his chisel."[4] Yet, as if doubting that Michelangelo would have let an obdurate stone keep him from proceeding with his task, he states, "or was it also that the judgment of this man was so great that he was never satisfied with anything he did."[5] At this point, Vasari seems to be merely speculating.[6]

Next, however, he proposes a third reason, about which he apparently feels more secure, because he heard it from Tiberio Calcagni (the restorer of the statue), who claimed Michelangelo was his source. Vasari records: "Tiberio Calcagni, a Florentine sculptor, had become a good friend of Michelangelo through Francesco Bandini and M. Donato Giannotti; and being one day in Michelangelo's house, where this *Pietà* was broken, after a long discussion, he asked the master why he broke the work and spoiled so much marvelous labor. He replied that the reason was the persistence of his servant Urbino, who every day urged him to finish it;

PLATE 38
Christ, lap and stump of missing left leg

59

and that, among other things, a piece of the elbow of the Madonna fell away, and even before that he had begun to hate it, and had many misfortunes because of a fissure; at which point losing patience he broke it, and he wanted to break it totally, which he would have done had not Antonio his servant asked to receive it as a gift."[7]

Various historians reiterate all the reasons Vasari gives,[8] a number of them favor one over another,[9] and others develop hypotheses of their own, possibly because Vasari's reasons are inconsistent with the fact that Michelangelo had never before or after set out to destroy one of his sculptures. Vasari himself observed that "whenever he made even the slightest error in a figure, he would set it aside and rush to take up another marble, thinking that this would not happen again; and he often said that was why he made so few statues."[10] An event so exceptional in Michelangelo's career, scholars seem to be saying, requires a deeper motivation than an obdurate stone, a recalcitrant idea, or even a nagging servant.

Christ's missing left leg haunts the modern history of the *Pietà* and has mesmerized scholars to the point of making its absence the focus of explanations of why Michelangelo wished to destroy the *Pietà*.[11] Henry Thode, in the early twentieth century, introduced the idea of the master's culpability for the leg, hinting at Michelangelo's professional embarrassment at how he was handling the limb.[12] Thode maintains that the artist carved the *Pietà* with only one leg, intending to insert the left one separately.[13] But, as this procedure would result in "not only an ugly but an impossible pose,"[14] Thode concludes that Michelangelo chose to demolish his work instead. Johannes Wilde also advocates the separate-leg thesis, but according to him, Michelangelo's concern was that the patchwork approach would violate conventional practice in statuary and call into question his ability as a sculptor.[15]

Both conjectures, however, are fatally compromised by careful examination of the area of the missing leg (plate 39). This reveals that Michelangelo had in fact carved the leg as an original part of the *Pietà*. Indeed, the leg is residually present in the original marble as a slight, semi-circular protuberance that extends outward from the Virgin's lap (plate 40) and completes the round shape the destroyed leg had before Tiberio Calcagni cut it back into the stump we now see when he attempted to replace the limb (plates 38 and 60). The weight of the leg caused its underside to be compressed as it lay over the Virgin's thigh, and this, too, is retained in the protuberance, which seems to sink into her limb. This condition of Christ's leg is evident in the restored leg in an eighteenth-century wax replica of the *Pietà* (plate 41).

Even those historians who agree that Michelangelo had carved the left leg as an integral part of the statue blame the limb for having aroused the artist's anger against his work. The evidence they often cite for this idea is a story Vasari tells of a late-night visit he had made to Michelangelo's studio during the pontificate of Julius III, in about 1553. Vasari wrote that he found Michelangelo "working on the marble Pietà . . . and as he turned his eyes he was attracted by a leg of Christ, on which he was working and attempting to change."[16] Vasari did not indicate why nor how Michelangelo was planning to change the leg, nor which of the two

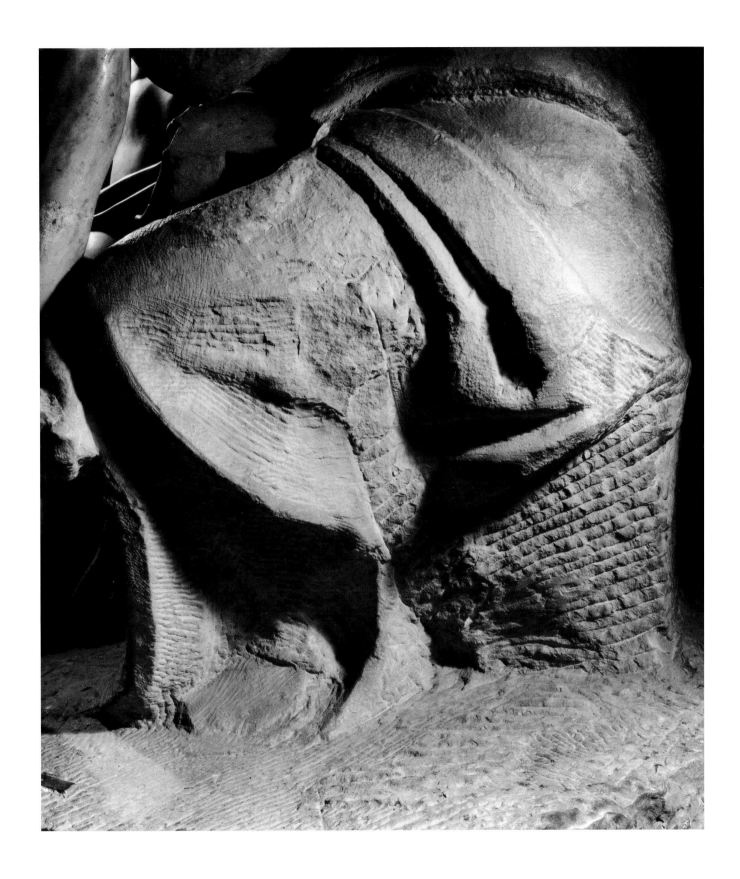

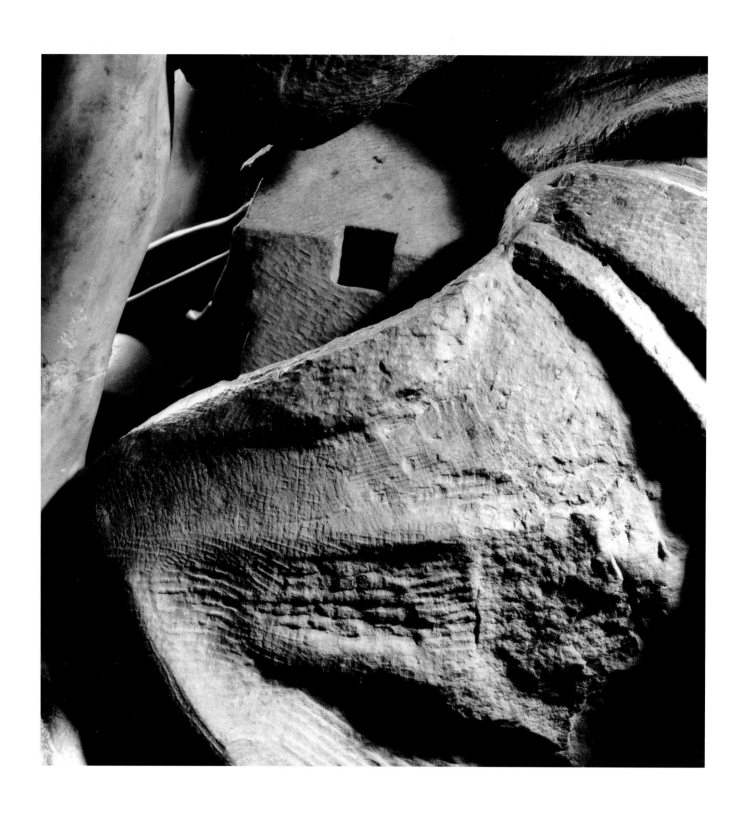

PLATE 40
Virgin's thigh and the stump of
Christ's missing left leg

it was. Scholars, citing Vasari's assertion that Michelangelo broke up the statue when a vein appeared in the marble, explain the change by assuming that a vein had destabilized the leg sufficiently to cause its severance.[17] I cannot see the relevance of Vasari's story to the motivation for the statue's mutilation. Vasari saw Michelangelo altering the leg at the latest in 1553, yet historians date the master's angry act two years later, to 1555. As additional proof that the leg had caused Michelangelo problems, some scholars cite a 1566 inventory of the estate of Daniele da Volterra, a friend of Michelangelo's, which lists a "marble knee of the Pietà of Michelangelo."[18] However, the Volterra inventory does not specify to which leg of Christ or to which of Michelangelo's *Pietà*s the knee belonged. It may, in fact, have been a fragment from the Rondanini *Pietà*, a statue Michelangelo recarved in 1564, two years before the inventory was compiled.

Leo Steinberg proposes an audacious theory about Christ's missing left leg.[19] Steinberg introduces two premises to prove that the leg was Michelangelo's principal worry,[20] neither of which withstands scrutiny. He claims, first, that Michelangelo concentrated his destructive efforts on the side of the statue where the left leg was located in order to remove it. There is no evidence that Michelangelo severed the left leg, except that it is missing and Vasari's contention that he saw Michelangelo attempting two years earlier to change a leg. The sculptor Calcagni may have been responsible for its removal. (I will return to this issue in chapter 4.) In fact, Michelangelo mutilated both sides of the statue equally. On the side of the leg, he broke away the arm of Christ inevitably together with the arm of the Virgin, as the two limbs are attached at the elbow. On the opposite side of the statue, he broke away separately the right forearm of Christ and the entire right arm of the Magdalene. Steinberg also claims that Michelangelo had prohibited Calcagni from inserting a new leg when restoring the statue, yet Calcagni did, in fact, make a serious effort to replace the amputated limb.

Steinberg bases his central thesis on what he believes was Michelangelo's concern with the arrangement of the left leg over the lap of the Virgin, which, he argues, the artist derived from classical, secular, and Old Testament representations of a man and woman embracing. Among the earliest, from the sixteenth century, is the *Isaac and Rebecca* from the frescoed vault of the Vatican Logge (e.g., plate 42).[21] Steinberg defined the gesture of the leg in the source examples (which he termed "slung leg") as "a token of marital or sexual union, of sexual aggression or compliance." However, when Michelangelo planned the position of Christ's leg in the *Pietà*, according to Steinberg, he wished to transform the original erotic significance of the motif into a Christian symbol, "as a coherent *concetto*" of the *sposalizio*, or mystic marriage of Christ and the Virgin, the latter functioning as the figure of the church.[22] But as Michelangelo was carving the *Pietà*, Steinberg points out, the "slung leg" was becoming vulgarized in works by his contemporaries, causing Michelangelo to worry that, in his own use of the motif, he might be "pushing the rhetoric of carnal gesture to a point where its metaphorical status passed out of control," or that his application of the "slung leg" motif would be misconstrued by his contemporaries as basely and offensively carnal, given the newly moralistic atmosphere that Giovanni Carafa had introduced in Rome when

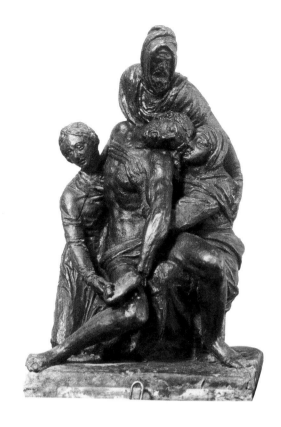

PLATE 41
Anonymous, Pietà, *18th century. Wax, 16⅛ in. (41 cm). Copy after Michelangelo's Florence* Pietà. *Private collection, Florence*

he was elected Pope Paul IV in 1555 (he reigned until 1559). The result, Steinberg concludes, was Michelangelo's "rageful attack on the sculpture in 1555."[23]

I doubt that Steinberg's "slung leg" thesis can apply to Michelangelo's *Pietà*. There is, first, a problem of chronology. Steinberg (as do most historians) assumes that the artist mutilated the statue in 1555, but neither he nor anyone else has argued the merits of the date.[24] In fact, no other evidence exists for it except for the idea Vasari received from Calcagni—that Urbino, who died on 3 January 1556,[25] was responsible for Michelangelo's anger over his statue. Yet, Steinberg joins most historians in implicitly rejecting the role that Vasari tells us Urbino played in the drama of the *Pietà*.

Mostly, however, my skepticism of Steinberg's thesis is provoked by his equating the position of Christ's left leg over the lap of the Virgin in the *Pietà* with the motive of the "slung leg" and its erotic implications in the classical, secular, and Old Testament representations. I also find unacceptable his characterizing the leg in Michelangelo's statue as a carnal symbol of Christ's actively taking possession of the Virgin in a *sposalizio*. Even Steinberg unintentionally provides the reason for doubting his theory in a second article he published on the *Pietà*.[26] In this essay he defines the "slung leg" in its "canonic" form as two lovers seated side by side so that one partner can, with overt purpose, throw a leg over a companion's lap or thigh. In its "non-canonic" form (from which carnal and symbolic meanings are absent), Steinberg explains, the leg involuntarily hangs over the Virgin's thigh and thus "suggests the condition itself."[27] Steinberg finds the non-canonic form of the "slung leg" in representations of the Pietà, citing a fifteenth-century bronze relief representation of the subject in Ferrara in which Christ sits directly on the lap of His mother and, Steinberg writes, His "left leg remains arched over the Virgin's thigh without, however, constituting the appropriate

action." In other words, the "slung leg" epithet does not apply to the position of Christ's leg in the Ferrara *Pietà*, which, therefore, does not have a carnal connotation nor does it symbolize Christ actively taking possession of the Virgin in a *sposalizio.* I (and presumably Steinberg) would apply the non-canonic treatment of the leg to all Pietà representations in which Christ sits or reclines on the Virgin's lap. A Pietà that is compositionally very close to and dates from about five years earlier than Michelangelo's Florence *Pietà* was executed by Giovanni Francesco Caroto in about 1545 (plate 43).[28] In both Caroto's painting and Michelangelo's marble, as in the Ferrarese relief adduced by Steinberg, Christ settles directly onto the Virgin's lap, one of his legs falling between her knees, the other hanging involuntarily over her lap.[29] So if the position of Christ's left leg in Caroto's painting does not constitute an aggressive action, then presumably neither does Christ's leg in Michelangelo's statue.[30] Therefore, we can interpret Michelangelo's work

PLATE 43
*Giovanni Francesco Caroto
(Italian, 1488–1563/66), Pietà,
c. 1545. Panel, 51½ x 38½ in.
(130.8 x 98 cm). Museo
Castelvecchio, Verona*

indeed as an unadulterated *Pietà*, without, that is, the carnal and symbolic accretions Steinberg imposes on it.

Valerie Shrimplin-Evangelidis takes an entirely different approach to the problem of Michelangelo's violence against the *Pietà*, absolving the left leg from responsibility. She attributes motivation for the statue's destruction, instead, to the bearded figure supporting Christ, because his features are those of Michelangelo (plate 37).[31] She identifies the figure as Nicodemus and asserts, therefore, that Michelangelo willingly exposed himself as a "Nicodemite."[32] She is alluding to John Calvin's introduction of the epithet in 1544 to characterize persons who held to Protestant doctrines and worked to reform the Roman Catholic church of its abuses but who participated in church ceremonies and concealed their true beliefs out of fear of reprisals.[33] Hence, Shrimplin-Evangelidis asserts that we can read the *Pietà* "as an indication of the artist's affinities with the sincere and genuine movement for reform within the Catholic Church."[34] Calvin, she notes, also gave the epithet a positive significance, declaring that "Nicodemus at the crucifixion behaved as a faithful and courageous Christian" by openly helping to remove Christ from the cross and burying him.[35] So, whatever their contemporaries may have thought then, the Nicodemites themselves "adopted their name as an honorable and proud defense."[36]

Shrimplin-Evangelidis then examines Michelangelo's spiritual state of mind at the period when the *Pietà* was created. Michelangelo, she said, was an adherent of an Italian group known as the Spirituali, which consisted of high-ranking churchmen and their lay followers who hoped to reform the doctrines of the church and its institutional procedures. The Spirituali, she contends, were referred to as Nicodemites because, even as they hoped to preserve the unity of the church, they nevertheless sought an accommodation with northern Protestants. Michelangelo's link to the Spirituali was his close friend, Vittoria Colonna, who, as Shrimplin-Evangelidis rightly notes, was a member of the group's inner circle.[37]

The Spirituali, Shrimplin-Evangelidis continues, were not afraid of being accused of entertaining Protestant thoughts before 1555, which is why Michelangelo could identify himself with Nicodemus in his statue. But they became alarmed, beginning in that year, when the atmosphere in Rome changed with the election of Paul IV, who "declared his main aim to be the suppression of heresy and false doctrine."[38] Paul IV's stringent opposition to all deviations from traditional Catholic doctrine caused individuals who had proudly considered themselves Nicodemites to assume Nicodemus's cautious behavior in order to avoid reprisal.[39] She asserts that Michelangelo expressed "many anxieties," "confusion," and "unhappiness" with the times in letters he wrote in 1555 and 1556.[40] She concludes that Michelangelo, feeling exposed to danger because he had doubled as Nicodemus in the *Pietà*, decided to destroy the statue.[41]

The trouble with Shrimplin-Evangelidis's interpretation of the *Pietà* is that she produces no essential documentary evidence from the sixteenth century to support her contentions concerning Michelangelo's beliefs and attitudes

or those of the Spirituali.[42] What evidence she did produce is tangential and hypothetical. Her thesis that the "Nicodemite" epithet had been applied to the Spirituali has no basis in fact, even were we to agree that the bearded figure in the statue represents Nicodemus—for which, as is noted in chapter 2, above, there is no consensus. She seems to construe a specific application of the epithet from its general use by historians of the Protestant Reformation, such as Delio Cantimori. He made no particular reference to the Spirituali when he characterized Italians who, in the sixteenth century, accepted Protestant doctrines, but "who preferred to disguise their convictions behind an outward conformity to Catholic rites."[43] Importantly, Carlo Ginzburg, another historian of the Protestant Reformation, cautioned against the misuse of the epithet, writing, "Throughout the literature of modern historians, the terms Nicodemite and Nicodemism are a constant, which might lead the unwary to think that they were in widespread use in Italy in the sixteenth century. They were not."[44]

Then there is the question of whether Michelangelo would have felt safe enough to identify himself as a Nicodemite in any sense before 1555. This seems unlikely considering the decree of the Council of Trent, promulgated on 13 January 1547 (the year many historians believe Michelangelo began his statue), declaring the basic Protestant doctrine of justification by faith alone to be heretical. The justification doctrine teaches that humankind merits salvation solely through faith in the redeeming sacrifice of Christ. Good works, which for the Catholic Church are essential accompaniments to faith, were considered merely to be worthy activities, without salvific value. The Council's decree effectively put an end to the possibility of accommodating Protestant groups and advocating Protestant views within the framework of the Catholic Church. There is also the matter of Michelangelo's letters of 1555–56, which Shrimplin-Evangelidis interprets as showing his despair over the changed religious atmosphere in Rome. In a letter Michelangelo wrote to his nephew Lionardo dated 4 December 1555 (but which he actually wrote on 4 January 1556),[45] he notes that when his servant Urbino was ill he "was more distressed at leaving me alive in this traitorous world, with so many troubles, than about himself dying."[46] And in a letter of 31 October 1556, Michelangelo informs Giorgio Vasari that he has just returned from Spoleto to Rome, where "one lives as may please God, considering the crisis that's going on."[47] These comments by Michelangelo do not include the reasons for his concerns and are in themselves too vague to carry the religious weight Shrimplin-Evangelidis attributes to them.[48] Finally, we must question whether Michelangelo, if he had so feared identifying himself as Nicodemus, would have even allowed the *Pietà* to leave his studio with his own features intact—presumably in the very year Paul IV began to introduce his repressive measures against perceived heretics.[49]

None of the theories I have cited—not even Vasari's—can account for Michelangelo's mutilation of the statue. He could have dealt with any one of the concerns mentioned above in other, less drastic ways. Moreover, those theories all presume that Michelangelo really wanted to destroy the *Pietà* outright. If we do

not accept that premise, Michelangelo's act can be seen quite reasonably as part of an effort to recarve the marble, not to destroy it.

What evidence is there for this new hypothesis? There is the fact that Michelangelo left the bulk of the statue intact, breaking away, it should be noted, only the limbs of individual figures: Christ's and the Virgin's left arms (attached at the elbows), the right arm of the Magdalene, Christ's right forearm, and—historians commonly believe—Christ's left leg (plate 45). What Michelangelo did not do is just as important as what he did do: there is the fact that Michelangelo left Christ's right leg untouched, despite its vulnerability in being directly accessible from the front. He did not damage any of the torsos, except Christ's left nipple, which presumably became detached accidentally, along with the Virgin's hand. In effect, Michelangelo seems to have been selective in pruning the *Pietà* only of what he considered expendable. This leads to me to conclude that he acted out of calculation—not impulse or anger, as is usually claimed—in breaking up the statue.

I believe further that Michelangelo's procedure for detaching the limbs was equally deliberate. He first severed Christ's and the Virgin's left arms and the right arm of the Magdalene. Then he turned to Christ's right forearm—which he could approach only by going around to the rear of the statue. But, significantly, he was careful not to damage the Magdalene's head, although it was so close to Christ's forearm (plates 34–36, 44). Nor does Michelangelo's method of removing the limbs fit with the spontaneous behavior one would expect from a man acting out of anger. Vasari does not tell us what instrument Michelangelo used to damage the statue; modern historians have offered that. Most claim he struck it with a hammer, some say a sledgehammer or even a steel pick-axe.[50] Peter Rockwell (see appendix A) convincingly argues against Michelangelo's direct use of a percussion tool to sever the limbs. Significantly, he points out that there is no evidence of the "network of micro-fractures" such tools normally make when striking the surfaces of marble, nor any evidence that they had once been present but polished away. He concludes, quite persuasively, that Michelangelo used a point chisel to pry loose the limbs of the figures.[51]

If, as I propose, Michelangelo's "destruction" was in fact a premeditated disassembly, then his purpose must have been to preserve the core block of the *Pietà*, including Christ's right leg, with the intention of recarving what remained of the statue into a new composition.[52] As Vasari tells us, he did such recarving later to a different block, with the Rondanini *Pietà* in Milan (plate 8),[53] which he carved drastically into Christ's formerly robust torso to rough out new arms, closer to his body—making the original right arm expendable—and altered the position of the heads of Christ and the Virgin.[54] As Juergen Schulz points out, "Constant revision...seems to have been the virtually universal principle of Michelangelo's work, on the level of both planning and execution."[55] The IBM virtual model allows us the extraordinary possibility of pulling away the reattached parts and viewing the Florence *Pietà* in a state similar to what it must have looked like in Michelangelo's studio (plate 45). When shorn of the limbs, the surviving block demonstrates visually the exact nature of the mutilation and

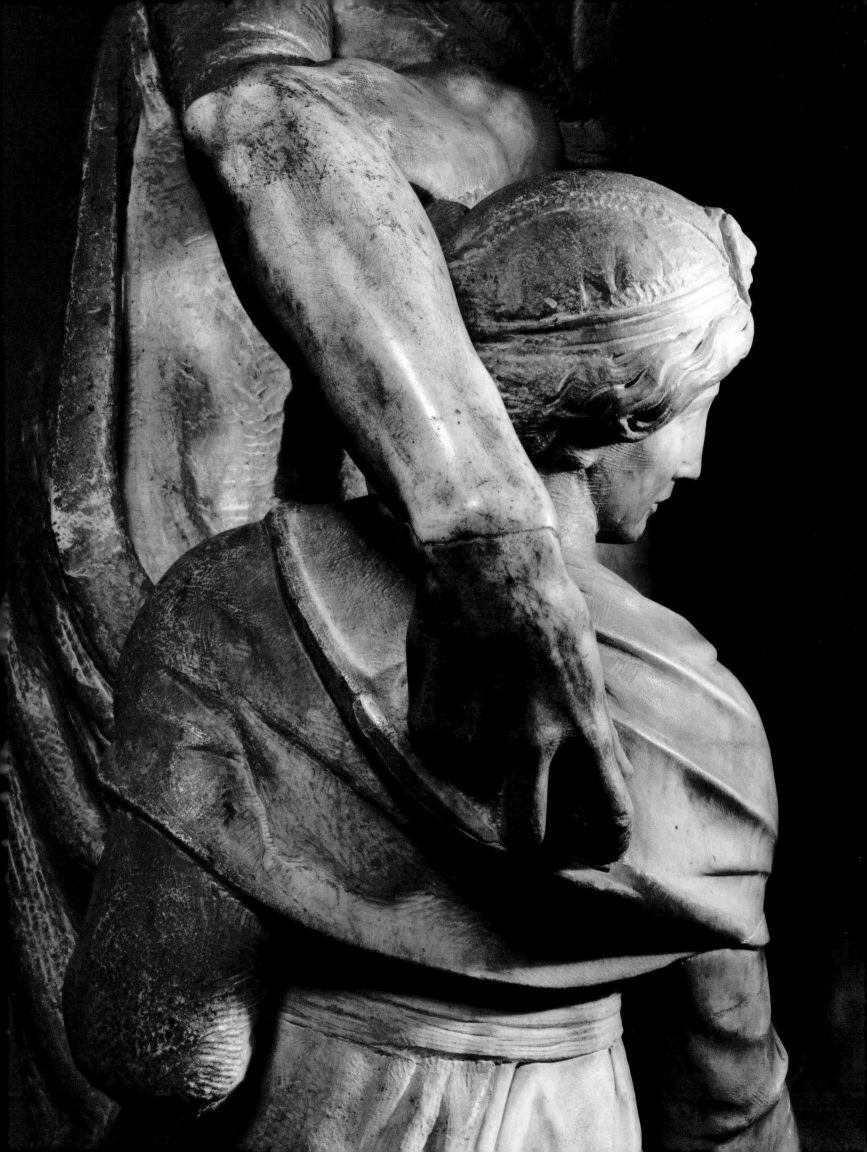

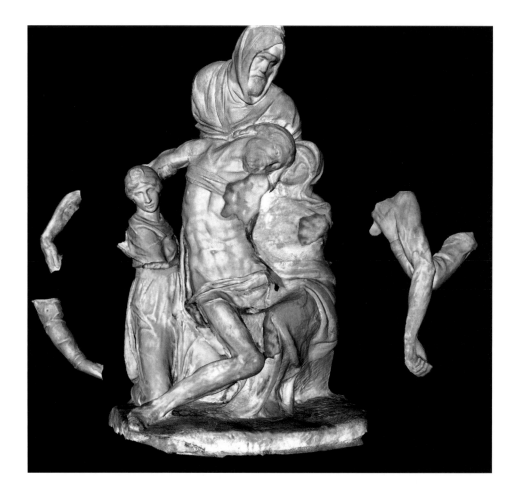

RIGHT PLATE 45
*Virtual image of limbless model,
flanked by the detached limbs*

BELOW PLATE 46
*Lorenzo Maitani (Italian,
1290–1330), Last Judgment
(detail), c. 1310–30. Marble relief.
Cathedral of Orvieto*

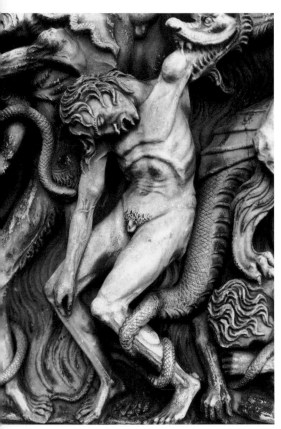

also unequivocally that the artist did not remove the limbs to gain access to Christ's left leg, as Steinberg claims; as pointed out above, too much else of the statue has been severed besides the left side of Christ for that to be true. The pruned model does, however, suggest what revisions Michelangelo may have had in mind. The model shows that the artist had a sufficient reserve of marble left in the area of the Virgin's leg to excavate a new left leg for Christ, in a position approximately parallel to his right leg, which seems to have been preserved for this eventuality. If this reading is correct, the position of the new leg would mean that Michelangelo intended to change the composition from one in which Christ is being eased onto the lap of the Virgin to one where he would be slipping directly to the ground—from a Pietà to a Deposition, or even an Entombment. Lorenzo Maitani's famous figure of a damned soul in the reliefs from the Cathedral of Orvieto (plate 46),[56] seen in reverse, gives an idea of how Michelangelo intended to alter Christ's figure. Perhaps in its new form, the statue might have resembled the Rondanini *Pietà*.[57]

Michelangelo's attempt at a radical iconographic transformation of the *Pietà* may have been fostered by technical problems; perhaps the inadequate dimensions of the block prevented him from correcting them. A *pentimento* such as that on the Virgin's left cheek (plates 47 and 107) and her oddly malformed lap in front (plates 38 and 48) demonstrate how he struggled to give proper form to the statue, overall and in detail. He may have abandoned the effort also to reconstitute the

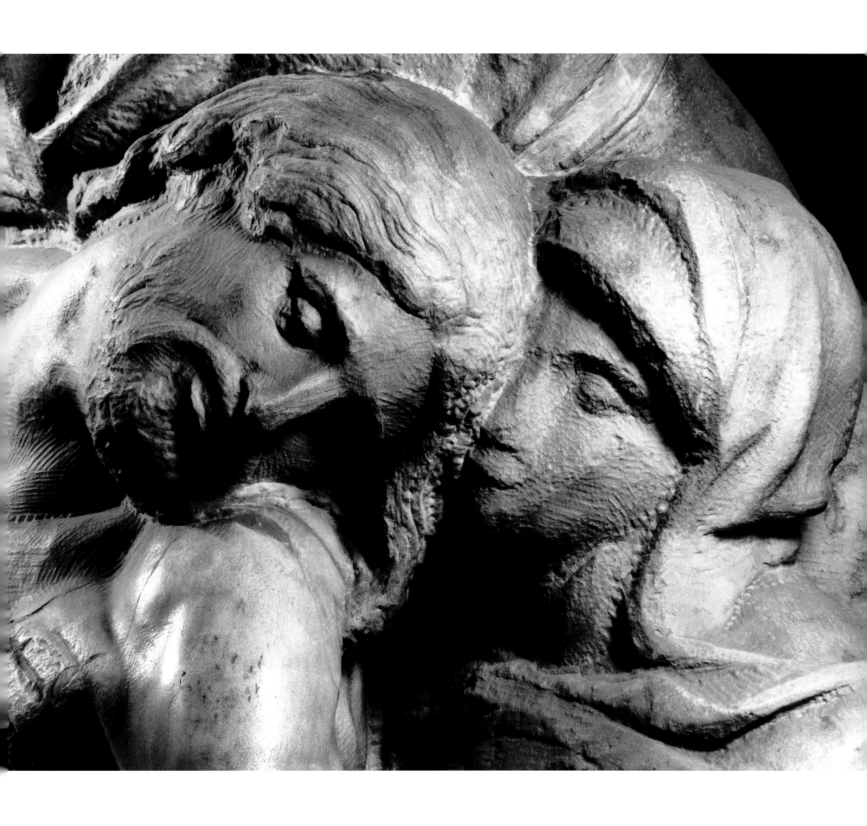

PLATE 47
Heads of Christ and the Virgin

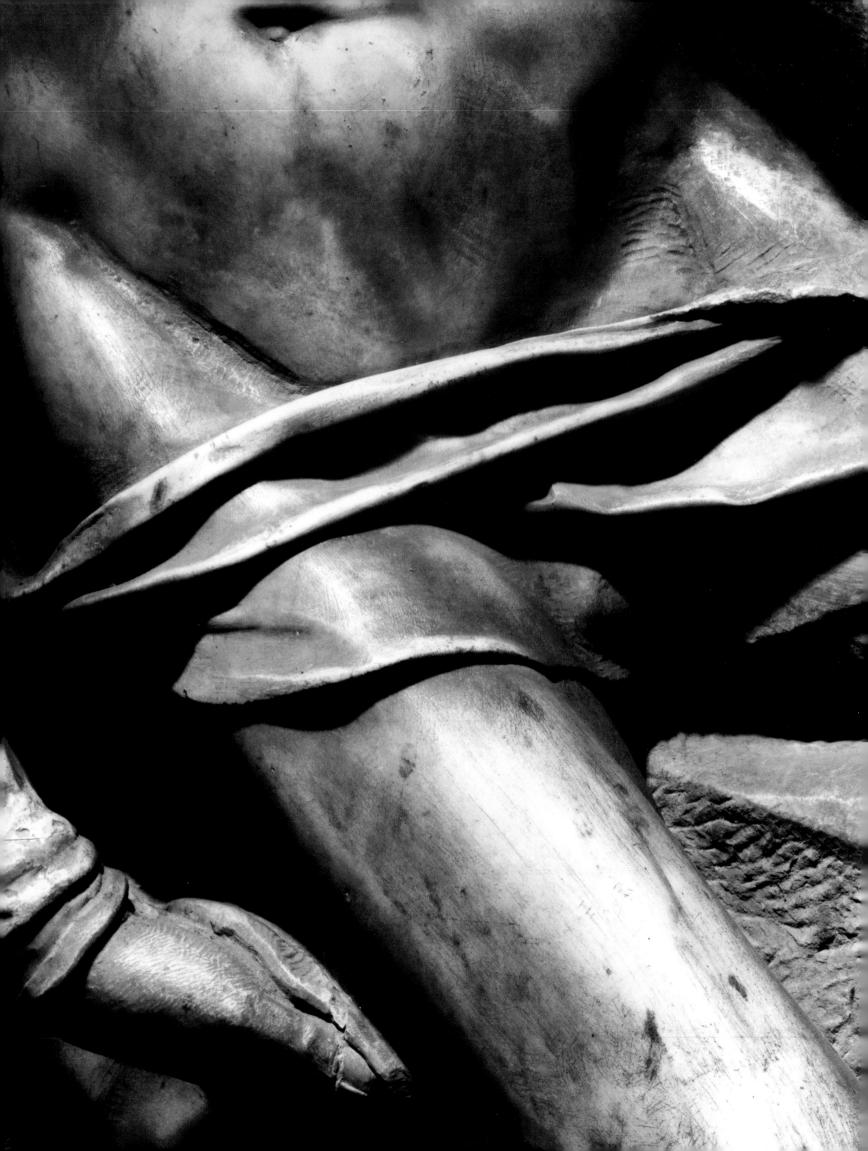

composition because he could no more succeed in making the changes he wanted than he could realize his original design. This stalemate could have encouraged him to revive the Rondanini *Pietà*, which, according to Vasari, he had begun before the Florence *Pietà*.[58] At his age and poor state of health, this might have seemed to him the prudent way to go. In any case, the smaller statue already represented an iconography toward which he appears to have become predisposed when he began to alter the Florence *Pietà*.[59]

PLATE 48
Christ, loincloth at lap

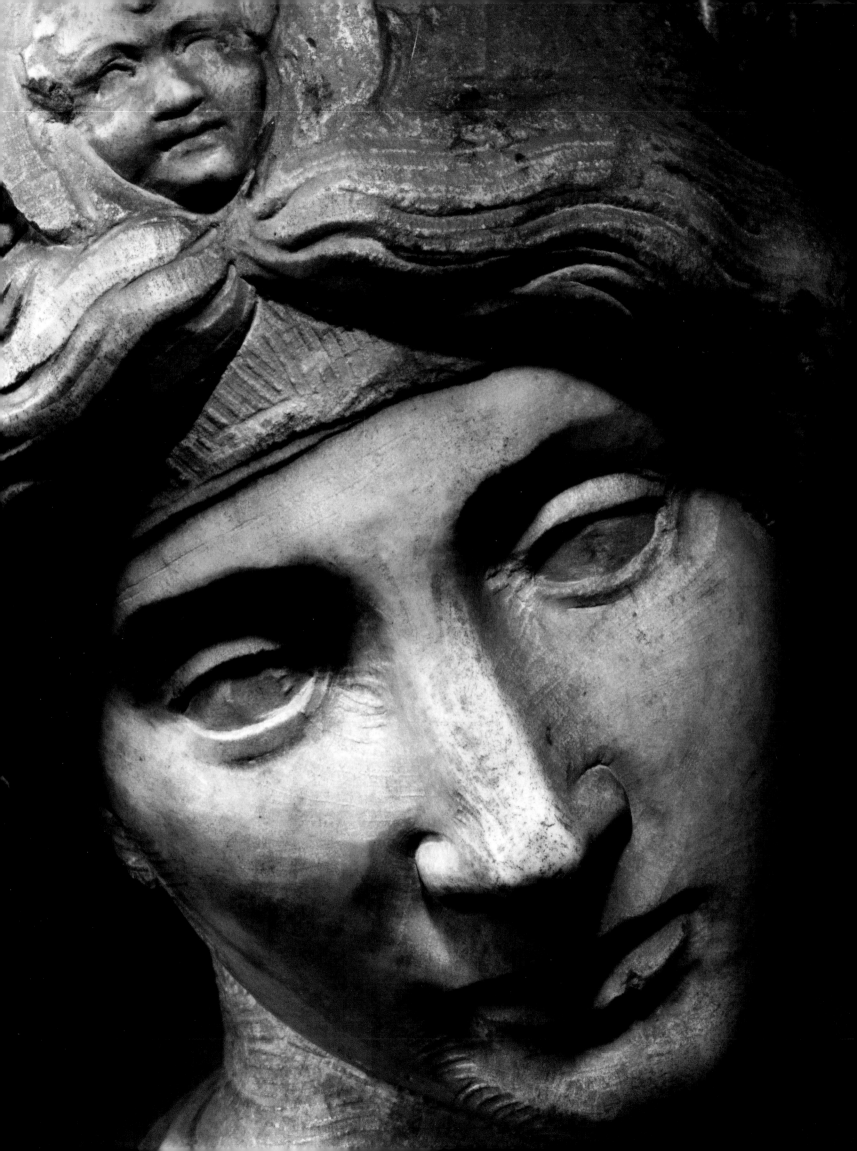

4

THE
RECONSTRUCTION

Vasari writes that Michelangelo made a gift of the damaged *Pietà* to his servant Antonio and that it was then acquired by Francesco Bandini.[1] Vasari seems to contradict himself when he states at one point that Francesco purchased the statue from Antonio for 200 gold scudi and at another point that he received it as a present from Michelangelo.[2] The problem is further complicated by Vasari's statement elsewhere that Michelangelo gave the statue both to Antonio and Francesco,[3] and by a document of 23 March 1564 (recovered by Franca Trinchieri Camiz) pertaining to the acquisition of the *Pietà* by Francesco's son, Pierantonio Bandini; here we read that Michelangelo had donated the statue to Francesco.[4] Perhaps we can reconcile the contradiction this way: Francesco may have required Michelangelo's permission to purchase the *Pietà*, which the master gave on condition that he pay Antonio the 200 scudi to console him for parting with the work. This may explain why Michelangelo gave Antonio another statue in 1561, commonly considered to be the Rondanini *Pietà*.[5] Vasari does not tell us, though, when Francesco acquired the Florence *Pietà*, and there is no documentation to this effect. Most historians agree that it was in 1555, that is, shortly after its mutilation by Michelangelo, which, as we now know, depends entirely Vasari's account of Urbino's having unduly pressed Michelangelo to finish it.[6] A minority of historians, however, claim that Francesco procured the statue in 1561,[7] possibly interpreting the "dead Christ" in the notarized gift Antonio received from Michelangelo in that year to be the Florence *Pietà* rather than the

PLATE 49
The Magdalene, full face

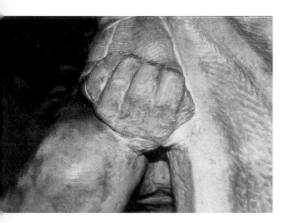

PLATE 50
*Marble bridge under Christ's
left hand*

OPPOSITE PLATE 51
The Magdalene, upper right arm

Rondanini *Pietà*.[8] Francesco must have received it, of course, before 1562, when he died.[9]

We learn from Vasari that Francesco had asked Michelangelo to allow the young sculptor Tiberio Calcagni to finish the *Pietà* (which implies also its restoration) and to help Calcagni in his completion by supplying him with models. Michelangelo agreed and, according to Vasari, they carried the *Pietà* away immediately.[10] The models have not survived, nor do we know whether Michelangelo made them for his own use in carving the *Pietà*, or specially for Calcagni, to aid him in restoring and completing the statue.[11] Vasari did not record where Francesco and Calcagni took the statue. Nor did he indicate how Calcagni proceeded, and what difficulties he encountered, in carrying out his charge to repair and complete a work that is considerably larger than life, of great compositional and physical complexity, in a rough state of finish, and badly ruined.[12] He simply stated that Calcagni restored it with "I do not know how many pieces."[13] There were, in fact, fourteen of them, five of which Calcagni carved as replacements for fragments Michelangelo had damaged beyond use (for a diagram of the pieces, see plate 108). Calcagni's own pieces can be distinguished by the method he used to replace them. His are carefully cut and implanted with regular seams where they are joined to their neighbors. To this group belong Christ's left nipple (plates 2, 15, and 108, no. 8),[14] the drum-like insert at the shoulder of the Magdalene's arm (plates 51 and 108, no. 4),[15] Christ's right forefinger (plates 36 and 108, no. 3), and the two parts of Christ's left hand (plates 52, 101, and 108, nos. 13 and 14).[16] The two parts of the hand are attached to the arm at an excessively oblique angle; they edge too deeply into the wrist bone to make an anatomically correct fit. Moreover, the back of the hand is without structure and, though composed chiefly of marble, it is completed with stucco on the far side (plate 53). Christ's original hand must have been damaged beyond use and the residue carved away by Calcagni, which is indicated by a strip of marble that stretches underneath the new hand from Christ's leg to the leg of the Virgin (plate 50). These are sufficient reasons for believing Christ's left hand to be the work of Calcagni.

All the other pieces are original to the statue, since they display a superior understanding of anatomy and quality of workmanship, and the seams between them where they are attached retain the rough edges of the original break. Stucco has been used to fill transitions from one piece to another; among them are: Christ's left arm, including the elbow patch (plates 54, 106, and 108, nos. 9, 10, 11); the insert in his shoulder (plates 56, 92, 104, and 108, no. 7); the left arm and hand of the Virgin (plates 15, 59, 106, and 108, nos. 7 and 9); and Christ's right forearm and hand (plates 44, 80, and 108, nos. 1 and 2).[17]

Calcagni reassembled the pieces, of various sizes and conditions, and attached them to the main block. The gamma-ray examination by ENEA scientists of the restored areas of the *Pietà* reveals the diverse types of pins Calcagni used in the restoration of the limbs and how, planning his work carefully, he adapted each type of pin to the relative difficulty of its function (for a diagram of the pinwork, see plate 109). Calcagni had employed two distinct types of pins in reattaching the fragments.[18] One type has a simple rodlike form, with each end embedded directly

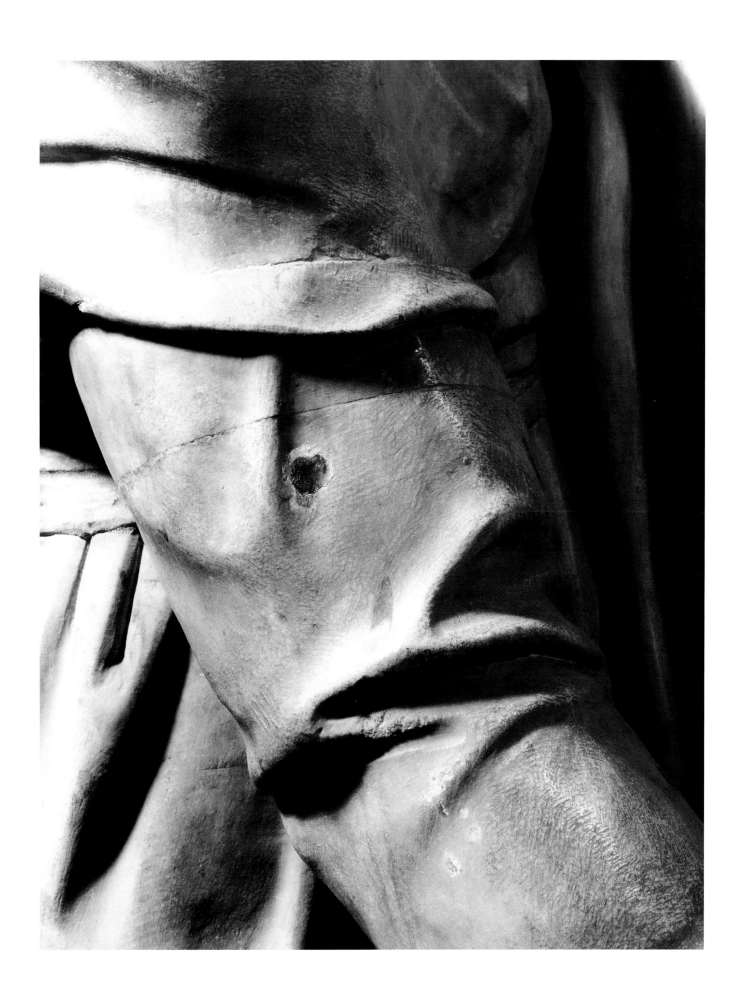

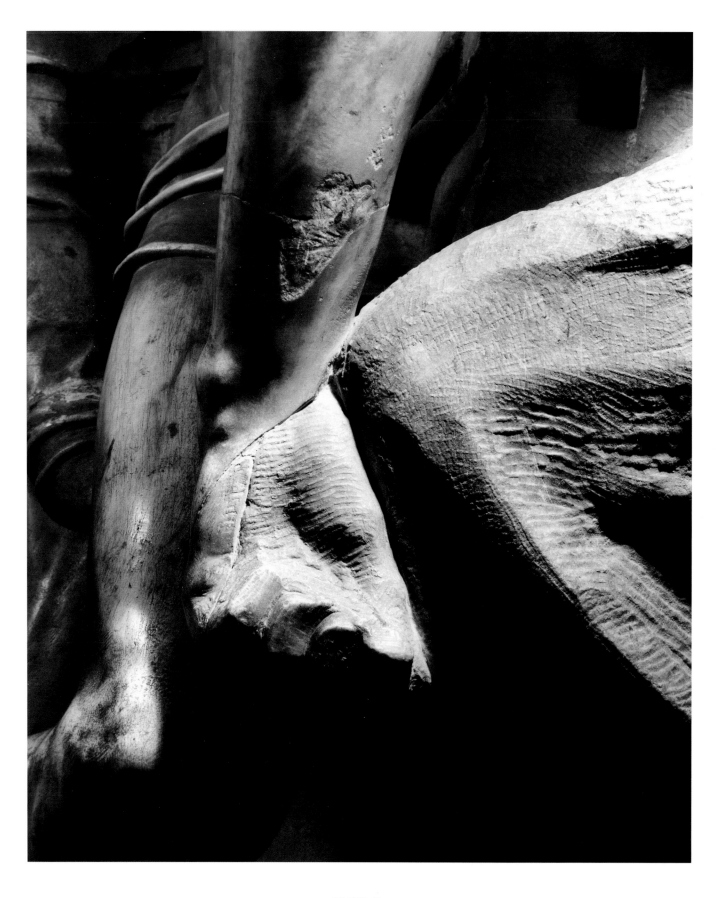

PLATE 52
Christ, left wrist and palm of hand

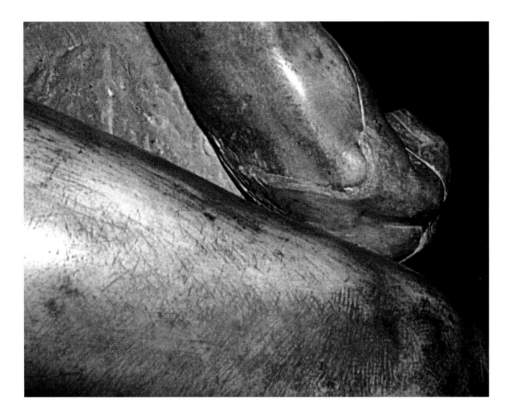

PLATE 53
Christ, back of left hand

in holes drilled into the marble fragments (plate 109, nos. 3, 6, 7, 12, 13). The second type, also rodlike, is put in with one end directly in one fragment, the other end set into a lead container that had first been hammered or poured as liquid into holes previously drilled into the joining piece (plate 109, nos. 1, 2, 8, 9, 11). He used the simple pin to connect small pieces to the main block of the statue: Christ's right hand to the back of the Magdalene, the Magdalene's wrist to her forearm, her hand to Christ's leg, Christ's left wrist and hand to the leg of the Virgin (plate 109, nos. 3, 6, 7, 12, 13). The pins set into the lead container connect large pieces to each other: the two parts of Christ's right arm, his right hand to the forearm, his upper left arm to the shoulder, the Virgin's left arm to her shoulder, and Christ's left wrist to his forearm (plate 109, nos. 1, 2, 8, 9, 11). Calcagni used variations of this stronger type for even more complicated assemblages: the large marble addition in the Magdalene's right arm, where a second pin is inserted perpendicularly into the arm to form a mortise and tenon joint with the inner vertical pin to stabilize it (plates 51 and 109, nos. 4 and 5),[19] and Christ's left forearm to the upper arm, where the pin is inserted into a lead container at both ends (plate 109, no. 10).[20]

Calcagni's attempt to replace Christ's left leg raises a difficult question, which we articulate here for the first time. Who was responsible for severing it, Michelangelo or Calcagni? Historians have always assumed it was Michelangelo. This would be a reasonable assumption in view of the fact that Michelangelo severed the arms of Christ, the Virgin, and the Magdalene. But the responsibility may have been Calcagni's. I will argue, though cautiously, that he removed the entire leg—foot, thigh, and calf alike—as he went about restoring the statue.[21] Let us note that the marble on the side of the missing leg was most likely continuous from the Virgin's arm to the base of the statue (plate 3). The path of the missing leg

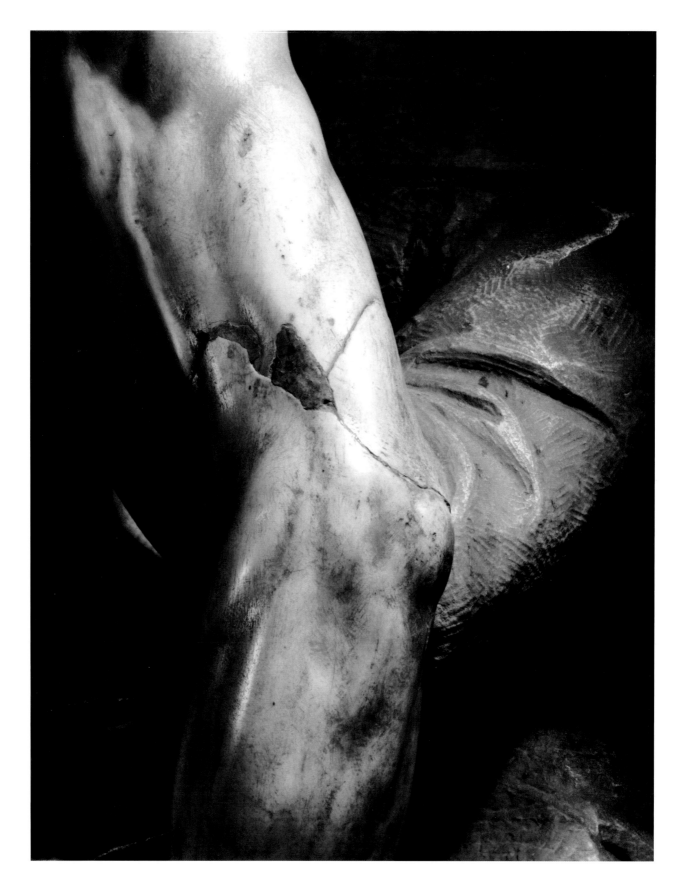

PLATE 54
Christ, upper left arm and elbow

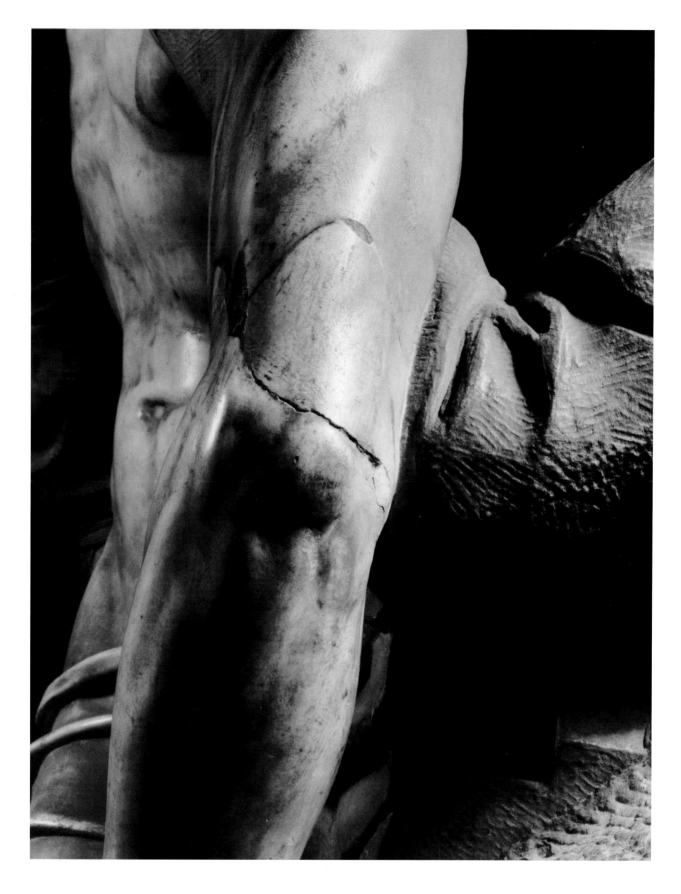

PLATE 55
Christ, patch on left elbow

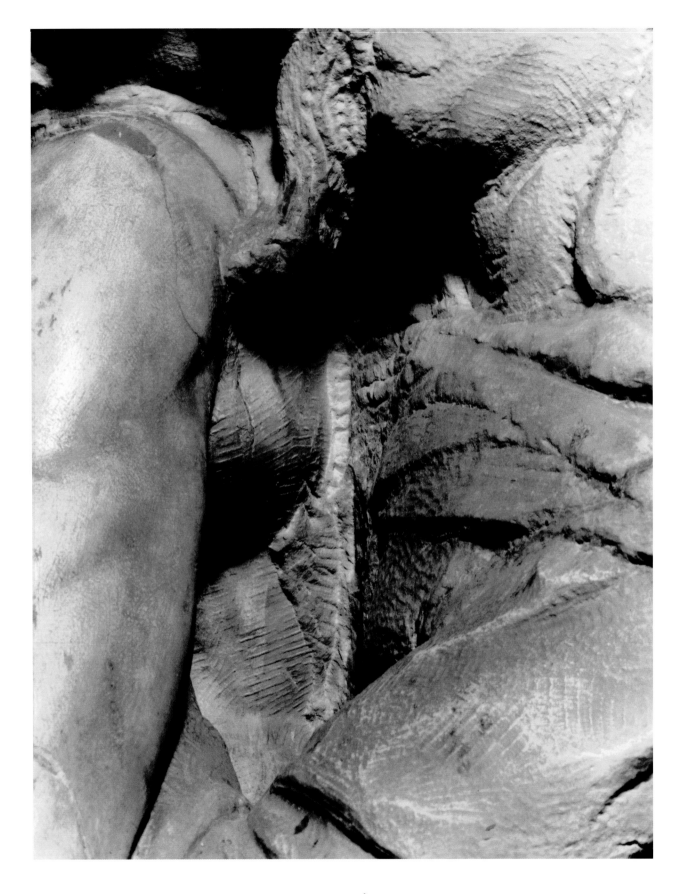

PLATE 56
Christ, left shoulder and back

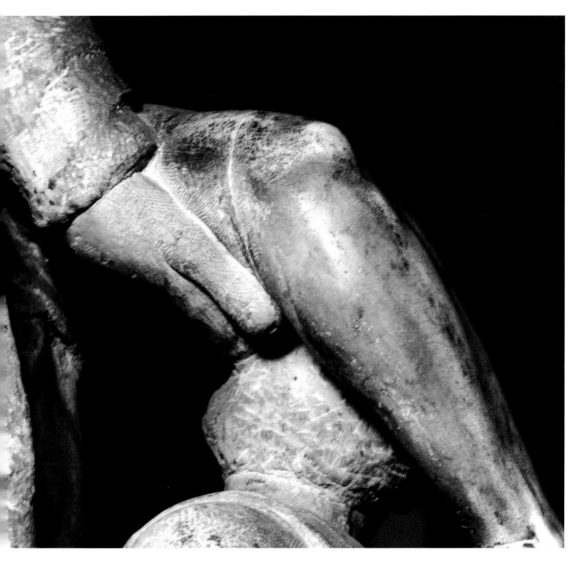

PLATE 57
*Christ, right arm held up by the
bearded figure, view of the back*

can be followed downward from the Virgin's lap. There the leg exists as a semi-circular projection (plate 40; as noted in chap. 3), and, below it, as a rough area (from which it was removed) that is neatly separated by an irregular vertical line from the more careful chisel work of drapery folds (plate 39). Christ's loincloth accompanied the fall of the leg and is now recognizable only in the contained vertical strip with the horizontal parallel marks that were made with a point chisel. On the base of the statue, a slight elevation, once somewhat taller, is visible as an island amid diverse tool marks (plate 58); this functioned as a pedestal to support Christ's foot or toe.

If it is true that the marble on this side of the statue had originally been continuous, then it is likely that the Virgin's full elbow had been attached directly to Christ's left leg. Indeed, photographs of the area show how close the elbow and Christ's leg were (plates 3 and 59). And if, as conjectured in the preceding chapter, Michelangelo had planned to change the iconography of the *Pietà* into a Deposition or an Entombment, he would presumably have contemplated also recarving Christ's left leg in another position.[22] It may be that he would have eventually removed the left leg had he continued to alter the statue. This would be

similar to Michelangelo's procedure in the Rondanini *Pietà*, where he would temporarily preserve the original right arm of Christ, despite the significant alterations he made to the statue, including the carving of a second right arm closer to Christ's body (plate 8).[23]

With these factors in mind, we may surmise that breaking off the Virgin's left arm also irreparably damaged the upper surfaces of Christ's thigh, to which it was attached. This may explain Vasari's statement that "among other things, a piece of the elbow of the Madonna became detached."[24] This is a dubious claim, since the elbow shows no damage. Moreover, a significantly lowered elbow would have been too close to the Virgin's lap to allow Christ's leg to have issued between them. So, Calcagni, when he sought to repair the statue, had to cut off the entire leg to the present stump (plate 40) in order to make room for a replacement limb. This would account for the fact that nothing of the leg has survived—unless, as some believe, the marble knee of a *Pietà* listed in an inventory of Daniele da Volterra's estate of 1566 had belonged the statue in Florence.[25] However, as I pointed out in my preceding chapter, the knee may have fallen off the Rondanini *Pietà*, which Michelangelo was recarving two years earlier, in 1564.[26]

Calcagni did not succeed in his attempt to replace the limb beyond forming the stump and drilling a dowel hole in its center for a pin that would hold a new one in place (plate 60). He probably did not make the new leg, or, if he did, he made no attempt to attach it to the statue, since no traces of binding stucco that would fix a pin in the dowel hole were found when scientists from the OPD performed their chemical examination of the stuccowork.[27] The leg-less *Pietà* appears in the late sixteenth century in two drawings, one by an anonymous draftsman (see appendix E, no. 28), the other by Cherubino Alberti (plate 117; appendix E, no. 27).

My hypothesis that Calcagni had pulverized Christ's left leg encourages the speculation that he had contrived the story, reported by Giorgio Vasari, that Michelangelo had intended to destroy the *Pietà*. According to Calcagni (as noted in chap. 3), Urbino, Michelangelo's servant, had prodded the master into finishing the statue, in the course of which the Virgin's elbow fell away. This, he claims, was the immediate basis for the artist's attack on his statue. The notion of Urbino's prodding (at an unspecified time) may be credible, but not, as I have just argued, the artist's belligerency toward his creation. I submit, therefore, that Calcagni desired to benefit from the fact that Michelangelo had broken away several other parts of the *Pietà* to disguise his own guilt for having demolished Christ's leg without replacing it, thereby irrevocably disfiguring the great work of art.

I came across a document in the Rome archives that complicates our discussion of Calcagni's role in the restoration. The document is a bill of sale, dated 1671, recording the purchase of the *Pietà* "with several pieces" by Cosimo III, grand duke of Tuscany, with no indication of their quantity or character.[28] Added to this new knowledge that the statue was possibly again in parts in the late seventeenth century are chemical analyses revealing that stucco of two different compositions was used in repairing the work.[29] As seen in a diagram illustrated in plate 110, rosin (colored orange in the diagram) appears exclusively at the shoulders of Christ and the Virgin and gypsum (green in the diagram) throughout the

PLATE 58
*Base of the statue, with remains of the
pedestal on which Christ's foot rested*

OPPOSITE PLATE 59
Virgin, back of left arm

ABOVE PLATE 60
*Virgin's lap, with stump of
Christ's missing left leg*

THE RECONSTRUCTION 87

rest of the statue.[30] There are several possible explanations for the disparity between the stuccos. One is that after Calcagni worked on the statue it again suffered damage and someone in the late seventeenth century undertook a second restoration. Another possibility is that two stucco compositions were used simply to satisfy different requirements—the rosin stucco, for example, for its greater adhesive strength so as to create maximum support for the heavy, joined left arms of Christ and the Virgin. Nevertheless, until decisive evidence is forthcoming, we should give Calcagni credit for the entire restoration and agree that he acquitted himself well.[31] His service to posterity is, indeed, enormous. As Aurelio Gotti wrote in 1875, were it not for Calcagni, "little more would remain of this work today than a memory and a yearning."[32] What would have remained of the *Pietà*, if the statue had survived the centuries without the restored limbs, is a pruned block of marble, approximately as it appears in the dismembered computerized virtual model (plate 45). The model possibly should be adjusted to include Christ's left leg, if Calcagni was responsible for its removal; but it should not include the Magdalene's surfaces in their present finished state, as I will now explain.

Having given Calcagni credit for the restoration, we can also breathe a sigh of relief that he did not proceed to recarve the *Pietà* beyond the front side of the Magdalene (plates 2 and 6), for there, unfortunately, he committed serious damage.[33] In the first place, he deprived her face of the "deeply grieved" expression that Condivi had seen when the figure was still roughed-out (plates 49 and 61).[34] Using a flat-head chisel (plate 97, nos. 9–10), its prismatic marks especially recognizable on the cheekbone,[35] Calcagni transformed the Magdalene's face into bland insensibility.[36] He emptied it of its armature of bone, sharpened excessively the physiognomic details of the eyes and lips, and removed the suppleness of the surfaces and the outer glow of the animated inner self for which the master is renowned. Of Michelangelo's hand, there remains only the top of the head and the hair on the right side, both still in rough states of finish. Evidently, Calcagni carved only what the beholder would easily see, using a flat chisel and a rasp (plate 97, nos. 11–12), as well as some sort of abrasive, to attain matte surfaces.[37]

Calcagni's treatment of the Magdalene's body is equally troubling. To recognize the changes he made to Michelangelo's aesthetic, we need but compare the front side (plate 32) with both the bulky right calf (from foot to knee) and rear of the figure as Michelangelo had carved them before he damaged the statue (plate 62). In these areas, the Magdalene's mass is perfectly analogous to that of the Virgin (plate 63). The two figures must have resembled each other also in front in substance and vitality, if not quite in their dimensions. Calcagni, we can see, not only excessively slimmed down the Magdalene's figure, he schematized the folds and surfaces of her garment and deflated the vital energy with which Michelangelo would have infused it if he had completed the work. The mutation is particularly evident in the comparison between Calcagni's treatment of the Magdalene's right shoulder and arm (plate 32) and the power and thrust of her left shoulder and arm, which is still as Michelangelo made it (plate 44).[38] The Magdalene's right arm in its descent toward Christ's leg is merely ornamental and figurative; its ability to sustain the weight of the lifeless leg of Christ is now deprived of conviction.

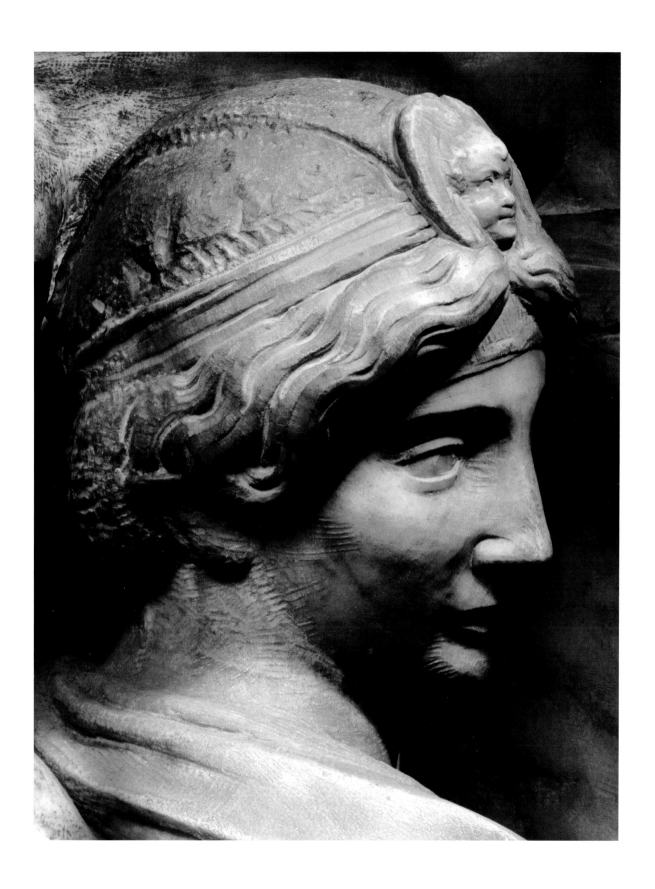

PLATE 61
The Magdalene, right profile

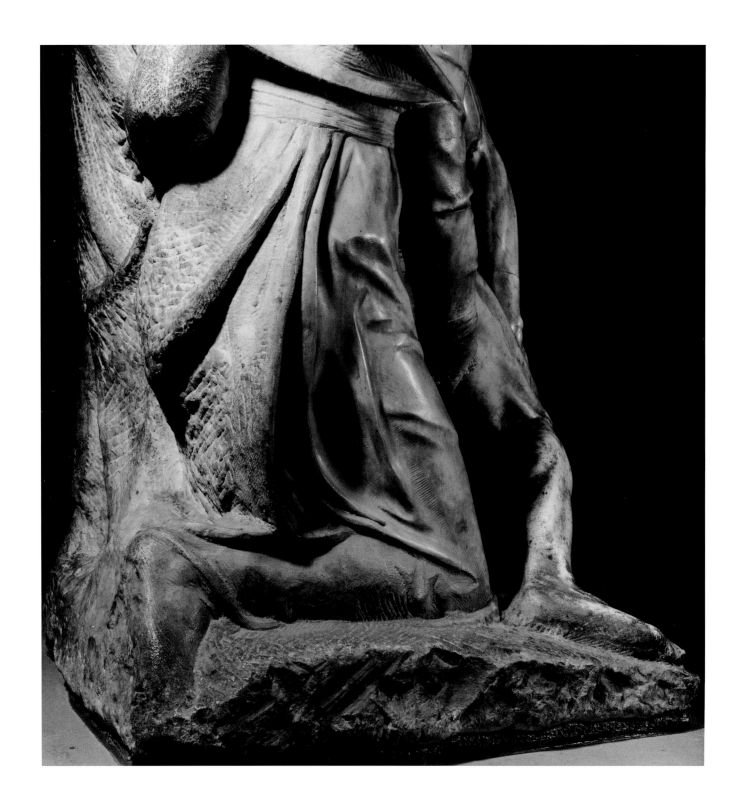

PLATE 62
*The Magdalene, lower part of
the figure from the right*

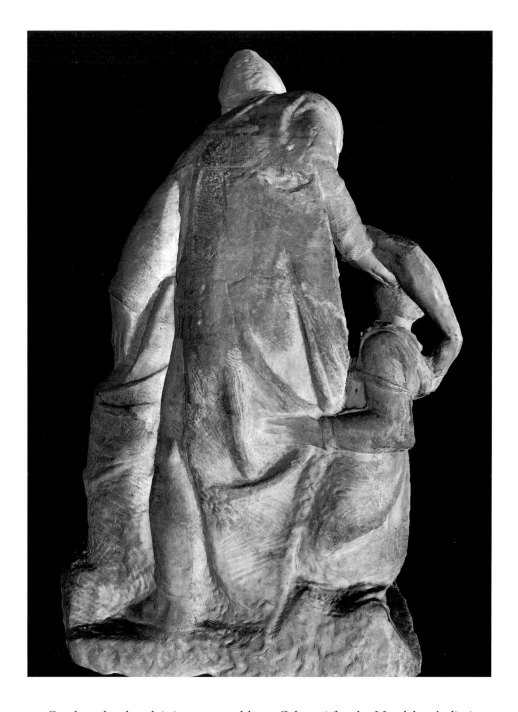

PLATE 63
View of the back

On the other hand, it is wrong to blame Calcagni for the Magdalene's diminutive size in relation to the other figures in the group.[39] That, for the most part, was Michelangelo's doing, since, as we saw earlier, her height is fixed by the finger of the bearded figure that touches the top of her head (plate 57) and by the marble bridge that had once extended from the back of the Magdalene's head as a support for Christ's forearm (plates 34 and 80).[40] Indeed, in diminishing the Magdalene's proportions, Michelangelo recalled her relative stature in earlier representations of the *Pietà*, as in a painting by Girolamo Romanino of the *Mass of St. Apollonio* in Santa Maria Calchera in Brescia (plate 64),[41] and even in one of his own drawings of the subject in the Albertina (plate 21).[42] Indeed, Calcagni should carry the burden of blame only for having diminished her in an expressive sense.[43]

PLATE 64
Girolamo Romanino (Italian, 1484/87–c. 1562), Mass of St. Apollonio, *1516–24. Panel, 10 ft. 6 in. x 6 ft. 7½ in. (3.6 x 2.2 m). Santa Maria Calchera, Brescia*

Also problematic is the assumption some make that Calcagni had a role in finishing Christ's body from the band across the chest through the arms and right leg (plates 6 and 65). Rolf Schott goes to one extreme in recognizing Calcagni's hand "in the feminine torso of Christ,"[44] as does Joachim Poeschke, who finds that "all the finished parts (including the polished Christ) are throughout somewhat minutely handled and ascribable to Calcagni."[45] At the other extreme, Johannes Wilde ascribes to Calcagni only "the polishing of the figure of Christ."[46] However, against the theory that Calcagni intervened in Christ's body are the obvious differences in the quality of the finish between the luminous surface that animates Christ's flesh and the dry surface of the Magdalene, which leaves flesh

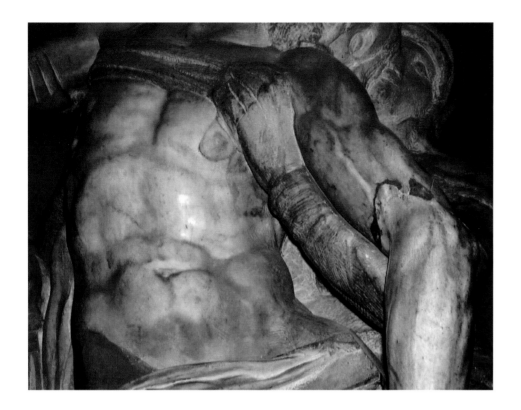

PLATE 65
Christ's torso

and cloth undifferentiated (plate 2). Only Michelangelo, I believe, could have created the high degree and consistency of power and refinement evident in Christ's anatomy and the vigor of the muscles as they interact with the skeletal form.[47]

By the time he broke up the *Pietà*, Michelangelo had reached an advanced stage in shaping the overall composition, in which, apparently, the front was as bulky as the back (plate 63).[48] This includes the Magdalene before Calcagni recarved her. Michelangelo's tooth (*gradina*) chiseling (plate 97, nos. 3–5; indicated in green in the diagrams represented in plates 98 and 99)[49] was probably also visible on all of the statue's surfaces, front and back, as they still appear on the parts of the Magdalene that Calcagni did not touch: her inner left arm (plates 63 and 66), fingers of right hand (plate 67), and right calf and foot (plate 62). Tooth-chisel marks are also visible on Christ's neck and head (plates 68 and 104), on the exposed areas of the bearded figure (plate 37), and on the face and body of the Virgin (plates 3 and 107). The tooth-chisel work here is characteristic of Michelangelo in its vigor and spontaneity, moving in different directions—in contrast to Calcagni's hesitant, nearly mechanical handling of the tool. We know little of Calcagni's work as a sculptor, but I would cautiously attribute to him the wide-channeled chisel marks on the hip of Christ up from the left stump (plate 103) and on his back (plate 56), a type of carving that, to my knowledge, does not appear in statuary for which Michelangelo is solely responsible. It can be associated with Calcagni if, as frequently maintained, he recarved the neck and garment of Michelangelo's *Brutus*, in the Bargello in Florence, which is dated to about 1539–40.[50] Here, a broad-spaced tooth chisel (as in plate 97, no. 8), like the one that made the marks on Christ's hip, etched its way repetitively along the surfaces of Brutus's garment,

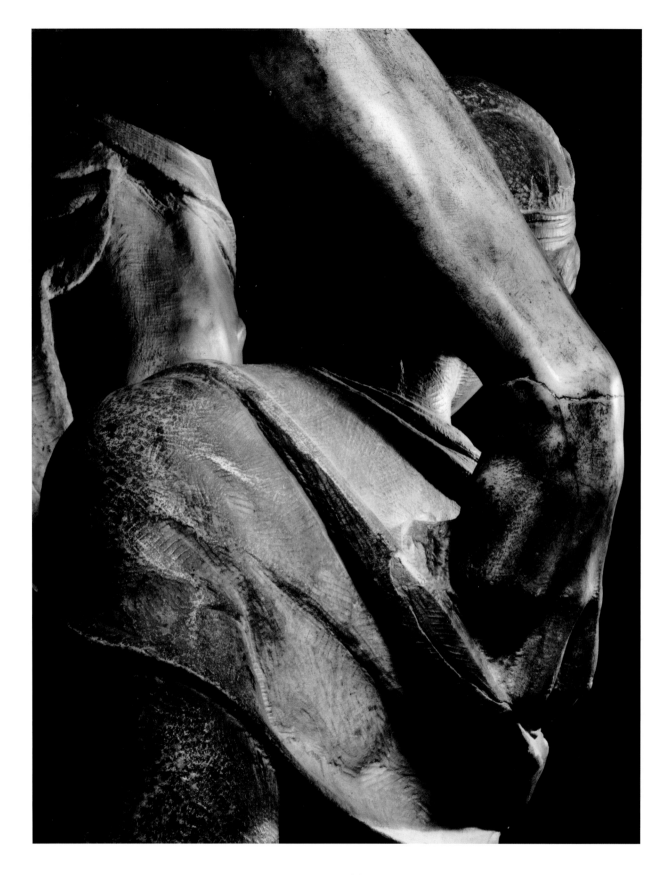

PLATE 66
*The Magdalene, left shoulder,
and Christ's right hand*

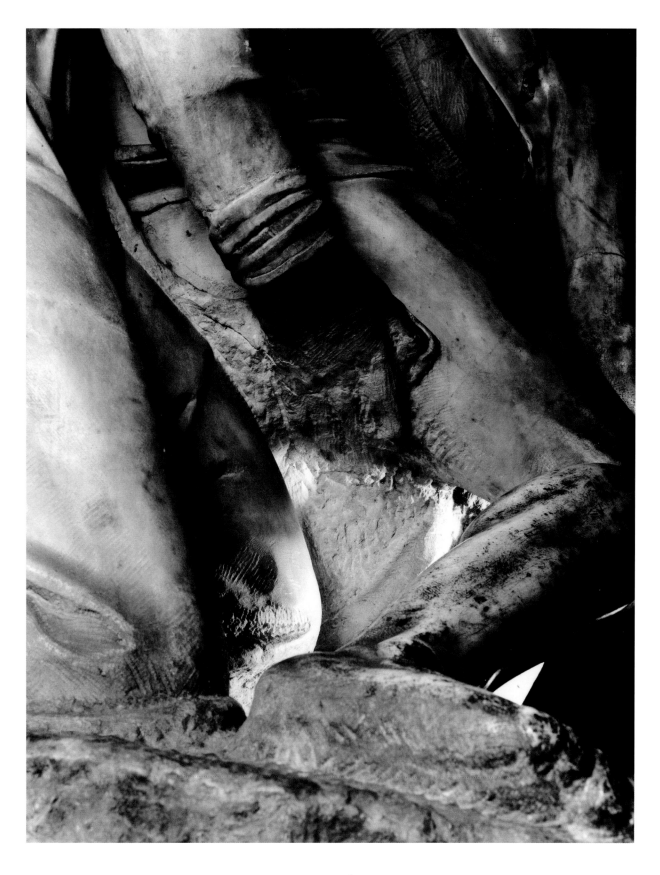

PLATE 67
The Magdalene,
hand on Christ's right leg

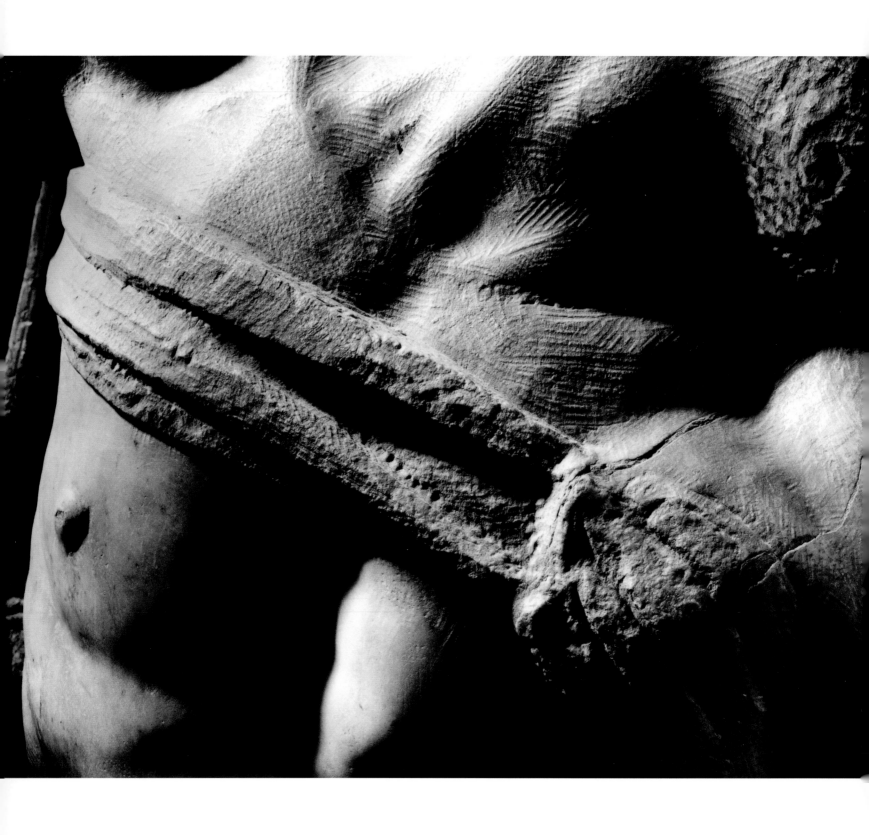

PLATE 68
Christ, band at chest and neck

leaving a series of wide grooves between ridges (plate 69). This contrasts recognizably with Michelangelo's spontaneous use of the narrowly spaced tooth chisel (e.g., plate 97, nos. 4–6) to define and refine the surfaces on the face. In the *Pietà*, when the Virgin's arm must still have been separated from the statue, Calcagni apparently recarved Christ's back as he replaced his left arm, and his hip as he attempted to replace Christ's left leg.

It is my contention, therefore, that Michelangelo, having arrived at this stage of carving with the tooth chisel, began to complete the individual figures, starting with the Christ (because it protrudes the most), which he brought to a high polish.[51] He stopped short of Christ's neck and head upward from the band across the chest. It is, in fact, common to find unfinished heads in otherwise polished figures in Michelangelo's later statues, where, however, he brought the tooth chiseling to a greater degree of refinement.[52] This is especially true of those statues that were to be seen at a distance, where the lack of finish in the upper regions would not be detected. Giorgio Vasari made this practice into a principle, though without directly referencing Michelangelo. "Figures whether of marble or of bronze that stand somewhat high," he wrote, "must be boldly undercut in order that the marble which is white and the bronze which tends towards black may receive some shading from the atmosphere, and thus the work at a distance appears to be finished, though from near it is seen to be left only in the rough."[53] Vasari might have added that faint tool marks also enliven the surfaces of marble sculpture.

PLATE 69
Michelangelo, Brutus *(detail),*
c. 1539–40. Marble, 29⅛ in. (74 cm).
Bargello, Florence

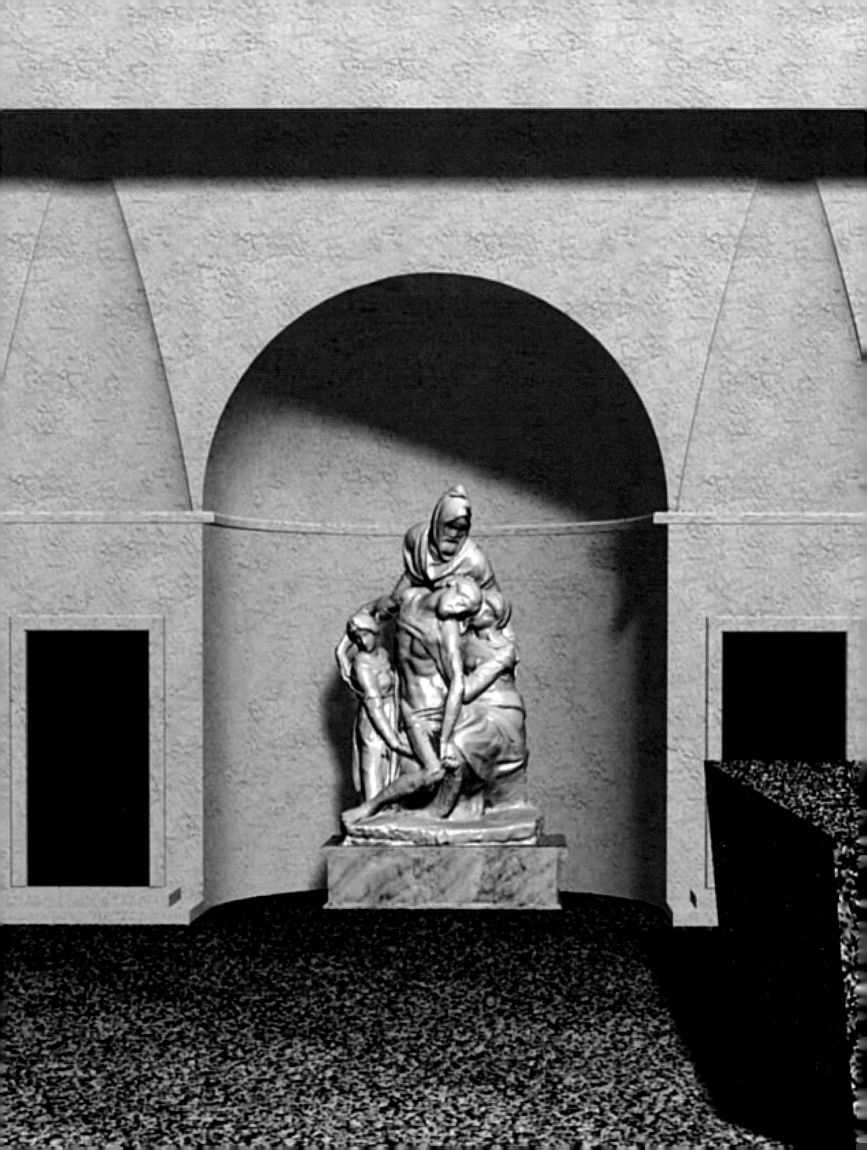

5

THE *PIETÀ* IN ROME

Franca Trinchieri Camiz

THE UNINTERRUPTED HISTORY OF the *Pietà* in Rome can be written now for the first time, thanks to the discovery of a number of previously unknown documents. The first document is the testament Francesco Bandini drew up in 1559 in which he divided his estate in Rome in equal parts among his three sons, Alemanno, Alessandro, and Pierantonio.[1] Two additional notarial documents show that, upon Francesco's death in September 1562, the terms of the will were honored as stipulated,[2] and that a month later Alessandro formally relinquished his share of the estate to his two brothers.[3] Although not mentioned in these documents, the *Pietà* must have been included in the tripartite division of Francesco's property, because in a final settlement of the inheritance, dated 23 March 1564, Pierantonio purchased Alemanno's share in the statue and thus became its sole owner.[4] However, he may already have had de facto possession of the work, since five days before the final settlement, on 18 March, Vasari wrote to Michelangelo's nephew, Lionardo Buonarroti, asking him to acquire the *Pietà* from Pierantonio for the Michelangelo tomb monument he was designing for Santa Croce.[5]

Vasari stated in 1568 that the *Pietà* is present in a *vigna* (a suburban villa) on the Quirinal Hill owned by Pierantonio Bandini (several maps of Rome—e.g., plate 71—show that the *vigna* extended along the "Strada Pia"—today Via XX Settembre—between the Jesuit church of Sant' Andrea al Quirinale and the Carmelite hospice and convent of Santa Anna).[6] But he failed to mention when it had entered the *vigna* (it may already have been there in 1564, the year Vasari asked Lionardo to acquire it from Pierantonio). Nor did he specify its precise location

PLATE 70

Virtual model of the Pietà *viewed in a niche in the Bandini garden*

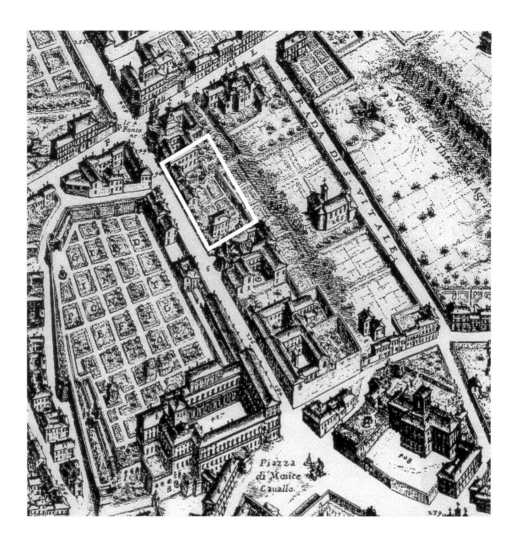

and how it was exhibited there. These questions are solved by an inventory of Pierantonio Bandini's estate, drawn up at his death in 1592.[7] It reveals that Michelangelo's *Pietà* was displayed in a garden loggia, above which was a terraced roof: "A marble statue or figure of the rough-hewn pieta/ Above the little loggia [*logetta*] of the statue, another small marble table with its seat." This site is confirmed by a document of 1628, which is a payment to a mason "for having broken and replastered the wall of the niche where the *Pietà* is located to find the damage to a conduit."[8] The term "niche" undoubtedly refers to the central area of the loggia mentioned in the inventory. Two previously unpublished watercolor drawings of 1739 by the architect Filippo Raguzzini preserve the plan and elevation of the loggia, since destroyed.[9] Raguzzini had been commissioned to make the watercolors to accompany a survey of the garden by the Jesuits of Sant'Andrea of the Roman Novitiate, who had purchased the *vigna* nearly a century earlier.[10] (The *Pietà* had been removed from the garden in 1649, so is not included in Raguzzini's watercolors.)[11] One of these watercolors (plate 72) shows the layout of the garden with the loggia situated in the lower right corner, at the head of an avenue that is separated from the Strada Pia by a wall enclosing the *vigna*.[12] The second watercolor includes the elevation of the loggia coincidentally with a view of the adjacent convent of Santa Anna (plate 73). It shows a tripartite structure with a

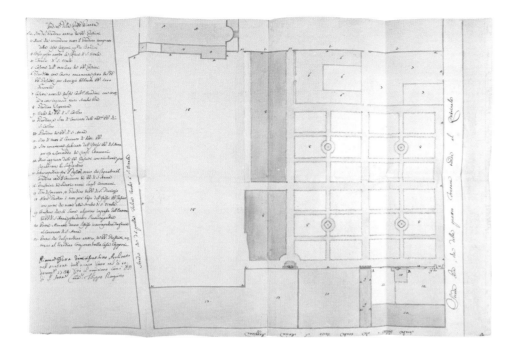

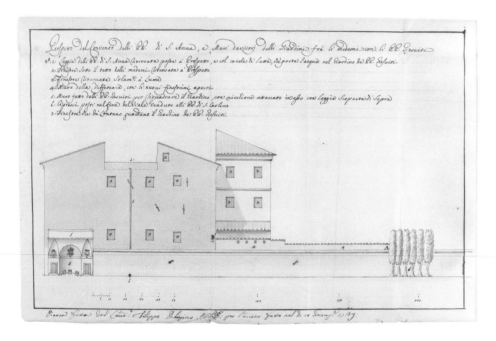

large central niche flanked by two lateral doors, the left one opening onto a small
staircase that gave access to the terrace above, the right one leading to the neigh-
boring Carmelite hospice.[13] Three coats of arms decorated the loggia: two in the
lunettes above the doors and one in the central niche. Raguzzini's written survey
of the property mentions two of the arms, both represented in the elevation
drawing: those of Cardinal Ottavio Bandini (barely recognizable above one of
the doors) and Pope Clement VIII in the central niche,[14] where the *Pietà* had
stood. A scale (in palmi) on the elevation drawing indicates that the central niche
of the loggia was 18 palmi (about 13 ft. or 4 m) tall, 13 palmi (about 9 ft. 6 in. or 2.9 m)
wide, and 10 palmi (7 ft. 3 in. or 2.2 m) deep.[15] Thus, it easily accommodated
Michelangelo's *Pietà*, which is 7 feet 5 inches (2.3 m) tall. The IBM scientists have

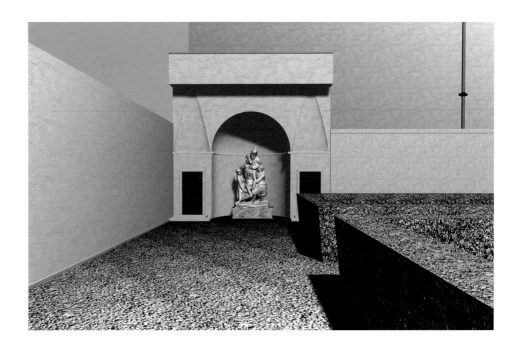

reconstructed what the loggia would have looked like with the statue in the central niche (plate 74).

The idea of setting the *Pietà* in a niche may have been Pierantonio Bandini's at the time he acquired full possession of the statue in 1564,[16] since the loggia is mentioned less than thirty years later in the 1592 inventory of his estate.[17] If so, then he expected that the statue would be enhanced by its architectural frame and displayed as the most important sculptural element in the garden, much the way antique sculptures were strategically sited in the gardens of prominent Romans. Pierantonio's own garden is described in the 1592 inventory as containing his collection of antiquities, consisting of thirty-two objects—including sarcophagi and fragments of statuary—set within three longitudinal pathways bordered by green espaliers, fountains, a small wooded area, a vineyard, grottoes, and a vegetable garden.

However, we do not know who designed the niche and its placement at the end of an avenue—Michelangelo or Tiberio Calcagni. While we know nothing of what might be Calcagni's architectural style, Michelangelo was certainly interested in such a staging of works of art. For example, he had positioned sculpture within an architectural setting in his design for the Capitoline Hill and prepared plans for transporting the ancient *Farnese Bull* into the second garden court of the Farnese palace. The latter was part of a grandiose project, which envisioned a bridge crossing the Tiber and a "great open vista embracing architecture, sculpture, greenery and water."[18] Thus by devising a scenographic scheme for the Bandini garden involving a statue with a Christian, rather than a pagan, subject, Michelangelo—if he was its designer—provided the *Pietà* with a setting that enhanced and immortalized the statue. He also redefined its role and meaning, possibly for personal spiritual reasons, but also to articulate in artistic terms the post-Tridentine spirituality then current.

So unexpected and original a concept as placing a religious statue in a secular garden may have been in response to the important urban-planning project Pope Pius IV (r. 1559–65) was realizing in these years. The Quirinal Hill had traditionally been associated with vacation homes of wealthy Romans, but the pope now planned to reappropriate and redefine the area in sacred terms, as a religious site,[19] a program with which Pierantonio Bandini was familiar as its treasurer.[20] It included a proposal for a new papal summer residence and the construction of the Porta Pia, a triumphal arch that Michelangelo designed as a grand architectural backdrop to the Strada Pia. Furthermore, the pope commissioned Michelangelo to convert the nearby ancient baths of Diocletian, where "in those unhappy times bodies were washed," into the church of Santa Maria degli Angeli (designed by Michelangelo), where "in happier times souls are cleansed of the dirt of sins."[21] Pius's influence in transforming the Quirinal Hill was great, since the area gradually became a privileged site for churches in the second half of the sixteenth century. Indeed, toward the end of the century, in 1587, Catervo Foglietta, a publicist for Pope Sixtus V's urban plan, described the Quirinal Hill as a Golgotha on which a symbolic cross could be traced with its head corresponding with the Jesuit church, and he defined the Quirinal palace, the Pope's summer palace, as the residence of "the Vicar of the Crucifix."[22]

Although historian Tod Marder has warned us not to "overemphasize the religious and abstract symbolic significance" of late cinquecento building plans, the religious objectives and influence of such plans cannot be dismissed out of hand.[23] They should be considered as relevant to the disposition of Michelangelo's *Pietà* in the Bandini garden, which, after all, was a place that parallels Golgotha as a setting for this representation of Christ's death and burial—a burial that the Gospel of John records took place in a garden (19:38–42). This interpretation would be reinforced by Titian's *Pietà* in the Accademia in Venice, of the 1570s (plate 75), if, by representing a *Pietà* enclosed in a rustic niche in a landscape setting, the painter had been alluding to Michelangelo's own intentions to endow a garden with sacred purpose.[24] The Bandini garden, transformed by the *Pietà* into a Christian garden,[25] corresponds, in spirit, to the first important Christian landscape painted by Polidoro da Caravaggio in San Silvestro al Quirinale, the church in which Pierantonio Bandini built his funerary chapel.[26]

The fate of the statue in Rome after the death of Pierantonio Bandini in 1592 has been commented upon in the earlier literature, but inaccurately, and with many gaps still to be filled.[27] Newly discovered documents largely clarify the succession of the statue's ownership within the Bandini family and reveal the previously unknown fact that the statue was sold to a member of the Capponi family decades before its departure for Florence. Hence its history in Rome can be divided into two consecutive phases, corresponding to its two families that owned it.

The inventory of Pierantonio Bandini's estate, drawn up at his death in 1592, indicates that his son, the Abbot Giovanni Bandini, inherited the *vigna* on the Quirinal Hill.[28] On 12 July 1593, Giovanni offered the garden to Caterina di Giuseppe Giustiniani, wife of his brother Orazio, for her dowry.[29] However, it is not

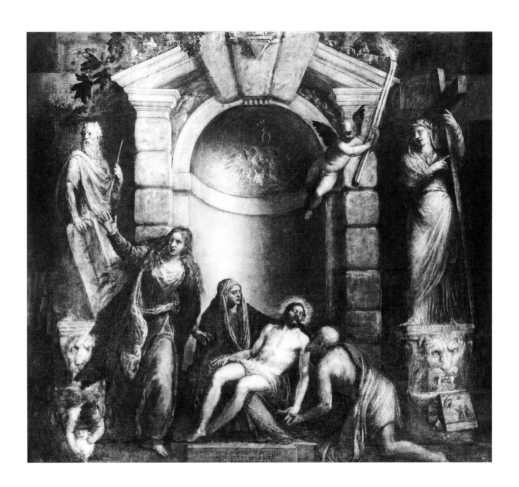

PLATE 75
Titian (Italian, c. 1488–1576),
Pietà, *c. 1576. Canvas,*
11 ft. 5¾ in. x 12 ft. 9⅛ in.
(3.5 x 3.9 m). Accademia, Venice

known if she actually took possession of the *vigna*, and if so, for how long. The *vigna* subsequently became the property of Giovanni's brother, Cardinal Ottavio Bandini, although when this happened and under what circumstances has not been determined, except that it is referred to as the "cardinal's vigna" on the Quirinal Hill in 1605, when the cardinal is reported to have given elaborate banquets there.[30] The *Pietà* was assuredly still in the *vigna*, although it is not mentioned until decades later (in 1628) when repairs were made "in the niche where the *Pietà* is placed" in the garden of Cardinal Bandini at Montecavallo (the Quirinal Hill).[31] Upon the cardinal's death in 1629, his niece and universal heir Cassandra Bandini Giugni inherited the *vigna*.[32] She sold the property to her husband, Niccolò Giugni, on 26 June 1632 for 18,000 Florentine scudi,[33] but she attached to the sale the condition that Niccolò dispose of the property within three or four years and use the money obtained as a dowry for her sister, Maria Maddalena Bandini. Niccolò was evidently unsuccessful in finding a suitable buyer, and Cassandra regained ownership of the property at some unknown time, since she succeeded in selling it to Scipione Capponi on 15 May 1646 for 20,000 scudi.[34] Though the *Pietà* is not mentioned in the cardinal's testament, in an inventory of his estate,[35] or in the instuments of sale of the property between Cassandra and Niccolò Giugni, we do know that Scipione acquired the statue with the purchase of the *vigna*.[36]

On 30 January 1649, Cardinal Luigi Capponi, acting as Scipione's agent, sold the garden to the neighboring Jesuits of Sant'Andrea of the Roman Novitiate for

21,500 scudi.[37] The two parties divided equally between them the flower vases, citrus plants (*agruminum*), and statues present in the garden. The cardinal retained possession of the *Pietà* for his nephew and transported it to Palazzo Montecitorio, his city residence. Sebastiano Casci wrote on 27 May 1649 in a diary he kept of the cardinal's activities, "Today, the unfinished marble *Pietà* by Michelangelo Buonarroti arrived [in the Palazzo Montecitorio];[38] it once stood in the garden of Monte Cavallo and was acquired by the cardinal as part of the division agreed upon with the Jesuit Fathers in the sale of the garden."[39]

Four years later, on 7 April 1653, Cardinal Capponi sold the Palazzo Montecitorio to Prince Niccolò Ludovisi for 25,000 scudi,[40] but he retained possession of its contents, including the Florence *Pietà*. He transported the statue to the Palazzo Rusticucci-Accoromboni on 2 May 1653,[41] where he was permanent guest of the owners of the palace, Ottavio and Maria Isabella Accoromboni Ubaldini. Upon the cardinal's death on 6 April 1659, the Collegio di Propaganda Fide, the cardinal's universal heir,[42] prepared an inventory of his belongings in the palace in the Borgo (Rusticucci-Accoromboni) and in a palace at Monte Giordano. The inventory, compiled three days later, on 9 April 1659,[43] divides the property into three unequal sections, but only the third and the largest pertains to the cardinal's personal possessions. The first two sections list the properties of Monsignor Luca Torrigiani, the cardinal's great nephew, and of Scipione Capponi and his wife, Hieronima Ursina.[44] The list of Scipione's belongings, which are what interest us, begins on folio 492, with the heading: "Here is described all and each possession of the Illustrious Marchese [Scipione] Capponi and the Marchesa Hieronima . . . in the palace in the Borgo," the Palazzo Rusticucci-Accoromboni. [45] Among Scipione's belongings are "a white marble *Pietà* with 4 figures about 12 palmi tall and unfinished from the hand of Michelangelo; a statue of Sant'Onofrio of similar marble about eight palmi tall."[46] Mixed in with the cardinal's belongings, in a location simply specified as "in sala," is "a wooden pedestal under a statue of S. Onofrio belonging to Sign. Marchese [Scipione] Capponi."[47]

Scipione Capponi died on 16 July 1667, leaving his property, including the *Pietà*, to his eldest son, Piero Capponi.[48] Piero then sold the statue to Cosimo III for 300 scudi on 25 July 1671.[49] Paolo Falconieri, a Florentine resident in Rome, was the grand duke's intermediary in the purchase.[50] A few years later, in 1674, Falconieri, together with Torquato Montauti, resident of the Tuscan legation in Rome, would assume responsibility for shipping the *Pietà* to Florence.[51] At the time of the purchase, the statue was still in the Palazzo Rusticucci-Accoromboni in the Borgo, where it had remained after the death of Cardinal Luigi Capponi in 1659. It may be that, upon purchasing the statue, Cosimo ordered it transferred to the Palazzo Firenze in the Campo Marzio in Rome, which was the seat of the Tuscan legation in Rome.[52] This is supported by a letter dated 20 June 1674, that reads "last night, after the hour of 24, the cardinal [Cardinal Altieri, who gave permission for the export of the *Pietà* to Florence], sent an usher to the Palazzo di Campo Marzio to inquire if the statue had already left."[53]

On 12 June 1674, Cosimo III ordered Paolo Falconieri to take the responsibility for the transfer of the *Pietà* to Florence.[54] The original copy of the order is lost, but a postscript that had been appended to it by Apollonio Bassetti, Cosimo's secretary and canon of the church of San Lorenzo, survives.[55] We learn from it that the idea of the transfer may have been on the grand duke's mind for some time (presumably from the time he acquired the statue in 1671); now he suddenly made it a priority.[56] The postscript reads in part: "The papal nunzio in Florence came this evening to request one of the grand duke's galleys in order to transport from Livorno to Genoa certain moneys which will be brought there from Civitàvecchia in another boat. His Highness thinks it now a good opportunity to ship the statue, since the papal administration will scarcely object to its passage to Livorno aboard their galley, requiring as they do the same favor of His Highness."[57] Bassetti advises discretion in dealing with this matter, presumably because the idea of removing works of art from Rome, especially a statue by the great Michelangelo, might be frowned upon by papal officials. Bassetti concludes the postscript by asking Falconieri to crate the statue in preparation for shipment.

Falconieri informed Montauti of these orders and indicated to him that he had already arranged to acquire the necessary materials with which to encase the statue.[58] They decided between them that Montauti would approach the responsible person in the Vatican—Cardinal Altieri, the pope's cousin—with Cosimo's request. Rome, as we know, was in those days a papal city. Subsequent events took the form of a tug of war between Falconieri and Montauti, on the one hand, and the impersonal forces of chance, on the other. This is recounted in letters and other documents dating to between 16 June and 30 October 1674.[59] Montauti wrote the first of a series of letters to Apollonio Bassetti on 16 June, in which he happily reports that Cardinal Altieri had acceded to the grand duke's request to permit the statue to leave Rome, provided that a transport license be obtained from the cardinal's auditor. Montauto's letter then turns dire. He notes that the soldiers responsible for guarding the papal money "were embarking the galley this very evening," and that Falconieri has written him "that the statue cannot be gotten out of the garden before the following Tuesday." Falconieri gives no reason for the delay. Montauti concludes: "I fear that it [the statue] cannot arrive in time to be shipped on this galley."

Meanwhile, the license for transporting the statue from Rome was obtained, and plans were made for the shipment to be divided into a series of stopovers. The first was at Civitàvecchia, where the statue would be placed on a papal galley headed for Livorno and then loaded onto another boat and taken to Florence. Cardinal Altieri wrote to the dispatcher of the galley in Civitàvecchia, instructing him to take all due care during the loading operation. Evidently, the cardinal was unaware of the problem Falconieri was having in removing the statue from the garden. Two days later, on 18 June, the cardinal received the dispatcher's disconcerting reply to the effect that the galleys were ready to leave but that the statue had not yet appeared.

The following day, Bassetti wrote to Montauti and requested him to explain the delay. By return mail, Montauti assured him that Falconieri had placed the

crated statue on a large cart and taken it to the Ripa, the port of Rome, from where it had departed the previous evening for Civitàvecchia. He further noted that Cardinal Altieri had given assurances that the galleys in Civitàvecchia would await the statue's arrival. But this did not end Montauti's woes, since on 22 June, Cardinal Altieri's usher in Civitàveccha reported that the boat with the *Pietà* on it had arrived, but that the statue could not embark the papal vessel because of its great weight. Finally, on 24 June 1674, Bassetti was informed by Camillo Capponi, his works manager (*provveditore*) in Livorno, that "His Highness's divine statue" has arrived.[60] We then have Bassetti's joyous message to Montauti of 26 June: "On the feast day of Saint John the galleys arrived in Livorno in good condition . . . so the statue is safe."[61]

Bassetti was too hasty in expressing his excitement, because he was soon to receive a letter dated 25 June from Capponi informing him that the water level of the Arno had sunk too low to permit the statue to depart for Florence.[62] In a second letter, of 29 June, Capponi writes that the statue had been unloaded and dispatched to the Rocca for safekeeping until it could be reloaded and shipped again. The water level, he continues, must be very high for the boat carrying the statue to pass under the sluice at Pisa, thereby avoiding having to launch it from a slip, which would necessitate the risky operation of unloading the statue at Pisa. In the margin of this same letter, Capponi proposes an alternative route to avoid the problem. He writes that when the level of the Arno River was sufficiently high, the statue would be shipped by sea.[63]

The problem of the unexpected delay was surmounted, but not until after several months of effort to placate the increasingly impatient grand duke. Stefan Tedaldi, who may have taken over Camillo Capponi's position at Livorno, had the anxiety-creating responsibility of overseeing the shipping. The letters he wrote to Bassetti contain repetitious justifications for the delay in expediting it, with equally repetitious references to the great weight of the statue and the low water level of the Arno.[64] However, by 17 October the Arno must have become navigable, because Tedaldi was then negotiating with shippers. Cost was the main issue, which, not surprisingly, was linked to the statue's weight and the risk involved in shipping it by boat. A debate thereupon ensued over the statue's poundage, which was probably overstated by the shippers at 14,000 libbre, and perhaps understated by Tedaldi at 11,000 libbre.[65] In the meantime, the cost differential being negotiated had gone down from 40 to 30 scudi, with a settlement price of 24 scudi, which the grand duke approved. At last, on 23 October, the boat carrying the statue left Livorno.[66] On 30 October, Bassetti wrote to Montauti, "The great statue of the Pietà of Michelangelo happily arrived two days ago and today it was transported to my church of San Lorenzo, where it is to be placed."[67] And so ended the *Pietà*'s association with Rome, more than a century after its creation.

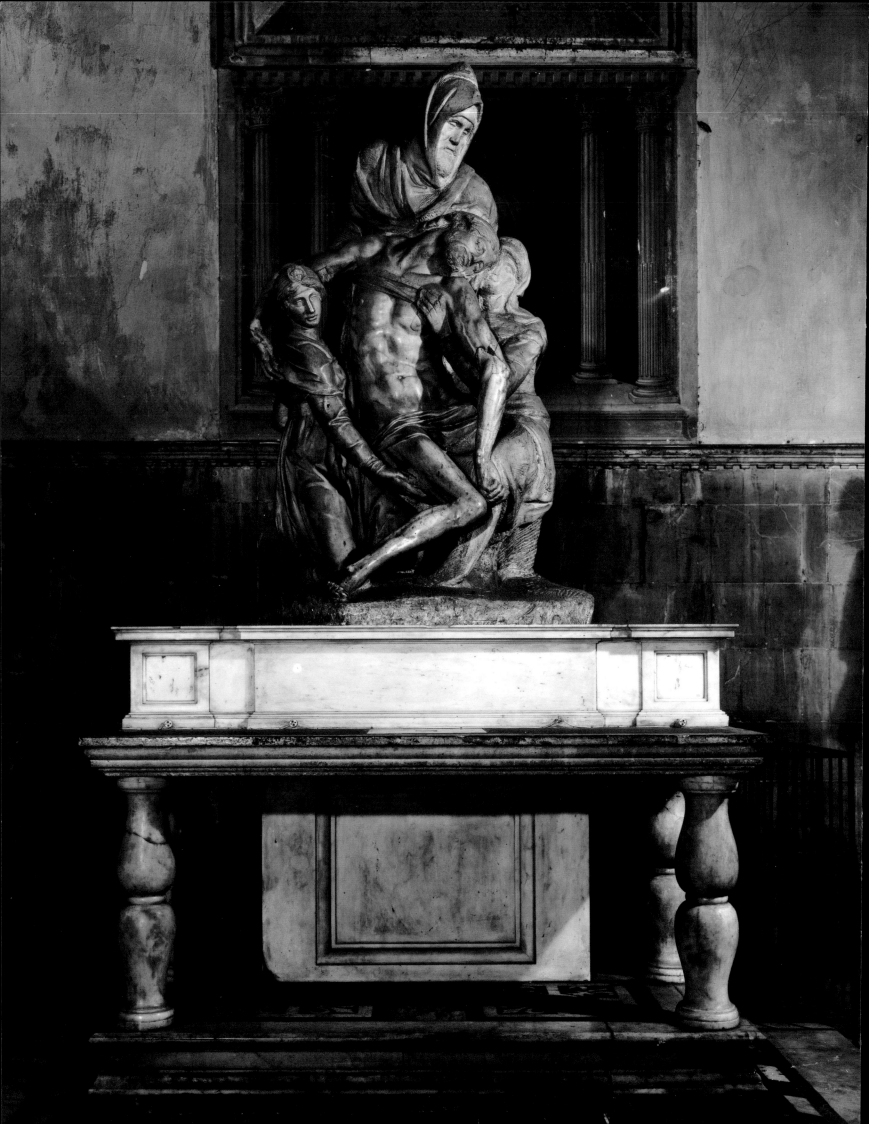

6

THE *PIETÀ* IN FLORENCE

T HE FASCINATING AND SOMETIMES bleak history of the *Pietà* after its arrival
 in Florence on 28 October 1674 has received little attention in the literature
devoted to the statue. Some mention is made of its presence in the Medici church
of San Lorenzo and how it arrived there, as well as its relocation from San Lorenzo
to the Duomo, where it occupied two sites before being permanently installed
in the Museo dell'Opera di Santa Maria del Fiore. Now, with information from
newly gathered archival material, it is possible to reconstruct the statue's entire
Florentine provenance.

The *Pietà*'s Florentine residency opens on a positive note, with a letter from
Apollonio Bassetti, the canon of San Lorenzo and grand-ducal secretary, to Tor-
quato Montauti, the resident of the Tuscan legation to Rome (both of whom we
met in the preceding chapter). In this letter of 30 October 1674 Bassetti writes,
"Two days ago the great [*grande*] statue of the Pietà of Michelangelo happily
arrived here [in Florence] and today was hauled to my church of San Lorenzo,
where it will be installed."[1] From Bassetti's letter we may infer that Cosimo III de'
Medici had intended to house the statue in this, his patronage church, already
before the statue's arrival in Florence.[2] Possibly the statue was predestined also
to be placed in the undercroft of the church (plate 77), a location to which Paolo
Falconieri, who had purchased the statue in Cosimo's name in 1671,[3] objected a
mere six days after its arrival in Florence. On 3 November 1674 he wrote to Bassetti,

PLATE 76

Pietà *on altar in the Chapel of*
Santa Maria della Neve, Duomo, Florence

PLATE 77
Undercroft of the Cappella dei Principi, San Lorenzo, Florence

"I am not very familiar with the undercroft of San Lorenzo, but from what I remember of it, the statue of the Pietà would be much better placed above with the other statues by the same author [i.e., in the Medici Chapel] than below, where it cannot be raised up sufficiently from the ground to be viewed properly."[4] He again states this preference for locating the *Pietà* in the Medici Chapel in a letter he addressed to Cosimo III on the same day: "For my part, I approve very much the collocation of the statue of the Pietà among the others, one may say, unfinished sculptures of Michelangelo, because, since all the other sides of the chapel are already decorated, it seems appropriate to place something on the fourth side."[5] A few days later, Falconieri further notes in a letter to Bassetti dated 10 November that the altar on the fourth side is, in his opinion, too isolated in a niche and therefore should be pushed back against the wall and the *Pietà* placed on it facing the entrance door.[6]

Nothing came of Falconieri's efforts. Someone—Bassetti or the grand duke, perhaps both—overruled him, as we learn from an anonymous document, dating to between 1674 and 1676, which notes that the *Pietà* "is situated presently in the undercroft of the church of San Lorenzo."[7] The decision to send it there may have been made by 17 November 1674, when a frustrated, even bitter, Falconieri wrote to Bassetti complaining that his advice had not been heeded:

It is an extraordinary thing, is it not, that you and I have always to find some matter or other about which to disagree! According to some in that city [Florence], the statue of the Pietà does not merit a place among the other works of the same author, and, therefore, is to be excluded from the [Medici] chapel. Fortune allows me to write of someone who has reached a different conclusion, but overcome as I am by boredom and exhaustion, I will only say in a few words what this person has himself said in many. Michelangelo executed this

work after he had already accomplished the highly celebrated version of the same subject in St. Peter's. Wishing to demonstrate how much more he could achieve, he thus created our later example, or so it is claimed. You might reply that this is merely a groundless fairy tale that I am unable to prove. Still, there is something which Bernini has told me and I know is true. He says that the Christ, which is almost finished, is a marvel of inestimable worth, not only for its own sake but because Michelangelo produced it when he was over seventy years of age. When Bernini was a grown man, and already an acknowledged master since he achieved mastery in youth, he studied this work continuously for six months. And now Sir, may I say with your gracious permission, that I know of no one in Florence better able to judge this matter than Bernini. I shall leave you then to draw your own conclusion.[8]

It is evident from Falconieri's advocacy of the Medici Chapel as a permanent installation for the *Pietà* that he had hoped the statue would serve a noble purpose in San Lorenzo. That also may have been Bassetti's initial plan, judging from his exuberant reception of the statue upon its arrival at his church. One might expect, therefore, that he had consigned the *Pietà* to the crypt when he sent it to the undercroft of the church, as most modern scholars believe.[9] The statue seems actually to have been dispatched to a storeroom. We learn this from a document dated 1692 I found in the archives of San Lorenzo, entitled "Inventory of objects which are found at present in the Royal Chapel of His Supreme Highness."[10] The "Royal Chapel" contained a huge quantity and large variety of objects of a surprisingly commonplace sort, including stools, cabinets, iron pots, and hammers,[11] as well as a variety of minor art works, such as alabaster columns, a marble relief representing the Annunciation, nine plaster busts, eleven gesso models, ninety paintings of curiosities [*anticaglie*], drawings with their ornaments, one coat of arms of his supreme highness, with two painted figures. A "pieta of marble made by Michele Agnielo bonaruoti [*sic*]" is the third item listed in the inventory.[12] Bassetti's and Cosimo's high expectations at the arrival of the *Pietà* at San Lorenzo must have changed to distaste when they set eyes upon this unfinished and mutilated work, with its unconcealed restoration and missing left leg. Neither, probably, had seen the statue before that fateful moment when it was removed from the crate in which it had been encased for shipment.[13]

From the reference to the storeroom in the inventory as the "Royal Chapel of His Supreme Highness," we may conclude that it had been located underneath the Cappella dei Principi, the mortuary chapel of the grand dukes—behind the main apse of the church, which was begun in 1605 and was still under construction in 1692 (plate 77).[14] Proposing this location as the site for the *Pietà*, however, conflicts with the fact that the area was consecrated a crypt two years before the inventory was drawn up, in 1690,[15] and remodeled with this spiritual use in mind in 1693 to commemorate the death of Cosimo's mother.[16] Oddly, the consecration document does not specify the *Pietà* among the crypt's contents, it mentions only an altar supporting a "crucifix and statues," which Giuseppe Richa, in

1757, identified as a *Madonna* and *St. John*.[17] The document, though, does hint at a solution to this dilemma. The site of the new crypt, it notes, "was formerly secular and was used as an arsenal,"[18] that is, a storageroom. Perhaps, then, the area under the Cappella dei Principi had been partitioned in two, one part serving as a crypt, the other remaining a depository in which the *Pietà* was stored.

Thus isolated among miscellaneous objects in a depository, the existence of the *Pietà* was forgotten by late-seventeenth-century historians of San Lorenzo, such as Ferdinando del Migliore,[19] and by foreign travelers to Florence, such as Petr Tolstoj and the Comte de Caylus. Yet, in diaries they kept during their visits in Italy (in 1697–99 and 1714–15, respectively), both these erudite travelers mention descending to the area beneath the Cappella dei Principi without referring to the *Pietà* of the great Michelangelo, only the *Crucifix* and accompanying statues in the crypt.[20]

On 24 August 1721, Cosimo III ordered the *Pietà* transferred from San Lorenzo to the Duomo. It arrived five days later.[21] The grand duke's decision was prompted by the need to find a suitable substitute for Baccio Bandinelli's *Adam* and *Eve*, which in 1551 the sculptor had arranged behind the high altar, on the lower story of a large choir enclosure of his own design.[22] The substitution was deemed necessary: religious zealots had been complaining that their nudity was unsuitable for a religious sanctuary. The statues were removed on 10 September 1721,[23] but the *Pietà* did not actually take their place behind the high altar (plate 31) until ten months later, on 13 July 1722.[24] The apparent reason for the delay was a decision to construct a new base for the statue, which had been designed by Giovanni Battista Foggini.[25] According to diarist Francesco Settimani, the base was constructed with variegated marbles and had an inscription attached to the front side that was composed by a descendent of Michelangelo's, Francesco Buonarroti. The inscription reads: "Cosimo the third Grand Duke of Tuscany, in this year 1722, commanded that the last work of Michelangelo Buonarroti, long ago brought from Rome, be placed here. Although it is scorned by artists for imperfections of the marble, it is, nevertheless, an excellent work of art."[26]

The *Pietà* acquired a new spiritual status in this prestigious site. For one thing, the statue linked the two chief sanctuaries of the Duomo: the high altar, which rose up behind it and had been the custodian of the holy cross reliquary since the middle of the fifteenth century,[27] and the central apse of the eastern tribune, which was dedicated to St. Zenobius, Florence's premier patron saint once removed. The apse had been the repository of the Most Holy Sacrament since 1494.[28] In addition, by replacing the *Adam* and *Eve*, the *Pietà* became associated iconographically with the two statues by Baccio Bandinelli—representing *Christ* and *God the Father*—that he had been placed on the high altar in the middle of the sixteenth century, as seen in a print by Bernardo Sgrilli (plate 78). Giovanni Bottari, in his edition of Vasari's *Lives* of 1759–60, may have been right that the *Pietà* "broke strangely the idea of Baccio, who having represented on the rear the crime of Adam and Eve, on the front he represented the remedy of this, which was the death of Christ and the absolution God gave in this to mankind."[29] One can say, rather, that

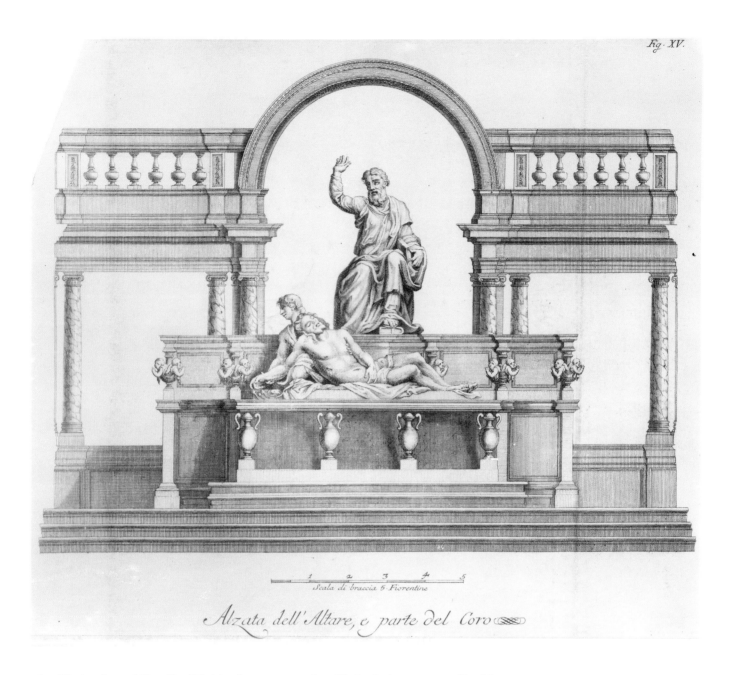

Fig. XV.

Scala di braccia 5 Fiorentine

Alzata dell'Altare, e parte del Coro

the *Pietà* enlarged Bandinelli's idea by representing Christ being mourned by his mother, whose suffering made her intercessor in humankind's redemption.

 Unhappily, the honored place of the *Pietà* in the Duomo was mitigated by physical indignities it suffered during the two centuries it remained there. As Charles Holroyd noted in his 1903 biography of Michelangelo: "The [right] arm of the Christ has become over polished and much worn because it is used as a balustrade by the acolytes, who carelessly run up and down the steps between the group and the back of the high altar to light the candles during service (plate 79). On the other side a rough metal handle has positively been let into the left side of Joseph of Arimathea, so that a clumsy boy may climb the [steps] more easily."[30] It is difficult to judge the extent of the wear to the polish on Christ's arm, but the holes left by the handle upon its removal were filled in with stucco (plate 5),[31] presumably when the statue was transferred to another site within the Duomo in the early 1930s.[32]

PLATE 78
Bernardo Sgrilli (Italian, active Florence c. 1733–55), main altar of the Duomo, 1733. Engraving, 8 x 11 in. (20.5 x 28 cm)

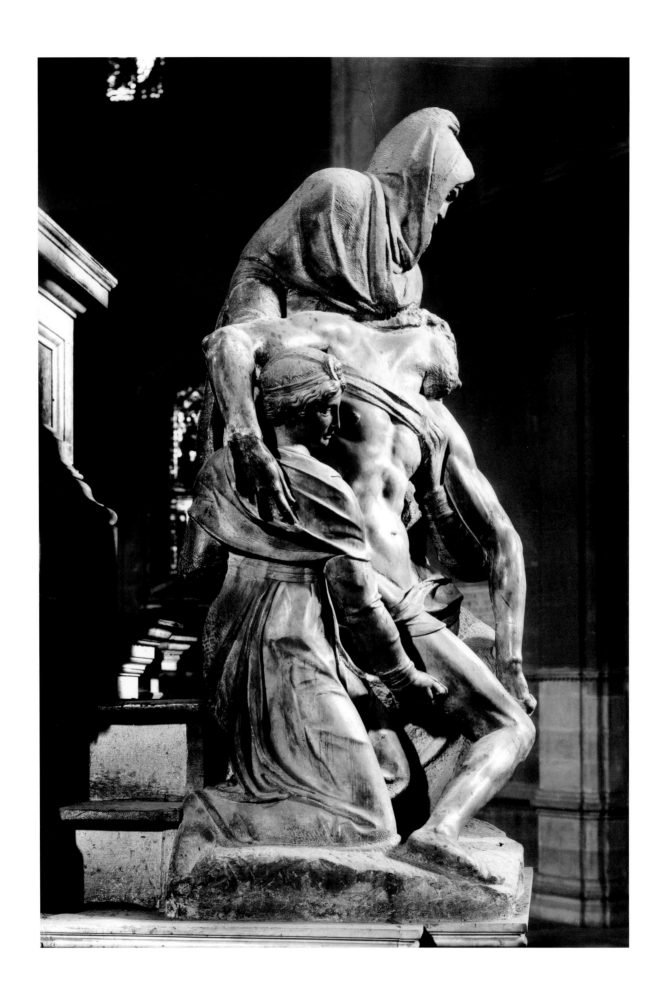

Another debasement is the yellowish patina of glaze-like intensity that covers the statue's surfaces in front, from side to side and top to bottom, on finished and unfinished areas, anatomy and apparel alike (e.g., plates 59 and 62). Scholars have not recognized the existence of the patina.[33] We do not know for certain when the patina was applied. Scientists from the Opificio delle Pietre Dure, who performed a chemical examination of its composition, would not speculate on the patina's date, other than that it was of recent origin.[34] I suggest that the patina might have been applied on either of two occasions, possibly no later than 1882, the year a plaster cast of the statue, today in the museum of plaster casts in Florence called the Gipsoteca, was given a similar yellow coating.[35] The first was during the ten or so months in 1720s when the *Pietà* awaited final installation behind the high altar of the Duomo. The patina would have been applied to give the statue greater luminosity in the cathedral's shadowy interior and help disguise the seams between the restored parts. The second occasion was a brief period in 1842, when most of Bandinelli's choir enclosure was dismantled (significantly, the reliefs on its lower story are covered with a patina similar to that on the *Pietà*). Sculptors at the time tended to paint their marble statues in response to recent discoveries of traces of polychrome on ancient statuary; in 1842 the English sculptor John Gibson, who was active in Rome, painted the flesh tones of his so-called *Tinted Venus* yellow.[36] So, it is possible that the custom of painting marble statuary may have influenced restorers to do likewise on the sculptures they were working on.[37]

The *Pietà* was not destined to remain behind the high altar of the Duomo, but dislodging it was not quickly accomplished. The effort began when the archbishop of Florence, on 9 February 1918, petitioned the Opera di Santa Maria del Fiore to replace the statue with a wooden pulpit for, he wrote, "the greater decorum of the temple."[38] Permission was granted on 8 November 1918,[39] but no action was taken. Five years later, according to the Opera minutes dated 6 March 1923, discussions took place between the officials of the Opera, the mayor of Florence, and other city officials over whether to relocate the *Pietà* within the Duomo or transfer it to Santa Croce. According to Generale Da Marchi, the president of the Comitato Provvisorio per il Monumento alla Madre Italiana, in Santa Croce "[the *Pietà*] could serve "as an expiatory image in a votive chapel." The resident deputy of the Opera, Don Filippo Corsini, on the other hand, was inclined to retain the statue "in the Florentine Cathedral, which is one of Christianity's major temples."[40] This time, no decision was taken, but in 1929 the French writer Camille Mallarmé revived the idea of moving the statue to Santa Croce. She began an intensive campaign that year to encourage the cathedral authorities to donate the statue to the Franciscan church,[41] even arguing that that had been Michelangelo's own aspiration.[42] She made a compelling case that the statue "remains indiscernible in a darkness so unpleasant that it requires effort just to find it."[43] She no doubt found support from complaints of such eminent figures as John Addington Symonds and Auguste Rodin. Symonds had declared in 1893 that "justice has hardly been done in recent times to the noble conception . . . of

this Deposition. That may be due in part to the dull twilight in which the group is plunged, depriving all its lines of salience and relief."[44] Particularly eloquent in this regard, and possibly directly encouraging Mallarmé in her campaign, was Rodin's account, published in 1910, of a personal experience he had with the statue. "I remember," he wrote, "being in the Duomo at Florence and responding with profound emotion to the Pietà of Michelangelo. The masterpiece, which is ordinarily in shadow, was lighted at the moment by a candle in a silver candlestick, and a beautiful child, a chorister, approached the candlestick, which was as tall as himself, drew it toward him, and blew out the light. I could no longer see the marvelous sculpture."[45] Mallarmé's campaign was only partially effective. The statue was given a new location, but not in Santa Croce. In October 1931 the resident deputy of the Opera, now the Marchese Roberto Ginori-Venturi, also displeased with the statue's location, requested authorization to find a more suitable place for it within the Duomo.[46] The curia concurred and the chapel of Santa Maria della Neve, the first on the right in the northern tribune, was selected. Here the statue was installed in the first days of September 1933, on a base attached to the back of an altar.[47] A chorus of approval greeted the new location because of its superior lighting (plate 76).[48] Whether it actually was well lit, with the stained-glass window in the chapel filtering light from the outside, is questionable. One visitor to the chapel, Nello Baccetti, wrote that the light was not much better here than it had been behind the high altar.[49] The new position did have one advantage, however: the Pietà finally acquired a relationship to an altar that agrees more, though not entirely, with Michelangelo's original plan, and with Timothy Verdon's eucharistic reading in his essay in chapter 8 of this book.

The Pietà had been comfortably ensconced in the chapel of Santa Maria della Neve for nearly thirty years when, in 1960, a concerted effort was again made to evict it from the Duomo.[50] As in 1918, the reason given was that the statue's presence seriously interfered with the liturgical services of the church. This time, the president (as he was now called) of the Opera di Santa Maria del Fiore, Rodolfo Francioni, was the spearhead, complaining to the archbishop of Florence, Cardinal Elia Dalla Costa, on 23 December that the Pietà was attracting so many visitors to the cathedral, especially foreigners, that they disturb "the tranquility of the temple."[51] Even his most persistent efforts, he said, did not avail in diminishing the "profane chattering" (chiacchiero profano) of the visitors and their guides. The only way to eliminate the annoyance, he insisted, was to eliminate its cause. He urged that the Pietà be transferred to the Museo dell'Opera di Santa Maria del Fiore.[52] There, he assured the archbishop, the statue would be displayed in a large and suitable room that had been created during a recent remodeling.

The archbishop gave official approval to president's proposal, and on 9 January 1961, the superintendent of galleries and museums, Filippo Rossi, wrote that the statue should be exhibited on the first floor of the museum rather than on the ground level.[53] But the proposed transfer met with strong resistance by the Commissione Diocesana per l'Arte Sacra, which stated bluntly that its members "disapprove taking an art treasure from the Duomo in order to enrich the

museum," cautioning that "doing so would elicit unfavorable comments in the press."[54] The commission prevailed, and the statue remained in the Duomo. But not for long: twenty years later, in April 1981, to protect it, the commission maintained, from being damaged by a restoration then being carried out on the dome of the cathedral, the *Pietà* was finally transferred to the Opera Museum.[55] A report in the Florentine newspaper *La Nazione* put it this way: "it is with this work of art that has attracted so much interest, that they [the Opera officials] want to re-launch a museum that has so much to offer."[56] The room that was prepared for the *Pietà* in the museum is relatively small and does not exhibit the statue to best advantage. However, plans are underway to transfer it to a much larger space that is presently being remodeled.

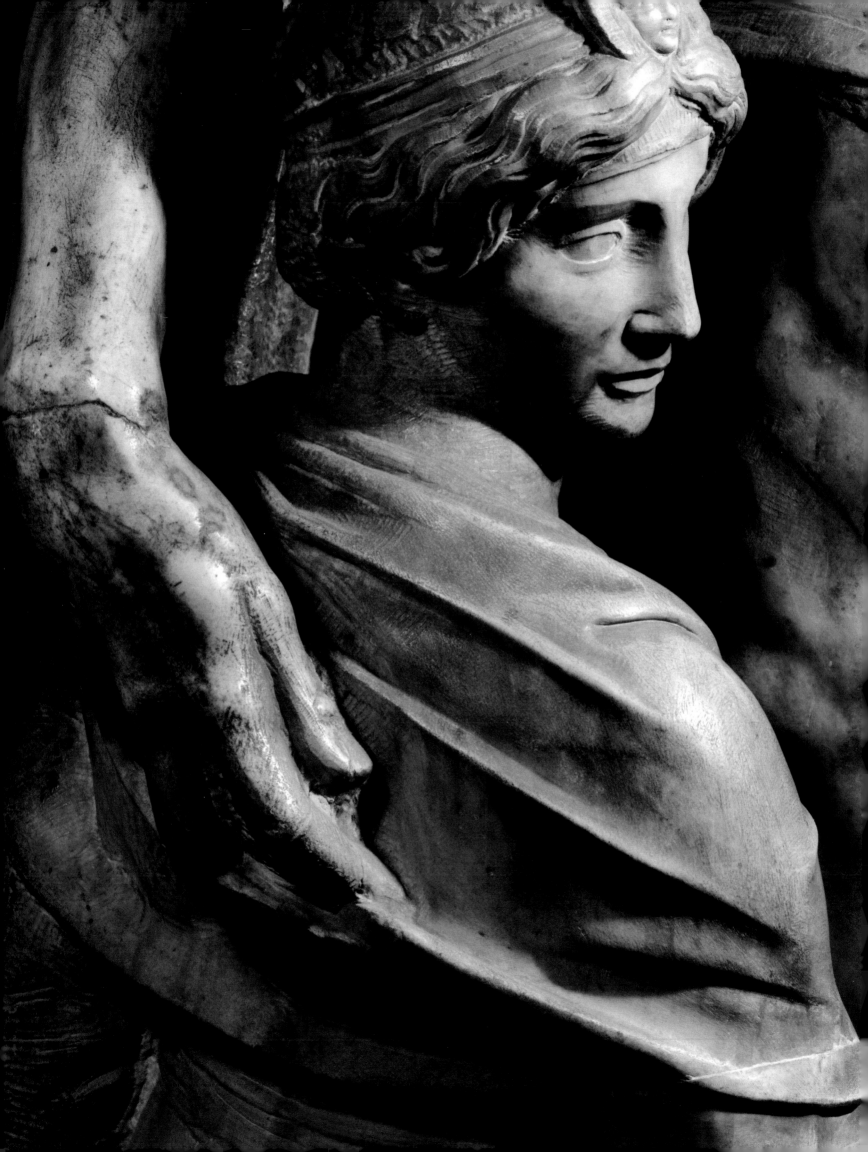

7

CRITICAL RECEPTION

MANY ARTISTS IN SIXTEENTH-CENTURY Rome shared the admiration for the *Pietà* that Ascanio Condivi and Giorgio Vasari expressed in their biographies of Michelangelo, and sought it out to study it, to emulate it, and to be inspired by it. But sculptors and painters did not respond to the statue in equal measure. Perhaps because sculptors were intimidated by the marble's great size and compositional complexities, we know of only three emulators who worked on monumental sculptures. Baccio Bandinelli, who had reports of the statue but never actually saw it, was moved to carve a *Pietà* for his own funerary chapel in the Florentine church of Santissima Annunziata in 1554–59 (plate 11). His is a two-figure composition and the emblematic inflection he gave it diverges radically from Michelangelo's. Ippolito Scalza, even though he probably never saw the Florence *Pietà*, nevertheless included two of its features in his own *Pietà* in the Cathedral of Orvieto. He created a statue with four figures, carved from a single block of marble (Christ, the Virgin, Mary Magdalene, and a bearded figure) and he conceived of it as a multiple composition, though only to be viewed from two sides, the front and left.[1] Tommaso della Porta was the most daring of the three. In 1586 he began a *Deposition* for San Carlo al Corso, Rome, that directly resembles his source in the motif of one figure's (St. John's) hand on the chest of Christ (plate 24). Tommaso's statue echoes the monumental, triangular, bilateral, and multi-figured composition of the *Pietà*, which he increased to five figures.[2]

PLATE 80
Christ's right hand on the Magdalene's back

Painters and printmakers, Italians and foreigners, approached the *Pietà* in different ways. Some, such as Lorenzo Sabbatini, Cherubino Alberti (plate 81), and Antonio Viviani, reproduced the statue, surrounded it with additional mourners, and placed it in a landscape setting.[3] Others incorporated elements, for example, the figure of Christ, in *Pietà* compositions of their own invention.[4] Still others, most notably El Greco, in his often copied (now lost) *Entombment*, incorporated motifs from the statue in a variety of other episodes from the Passion.[5]

In the seventeenth century interest in the Florence *Pietà* waned noticeably among sculptors and painters in Rome, if we can judge from the few surviving examples of its influence. The painter Pietro da Cortona made a sketch of the figure of Christ, though with legs in a different position,[6] which the sculptor Cosimo Fancelli used as a model for his bronze *Trinity* relief.[7] Some scholars maintain that the sculptor Gian Lorenzo Bernini was influenced by Michelangelo's *Pietà* in his own *St. Sebastian*.[8] Although I do not detect a connection, Paolo Falconieri claimed in 1674 (as we saw in chap. 5) that Bernini admired and studied the *Pietà*. Finally, Guglielmo Courtois (il Borgognone) painted a *Pietà* in a version of Michelangelo's composition but without Mary Magdalene.[9] There were even fewer citations of the statue in the literature of the period. Indeed, only Pietro da Cortona and Giovanni Ottonelli mentioned it in a treatise they coauthored in 1652. They praised the *Pietà* as being of such beauty that artists who copied it were well employed, yet, paradoxically, they cited only one sixteenth-century painter as an example of an artist so engaged.[10]

Once the *Pietà* was moved to its new and privileged site behind the high altar in the Florentine Duomo (plate 31), the statue seems to have had only limited attention by artists in the eighteenth century.[11] A 1792 sketch of the *Pietà* by William Young Ottley (plate 82) and several very small, inconsequential replicas in wax and clay are all that survive to record the statue's existence at that time (e.g., plate 41). A curious example of this indifference of artists to the statue is evident in a volume of engravings dedicated to the Duomo, which the architect and sculptor Bernardo Sgrilli published in 1733, a decade after the *Pietà* was installed behind the high altar. Michelangelo's statue does not appear in a single illustration in this volume, even though it is mentioned in the text accompanying the engraving in which Bandinelli's *Christ* and *God the Father* are represented. The author of the text, Girolamo Ticciati, an architect and sculptor, wrote: "although unfinished, [the *Pietà*] is nonetheless a glorious testimony of the incomparability of its author."[12] Praise and indifference seem to go hand in hand in this eighteenth-century publication, but even the praise is qualified—the general expression of admiration, despite the statue's unfinished state, was probably derived from Francesco Buonarroti's inscription on the base of the statue (appendix F, doc. 69).

Qualified admiration for the *Pietà* became a leitmotif of some nineteenth-century written criticism.[13] After the middle of the century, however, opinion soured. Jakob Burckhardt in the 1860s, for example, wrote that "it is a highly unpleasant work," and that Christ "cannot even remotely be compared with the Christ in the Vatican Pietà."[14] Charles Heath Wilson in 1876 was more explicit in reproving the statue for being ill-proportioned. He wrote, "In his old age when his inspiration began to fail and probably his sight, defects of proportion became still more apparent; especially observed in the group of a descent from the cross now in the Cathedral of Florence. The figure of the Saviour is too large for the others, that of the female [i.e., Mary Magdalene] much too small."[15]

In 1856, one Count Ottavio Gigli sought to sell a wax statuette to the city of Florence (plate 41), claiming it was an original model for the *Pietà*.[16] Arcangelo

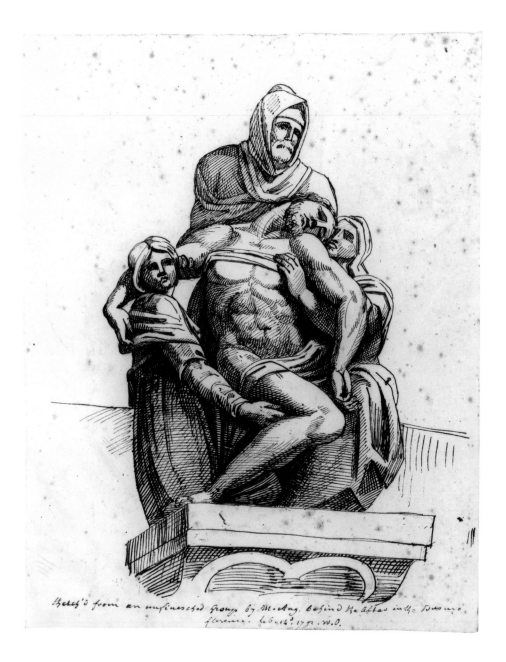

Migliorini, conservator of Antiquities and Egyptian Museums of the Royal Gallery of Florence, confirmed the authenticity in a short article he published that year. Migliorini, however, went beyond simple certification to attest to the statuette's superior quality to the statue; having Vasari's text in mind, he maintained that Tiberio Calcagni had stripped the work of Michelangelo's genius. He wrote, in a strange perversion of taste, that "Tiberio [Calcagni] put his hand to [the statue]; whereas the wax is entirely the work of the great master, in which we recognize his genius, his method of work."[17]

Evidently, the sale did not take place, since about ten years later Count Gigli renewed his offer to sell the statuette to the city. This time, he solicited the opinion of the French sculptor Jean Dupré, who, in a letter dated 4 March 1871 to the count, expressed unbounded admiration for the wax figure and admitted to having been surprised, "such is the beauty of this work," as compared to the marble

group. He blamed Michelangelo himself for changing for the worse in the statue the facial expressions and the fall of the draperies one sees in the wax statuette.[18] This falling off in quality he attributes to the fact that "no human force, not even that of the divine Buonarroti, was capable of conserving the first impression of the enthusiasm and faith in art he instilled in the wax model."[19]

Dupré's letter and Migliorini's article were included in a report issued in 1873 by a commission that the city of Florence had formed to advise on the purchase of the Gigli statuette. The commission unanimously agreed to its authenticity.[20] Even Gaetano Milanesi, who produced the standard edition of Vasari's *Lives* of 1568 between 1878 and 1885, attested in the commission's report to the statuette's superiority over the marble. He wrote: "Comparing the wax model with the work in marble, several changes appear in the latter, all for the worse, in the movement of the figure, in the fall of the drapery, and in the feel of the folds."[21] Further on in his discussion, however, Milanesi softened the severity of his criticism of the *Pietà* by blaming its presumed poor quality on the difficulties Michelangelo encountered in carving the marble (which, he said, had caused him to break up the statue) and on Calcagni's intervention in its restoration. About Calcagni's intervention he wrote, "the work of Calcagni in restoring the statue was so extensive that it is not surprising that little of the original form Michelangelo gave it survives."

The great fourth centennial celebration of Michelangelo's birth, which took place in Florence in 1875, was pivotal for the fortunes of the *Pietà*. To be sure, a residue of negativism survived among the organizers of the event, for example, in the minor role they assigned the statue in their celebrations. Although they included references to it in published lists of Michelangelo's oeuvre,[22] they excluded it from the daily eulogistic visits to his works and to the locations that evoke the master's spirit.[23]

Nevertheless, the centennial celebration sparked a renewed appreciation of Michelangelo's *Pietà* by Italian art historians, as well as northern European artists and cultural historians. In the *Life of Michelangelo* published in 1875, Aurelio Gotti, director of the Royal Galleries and Museums of Florence, carefully recounted the history of the *Pietà*, with information available at the time, and included documents such as letters and inventories.[24] Northerners introduced a critical methodology into a study of the *Pietà*, stemming from their direct observation of the statue and its location in the dim environment of the Duomo. They also displayed a heightened sensibility to its spiritual and formal qualities, which they communicated in sophisticated language.

The French sculptor Eugène Guillaume initiated the new approach in a seminal article on Michelangelo's sculpture in 1876.[25] He acknowledged in romantic and impressionistic terms the rapturous effect the group had on his feelings because of its immersion in a transient luminosity. He wrote, "In the shadowy light where it is placed the eye scrutinizes and is repaid with an insatiable avidity. The uncertain glimmer which comes from the elongated windows, the illumination which changes with the hours of the day, the suddenly alternating shadow and

light produced by the clouds which traverse the sky add their unexpected effects to that which evokes saintly poetry and to that which inspires melancholy." Guillaume perceived the *Pietà* as a universal evocation of Christian redemption and as an expression of Michelangelo's own spiritual aspirations. He wrote: "Christ retains something of the attitude of the crucified and his arms remain open as if to receive us. The divine is charged with the weight of our sins."[26] Indeed, for him the statue "exhales the idea of penitence." It objectified Michelangelo's piety, he asserted, because the supporting figure behind Christ represented the artist himself, "his saddened features speaking of redemption."[27] These are ideas that have been explored in over a century of modern scholarship on the statue.

If for the Frenchman Guillaume the shadowy environment that veiled the *Pietà* enhanced its effect for the observer, for the English historian John Addington Symonds, writing in 1893, it obscured it. Referring to Guillaume simply as the "French critic,"[28] Symonds rejected his romantic-impressionistic interpretation in favor of uninhibited observation. He declared, "Justice has hardly been done in recent times to the noble conception . . . of this Deposition. That may be due in part to the dull twilight in which the group is plunged, depriving all its lines of salience and relief. . . . The best way to study Michelangelo's last [*sic*] work in marble is to take the admirable photographs produced under artificial illumination by Alinari."[29] Two ideas emerge from Symonds's evaluation of the *Pietà* that bear on art history as practiced today: one is the view that the essence of the statue—"its lines of salience and relief"—is discerned only under "artificial illumination";[30] the second is the role that photographs play in appraising the statue.

The historian Charles Holroyd struck a balance between Guillaume's awed interpretation of the statue's spiritual content and Symonds's clear-eyed search for its formal elements. Holroyd wrote in 1903: "Those who would see this group aright must visit the Duomo before seven o'clock on a summer morning, when the light from the sun falls, through the white robe of a bishop in one of the high eastern windows, upon the neighboring pillars and the floor, and lights up that end of the church; at other times the darkness of the church covers the group as the darkness covered the earth during the tragic hours at Golgotha."[31]

To arrive at such reevaluations of the *Pietà* required of these late-nineteenth-century critics a tolerance for the statue's unfinished surfaces and fragmentary condition.[32] But to effect a true appreciation of the statue, these characteristics had to be admired as aesthetic virtues. The change occurred under the influence of the ideas and methods of the French sculptor Auguste Rodin and the enduring fame of the antique sculptural fragment known as the *Torso Belvedere* in the Vatican.

Rodin was the key figure in introducing the aesthetic of the unfinished work, that is, the virtue of leaving the surfaces of the marble in a relatively rough state as a necessary aspect of sculpture. Rodin may have been influenced by his compatriot Guillaume, who, with the Medici Chapel figures in mind, wrote in 1876 that Michelangelo used the chisel as the painter uses the brush and pencil, to achieve the effects of light and shadow through the opposition between bright and polished surfaces and half-tinted backgrounds.[33] The concept of the unfinished

as a fundamental aspect of Michelangelo's sculpture blossomed in the 1950s under the rubric *non-finito*, and was often infused with metaphysical overtones.[34] Although this abstract formulation has rarely been applied directly to the roughly finished surfaces of the *Pietà*, it may nevertheless have contributed to the aesthetic appreciation the statue.

The *Torso Belvedere* was acclaimed immediately upon its discovery in Rome in the fifteenth century and was spared the restoration process that befell many other beheaded and dismembered antique statues.[35] By the nineteenth century it came to personify the arts of design and sculpture.[36] "That which is more beautiful than a beautiful thing is the ruin of a beautiful thing," said Rodin, who made the *non-finito* a feature of his original statuary and further introduced his aesthetic of the fragment into sculpture by composing a large-scale copy of the *Torso* for the courtyard of the Académie d'Art in Brussels.[37] Since Rodin, the scholar Herbert von Einem writes, the fragment "has become a favored theme" of artists and art historians alike.[38] The acceptance of the fragment as an aesthetically complete work of art during the nineteenth and early twentieth centuries may have conditioned historians, as well as the lay public, to appreciate the *Pietà* as if the left leg had never existed.[39] Rodin may already have done so visually when he made a drawing of the limbless *Pietà*, in order—we are told by his intimate friend, Helene von Nostitz—to study its rhythms.[40]

Today, we have gone further than Rodin and others of the late nineteenth and early twentieth centuries in justifying our appreciation of the *Pietà*. Many of us still hold to Rodin's aesthetic principle that roughness and fragmentation are inherently rewarding. But in the unfinished surfaces and mutilated and fragmentary condition of the *Pietà* we also see the evidence of Michelangelo's great effort to give conclusive form to the statue. We can sense his vital struggle to bring to fruition his dream of a personal tomb memorial in the form of a transcendent work of statuary, and we can better understand the crisis that drained him of his purpose and will. What is more, we now have a far more complete documentary record of the Florence *Pietà* on which we can rely to explain not only the nature and causes of Michelangelo's ambivalence toward the statue, but also his artistic "idea," in terms of its subject, style, content, and intended place at the altar of his funerary chapel. Modern scholars consequently have a new perspective from which to study Michelangelo's extraordinary creation.

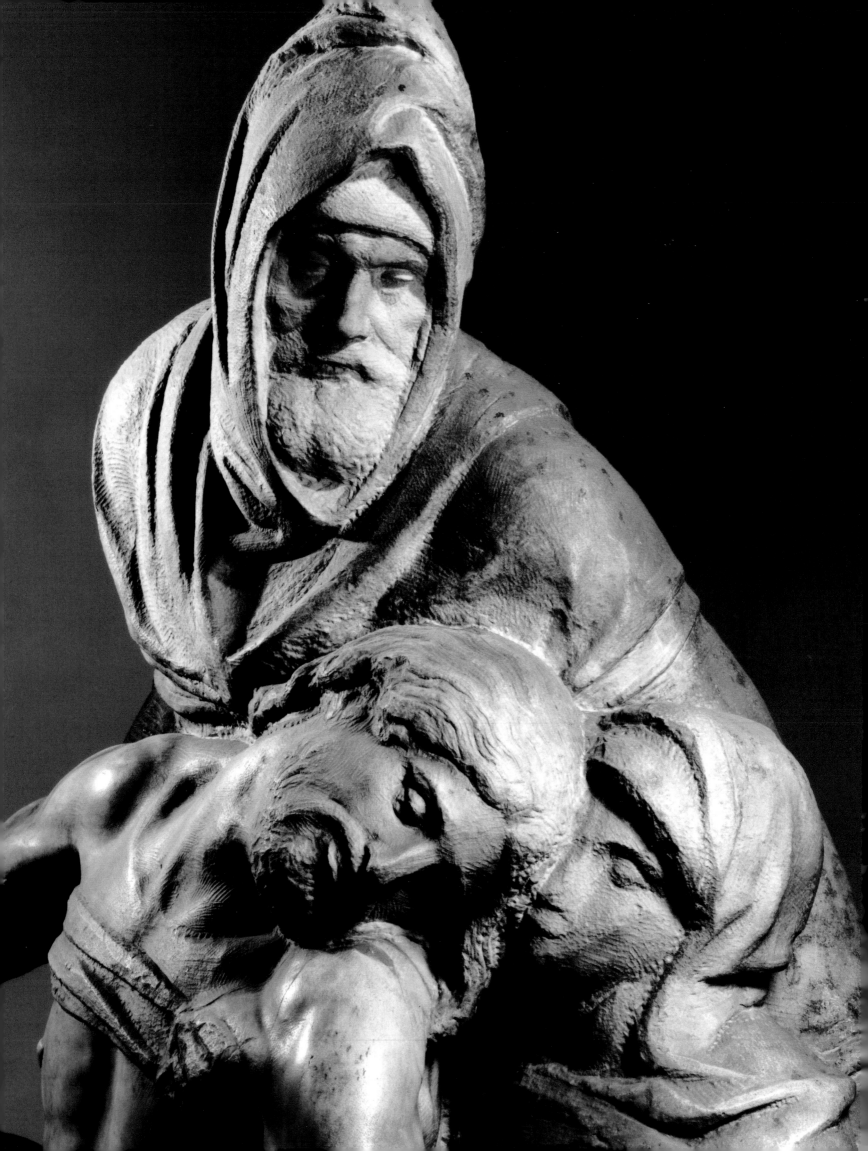

<center>8</center>

MICHELANGELO AND THE BODY OF CHRIST

RELIGIOUS MEANING IN THE FLORENCE *PIETÀ*

Timothy Verdon

THERE ARE DIFFERENT WAYS OF LOOKING at Michelangelo Buonarroti's Florence *Pietà*. In its present position, on a landing of the main staircase in the Museo dell'Opera di Santa Maria del Fiore, it appears frankly as a museum piece: well lit, visible from all angles, inviting viewers to walk around it. This indeed is how the *Pietà* has been seen for much of its history: saved originally for its artistic value, it was exhibited in the Bandini garden in Rome, then in the undercroft at San Lorenzo, and finally transferred to the cathedral as a replacement for Baccio Bandinelli's *Adam* and *Eve*. That so personal and dramatic a work should, across the centuries, have been perceived in this way is curiously consistent with Giorgio Vasari's assertion, twice repeated in his life of Michelangelo, that the aging master carved it "to keep himself busy"—"per suo passatempo"—and then mutilated it because the marble was flawed, as if the work were primarily a technical exercise.[1]

Modern art historians have rejected this mannerist reading, preferring to emphasize other parts of Vasari's and Ascanio Condivi's accounts. Above all, those sixteenth-century writers' assurance that Michelangelo carved the work for his

<center>PLATE 83</center>
<center>*Heads of Christ, the Virgin, and the bearded figure*</center>

own tomb and gave his own features to the old man supporting Christ has led twentieth-century scholars to see the group in confessional terms, as an act of contrition and profession of faith—an interpretation made plausible by what we know through his letters and poetry of the aging master's inner life during the years he worked on the group. Finally, studies in the spread of Protestant thought in Italy in the cinquecento have suggested a more specific reading of the group's autobiographical dimension. Michelangelo's inclusion of himself in the role of Nicodemus (as both Vasari and Condivi identify the old man behind Christ) may be intended as an admission of Protestant sympathies: in the mid-sixteenth century, those who cautiously explored the ideas of the northern reformers without declaring themselves publicly for the new faith were called "Nicodemites," in analogy with the pharisee described in John 3 as seeking Christ by night, attracted but afraid to openly avow himself a disciple.[2]

Each of these views sheds light on the work in question, even the "museum piece" interpretation. Without going so far as to consider the *Pietà* a "passatempo," we feel instinctively that the group's technical and formal characteristics were of great importance to Michelangelo. As Juergen Schulz has observed in reference to the missing left leg of Christ and the solution Michelangelo briefly contemplated—mortising a separate leg to the group—such "piecing was generally uncommon in the Renaissance, and was considered a sign of technical incompetence. To an artist like Michelangelo, with his almost mystical conception of the integrity of the block, it must have seemed a defect and a crime. Hence the final rage and rain of blows."[3] Beyond these formalist preoccupations, it is also true, however— as Charles de Tolnay noted—that "like other late works, this group has the significance of a personal confession of the master," and it is closely related to the conversion experience that Michelangelo attests in the closing lines of a famous sonnet: "Neither painting nor sculpture can any longer calm my soul, turned now to that Love divine which, to embrace us, opened his arms on the cross."[4]

And Michelangelo's involvement, through Vittoria Colonna, with thinkers open to Protestant ideas—the "Spirituali," based in Viterbo—could well be part of the uncertainty and psychological depression that descended on Michelangelo at about the time he mutilated the statue, and which coincide with the election in 1555 of Paul IV, whose intransigence in the face of everything Protestant dramatically polarized a previously fluid situation. As Valerie Shrimplin-Evangelidis has noted, the definitive split between Catholic and Reformed Christians, confirmed in 1555 by the Diet of Augsburg and by Paul IV's draconian countermeasures, "could well have brought Michelangelo immense disappointment as well as despair, not only for his own situation but for others who shared it."[5]

Yet there is a further aspect of the Florence *Pietà* deserving of attention, to which both Vasari and Condivi refer, but that few modern scholars have explored: Michelangelo's sculpture of the dead Christ supported by three figures *was meant for an altar*, as a monument associated with the artist's tomb. Vasari says that this tomb was to be "at the foot of that altar where Michelangelo thought to set the Pietà," and Condivi similarly states that Michelangelo "plans to give this Pietà to some church, and have himself buried at the foot of the altar where it is placed."[6]

That the *Pietà* was meant as a funerary monument on or above an altar has significant implications for the period in which the work was conceived. In 1542 Gian Matteo Giberti, bishop of Verona, published a treatise in which elaborate funerary monuments on altars are condemned. He stressed the inappropriateness of situating individual tomb markers where, to paraphrase his text, every day God's only-begotten son is offered to his eternal father as a victim for the salvation of the human race—that is, where Christ's crucified body is made present, in the sacrifice of the Mass.[7]

Giberti's eucharistic motivation for banning altar tombs offers a key to our problem. Although he died before the Council of Trent began, this bishop of Verona is in fact recognized as the originator of what would become one of the Catholic Reformation's most significant liturgical innovations: the placing of eucharistic tabernacles in the center of main altars in Catholic churches. In his own cathedral he had a new high altar built, with the tabernacle in the middle "tamquam cor in pectore et mens in anima," as a contemporary described it (occupying a position analogous to the heart in a human breast, that is, or the intelligence in a human soul). This novelty was taken up by St. Charles Borromeo, in Milan, and by Pope Paul IV for the churches of Rome, and in the late sixteenth and early seventeenth centuries it would spread outside of Italy.[8]

These complementary notions—that funerary monuments should not occupy church altars, but that altars should be reserved for the Eucharist celebrated every day and permanently present in the tabernacle—suggest the immediate background of Michelangelo's *Pietà*, which was intended for the altar before which he was to be buried. The incongruence of a human sepulture where Christ's body is laid in the Eucharist was overcome by making Christ's body itself the central theme of the monument: a solution adopted also by Bandinelli, several years after Michelangelo, in the only contemporary work really comparable with Buonarroti's group, the dead Christ supported by an old man in the Pazzi-Bandinelli Chapel in Santissima Annunziata, Florence (plate 11). In this other Florence *Pietà*, as in Michelangelo's, the figure supporting Christ is a self-portrait of the artist.[9]

Bandinelli's altar monument, executed in the late 1550s, may simply be an imitation of Michelangelo's *Pietà*, as Vasari unkindly implies. An earlier work by the younger sculptor, however, carved while Michelangelo was still at grips with his *Pietà*, provides information essential to understanding Buonarroti's group. This is Bandinelli's enormous figure of the dead Christ commissioned and sculpted for the high altar of the Florence Duomo between 1547 and 1552 (plates 78 and 84), part of a theologically complex program that included a monumental *God the Father* and, behind the altar, statues of *Adam* and *Eve*.[10] The message of this ensemble of colossal figures revolved around the central Christian belief that, in accepting death on the cross, Christ made reparation to God the Father for the sin of Adam and Eve and of their children down through history, winning salvation for all humankind.[11]

These several components of the cathedral altar program correspond exactly to the issues treated in official statements of Catholic belief published by the Council

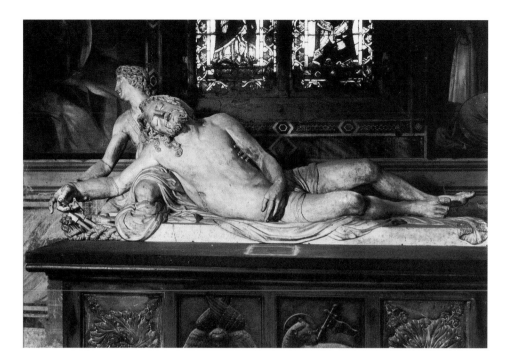

of Trent in the same years: the decrees on original sin, justification, and the
Holy Eucharist. Indeed, the first of the figures carved, the 9 foot 10 inch (three-
meter-long) Christ for the altar, was set in place barely nine months after publi-
cation of the Decree on the Eucharist, the opening chapter of which is concerned
with affirming traditional faith in the real presence of Christ's body in the sacra-
ment, over against Protestant suggestions that, in the Eucharist, Christ is present
spiritually but not corporeally. The titanic cadaver by Bandinelli, laid directly on
the altar table—filling the altar to the extent that (according to Vasari) there was
hardly room for the liturgical objects required for Mass—constituted a powerful
answer to such doubts, offering believers something like the vision of Pope St.
Gregory the Great (c. 540–604): at the consecration, beyond the bread wafer one
saw the physical body of Christ supported by an angel (plate 85).[12]

Bandinelli's ensemble of separate statues and Michelangelo's unitary group are,
of course, different in significant ways. The first was a public program, commis-
sioned by Cosimo I de' Medici as an explicit doctrinal statement; the second was
private, personal, and autobiographical. Yet the dominant component of both
works is the same: a powerfully carved, larger-than-life body of Christ meant to be
seen beyond the priest celebrating Mass, visual confirmation of the Savior's real
presence in the bread and wine of the altar.

Today it is difficult to grasp the drama these massive eucharistic images must
originally have conveyed: Bandinelli's *Christ* is now in the crypt of Santa Croce,
separated from *God the Father*, and Michelangelo's group is in a museum, on a low
pedestal that presents at eye-level a work meant to be seen from the foot of that
altar where Michelangelo wanted to be buried.

Photographs typically present the *Pietà* head-on, if not indeed from slightly
above. But if we change the angle of vision, taking position where Michelangelo
supposed the priest would stand and the faithful kneel, then the dominance and

PLATE 85
French school, Mass of St.
Gregory, *15th century. Panel,*
23⅝ x 15½ in. (60 x 39.5 cm).
Musée du Louvre, Paris

power of Christ's body would be clear (see the raised virtual model in plate 10). Vasari (who, notwithstanding his ideas as to why Michelangelo carved it, knew the *Pietà* was destined for placement upon an altar) seems to have seen it in precisely this way: after a general description of the group, he expands on the impact of the Christ figure in terms that suggest he had seen or imagined it *di sotto in su*. "Nor can one see in Michelangelo's, or in another sculptor's, works a dead body comparable to that of this Christ which, falling with its limbs abandoned, assumes several positions, all different ... a complex work ... which was to mark Michelangelo's burial place at the foot of that altar where he thought to set the group."[13]

The visual association of the body of Christ with the Eucharist is well known. The crucified or deposed Christ, often in the *imago pietatis* format, appears on altarpieces, tabernacle doors, and even stamped on the eucharistic wafer, from

the later Middle Ages onwards. To all effects and purposes, this image was stamped on the religious sensibility of Latin Christendom, for in 1330 Pope John XXII (r. Avignon, 1316–34) had officially urged believers to evoke the Man of Sorrows in their mind's eye at Mass, during the consecration and communion.[14] The specificity and theological exactitude of this mental association is suggested by a handsome wood tabernacle of the late fifteenth century in the Museo d'Arte Sacra della Abbadia a Rofeno, Asciano, where the outer door shows the dead Christ in the "pleading" pose of the *Vir dolorum* (Man of Sorrows), while the rear inner wall, immediately visible when the priest opened the door, presents an altar with candles, the chalice and host and, above these, the Holy Spirit descending: precisely the configuration "imagined" at the moment of consecration, when the priest invokes the Holy Spirit on the bread and wine so that they will become the Body and Blood of Christ.[15] Recent studies have called attention to the importance of Corpus Christi imagery in Florence in the 1570s and 1580s, in the series of large altarpieces by Alessandro Allori that recast great *Depositions* of the earlier cinquecento in liturgical terms, visually pairing the dead body of Christ with the altar and chalice (plate 86). Clearly related to antecedent eucharistic iconography, these paintings by Allori—and, in our reading, Bandinelli's Christ figure on the altar of the Duomo and Michelangelo's Christ in the *Pietà*—bore doctrinal messages particularly meaningful to Counter-Reformation Catholics.[16]

It might be objected that all the works adduced are theological extrapolations—what German art history has called *Andachtsbilder*—whereas Michelangelo's group is narrative in character: Christ is not presented alone nor held by an angel, in an imagined moment "out of time," but supported by his mother, together with another woman and the powerful old man in whom Michelangelo gives us his own likeness. Yet narrative scenes, too, were visually associated with the Eucharist: in Fra Angelico's San Marco altarpiece (today in the Alte Pinakothek, Munich), for example, the central predella panel situated directly in front of the priest handling the bread and wine shows the Entombment (plate 18), with the dead body of the Savior handled by an old man, Nicodemus or Joseph of Arimathea, while Mary and St. John at right and left complete the composition. In this panel, which Michelangelo must have known and which plausibly was among his sources for the *Pietà*, the horizontal sepulchre awaiting the body, and the beautiful white cloth spread beneath Christ could not but have evoked significant parallels with the cloth-draped altar where the priest said Mass, immediately in front of the predella.[17] Indeed, from the patristic age on, Christians have seen the altar as a symbol of Christ's tomb, and late medieval allegorical interpretations of the celebrant's liturgical movements—the lifting up and putting down of the consecrated bread and wine—made the association with Christ's historical lifting up on the cross and deposition into the tomb.[18] Works closer to Michelangelo's *Pietà* than Angelico's predella panel—Jacopo Pontormo's great *Deposition* in Santa Felicita, Florence, for example—partake fully of these eucharistic associations.

The eucharistic framework gives specific significance to another feature of Michelangelo's group: the sweet calm of Christ's facial expression, surprising in the overall context of suffering and sorrow. We have noted the association of the

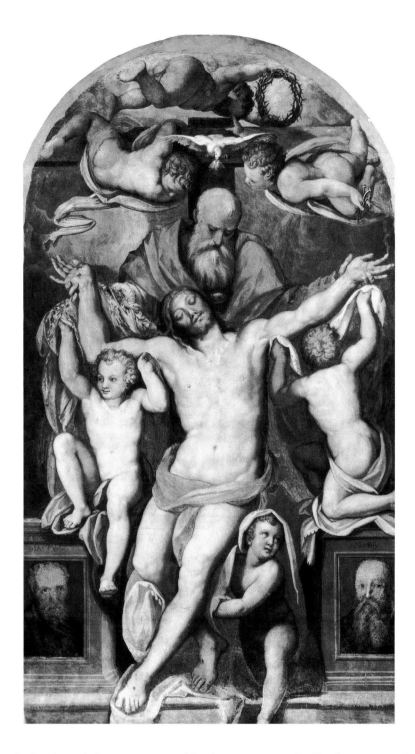

PLATE 86
Alessandro Allori (Italian,
1535–1607), Trinity, 1571. Fresco,
11 ft. 3¾ in. x 6 ft. 4¾ in.
(3.5 x 2 m). Chapel of St. Luke,
Santissima Annunziata, Florence

Savior's death with his sacramental body present in the Eucharist, yet the full story is more complex, for the Eucharist is possible not because Christ died but rather because he rose: it is the risen Christ who, with the Father, sends the Holy Spirit to transform man's gifts of bread and wine. In Holy Communion, the believer receives not the dead, but the risen Christ. Of numerous images that emphasize this point, one of the most eloquent is a fresco by Ambrogio Bergognone in Sant'Ambrogio, Milan (plate 87), where the risen Christ is shown at the center of an altar, standing where the bread and wine are consecrated, and on the cloth beneath his feet are the words of Revelation 1:17–18: "It is I, the First and the Last;

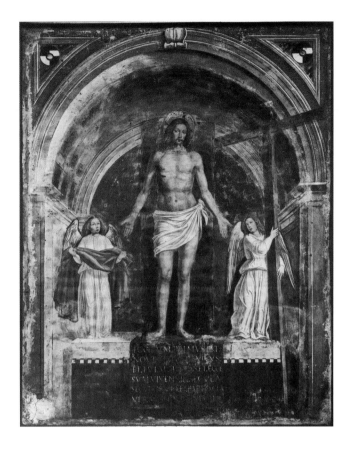

ABOVE, LEFT PLATE 87
*Ambrogio Bergognone (Italian,
active 1472–1523), Resurrected
Christ, 16th century. Fresco.
Sant'Ambrogio, Milan*

ABOVE, RIGHT PLATE 88
*Anonymous (Italian), Eucharistic
Christ, 14th century. Woodcut,
4½ x 4 in. (11.5 x 10 cm). Biblioteca
Nazionale, Florence*

I am the Living One, I was dead and now I am to live forever and ever, and I hold the keys of death and of the underworld." An analogous Florentine image, which Michelangelo could have known, is the handsome eucharistic Christ in a Savonarolan tract (plate 88): standing in the middle of the altar, where the bread is normally placed, this figure too was dead, but now has come back to life, and from his wounded right hand he fills the chalice with his blood.[19]

This understanding of the Eucharist as the living body of the crucified Christ extends even to images in which the narrative required that Christ be shown dead in Italian fifteenth- and sixteenth-century Depositions; for example, it was customary to suggest Jesus' imminent resurrection through the lyric peacefulness of his visage—thus Fra Angelico in the Strozzi altarpiece in the San Marco Museum, Florence (plate 89), thus Bandinelli in his Christ for the Duomo altar (plate 90), thus Rosso Fiorentino at Volterra (plate 91), and thus Michelangelo (plate 92). The sense of almost joyous release we find in Michelangelo's Christ, indeed, is closely related to what Rosso depicted twenty-five years earlier, as are elements of the figure composition.

The eucharistic frame of reference was thus primary—and, indeed, the physical body of Christ clearly dominates Michelangelo's composition—but it did not exclude other meanings. On the contrary, the central eucharistic focus of the *Pietà* is all-inclusive, in a way similar to Gian Matteo Giberti's placement of the tabernacle, mentioned above, that made it "tamquam cor in pectore et mens in anima" (like the heart in a human breast, or intelligence in the human spirit). Like

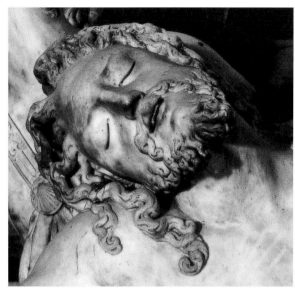

ABOVE, LEFT PLATE 89
*Fra Angelico (Italian, c. 1387–1455),
Deposition (detail from the
Strozzi altarpiece), 1437–40. Panel.
San Marco Museum, Florence*

ABOVE, RIGHT PLATE 90
*Baccio Bandinelli, Christ (detail),
1552. Marble. Santa Croce,
Florence*

BELOW PLATE 91
*Rosso Fiorentino (Italian,
1495–1540), Deposition (detail),
1521. Panel. Pinacoteca, Volterra*

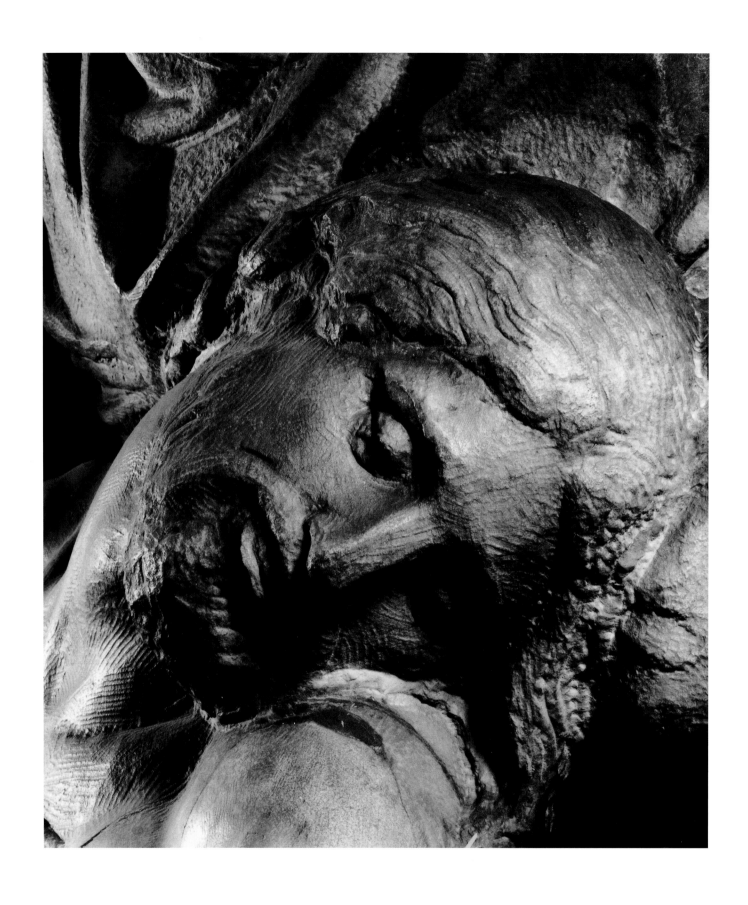

PLATE 92
Christ's head, full face

the many grains of wheat that together make bread, and the many grapes that, pressed together, make wine, the sacrament of Christ's body and blood unifies and gives infinite depth to other meanings that believers find in the Mass. In the case of Michelangelo's *Pietà*, the main other meaning is personal and autobiographical, a "real presence" not only of Christ but also of the sculptor represented in the figure above and behind Christ, the old man whose upright body initiates the downward curve of Christ's body, and whose interior compunction complements Christ's lyric serenity.

Does this figure represent Joseph of Arimathea, the rich man who gave his tomb, fresh hewn from the rock, for Jesus' burial? Or does it represent Nicodemus, the old man who sought Christ in secret to ask: "Can a man be born when he is already old? Can he go back into his mother's womb and be born again?" (John 3:4)? A good case can be made for each of these possibilities, and the question has often been treated in relation to Michelangelo's group and to other representations of the Deposition and Entombment without any definitive conclusion, and perhaps without any real chance of coming to one.[20] The fact that both Vasari and Condivi call the old man Nicodemus must weigh heavily in our choice, however, as do also the facts that Michelangelo gave his own features to this figure and that he was old and thinking of death when he did so. Tuscan tradition maintains that Nicodemus was a sculptor, author of the venerated figure of Christ in Lucca, the *Volto Santo*,[21] and that in John 3:4 this personage refers to himself as "old" and preoccupied with death, facts that incline us to see the old man in the *Pietà* as Nicodemus. Moreover, recent reflection on the *Pietà*, noted above, suggests topical reasons for seeing the figure as Nicodemus.

While the analogical identity of the old man can be questioned, the historical one cannot: the figure holding Christ's body stands for Michelangelo himself, as Vasari and Condivi affirm and as later scholarship has accepted without hesitation. More important than the Nicodemus/Joseph of Arimathea question, in fact, is the one regarding Michelangelo and Jesus Christ. A relationship that here seems to go beyond what we find in comparable Deposition or Entombment scenes containing an artist's portrait: Donatello's in the San Lorenzo pulpits, for example, was similarly executed in the artist's last years, or Titian's in the monumental *Pietà* in the Venice Accademia (plate 75), in fact painted for the altar where the master was to be buried just as Michelangelo intended his *Pietà* for an altar near his tomb.[22] The distance separating the artist's self-portrait and the Christ figure in these works—Donatello does not touch Christ at all, and Titian kneels at his feet—gives way, in Michelangelo's *Pietà*, to a virtual symbiosis, practically a fusion of the two male figures, to the extent that the eye has a certain difficulty distinguishing where Christ ends and Michelangelo begins. Particularly if we imagine a more sharply angled *di sotto in su* view of the work—the view from below of the priest celebrating Mass at the altar, or of the kneeling faithful—it is clear that the figure looming above Christ would have constituted a physical and psychological extension of the Savior (plate 10). Or, to put it differently, Jesus' youthful torso, powerful even in death, would have been seen as flowing from the hunched form above it, the old man tensed in his effort to bear Christ's weight.

The religious implications of Michelangelo's extraordinary melding of forms—of old and young, living and dead—must be sought in the same Gospel of John, which recounts Nicodemus's visit to Christ by night. Two passages in particular, related to the Nicodemus episode but not dependent on it, suggest what Michelangelo wanted to convey in marrying his own figure with that of Christ in such a way as to render them indistinguishable: passages explicitly relating the believer's (and Nicodemus's) hope for rebirth after death with the mystery of the Holy Eucharist. In John 6, the long discourse where Jesus deeply troubles his listeners by insisting that he, Christ, is the "bread of life" and whoever eats this bread will live forever, he finally states: "My flesh is real food and my blood is real drink. He who eats my flesh and drinks my blood lives in me and I in him. As I, who am sent by the living Father, draw life from the Father, so whoever eats me will draw life from me. This is the bread come down from heaven; not like the bread our ancestors ate: they are dead, but anyone who eats this bread will live forever" (John 6:55–58).

The second passage is the farewell discourse that Jesus pronounces at the Last Supper, and which in the Gospel of John takes the place of an explicit account of the institution of the Eucharist. The recurrent theme is that of communion—the perfect communion of life between Christ and his heavenly Father that, as he prepares to die, Jesus extends to his disciples. "Do you not believe that I am in the Father and the Father is in me?" he asks them at the beginning of this long monologue (John 14:10), and then, presenting his relationship to his followers as that of a vine to its branches, he tells them: "whoever remains in me, with me in him, bears fruit in plenty" (John 15:5). He teaches them these things, he says, "so that my own joy may be in you and your joy be complete" (John 15:11), and "so that you may find peace in me" (John 16:33). Finally, for these followers who will find joy and peace in him, Christ asks his Father: "May they be one in us as you are in me and I am in you. . . . With me in them and you in me . . . so that the love with which you loved me may be in them, and so that I may be in them" (John 17:21, 23, 26).

These passages describe a physical as well as a spiritual communion of life in which, by eating Christ's body and drinking his blood, his followers live in him and he in them: they draw life from him as he himself draws life from God his Father. Part of the meaning of Michelangelo's composition in the *Pietà*—the aging body fused with the youthful one, a man facing death supporting the God who would rise from death—has to do with this "communion" made present in the Eucharist.

The idea of a perfect communion of life between Christ and the believer is explicit in the writings of the church fathers. Pondering the Eucharist in relation to the Incarnation and the Holy Trinity, for example, St. Hilary asks: "if the Word was truly made flesh, and if we truly receive the Word made flesh in the Lord's food, why should we not maintain that he remains within us naturally?" Hilary concludes that "we are all one, because the Father is in Christ and Christ is in us. He is in us through his flesh, and we are in him; and being united with him, what we are is in God. . . . We can learn how natural this unity is in us from

his own words: 'He who eats my flesh and drinks my blood abides in me and I in him.' "[23]

This "natural" unity of bodies and spirits is given dramatic purpose in a sermon by Peter Chrysologus (380–450). Reflecting on St. Paul's appeal to Christians to "offer your living bodies as a holy sacrifice" (Romans 12:1), Chrysologus has Christ tell the faithful soul: "You see in me your body, your limbs, your organs, your bones, your blood."[24] That is, the believer, called upon to offer his own body, really offers Christ, who is in him! The church father concludes that St. Paul's words raise all believers "to the level of priests," offering their living "bodies as a holy sacrifice." Chrysologus's reasoning here is based on well-known New Testament sources that characterize the believer's union with Christ in similar terms. In Galatians 2:20, for example, St. Paul applies the idea of perfect union with the Lord to himself, saying: "I live now, not with my own life but with the life of Christ who lives in me."

If we read the Florence *Pietà* in light of these passages, much becomes clear. Just as the priest in front of the altar offers bread and wine that become the Body of Christ, so Michelangelo, above the altar, offers his aging body as a holy sacrifice and we see it transformed into Christ. He lives, but with the life of Christ who lives in him. In his conversion, Michelangelo seems to have made his own St. Paul's invitation to "put aside the old self, which gets corrupted by following illusory desires," and "put on the new self that is created in God's way" (Ephesians 4:22–24), thus "building up the body of Christ" and becoming "the perfect man, fully mature with the maturity of Christ himself" (Ephesians 4:13).

There is a further dimension to this relationship of total union, which perhaps sheds light on the formal genesis of the *Pietà*. St. Gregory of Nyssa (c. 330–c. 394), reflecting on the passage in Ecclesiastes: "There is a time for everything . . . a time for giving birth, a time for dying" (Ecclesiastes 3:1–2), says: "We are ourselves in a certain sense fathers of ourselves, when, by our good intentions and our free choice, we conceive and give birth to ourselves and bring ourselves to the light."[25] The saint then specifies that a believer's "self-fathering" consists in allowing "the form of Christ" to be produced in him: this is the "time to be born." And the "time to die" is not in contrast with such spiritual birth, but its necessary complement: the believer "who never lives to sin, who mortifies continually the limbs of his flesh, and bears about in his body the dying of the body of Christ, who is always being crucified with Christ, who never lives to himself but has Christ living within himself" experiences, according to Gregory of Nyssa, "a timely death which has produced true life."[26]

Now if, with de Tolnay, we see the Florence *Pietà* as having developed from the composition of a black chalk drawing made for Vittoria Colonna depicting the body of Christ deposed from the cross and placed between the spread legs of Mary, his mother (plate 19),[27] then Gregory of Nyssa's metaphor of the believer's "parenting" of Christ suddenly has remarkable force. In the sculpture intended for his own tomb, Michelangelo puts himself in place of Mary: not mother, but father of Christ, who is born from the artist's aging body upon the altar. Michelangelo the penitent produces the form of Christ in his own flesh, for indeed—as

the fourth-century St. Ambrose teaches—"every soul who has believed conceives and generates the Word of God.... According to the flesh, one woman is the mother of Christ, but according to faith Christ is the fruit of all men."[28] Thus to Nicodemus's question as to how a man already old could be born again, the Florence *Pietà* answers, in the spirit of the fifth-century St. Cyril of Alexandria, that "the body of Christ gives life to those who share with him. By being one with those who must suffer death, Christ's body drives death out; by bringing forth in itself a principle capable of utterly destroying corruption, his body expels corruption."[29]

Yet this fusion is an equation made of unequal parts: if Christ dies, it is in the body received in Mary's womb, when he became "son of man"; if we can now be reborn (as Nicodemus scarcely dared hope), it is thanks to Christ's resurrection as the Son of God. "From you he incurred death, but from him you gained life," St. Augustine, bishop of Hippo, says, "in your flesh he allowed himself to be tested, but in him you were victorious."[30] In another context, St. Augustine adds that Christ "had nothing to hang upon the cross except the body he received from us.... Our unregenerate nature has been fastened to the cross along with him, in order that our sin-stained humanity may be renewed and cleansed, and we ourselves may no longer be slaves to sin."[31] The most lucid statement of this mystic life-death, Christ-man equation—the expression of its complex simplicity nearest to Michelangelo—is again found in St. Augustine. Pondering the mystery of God's Son having accepted death to save a sinful humankind, the bishop of Hippo muses, "on the one hand, he is the Creator, on the other he has become a creature; without the need for any change or alteration in his divinity, he has adapted to himself our changeable creaturehood, and has gathered us up into himself, to become with him one single man, head and body."[32] To become with him one single man, head and body: there could be no more eloquent description of what Michelangelo achieved in melding the two forms, Christ's and his own, in a powerful communion of life above the altar and the priest.

Again, this reading makes sense in the context of the Eucharist. "When the mixed chalice and the baked loaf receive the word of God, and when the eucharistic elements become the Body and Blood of Christ, which bring growth and sustenance to our bodily frame," the second century St. Irenaeus argues, "how can it be maintained that our flesh is incapable of receiving God's gift of eternal life? For our flesh feeds on the Lord's body and blood, and is his member," he concludes. "Thus St. Paul writes in his Letter to the Ephesians [cf. Ephesians 5:30]: 'We are members of his body,' of his flesh and of his bones. He is not speaking about some spiritual and invisible man, 'for a spirit has not flesh and blood as you see I have'; on the contrary, he is speaking of the anatomy of a real man, consisting of flesh, nerves and bones, which is nourished by his chalice, the chalice of his blood, and gains growth from the bread which is his body."[33]

That Michelangelo had access to these ideas, at least in simplified form, is apparent if we look at the kind of religious information he probably received as a boy. In the *Libretto della dottrina cristiana* attributed to the archbishop of Florence St.

Antoninus—the "Florentine Catechism" of the later quattrocento—the Holy Eucharist is explained in fact as a communion of life between God and man, made visible in the *Communio Sanctorum*. The "communion of saints is the body and blood of Christ, since when saintly persons receive [the Eucharist] devoutly and without sin, God unites himself to them, and makes them become a single thing with himself. . . . Thus the body of Christ makes the person who receives it worthily God. And this is what the Psalm says: Ego dixi dei estis, et filii excelsi omnes. Christ says to those who receive him worthily: I tell you, you are gods and sons of the Most High God."[34]

This unity of life which so elevates our human nature—this becoming "a single man with Christ, head and body"—colors quattrocento humanist reflection on the Eucharist, too. When Christ converts the bread of the altar into his own flesh, Lorenzo Valla reasons, he fuses God with man: as today he transforms the bread, so in the day of Judgment will he transform humankind into God.[35] Donato Acciaiuoli characterizes the Eucharist, in terms at once scriptural and humanistic, as the fullness of *amicitia*, perfectly bonding Christ and the believer: "If it is said to be a most grand sign of friendship when friends consider all their things to be in common, how great an indication of love and benevolence did our Lord show in sharing not only his possessions but even himself, according to the truth of his saying: 'Who eats my flesh and drinks my blood remains in me and I in him.' "[36]

In this communional context, and in light of the perfect unity of life that seems to be the spiritual subject of Michelangelo's group, the vexed question of the old man's identity is at once more difficult and less important. To be sure, if we consider him to be Nicodemus then the prominence given this figure, and Michelangelo's assumption of his dramatic persona, have special poignancy. St. Cyril's affirmation that "Christ gave his body for the life of all, and through his body planted life among us again," becomes the correct answer to Nicodemus's question, as to how a man already old can be born again.[37]

Yet the frame of reference is really broader: mystical rather than narrative, universal rather than particular. We have suggested that in using the drawing made for Vittoria Colonna as a formal source Michelangelo also transferred elements of its meaning to his sculptured *Pietà*: Christ "born from the body" of the figure behind him, who here is not Mary but an old man. "Fathering Christ" was moreover the theme developed by St. Gregory of Nyssa in the passage cited above: "we are ourselves in a certain sense fathers of ourselves," producing the form of Christ in our own bodies. And as St. Ambrose said, Christ the son of Mary is also the fruit of all men's lives. This is a universal task: all human beings are called by Ambrose to produce the form of Christ in their lives, and the man whom Michelangelo impersonates in the sculptured group is Man *tout court*, beginning with the first man, Adam (as in an extraordinary Byzantine ivory of the tenth century, where the cross of Christ grows out of the "womb" of Adam [plate 93]). Every human being is called to accept a share in Christ's suffering, and thus "father" Christ, produce his form in himself.

At this point, however, another possibility emerges. If we read the standing figure in Michelangelo's *Pietà* as "fathering" Christ (plate 10), then he is man taking the place of God, and the analogies of Michelangelo's composition with representations of the Holy Trinity become comprehensible.[38] Should we perhaps see the standing figure not only as man who fathers Christ in his mortal body, but also as God who bears the weight of his son's mortality? To be one with Christ and with his Father, in the eucharistic and mystic terms of St. John's Gospel cited above, effectively implies a willingness to put oneself in the position of God, the

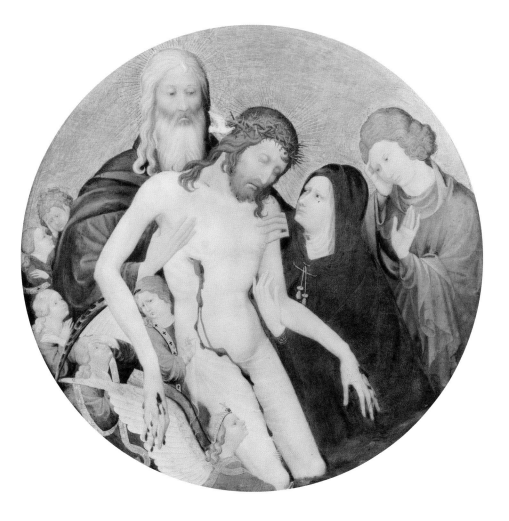

PLATE 94
*Jean Malouel (French,
c. 1365–1415), Pietà, 15th century.
Panel, diam. 25½ in. (64.5 cm).
Musée du Louvre, Paris*

Father, who sacrificed his beloved son, to share his paternal resolve and his pain. One of the closest parallels to Michelangelo's *Pietà* composition, indeed, is the Holy Trinity by Jean Malouel, now in the Louvre, where the old man supporting the body of Christ is God the Father, evidently distressed as he offers his son's life for the redemption of humankind (plate 94).[39]

The polyvalence I attribute to this figure in whom Michelangelo saw himself—God and man, father, mother, and disciple—is not unusual in a context of religious belief. The fourth-century St. Gregory Nazianzen, reflecting on the Passion in relation to the Eucharist, stressed that the narrative components of the scriptural account, like the sacramental bread and wine, are in fact figures, and that the full meaning of these fluid spiritual topoi will become clear only in eternity, "for what is now being made known is ever new." Then, applying this same "figural" logic to the believer's reception of the Passion narrative, Gregory invites Christians to identify now with one, now with another of the actors, if they would grasp the fullness of the mystery adumbrated in sacred Scripture. "Let us imitate the Passion by our suffering," he says; "let us reverence the blood by our blood, let us be eager to climb the cross. If you are Simon of Cyrene, take up the cross and follow. If you are crucified with him as a robber, have the honesty to acknowledge God. . . . If you are Joseph of Arimathea, ask the executioner for the body: make your own the expiation of the world. If you are Nicodemus, the

man who served God by night, prepare him for burial with perfumes. If you are one or other Mary, or Salome or Joanna, shed tears in the early morning."[40]

Michelangelo, in this work for his own tomb, could have seen his role in any, or several, or even all of these ways, incorporating the full range of divine and human reaction as he fathered, mothered, and served Christ by night, prepared him for burial and "shed tears in the early morning."

Beyond the artist himself, there is another figure in Michelangelo's group whose body and spirit are intimately bound up with Christ's: Mary, his mother, shown supporting, embracing, keening Jesus, her head bearing the weight of his head (plate 47), as if she were thinking him, dreaming him, in a perfect union of minds. As opposed to the other female figure, who is physically and psychologically detached (and not only because she has been finished by Tiberio Calcagni), Michelangelo's Mary is intensely and intimately involved: she has shared in her son's death by com-passion, she has mothered him spiritually as well as physically, she holds him tightly in her arms and in her heart.

Mary's role in this *Pietà*, while not central, is important. A possible key to its significance was suggested by Leo Steinberg, who observed that in the planned composition, Christ's left leg would have rested on his mother's thigh: an arrangement with sexual connotations, in both ancient and Renaissance art.[41] Without fully accepting Steinberg's view, one must still note that such an extension of the intimacy between mother and son, at the moment of his death, to include an erotic element, has precedents. In Jacopone da Todi's fourteenth-century *lauda* dramatizing Christ's death, for example, Mary apostrophizes Christ as "figlio, pat[r]e e marito" (son, father, and husband), allowing us to glimpse, among other things, the dramatic function of this most intimately involved of the characters close to Jesus in his death. Mary's role in representations of the Passion was to express the full range of human response to the Savior; in her love for Christ, every conceivable relationship between a woman and a man is somehow operative.[42]

A work of art expressive of this pluri-dimensionality of relationships, including the sexual, is Cima da Conegliano's large *Pietà* for San Niccolò in Carpi, painted in the last years of the fifteenth century (plate 95).[43] There, more explicitly than in Michelangelo's *Pietà* (which made, at most, allusive reference to erotic intimacy), Jesus' left hand is shown between his mother's legs in an overtly sexual gesture. There is perhaps an evocation of the "womb-tomb" topos here: the open door of the new-hewn sepulchre behind Christ in fact balances the hand placed in Mary's lap.[44] But the larger framework of meaning is another: the patristic association of Mary with the church, characterized in the New Testament as "sponsa Christi," or the "bride of Christ."[45] It is, indeed, in light of the early Christian understanding of the church as "woman" and "bride" that the Pauline letter to the Ephesians interprets Genesis 2:24, the injunction that "a man must leave his father and mother and be joined to his wife, and the two will become one body," as applicable to Christ's relationship with the church (cf. Ephesians 5:31). "Husbands should love their wives just as Christ loved the church and sacrificed

himself for her to make her holy" (Ephesians 5:25); the text goes on to maintain that the ultimate rationale for the love between a man and a woman is to be found in the passionate love of Christ for his church, made evident when he died to save those who believe in him.

The Fathers of the church in fact read the sponsal and erotic parts of the Old Testament in light of this New Testament identification of Christ as bridegroom and the church as bride. The physical longing described in the Song of Songs, for example, was taken as expressing this spiritual relationship: "Let him kiss me with the kisses of his mouth," the Song begins (1:1); the many medieval and Renaissance Depositions in which Mary puts her mouth close to that of her dead son should be seen in these terms.[46] The Song's woman protagonist, traditionally called "the Bride," then inquires anxiously: "Have you seen him whom my heart loves?" and the city guards say no, they have not. But "scarcely had I passed them than I found him whom my heart loves," she goes on; "I held him fast, I would not let him go" (3:3–4). The male character, called "the Bridegroom," then knocks at his bride's door, saying: "Open to me, my sister, my dove, my perfect one" (5:2), and she tells the reader: "My beloved thrust his hand through the hole in the door; I trembled to the core of my being. Then I rose to open to my beloved, myrrh ran off my hands, pure myrrh off my fingers, on to the handle of the bolt" (5:4–5).

The underlying spiritual meaning of this passionate physical love is, again, made evident only in Christ's giving his body for his bride, the church. "For a man to love his wife is for him to love himself," says Paul in his letter to the Ephesians; "A man never hates his own body, but he feeds it and looks after it; and that is the way Christ treats the Church, because it is his body—and we are its living parts" (Ephesians 5:28–30). Thus whatever erotic connotations the overlaid leg may have had for sixteenth-century viewers, the detail like that of the hand between Mary's legs in Cima's altarpiece is an ecclesiological allusion, with an ultimate significance related to the eucharistic function of both works. The individual believer—Nicodemus, Michelangelo—is one flesh with Christ, in total physical and spiritual communion. But so, too, is the collectivity of believers, the assembly, the church prefigured in Mary, the mother, the bride.

Michelangelo's *Pietà* shows Christ born from the artist's waning life into the arms of this mother and bride, who is the church. Artist and institution are both lovers, and to the man who supports him, as to the woman who embraces him, Christ can say (in the bridegroom's closing words from the Song of Songs 8:6–7): "Set me like a seal upon your heart, like a seal upon your arm. For love is strong as death, jealousy as relentless as the underworld. The flash of it is a flash of fire, a flame of the Lord himself. No flood can quench love, nor torrents drown it, and were a man to offer all the wealth he possessed to purchase love, he would buy only contempt."

In the notes section of his final volume on Michelangelo, Charles de Tolnay characterizes the artist's late religious drawings with a term we might apply to the Florence *Pietà*, calling them "monologues on the Passion of Christ," in which

"simplified shapes invite the viewer to forget forms and concentrate on the religious essence."[47] The present study has sought to reconstruct Michelangelo's monologue in the Florence *Pietà*, concentrating precisely on the group's religious essence. If our essay leaves questions unanswered, that is perhaps usual in a monologue, and especially in the monologue of a believer, such as Michelangelo, seeking God.

Michelangelo was a Catholic Christian closely associated with the central Ecclesiastical authority, for which he worked in different capacities much of his life. Whatever sympathies he may have felt for Protestant ideas, the existential context of his religious search remained, in his old age in papal Rome, similar to what it had been in his boyhood in Savonarola's Florence. And despite ordinary Italian skepticism regarding priests, Michelangelo seems not to have wavered in his faith in the church and its rites. When a friend died in Florence in the 1540s, Michelangelo told his nephew Lionardo Buonarroti that he wanted to assist the man's soul, "as I did for your father's soul": an expression meaning, presumably, that the master meant to have Mass said for his friend's eternal rest, and he authorized expenditure of the customary sum as an offering.[48]

Alongside references to his own sense of sin, Michelangelo's late poetry bears moving witness to his preoccupation with the Passion of Christ and, indeed, with Christ's blood: "I talk to you, Lord, of all my trials: without your blood, no man can be at peace";[49] "your blood alone can wash and heal my sins";[50] "and in your blood understanding dawns."[51] These are not eucharistic allusions, properly speaking, yet such expressions suggest the concreteness of Michelangelo's monologue on the Passion of Christ and its deeply personal dimension. Brought into connection with "that altar where Michelangelo thought to set the *Pietà*," I believe his vivid awareness of the Savior's blood shed for sinners cannot but have assumed eucharistic connotations. The final line of another late sonnet suggests Michelangelo's sensitivity to the church's sacraments in these years: "only the man reborn in Baptism will rejoice."[52] And that is the real point of Nicodemus's exchange with Christ in the Gospel of John. "How can a grown man be born?" asks the pharisee (John 3:4), and Jesus replies: "I tell you most solemnly, unless a man is born through water and the Spirit, he cannot enter the kingdom of God; what is born of the flesh is flesh; what is born of the Spirit is spirit" (John 3:5–6). The Nicodemus passage is a New Testament catechesis on the sacrament of Baptism.

As he drew near bodily death, Michelangelo sought spiritual rebirth, which he knew to be his right as a baptized Christian: "only the man reborn in Baptism will rejoice." Laying aside "the old self... corrupted by following illusory desires," he brought forth Christ in his waning life, a holy sacrifice expressive of communion with God. Using literary figures drawn from the Bible and from his tradition of religious faith, Michelangelo could see himself as father, mother, disciple and—if we believe his own poetry—bride, within the collective sponsality of the Church. "Send, O Lord, the promised future enlightenment to your fair bride," he asks, "that I might burn with love, my heart free from doubt and feeling only You."[53]

What de Tolnay called "monologues on the Passion of Christ" is thus revealed as dialogue, or—better still—prayer. The biblical topoi, like the sacramental signs of bread and wine, adumbrate a future enlightenment, "for what is now being made known is ever new," as St. Gregory Nazianzen maintained. The communion of life was real, as we should assume Michelangelo believed, yet limits of sense and human sinfulness did not let him see it, and he suffered. "Rend the veil, O Lord," he asked: "break through the wall/whose hardness holds back/your solar light, already spent in worldly hearts."[54] The Florence *Pietà* is one of several attempts, from Michelangelo's side, to rend the veil. It shows spirit born out of flesh, the body of Christ produced in the life of Michelangelo.

Notes to Part I

PREFACE

1. Marc Levoy of Stanford University has since been engaged in scanning other statues of Michelangelo. His chief interest as a computer scientist is in developing the digital technology, but he seems also to be developing an archive of art images for eventual use by scholars and others. To my knowledge, he has not produced a formal publication describing his efforts.

2. The prints produced by all these photographers are now available at Fratelli Alinari in Florence, Rome, and Milan. In 1893 the Englishman of letters John Addington Symonds singled out the glass-plate photographs made by the Alinari brothers as the best way to study the *Pietà* (Symonds 1893, 2:200).

3. Aurelio Amendola made an earlier, less extensive campaign for a volume he and Antonio Paolucci published jointly on Michelangelo's three *Pietà*s (Paolucci 1997, pls. 75–85).

INTRODUCTION

1. The Florence *Pietà* is not the tallest of Michelangelo's statues. Taller are the *David* at 16 ft. 11½ in. (5.2 m), *St. Matthew* at 8 ft. 10¹¹⁄₁₆ in. (2.7 m), *Dying Slave* at 7 ft. 6⅛ in. (2.3 m), *Moses* at 7 ft. 8½ in. (2.4 m), *Victory* at 8 ft. 6¾ in. (2.6 m), the four *Slaves* in the Accademia at between 8 ft. 5⁹⁄₁₆ in. and 9 ft. 1¹⁄₁₆ in. (2.6 and 2.8 m). The Medici *Madonna* is equal in height to the *Pietà*. Penny 1993, 56, points out that with the exception of a few bronzes, Michelangelo executed all his statues in white marble.

2. See appendix F, docs. 2 and 10. Ascanio Condivi published his biography of Michelangelo in 1553. Giorgio Vasari published the life of the artist in two editions of *The Lives of the Painters, Sculptors, and Architects*, one in 1550, the other, greatly enlarged, in 1568. The Vasari reference in my text is to his 1568 edition.

3. Just prior to carving the Florence *Pietà*, Michelangelo composed a famous drawing, as a gift to his friend Vittoria Colonna, with a representation of a *Pietà*. This work is discussed in chap. 2. The so-called Palestrina *Pietà* in the Accademia delle Belle Arti, Florence, is not accepted here as an authentic work of Michelangelo. John Pope-Hennessy convincingly argues against the authenticity of the Palestrina *Pietà* (Pope-Hennessy [Kongress] 1964, 105–14).

4. The fingers of the left hand of the Virgin were broken off in one of the several moves it underwent in St. Peter's. The fingers were reattached, one of them with a new piece of marble (Hartt 1975, 27, and fig. 7), but no apparent changes have been made to the gesture of the hand as we see it today.

5. Historians debate the date of the Rondanini *Pietà*. Some date it to 1552–53, because it is mentioned neither by Vasari in his 1550 edition of the *Lives*, nor by Condivi in his 1553 biography of Michelangelo. If this dating is accurate, then the Milan statue would be the third of the three *Pietà*s. This volume is not the place to debate the dating of the Rondanini *Pietà*, except to note that I prefer to follow Vasari, who in the 1568 edition of the *Lives* implies that it was begun before the Florence *Pietà*. For the most recent study of the Rondanini *Pietà*, see Paoletti 2000, 53–80.

6. According to Paoletti 2000, 58–59, Michelangelo had originally conceived Nicodemus as the figure supporting Christ and subsequently changed it into the Virgin. Paoletti may be right, but he makes one mistake. He states that, like the left leg of the Virgin in the Rondanini *Pietà*, the right leg of the bearded figure (whom he identifies as Nicodemus) in the Florence *Pietà* is uncovered. It is actually tightly fitted with trousers, as the cuff at the ankle indicates. Paoletti does not mention an anonymous sandstone figure of about 1500, in which a standing Virgin holds Christ from behind (see Panofsky 1927, 274, fig. 19). The group, in 1927 in a private collection in Cologne, is of undisclosed dimensions.

7. For a discussion of the chronological relationship between the Florence and Rondanini *Pietà*s, see note 5, above.

8. Vasari noted that Michelangelo portrayed himself as Nicodemus in the sculpture in a letter dated 18 March 1564 (appendix F, doc. 5). Vasari addressed the letter to the artist's nephew, Lionardo, then in Rome attending to his uncle's estate.

9. See appendix F, doc. 10: "si messe attorno a un pezzo di marmo per cavarvi drento quattro figure tonde maggiori che 'l vivo, facendo in quello Cristo morto, per dilettazione e passar tempo, e, come egli diceva, perchè l'esercitarsi col mazzuolo lo teneva sano del corpo." The Magdalene figure, although she seems diminutive in relation to the other three figures, is, nevertheless, larger than life. Were she to stand up, she would measure about 5 ft. 9 in. (1.8 m) and reach the level of the bearded figure's shoulder.

10. Michelangelo wrote on 2 May 1548 and 15 March 1549 that he was suffering from gallstones and could not urinate or climb stairs (see Gilbert 1980, 276 and 280). To his nephew, Lionardo, he wrote on 2 March 1549, "So open your eyes and think, and realize in what wretchedness and toil I live, old as I am" (see ibid., 278).

11. According to Schütz-Rautenberg 1978, 160, Michelangelo's refusal to accept commissions was ideologically motivated. She notes the artist's insistence that he was not a mere craftsman, rather making statuary had an intellectual basis. In this regard, one may recall Michelangelo's remark of 1548 that "he had never been a painter nor a sculptor, as he who maintains a workshop" (see Butters 1996, 2:193–96).

12. The full name of Michelangelo's servant is Antonio del Francese di Castel Durante. For a biography of Antonio, see Leonardi 1995, 6–8.

13. Chapter 6 is a modified and elaborated version of an article I wrote on the statue in the Duomo (Wasserman 2001, 289–98).

14. Rockwell, with the assistance of Giovanna Martellotti of the Conservazione Beni Culturali (CBC), Rome, prepared thirteen important color and black-and-white diagrams with which to illustrate his essay and mine. Nine of the diagrams are color-coded maps of the tool marks on the four sides of the statue. Another diagram, of the front of the statue, indicates with consecutive numbers each of the parts Calcagni used in his restoration. The final three are unnumbered and illustrate the restored parts on the other three sides of the statue. Three of the diagrams are illustrated in the text (plates 98, 99, 108); the others are included in the CD-ROM that accompanies the book. The diagrams were beautifully produced by the Associazione Professionale Architetti (APA) in Rome. I wish to thank Marina Cristiani, Isabella Diotallevi, and Marina Gentili of the APA for their cooperation in producing the diagrams.

15. The ten photo plates on the pinwork that accompany the report are included in the CD-ROM. A diagram with each pin numbered consecutively is used to illustrate the text. By penetrating the marble to the pins themselves, the gamma-ray examination reveals that, with the exception of the pin on the exterior of the Magdalene's right arm (plate 51) and the one between the middle and index fingers of Christ's right hand (the pin is too small to see in plate 80), none of the interior pins is corroding. Thus the marble is in no danger of coming apart.

16. Similar drip marks appear on a plaster cast of the statue in the Gipsoteca of the Istituto d'Arte, at the Porta Romana, Florence, which was made in the 1880s. For the date of the cast, see Bernardini, Calloud, and Mastrorocco 1989, 182. The ultraviolet light examination produced eighteen paired photographs of the individual surface areas of the marble, each pair consisting of an exposure under normal lighting and under ultraviolet light (one of these, plate 111, illustrates the text, the rest are found in the accompanying CD-ROM). A single photograph showing an area from which a stucco sample was taken, with the accompanying number reference sticker, is included in the text (plate 113); the remaining fourteen are included in the accompanying CD-ROM. A color diagram in the text (plate 110) illustrates the results of the spectrometric examination of the stucco compositions.

I. ORIGIN AND FUNCTION

1. Appendix F, doc. 10: "egli avessi avuto animo che la dovessi servire per la sepoltura di lui, a piè di quello altare, dove è pensava di porla." Vasari was echoing Ascanio Condivi, who had introduced the idea that Michelangelo "plans to donate this Pietà to some church, and at the foot of the altar, where it is placed, to have himself buried" (Fa disegno di donar questa Pietà a qualche Chiesa, ed a piè dell'altare, ove sia posta, farsi seppellire; doc. 2). Vasari recorded Michelangelo's intention to place the *Pietà* at his own tomb in a letter of 1564 to his nephew Lionardo Buonarroti: "From what I heard and Daniello and Tomaso Cavalieri and many other friends know, Michelangelo made the pietà with five figures that he broke for his own tomb" (doc. 5). Daniello is the painter Daniele da Volterra. [I include Italian texts for quotes that are essential to

my arguments or that are not included in the documents in appendix F.]

2. Ibid., doc. 7. Francesco Bocchi repeated Varchi's account (doc. 16). Michelangelo left Florence permanently for Rome in 1534.

3. For example, Weil-Garris 1981, 249, n. 48. Wallace 1992, 255, and Nagel, 1996, 564, misinterpreted the texts of Condivi and Vasari by asserting that Michelangelo intended the statue to stand at the foot of an altar.

4. Baccio Bandinelli's *Christ* in the Duomo is unique in that it rests directly on a freestanding altar, the main one of the cathedral. This anomaly is perhaps explained by the fact that the elevated rear part of the altar is occupied by *God the Father* in a comprehensive iconographic scheme. For another explanation, see chap. 8.

5. For an illustration, see Montanelli 1970, fig. 206.

6. There is a slight difference of about $1\frac{1}{2}$ inches (4 cm) between the two arms. The IBM scientists made the following measurements of Christ's arms with the computer: left upper arm $17\frac{3}{4}$ in. (45 cm) and forearm $14\frac{1}{8}$ in. (36 cm) for a total of $31\frac{7}{8}$ in. (81 cm); right upper arm $15\frac{3}{4}$ in. (40 cm) and forearm $14\frac{5}{8}$ in. (37 cm) for a total of $30\frac{3}{8}$ in. (77 cm). The hands are not included in these measurements because the left one is bent into a fist (it measures about $7\frac{7}{8}$ in. [20 cm]), while the fingers of the right hand are extended (measures about $10\frac{5}{8}$ in. [27 cm]).

7. To my knowledge, the statue has never been weighed. For an estimate of its weight made in the late seventeenth century, see chap. 5, text, and n. 65.

8. I took these measurements. Four feet (1.2 m) seem to be the typical height for an altar in the sixteenth century.

9. Del Sarto's original composition is lost, but it is reproduced in the sixteenth-century print by Agostino dei Musi, called Agostino Veneziano. For an illustration of the print, see de Tolnay 1945–60, vol. 5, fig. 360, where the name of the printmaker is cited as Agostino Veneto.

10. According to Schütz-Rautenberg 1978, 151, "the Pietà group was to be placed on or more accurately behind an altar as a free-standing (*freiplastisches*) work."

11. See, for example, Michelangelo's effigy figures in the Medici Chapel in Florence. This position was advocated, among others, by Joachim Poeschke 1990–92, 2:120. An oblique systematization of the *Pietà* was defended by Pavlinov 1965, 115–42. In its present installation in the Museo dell'Opera di Santa Maria del Fiore, the statue is positioned obliquely, probably to disguise the absence of the left leg.

12. Michael Hirst noted Michelangelo's preference for rectangular niches in a lecture he delivered at the Biblioteca Hertziana in Rome in 1999.

13. Appendix F, doc. 2.

14. For example, de Tolnay 1945–60, 150, and Fehl 2002, 18–24.

15. Paoletti 2000, 78, n. 49, also questioned the accuracy of Vasari's assumption that Michelangelo had chosen Santa Maria Maggiore as his burial church. He, too, pointed out that Michelangelo had no direct connection with the basilica in these years. Karl Frey in the early twentieth century already questioned the propriety of naming Santa Maria Maggiore as Michelangelo's burial church, noting that Vasari had "made the point especially fleetingly" (Frey 1923–30, 2:35). Frey, in fact, went so far as to doubt that Michelangelo had made the statue as a marker at his own tomb.

16. See Ackerman 1970, 342.

17. See Vasari (ed. Milanesi) 1878–85, 7:286.

18. See Hollanda 1928. See also de Tolnay 1975, 106.

19. Polverini Fossi 1991, 159. Bruni 1940, 247 and n. 3, cited a document to the effect that the Confraternita della Pietà was responsible for bringing Michelangelo's body to the church of Santissimi Apostoli. Tiberio Calcagni, the assistant of Michelangelo who repaired the *Pietà*, is buried in the cloister of San Giovanni Decollato (see Wallace 2000, 91).

20. Appendix F, doc. 9.

21. See Vasari (ed. Milanesi) 1878–85, 7:245: "Sappiate per cose certa, che io arei caro di riporre queste mie debili ossa accanto a quelle di mio padre." See also Barocchi and Ristori 1965–83, 5:21. For the complete English text of the letter, see Ramsden 1963, 2:146, no. 390, and Gilbert 1980, 301, no. 98. Vasari may also have been familiar with a letter that Michelangelo sent Cosimo I in May 1557 in which he states that upon completion of St. Peter's he would "return to Florence with a mind to rest there in the company of death" (e poi tornarmi a Firenze con animo di riposarmi co[n] la morte). For the entire letter in an English translation, see Gilbert 1980, 174–75. For the entire Italian text, see Barocchi and Ristori 1965–83, 5:102–3.

22. See Frey 1923–30, 2:40; and Barocchi and Ristori 1965–83, 5:21. Lotti 1975, 67, proposed an unlikely compromise: Michelangelo had first wanted his tomb in Santa Maria Maggiore in Rome and then changed his mind in favor of Santa Croce. We will see below that Vasari, years before he completed the second edition of the *Lives*, was aware of Michelangelo's preference for Santa Croce in 1554 and for his sepulchre in 1564.

23. See n. 21, above, for the bibliographical citation. According to Shrimplin-Evangelidis 1989, 65, n. 79, "the construction in Rome of a large-scale work intended for his own tomb would indicate [Michelangelo's] wish for burial in Rome, especially considering the difficulties of transporting large-scale sculpture, known from the experience of the *David*." On the other hand, Rudolf Wittkower stated that "there could be no doubt" about Michelangelo's desire for his body to be returned to Florence; see Wittkower and Wittkower 1964, 11–12.

24. Vasari (ed. Milanesi) 1878–85, 7:292. Vasari wrote: "having understood from Daniello da Volterra . . . and as well from others who were close to that old saint, that he had asked and begged that his body be carried to Florence, his most noble country, of which he was always a tender admirer" (avendo inteso da Daniello da Volterra, stato molto familiare amico di Michelagnolo, e da altri ancora che erano stati intorno a quel santo vecchio, che egli aveva chiesto e pregato che il suo corpo fusse portato a Fiorenza sua nobilissima patria, della quale fu sempre tenerissimo amatore).

25. See Gotti 1875, 357–58. Other evidence of Michelangelo's deathbed plea to be returned to Florence is found in a letter his physician, Gherardo Fedelissimo, wrote Cosimo I on 18 February 1564. He reported that as Michelangelo lay dying, he spoke of his "desire . . . to have his body transported to Florence" (Gaye 1839–40, 2:126–27, no. 121). On 18 March 1564 one Giovanni di Simone informed Michelangelo's nephew that Vasari had evidence of "the desire of [Michelangelo] to be buried under the said Pietà and near the bones of Lodovico, his father of good memory" (Barocchi and Ristori 1965–83, 5:179, no. 2, and 180, no. 6). Giovanni di Simone is probably referring to the letter from Michelangelo Vasari published in the *Lives* (see n. 21, above). On the other hand, Michelangelo wrote to Vasari of 22 May 1557 that he was resigned to dying

in Rome, but this need not be taken as evidence that he actually wanted to be buried in the papal city.

26. Michelangelo made a comparable slip of the pen in a letter to Vasari he dated 3 December 1555 announcing the death of his servant Urbino. Urbino actually died on 3 January 1556. See chap. 3, n. 25, for the documentation that establishes the later date for Urbino's death. Wallace 1992, 255, also slipped up in naming Santa Maria sopra Minerva as the church in which Michelangelo presumably wanted to be buried.

27. Vasari mentioned Cosimo's suggestion in a letter to Lionardo Buonarroti, Michelangelo's nephew, from March 1564. The Italian text of Vasari's letter is transcribed in Frey 1923–30, 2:28–29, no. 181: "Dicovi bene, che il nostro Ill.mo Principe a caro che venga il corpo per dir meglio lossa, perché avisano da S.E.I., che ne scrive di Pisa, che non mancherà fargli la stanza in Santa Maria del Fiore."

28. See Vasari (ed. Milanesi) 1878–85, 7:293.

29. Appendix F, doc. 9: "Baccio [Bandinelli] wished to finish that statue of a dead Christ supported by Nicodemus . . . because he had learned that in Rome Buonarroto [i.e. Michelangelo] had finished one, which he had begun in a large marble, where there are five figures, to put it in Santa Maria Maggiore at his sepulchre."

30. Ibid., doc. 1. Vasari saw the *Pietà* at least twice, in about 1550 (doc. 1), prior to publishing the first edition of the *Lives* in that year, and in about 1553, when he visited Michelangelo in his studio and saw the master altering a leg of the *Pietà* (doc. 15).

31. See Perrig 1960, 46, n. 21, for a list of historians who date the inception of the *Pietà* to between 1545 and 1550. The 1545 dating depends unconvincingly on the fact that, in the 1550 edition of the *Lives*, Vasari mentions the *Pietà* immediately after citing the frescoes in the Pauline Chapel. The question of the chronological relation between the statue and the frescoes is discussed below. In his review of Perrig's book, Isermeyer 1965, 307–52, suggested a date as early as 1541–42, because the statue was cited by Vasari in relation to the installation of the Julius tomb in San Pietro in Vincoli, Rome. Isermeyer's suggestion is unacceptable, since Vasari mentions the installation as being completed, which occurred in 1545. Salvini 1977, 169, proposed a date of 1546 without argumentation. Lavin 1978, 18 and n. 17, also suggested 1546 as the starting date for the statue. He maintained that Michelangelo had been seriously ill in that year and made the statue in thanksgiving for his recovery. This seems a questionable reason for making a funerary monument.

32. Perrig 1960, 37, introduced the death of Michelangelo's close friend Luigi del Riccio as an additional reason for Michelangelo's despair.

33. See de Tolnay 1945–60, 5:51–69.

34. For a discussion of the preparation and publication of the 1550 edition of the *Lives*, see Vasari (ed. Bellosi) 1986–91, 1:xxix–xxxiv, and Rubin 1995, 106–14.

35. For example, Perrig 1960, 39.

36. The Italian text is in Frey 1923, 209, no. 104: "Io notai quel poco che mi parve et vi conforto a stampare il libro a buon conto." Several of Giovio's other surviving letters from this period refer to the manuscript, but none mentions the *Pietà* (see, for example, ibid., 195, no. 92, 200, no. 97, and 209, no. 104).

37. See Perrig, 1960, 46, n. 2, for a list of scholars who favor a 1550 dating for the statue.

38. Vasari (ed. Milanesi) 1878–85, 7:216. Condivi also mentions the *Pietà* immediately after discussing the Pauline frescoes. For this, see Condivi (ed. Nencioni) 1998, 51.

39. Vasari (ed. Milanesi) 1878–85, 7:216: "Queste furono l'ultime pitture condotte da lui d'età d'anni settantacinque, e, secondo che egli mi diceva, con molta sua gran fatica: avvengachè la pittura, passato una certa età, e massimamente il lavorare in fresco, non è arte da vecchi."

40. Appendix F, doc. 10. In the second edition of the *Lives* of 1568, Vasari asserted that Michelangelo produced no paintings after 1550, but devoted much of his old age to sculpture, the *Pietà* among them. According to Vasari, he began the Rondanini *Pietà* in Milan before he took up the block for the Florence *Pietà*. Two additional sculptures are recorded in an inventory of Michelangelo's estate drawn up in 1564; see Gotti 1875, 150. One is a small Christ carrying a cross, which may have been an earlier work related to the *Resurrected Christ* of 1519 in Santa Maria sopra Minerva in Rome. The other is an unfinished marble *St. Peter*, whose whereabouts today are unknown and about which we have no other information. Whether or not the Rondanini *Pietà* should be included among the statues Michelangelo made after 1550 (its inception is often dated to 1552–53) is a question that cannot be answered in this study. For a discussion of the dating of the Rondanini *Pietà*, see Paoletti 2000, 54.

41. For this, see Vasari (ed. Bellosi) 1986-91, 1:xxix–xxxiv, and Rubin 1995, 106–14.

42. Vasari must have left for Rome shortly after 8 February, when del Monte was elected pope after one of the longest and most contentious conclaves of the sixteenth century (see Pastor 1923–53, 13:2, n. 1). Vasari remained in Rome until 1553 (see Perrig 1960, 47).

43. We learn that Vasari stopped the press in a letter Cosimo Bartoli sent him dated 23 February 1550. The letter is transcribed in Frey 1923–30, 2:265, 127.

44. The letter is discussed by Rubin 1995, 114. The Italian text, transcribed in Rubin, reads: "quella brevissima aggiunta che vi è piaciuta."

45. See ibid., 110.

46. See Vasari (ed. Bellosi) 1986–91, 2:910–11.

47. As Paoletti 2000, 79, n. 61, rightly noted, it "is becoming a small cottage industry" those attempts "to attach Michelangelo to the teachings and writings of Protestant reformers within the Roman church accused of heresy." I would point out that any evaluation of Michelangelo's relationship with Protestant reformers must take into account the artist's association with Fra Ambrogio Caterino. According to Fransisco de Hollanda, Michelangelo and Vittoria Colonna met several times at San Silvestro al Quirinale in Rome in 1538 or 1539 to discuss questions relating to art. At the beginning of each session, Fra Ambrogio delivered a sermon on St. Paul's epistles that were virulently anti-Lutheran. Fra Ambrogio published the sermons in 1551. References to the meetings between Michelangelo and Colonna and to the Fra Ambrogio's sermons are found in Deswarte-Rosa 1997, 349–73, and Anderson 1969, esp. 35–39. For a defense of Michelangelo's Catholic orthodoxy, see Clements 1966, 41–43 and 222–26, and Timothy Verdon's chapter in this volume (chap. 8).

48. For Santiago de Campostella, see Clements 1968, 71, n. 195. For the seven churches of Rome, see Partner 1976, 207. For the quote regarding the Jubilee indulgence, see Pastor 1923–53, 13:56.

49. For a reference to the brother who died "confesso," see Clements 1966, 222. For a reference to the brother who died with "all the sacraments," see Gilbert 1980, 304, no. 102.

50. See ibid., 306, no. 105.

2. SUBJECT, CONTENT, AND FORM

1. Not all modern scholars would agree. As we will see below, de Tolnay 1945–60, 5:88, for example, wrote: "The group is usually called a Pietà, but it is in truth a Deposition and was rightly called such by Condivi and Vasari." Vasari, in fact, never used the word "deposition" in its noun form in his references to Michelangelo's statue.

2. For Condivi's use of the term *Pietà* in his biography of Michelangelo, see doc. 2. Vasari used the term once in a letter he wrote to Michelangelo's nephew, Lionardo, in 1564 (appendix F, doc. 5), and five times in his *Lives* of 1568 (docs. 11–15).

3. Landucci's statement is cited in Hartt 1975, 19. Condivi's entire text in translation reads as follows: "Christ deposed from the cross, the dead body held thus by His mother, whom we see entering under that body with her breast, arms, and knee in a remarkable act. However, she is assisted from above by Nicodemus, who, erect and firm on his legs, supports him under the arms with vigorous strength; and by one of the Maries on the left side, who, still deeply grieved, reveals herself nevertheless capable of performing the task, of which the mother is incapable because of her extreme sorrow. The released Christ falls with all his limbs slackened, but in a very different position from the one Michelangelo did for the marchioness of Pescara or the one of the Madonna della Febbre. It would be impossible to describe the beauty and the emotions shown in the grieving and sorrowful faces of the anguished mother and all the others" (see appendix F, doc. 2, for the source of the English translation). The "marchioness of Pescara" refers to Marchesa Vittoria Colonna of Pescara for whom Michelangelo made drawing of a Pietà in about 1540. The drawing is today in the Isabella Stewart Gardner Museum in Boston (see plate 19). The "Madonna della Febbre" is the *Pietà* in St. Peter's, Rome (plate 7). Vasari echoes Condivi's text in the *Lives* of 1568. He wrote: "Christ, deposed from the cross, is supported by Our Lady, her body entering under him; she is aided by Nicodemus, firm on his feet and with an exertion of strength, and by one of the Maries, seeing as the Mother herself lacks that strength, and is so overcome with grief that she cannot support Him" (see doc. 10 for the source of the English translation). John alone (19:25–27) of the four Evangelists placed the Virgin at the scene of her son's death, but as a neutral observer at the foot of the cross. The intimate episode of the mourning Virgin with Christ in her lap or on the ground before her is an apocryphal invention that became a familiar subject in art only when devotion to the mother of Christ increased in the Middle Ages and beyond.

4. The statue was called a Pietà in letters, diaries, official documents, guidebooks, and in a variety of commentaries. See the documents in appendix F dated after 1568.

5. For the Vasari and Condivi quotes, see documents 1, 2, and 10. Gaetano Milanesi wrote, "Questo gruppo, che non rappresenta una Pietà, ma un Deposto di Croce, come lo stesso Vasari lo ha chiamato (Vasari [ed. Milanesi] 1878–86, 7:244, no. 1)." See also Mackowsky 1925, 299.

6. Scholars use the *Pietà* term mostly as titles of books, chapters, articles, and in the legends of illustrations. Olson 1992, 176, calls the statue anachronistically the Duomo *Pietà*.

7. Einem 1940, 84.

8. For the distinction between a Lamentation and a Pietà, see Schiller 1971–72, 2:174–81.

9. Einem 1959, 246. For a discussion and illustration of the Man of Sorrows imagery, see Schiller 1971–72, 2:197–224, figs. 667–751.

10. Hartt 1975, 299–300. Davies 1909 may have introduced the Entombment iconography, but he vacillated between referring to the statue as an Entombment (p. 187) and a Pietà (p. 188), as did Gottschewski n.d., who called the statue a Pietà on p. 12 and an Entombment on p. 18. Others who favor the Entombment iconography are Knapp 1910, legend to fig. 175; Steinberg 1968, 345, Lavin 1978, 19; and Weil-Garris, 1981, 238 and n. 48.

11. For example, Matthew 27:60.

12. Hartt 1975, 299–300. Hartt's entire text follows: "The artist in the person of Joseph of Arimathea gives his tomb to Christ, who sinks toward it with a downward motion generally considered one of the most compelling, even irresistible movements in all of man's artistic expression. The mortal figures are powerless against it. Their futile attempts to hold the body of Christ dramatize only the inescapable fact that they, too, are drawn into the grave with Him." Vasari first mentioned the fact that Michelangelo's features are imprinted on the face of the bearded man behind Christ in a letter he wrote to the artist's nephew, Lionardo, on 18 March 1564 (appendix F, doc. 5).

13. De Tolnay 1945–60, 5:86.

14. Hibbard 1974, 284.

15. Andres, Hunisak, and Turner 1988, 52. Dixon 1994, 139, accepts this characterization of the statue and concludes, "Since the psychological form of the work is Mary holding the body, the present title [*Pietà*] will serve."

16. Keller 1976, 252.

17. For a discussion and illustration of the Ecce homo subject, see Schiller 1971–72, 2:74–76 and figs. 261–73.

18. Schütz-Rautenberg 1978, 151–52, suggested this concept when she wrote that the "Pietà represents a moment after the Deposition in which Christ is supported both by the Virgin and Nicodemus."

19. The Virgin has been represented embracing Christ in this manner in representations of the Deposition and Lamentation since the fourteenth century. See Panofsky 1927, figs. 2, 10–12, and 14–17.

20. Condivi and Vasari referred to this figure as "the other Mary," but the Mary Magdalene identification is now the accepted one. Recently, however, there was an implausible attempt to switch the identities of the two women in the *Pietà*. In the opinion of Arkin 1997, 500, Mary Magdalene is actually the Virgin and the Virgin, Mary Magdalene. He wrote, "It appears that in the entire history of the Renaissance it is difficult to find another composition such as this, be it a *Pietà*, or a Descent from the Cross, or a Deposition, or even a Crucifixion, in which Christ is in the center of the picture and the Madonna is to His left and the Magdalene to his right." Arkin narrowed the playing field considerably and arbitrarily by eliminating from consideration representations in which the Madonna "is fainting or turning away from the tragic scenery, or is depicted at the bottom of the picture." This does not leave much. The evidence against Arkin's idea is strong. For example, the Virgin is on the left and the Magdalene on the right in Giovanni Francesco Caroto's *Pietà* (plate 43), Titian's *Pietà* of c. 1576 (plate 75), Jacopino del Conte's several *Pietà*s (illustrated in Vannugli 1991, 59–93), and Pietà representations attributed to Scipione Pulzone (see appendix E, nos. 8 and 9). The Virgin is also on the left side of Christ and the Magdalene on his right in Michelangelo's own drawings for a *Pietà* in the Louvre and the Albertina (plates 20 and 21). Arkin wrongly believes that the brooch on the Magdalene's head,

which contains the head of a child, supports his thesis that she is the Virgin. See also note 72, below.

21. Michelangelo is anticipated by an *Entombment* by Filippino Lippi in the motif of the Magdalene supporting Christ. For an illustration of Lippi's painting, see de Tolnay 1945–60, 5:fig. 372. According to Sanminiatelli 1965, 174, the Magdalene functions as a simple support ("come semplice sostegno"). Tacha Spear 1969, 410, notes the left hand of the Magdalene's "embracing Joseph's thigh," but only to question its purpose. Steinberg 1968, 348, interprets the gesture this way: "The Magdalene's approach to Christ's body betrays a sexual intimacy either uninterrupted or generated by death."

22. Steinberg 1968, 345, interprets Christ's arm differently, as embracing the Magdalene rather than "merely caught in the peripheral sweep of a circuiting rhythm."

23. The cloth as an aid to deposing Christ from the cross is found in earlier works of art: Signorelli's *Deposition* in Santa Croce, Umbertide; Perugino's *Deposition* in the Uffizi; and Begarelli's terracotta *Deposition* in San Pietro, Modena. In Perugino's and Begarelli's representations, the cloth is still hanging from the cross. For illustrations, see Venturi 1900, 369, 371, and 378. For the burial shroud, see Weil-Garris Brandt 1987, 91.

24. Several of these works are enumerated in Perrig 1960, 68, n. 61.

25. See for this Lavin 1978, 20–22. For illustrations of the *Laocoön* and *Farnese Bull*, see ibid., figs. 17 and 19.

26. De Tolnay, 1945–60, 5:fig. 370.

27. Lippi's painting is in the Musée Thomas Henry, Cherbourg, France. For an illustration, see ibid., fig. 372. In a private communication of 27 April 1999, the conservator of the museum, Jean-Luc Dufresne, informed me that the painting was recently reattributed from Fra Lippo Lippi to Filippino Lippi.

28. Levi 1932, 51, introduced the connection between the Patroclus relief and the Florence *Pietà*. See also Einem 1940, 77–79 and fig. 10.

29. Andrea del Sarto's drawing is lost, but its composition is preserved in an engraving by Agostino Veneziano (for an illustration, see de Tolnay 1945–60, 5:fig. 360).

30. For discussions of the Colonna *Pietà*, including its date, see Hartt 1970, 323, no. 455; Campi 1997, 408–11; and Goldfarb 1997, 426–28, no. 4.36.

31. Nagel 2000, 202, instead, argues an "inevitable" progression from "the highly narrative conception" of the Haarlem *Deposition* (plate 23) to "the concentrated solution" of the Colonna *Pietà* (plate 19). He views the Florence *Pietà* as Michelangelo's conscious return to a narrative conception of the theme (ibid., 204), where it is "reduced to a sculptural formula."

32. Vasari (ed. Milanesi) 1878–85, 277–78.

33. For this dating, see Nagel 1996, 553. Actually, the dating of the two drawings is controversial. De Tolnay 1975–80, 2:nos. 268r and 269r, dated the one in the Louvre to between 1532 and 1536 and the one in the Albertina (inv. no. 102) to the period of the frescoes of the Pauline Chapel, begun in 1542. Hartt 1975, 70, dated them to about 1550 as projects for the Florence *Pietà*. For different analyses of the Louvre and Albertina drawings and their relationship to the Florence *Pietà*, see Nagel 1996, 548–67, Nagel 1997, 659–61, and Nagel 2000, 163–68. For the authenticity of the drawings, see also de Tolnay 1975–80, 2:nos. 268r and 269r. There are two other drawings of a *Pietà,* in the Teylers Museum, Haarlem (inv. no. 35v), and in the Albertina in Vienna (inv. no. 103). The Haarlem drawing

is by Michelangelo and is so seriously damaged that it cannot be properly analyzed. It consists of three fragments, with most of the lower part of the composition missing. For an illustration of the drawing, see Nagel 1996, 569, fig. 17. Nagel attributes the Albertina drawing to Michelangelo (Nagel 1996, 556–58, fig. 9) and claims that the figure of Christ replicates that of the Christ in a painting of an *Entombment* in the National Gallery, London, which he (Nagel 1994, 164–67) and other scholars believe is an early work of Michelangelo (e.g., Shearman 1992, 79–81 and Hirst and Dunkerton 1994, 57–81). I disagree with both attributions. For a recent discussion in which the attribution of the London painting to Michelangelo is rejected, see Beck 1996, 181–98.

34. Another source for the Albertina drawing may be the fainting Virgin from Sandro Botticelli's *Pietà* in Milan (for an illustration, see Lightbown 1983, pl. 81). In Michelangelo's Albertina drawing, the Virgin falls back against a neighbor on the right, upon whose leg she rests her head and surrounds with her left arm.

35. The Magdalene motif appears in two sixteenth-century *Deposition*s by Bacchiacca (in the Uffizi in Florence and in the Museo Civico in Bassano), and one by Domenico Puligo in the Seminario in Venice (illustrated in Freedberg 1972, 2:figs. 633, 617, and 623). The motif appears in the later 1540s in Daniele da Volterra's *Deposition* in Trinità dei Monti in Rome (illustrated in Freedberg 1971, fig. 205). Hartt 1975, 71, describes the composition in the Albertina drawing incorrectly. He identifies the figure on the left that clasps Christ's hip (which I recognize as the Magdalene) as St. John and the one between whose knees Christ descends as the Magdalene, but I believe her to be the Virgin. He also claims that the hand resting on Christ's left breast is the Virgin's, but it obviously belongs to the standing figure on the right, who may represent St. John.

36. The Ganymede drawing is one of several copies of a lost original that Michelangelo made as a gift to Tommaso Cavalieri (see Panofsky 1962, 216).

37. Michelangelo's choice of a classical figure for his Christ is possibly explained by Panofsky's interpretation of the drawing (ibid.): "It shows Ganymede in a state of trance without a will or a thought of his own, reduced to passive immobility by the iron grip of the gigantic eagle, the posture of his arms suggesting the attitude of an unconscious person or a corpse, and his soul really *rimossa dal corpo*." In other words, the drawing depicts a supreme being transporting a soul to heaven.

38. Although formerly doubted, many scholars today accept the attribution of the *Deposition* drawing to Michelangelo, including de Tolnay 1975–80, 1:89r; Hartt 1975, 321, no. 452; and Nagel 1996, 548–50.

39. According to Hirst 1988, 49, the *Deposition* drawing may have been a project for a relief and the *Pietà* drawing a project for a painting (Hirst 1997, 452).

40. Pope-Hennessy 1970, 3:38–39, also noted the *Pietà's* pictorial qualities and associated them with Michelangelo's late paintings. He wrote "The primacy of painting is maintained visually in the *Deposition* group. The linking of the three main figures in a single visual unit with a strong vertical emphasis is a device that was repeatedly employed by Michelangelo in the *Last Judgment*, and the Virgin and Nicodemus can indeed be looked upon as figures from the fresco invested with physical instead of notional reality." In his recent book on Michelangelo, Nagel stressed the pictorial aspect of the Florence *Pietà*: "So far from simply ignoring or rejecting the lessons of painting, the very project of the late sculptures was determined by an effort to address the challenges set by painting to sculpture.... But it was above all the pictorial preoccupation with narrative that affected the nature of the late *Pietàs*," (Nagel 2000, 202). There is a certain implicit narrative also in Michelangelo's early statuary, manifested as an individual's alertness to some human or spiritual presence that is invisible to the observer. In sculpture, this element is found in the *David, St. Matthew, Giuliano de' Medici*, and the Accademia *Slaves*. It is found also in painting, in several *Ignudi* in the Sistine Ceiling. The narrative in the Florence *Pietà*, however, is treated differently: it is explicit, as in narrative painting and relief representations.

41. Appendix F, doc. 2.

42. For an illustration of Jacopo Sansovino's statue in Sant' Agostino, Rome, see Wallace 2000, 83, fig. 2.

43. For an illustration, see Venturi 1925–37, 10: pt. 3, 978, fig. 856.

44. The statue is about 4 ft. 8 in. wide (1.2 m) and 3 ft. 1 in. deep (94 cm). The block is too small to contain the four figures. We should consider the fact that single figures by Michelangelo, such as the *Moses* and the Accademia *Slave* with crossed leg, were carved from a deeper block of stone than the *Pietà* (the *Moses* is deeper by 2 in. or 7 cm, the *Slave* by as much as 5 in. or 13 cm). The underside of the base of the *Pietà* is irregular and balanced by an under-base that was installed in the late seventeenth century, when the statue was placed behind the high altar in the Duomo (plate 31). The under-base that balances the statue today is a new piece.

45. This was pointed out also by Wilde 1978, 181, and Parronchi 1981, 25, who stated that Michelangelo carved the *Pietà* from a block that had previously been consigned to the Julius tomb. An account of Michelangelo's reuse of marble is given by Blaise de Vigenière, who visited the artist's studio in 1550 and claimed he saw Michelangelo carving a *Pietà* out of a large ancient capital from Vespasian's Temple of Peace in Rome (cited in Thode 1908–13, 2:275–76). Several historians assume the work was the Florence *Pietà* (see Gotti 1875, 1:328; Symonds 1893, 2:201; Sutherland Gower 1903, 55–56; Gargano 1929, 2; and Sanminiatelli 1965, 168). Pope-Hennessy 1964, 110–11, wrote that the Palestrina *Pietà* was carved from a Roman capital, pointing to traces of acanthus on the back. Steinberg 1968, 350–53, rightly disputes Vigenière's claim.

46. See Hirst 1988, 62.

47. Wilde 1978, 181, wrote that it was usual for Michelangelo in his old age "to have blocks of marble ready in his studio and work on them from time to time to keep his hand and body sound."

48. De Tolnay 1945–60, 5:88, wrote that the "Magdalene looks directly at the beholder as if to draw his attention to the Passion of Christ; she fulfills a function similar to the angel in the *Madonna in the Grotto* by Leonardo." See also Wallace 2000, 92, who claims that the Magdalene presents the body of Christ to the spectator.

49. Parronchi 1981, 32, fig. 15, first called attention to the Virgin's right hand.

50. Henry Thode, at the beginning of the twentieth century, already pointed out that the Virgin's right arm and right leg could not be seen. He considered this anomaly an error and one of the reasons Michelangelo decided to destroy the *Pietà* (Thode 1908–13, 2:277).

51. Michelangelo used illusionism in the *Pietà* as a practical method of obtaining a specific end. This approach should therefore be understood separately from his intellectual position concerning the relationship between painting and sculpture, as communicated in a letter of 1547. For opposing interpretations of the letter, see Hibbard 1974, 185, and Mendelsohn 1982, 58. As for the hands in

back of the statue, they would have been visible had Michelangelo intended for his work to be seen in the round. Even so, my interpretation of the Virgin's limbs in front as conceived pictorially would be unaltered.

52. Probably influenced by Michelangelo's *Pietà*, Ippolito Scalza also employed a multiple view in his statue of a *Pietà* of 1574 in the Cathedral of Orvieto. Scalza's statue, however, has only two views, from the front and left sides. For additional information on Scalza's statue and an illustration from the front, see bibliographical reference in n. 43, above; and Satolli 1993, figs. 13 and 15. The view of the statue from the left side is unpublished but it is seen in a photograph (negative E8844) in the Ministero per i Beni Culturali e Ambientali, Istituto Centrale per il Catalogo e la Documentazione, Rome.

53. For a discussion of the *Resurrected Christ* and its multiple views, see Wallace 1997, 1251–80.

54. Einem 1959, 246, wrote: "The wealth of movement and expression in the *Pietà* is such that it can be viewed from different angles." See Summers 1972, esp. 208–93, for an examination of Michelangelo's use of *contrapposto* in its more developed *serpentinata* mode, key features of which are movement and compositional variety. Summers, however, does not discuss the Florence *Pietà* in his essay.

55. See Humfrey 1983, 89.

56. St. Bonaventura writes as follows about the Virgin: "And she wept and dropped tears when she saw the wounds in his side and on his hands, and gazed at his face and head" (cited in Hirn 1912, 398–99).

57. For the Virgin's share in Christ's redemptive martyrdom, see ibid., 392–94. See Humfrey 1983, 89, for the two ways of interpreting the Virgin's role in the historical Pietà. On the subject of the Virgin as mediatrix, Humfrey writes that it "permeates medieval and post-Tridentine spirituality." See also Ostrow 1996, 167.

58. St. Brigit quotes Christ as saying, "and therefore I wish to say that my mother and I saved mankind as with one heart, I suffering in body and heart, and she suffering the heart's sorrow and love." St. Brigit then quotes the Virgin as saying, "For as Adam and Eve sold the world for an apple, so we redeemed the world with a heart" (cited in Hirn 1912, 393). Jean de Gerson made the Virgin say at the Crucifixion, "I am willing to suffer, since it pleases God. I consent that I be in some small way a partner and cause of redemption for the human race" (cited in Ellington 1995, 227).

59. Colonna's tract is transcribed in Simoncelli 1979, 423–28, with the title "Meditatione del Venerdì Santo." Simoncelli points out (p. 423) that its original title was "Pianto della Marchesa di Pescara sopra la Passione di Christo."

60. Ibid., 423.

61. Ibid., 424: "Io penso Padre che la Regina del Cielo lo pianse in più modi, prima come humano, vedendo il bellissimo corpo formato de la sua propria carne tutto lacerato. . . . Poi considerava anzi vedeva nel Divin volto depinto i vestigij della charità, della obedientia, della humiltà, della pacientia, et della pace. . . . Considerava ch'el pianto suo era cagion di alegreza a tante anime charissime a lei, quali sì longamente havevano expectato quel benedetto giorno, né questo li moderava la pena, anzi ce l'accresceva perché faceva magior l'obligo suo et della redempta sua generatione."

62. De Tolnay 1945–60, 5:87, considers the core meaning of the statue to be a *sposalizio,* or mystic marriage, of Christ and the Virgin. Steinberg 1968, 344, agrees. I take up objections to Steinberg's interpretation in chap. 3. Since de Tolnay does not offer his premises for asserting that Michelangelo's *Pietà* represents a mystical mar-

riage and that the Virgin symbolizes the church, they cannot be evaluated.

63. Simoncelli 1979, 425. The full passage of Colonna's text reads: "Hor con quanto amor li basava le santissime piaghe, et come si rechiudeva con la mente in quella del sacro lato ove sapeva che eran usciti i sacramenti di tante gratie nostre, con che sincera charità credo desiderava che tutto il mondo fosse a veder quello che lei vedeva perché godessero de sì immense gratia" (Now with such love she kissed the most holy wounds, and how she contemplated that holy side from which the sacraments our grace flow, with what sincere charity I think she desired that the whole world were present to see what she saw because they would enjoy such immense grace).

64. Other historians have mentioned the eucharistic character of the statue as well, but Verdon is the first to set it into the context and writings of medieval and Renaissance theologians.

65. Steinberg 1968, 345, wrote, "She is embraced. That she is truly embraced, not merely caught in the peripheral sweep of a circuiting rhythm, is confirmed by one small nuance. The drapery fold between the Magdalene's breasts that flows down her abdomen is not her own garment but the loose end of Christ's winding sheet. Released from his chest it presses gently against her body. The delegated caress of the shroud confirms the Magdalene as an object of love." See also Steinberg 1985. Partridge 1996, 106, echoed Steinberg's hypothesis.

66. Steinberg 1968, 345. Steinberg's interpretation of the symbolic relationships between Christ, the Virgin, and the Magdalene, is echoed by Olson 1992, 176.

67. Christ's identical gesture is found in a drawing for a *Deposition* attributed to Daniele da Volterra in the Uffizi, Florence (inv. no. 1138E). In Volterra's drawing Christ's right arm encircles a male figure who assists in his descent. For an illustration, see Barolsky 1979, fig. 28.

68. Voragine 1993 1:375. Voragine was the author of many works, the *Golden Legend* being his most famous and widely consulted in the Middle Ages and the Renaissance.

69. Ibid. According to de Tolnay 1945–60, 7:87, the figures of Mary Magdalene and the Virgin in Michelangelo's statue are allegorical expressions, respectively, of life and death. This thesis lacks specificity and so cannot be gainfully evaluated.

70. Cited in Simoncelli 1979, 426: "Como non viene a lavarsi nel puro pretiose sangue."

71. Hartt 1975, 80. To justify his identifying the child as an *amorino*, Hartt cites "Christ's remark to Simon in the house of the Pharisee after Mary had washed, anointed, and kissed His feet: 'her sins, which are many, are forgiven; for she loved much.' "

72. Wallace 2000, 92, explains that the "seraphic headdress suggests priestly garments and metaphorically sheds light." Arkin 1997, 493–517, was responsible for the seraphic identity of the head, however I believe he went too far in claiming that the head identifies the kneeling figure as the Virgin Mary. He noted the appearance of cherubs or seraphs on the headdress of the Virgin in the *Pitti Tondo* in the Bargello in Florence and on the *Madonna del Silenzio*, a drawing in the collection of the Duke of Portland in London, and on the Virgin's chest in the Colonna *Pietà* in the Isabella Stewart Gardner Museum in Boston (our plate 19). He did not, however, seem to know that these angelic figures appear also in two genre drawings assumed to be copies after originals by Michelangelo: an imaginary female head and a warrior's helmet; for illustrations, see

Joannides 1996, 40, no. 2, and 48, no. 6. Furthermore, cherubs or seraphs ornament the vase the Magdalene holds in a painting by the Maestro delle Mezze Figure (illustrated in Mosco 1986, 71, fig. 10) and there is one on her breast in a painting by Vasari (illustrated in Suida 1953, 29, plate 11). De Tolnay does not mention the emblem on the Magdalene's head, but in his discussion of the *Pitti tondo* in the Bargello, Florence, he identifies the celestial figure on the head of the Virgin as a cherub that symbolizes the "gift of knowledge, in the sense of a prophetic faculty" (de Tolnay 1945–60, 1:160).

73. In fact, Cherubino Alberti, in his famous engraving after Michelangelo's Florence *Pietà* of the 1580s (plate 81), treated the lateral elements as ornaments. Lorenzo Sabbatini did not include the child's head in his painted copy after Michelangelo's *Pietà* in St. Peter's (for an illustration, see Venturi 1925–37, 9:pt. 6, fig. 468), but Antonio Viviani did in his painted *Pietà* in Madonna dei Monti in Rome (for an illustration, see Guerrieri Borsoi 1993, 231–33, no. 23a). Francesco Salviati also included a more mature head without wings in a brooch on the Magdalene's arm in a *Pietà* in the Brera in Milan (illustrated in Monbeig Goguel 1998, 125), but the frame of the brooch is different from that in Michelangelo's statue. Vasari, in his *Pietà* in Ravenna, included a similar ornamental brooch, this time without a head altogether, on the sleeve of the garment of a woman who is not the Magdalene (see Venturi 1925–37, 9:pt. 6, fig. 181). Another such brooch with a wingless head is seen on the shoulder of the white-bearded man in Agnolo Bronzino's *Lamentation* in the Musée des Beaux-Arts, Besançon; for an illustration, see Cox-Rearick 1989, 68, fig. 31.

74. Voragine 1993, 1:380.

75. For a systematic and unbiased examination of the Nicodemus/Joseph of Arimathea problem, see Stechow 1964, 289–302. Stechow introduces arguments in favor of both identifications and concludes that the problem may never be solved. Among those scholars who favor Joseph of Arimathea for the identity of the bearded figure in Michelangelo's *Pietà* are de Tolnay 1945–60, 5:86; Hartt 1975, 299; and Steinberg 1968, 345 and n. 11. Among those who favor the Nicodemus identity are Cox-Rearick 1989, 66; Shrimplin-Evangelidis 1989, 58–66; Schleif 1993, 599–626; Paoletti 2000, 60–64 and nn. 28–35; and Timothy Verdon (see chap. 8). Three arguments in particular are made in support of the Nicodemus option. One, that Nicodemus is traditionally noted as being a sculptor who painted the mystical *Crucifix* in Lucca known as the *Volto Santo*, is compelling yet circumstantial. A second is based on the presumption that Michelangelo's figure is an old man and that Nicodemus is supposed to be the younger of the two saintly personages. However, this argument is negated by Fra Angelico's representation of Nicodemus as older than Joseph of Arimathea in his San Marco *Deposition* (for an illustration, see Pope-Hennessy 1974, plate 98). Timothy Verdon, in fact, argues that Nicodemus is an old man (see chap. 8). The third argument is that both Vasari and Condivi call the figure Nicodemus; as they were friends of the artist and could have had knowledge of the figure's true identity. However, I should note that Vasari, who made numerous references to the two pious men in the context of various *Deposition*s and *Pietà*s, invariably mentions only Nicodemus when one man is represented (Vasari [ed. Barocchi] 1966–87, 2:205 and 234, 4:498, 5:11, 249, and 270). As such, he may be exhibiting a personal bias or adhering to contemporary tradition, since he called him Nicodemus in his own paintings of the subject (Vasari [ed. Barocchi] 1966–87, 6:373 and 398).

For those who might believe that artists placed their own features only on Nicodemus, I would cite Vasari's description of a painting by Fra Giocondo, in which he is uncertain with which of the two men Fra Giocondo identified himself. He writes that "in uno di questi [Nicodemo and Giuseppe] ritrasse se stesso" (Vasari [ed. Barocchi] 1966–87, 4:568). Vasari makes no effort to distinguish between them when both appear in paintings he cites: he refers to one as Nicodemus (in several variations) and the other as Giuseppe or Joseffo da Baramatìa (Vasari [ed. Barocchi] 1966–87, 4:444 and 588, 5:75, 321, 525, and 541). Perhaps Vasari did not know how to distinguish between them. He wrongly identified the architect Michelozzo as Nicodemus in Fra Angelico's *Deposition* in San Marco, Florence (Vasari [ed. Barocchi] 1966–87, 3:240). Nicodemus is actually the beautifully dressed elderly person with white hair and beard at Christ's shoulders on the opposite side of the composition, and Joseph of Arimathea is the younger, bearded man taking hold of Christ's right arm directly above the genuine representation of Michelozzo. The statistics just cited are based on the *Vasari Frequenze* (Vasari [ed. Barocchi] 1994). I am grateful to Sonia Maffei, who coedited the *Frequenze*, for having done the website research on Vasari's use of the Nicodemus and Joseph of Arimathea terminology.

76. Simoncelli 1979, 426: "ma exclamò con dolorosa voce tanti ingrati homini che dettero a Josep et Nicodemo soli et triompho et la gloria de la più bella opera che se potessi far mai."

77. As Vasari also conflated their identities, using the generic term *Nicodemi* when referring to their presence in paintings (Vasari [ed. Barocchi] 1994, 3:609, 5:121), thus so might have Michelangelo. This analogy was suggested to me by Louis A. Waldman.

3. THE DESTRUCTION

1. Appendix F, doc. 11: "Lavorava Michelagnolo, quasi ogni giorno per suo passatempo, intorno a quella pietà che s'è già ragionato, con le quattro figure; la quale egli spezzò."

2. Appendix F, doc. 12: "dove scappatogli la pazienza la roppe, e la voleva rompere affatto." Vasari (Vasari [ed. Milanesi] 1878–85, 263) records another incident of a sculptor's breaking up one of his statues. Pietro Torrigiani destroyed a *Madonna and Child* because he was not adequately paid. For having committed this act of sacrilege, he was imprisoned by the Inquisition in 1528, went on a hunger strike, and died. See Thieme and Becker 1907–26, 33:306, and Darr 1980, 1:63–64.

3. Parronchi 1996, 3:124, is alone among scholars to claim that Vasari errs in maintaining that Michelangelo broke up the Florence *Pietà*. According to him, the statue was damaged in a fall.

4. Appendix F, doc. 11: "perchè quel sasso aveva molti smerigli, ed era duro, e faceva spesso fuoco nello scarpello."

5. Ibid.: "o fusse pure che il giudizio di quello uomo fussi tanto grande, che non si contentava mai di cosa che e' facessi."

6. When assuming that a vein in the marble prevented Michelangelo from proceeding with his carving, Vasari may have been influenced by other instances in which Michelangelo encountered veins. One is the *Resurrected Christ* in Santa Maria sopra Minerva of 1519–20. For this, see Vasari (ed. Milanesi) 1878–85, 4:194, n. 2; and Baldriga 2000, 740. (I wish to thank Louis A. Waldman for calling the Baldriga article to my attention.) Michelangelo completed the *Rebellious Slave*, which is in the Louvre, despite a serious crack that runs

from shoulder to shoulder over the forehead. See de Tolnay 1945–60, 4:100 and plates 13–17. Vasari may have taken the second explanation, that Michelangelo's hand was not equal to his idea, from Benedetto Varchi's *Due lezioni* of 1547, who writes, "One who does not possess this [practice], though he can conceive well enough, may still execute poorly" (quoted in Mendelsohn 1982, 100). As Murray 1980, 175, explains it, the hand obeys the intellect in retrieving an idea from the block, and if an inferior work results, it is because the hand was not equal to the intellect.

7. See appendix F, doc. 12 for the source of the English translation. The Vasari-Calcagni story is evaluated in chap. 4.

8. De Tolnay 1945–60, 5 :149. See also Hibbard 1974, 186.

9. Symonds 1893, 2:201–2, and Poeschke 1990–92, 2:120, are among those who accept Vasari's thesis of the flawed stone; Einem 1940, 86, n. 1, seems to be alone in accepting the view that Michelangelo's idea outran his dexterity; Perrig 1960, 55, and a few other scholars believe the story of Urbino's intervention, including Poeschke 1990–92, 2:120; and Poeschke 1996, 119–20. See Perrig 1960, 55, n. 44, for a list of other scholars who accept the Urbino story.

10. Appendix F, doc. 11: "vedendosi che gli era ito tanto con l'arte e col giudizio innanzi, che come gli aveva scoperto una figura, e conosciutovi un minimo che d'errore, la lasciava stare, e correva a manimettere un altro marmo, pensando non avere a venire a quel medesimo; et egli spesso diceva essere questa la cagione che egli diceva d'aver fatto sì poche statue e pitture."

11. In the most recent article, Wallace 2000, 87, suggests that Michelangelo abandoned the *Pietà* (with no reference to its mutilation) because of the statue's function as a personal tomb memorial: "To carve one's tomb is to confront one's mortality," he writes.

12. Thode 1908–13, 2:277–78. The leg's absence had never before been noted in writing or in print, although it was recorded in late-nineteenth-century photographs, in two sixteenth-century drawings, and in a drawing of the eighteenth century (see appendix E, nos. 27, 28, and 32; no. 32 is published for the first time in this volume). The leg is one among several reasons Thode cited for Michelangelo's destructive bent. Other reasons he gives are the statue's lack of a unified compositional effect, whether viewed from the front or the sides; the invisibility of the right arm and leg of the Virgin; and the disproportionately small dimensions of Mary Magdalene.

13. Ibid., 2:278: "Für das linke Bein Christi ist gar kein Platz vorhanden: es müsste durch den Schooss der Maria hindurchgehen." According to Thode, "Ein Loch in dessen Mitte verrät, dass der Künstler wohl an den Ausweg gedacht, ein über Marias Schenkel herabhängendes Bein einzusetzen" (The hole in the middle of the stump indicates that the master, as an expedient, thought to insert a leg to hang over the Virgin's thigh).

14. Ibid.: "Dies hätte aber eine nicht nur unschöne, sondern unmögliche Stellung ergeben."

15. Wilde 1978, 181, writes that the leg's absence was "not due to the attempted dismembering; it was Michelangelo himself who, for some reason or other, perhaps because of a defect in the stone, was forced to piece on a separate bit of marble for this limb." Other scholars who believe that Michelangelo intended the left leg as a separate piece are de Tolnay 1945–60, 5:149; Schulz 1975, 369–70; and Partridge 1996, 107.

16. Appendix F, doc. 15: "voltò intanto gli occhi il Vasari a guardare una gamba del Cristo, sopra la quale lavorava e cercava di mutarla."

17. See especially Schulz 1975, 369; Salvini 1977, 169; Baldini 1981, 61, no. 49; and Battisti 1989, 180. Parronchi 1981, 29, argued that Michelangelo wanted to shorten the leg a few centimeters.

18. E.g., Schulz 1975, 369. See appendix F, doc. 8.

19. Steinberg 1968, 343–53; Steinberg 1970, 239–54; Steinberg 1985, 185–92; and Steinberg 1989, 480–505. Steinberg's interpretation of the leg's role in the damage Michelangelo caused the statue has divided scholars into detractors and defenders. For list of both groups, see Steinberg 1989, 480–505. We can add to the list of his partisans Olson 1992, 176; Partridge 1996, 106; and Nagel 2000, 206.

20. Steinberg 1968, 346.

21. Dacos 1986, 92, attributes the composition to Giulio Romano. Marilyn Lavin has recently dated the earliest genre representation of the canonic "slung leg" to c. 1213–18 (Lavin 2001, 14 and fig. 5), and possibly its appearance in Italian religious art to c. 1272–80, in Cimabue's *Assumption of the Virgin* in the upper church of San Francisco in Assisi (ibid., 9 and figs. 1 and 2).

22. See Steinberg 1968, 344 and 348, and Steinberg 1989, 502. See also chap. 2 (in this volume). Steinberg pointed out that de Tolnay, twenty years earlier, had already maintained that the *concetto* of the statue was "a kind of ultimate *sposalizio*" (de Tolnay 1945–60, 5:87). It should be noted that there is no such iconography as a *sposalizio* in the entire history of art, unless, of course, it refers to the marriage of Joseph and the Virgin.

23. Steinberg 1968, 347.

24. Among those who accept the 1555 date for the destruction of the *Pietà* are: Thode 1908–13, 3:274; Einem 1956, 244; de Tolnay 1945–60, 5:88; and Isermeyer 1965, 347. Pope-Hennessy 1970, 38, and Schütz-Rautenberg 1978, 160, date the mutilation to 1554. Perrig 1960, 54–55, suggests a date of 1556, following Michelangelo's return to Rome from Spoleto (Vasari [ed. Milanesi] 1978–85, 7:24–43, mentions Michelangelo's trip to Spoleto). Goldscheider 1967, 22, without discussion, also dates the mutilation to 1556.

25. The date of Urbino's death is usually given as 3 December 1555, because Michelangelo applied that date to a letter he wrote to Vasari announcing the death of his beloved servant. Actually, Urbino died on 3 January 1556. Two facts substantiate the later date. One is that Urbino made his last will and testament twenty-one days after the presumptive death date, on 24 December 1555; see Corbo 1965, 136–37, no. 99. The other is a letter Bastiano Malenotti sent to Lionardo, dated 4 January 1556, to the effect that Urbino died the previous night: "questa notte passata successo la morte sua." For a thorough discussion of this question, see Barocchi and Ristori 1965–83, 5:51–52, no. 1217. See also Leonardi 1995, 10, who repeats Barocchi's arguments. The Leonardi text was brought to my attention by Deborah Stott.

26. Steinberg 1970, 272.

27. Steinberg writes (ibid.): "The 'canonic form' [of the slung leg] requires that each partner maintain his own seat so that the leg that is thrown across becomes a gesture toward the other, a wooing or claiming, an action that visibly changes a relationship or establishes a condition. Whereas the settled intimacy of the lap-sitting pose even though it include a slung leg, suggests the condition itself." In the non-canonic examples we should avoid the use of the highly charged "slung leg" epithet.

28. For dating Caroto's painting, see Del Bravo 1964, 3–16.

29. A similar arrangement of legs is found in a drawing by Parmigianino in the Pierpont Morgan Library, New York. For an illustration, see Popham 1971, 1:122 and plate 213. The general composition of

Parmigianino's drawing derives from Michelangelo's *Pietà* in St. Peter's. Nagel 2000, 206, must have noted this flaw in Steinberg's hypothesis, because he attempts to salvage it by writing: "The twisted posture [of Christ] multiplies the points of contact with the Virgin, allowing Christ to sit on her lap and at the same time join his head to hers. This is not merely a piece of formal virtuosity but rather an effort at semantic and theological enfoldment: The pose allows Christ to be both on her and next to her, both son and spouse. The two roles are expressed emblematically in the two legs: One falls between the Virgin's knees, and the other (now missing) was slung over the Virgin's thigh." Must there really be more to Christ's posture than the twist and turn of a lifeless body being lowered and settled onto the lap of the Virgin by the bearded figure and Mary Magdalene?

30. As Hartt 1975, 82, points out, the leg is not thrown but sinks into this position. We cannot exclude the possibility that Caroto had been aware of Michelangelo's *Pietà* when planning the composition for his painting in Verona, but there is no evidence that he had visited Rome or was at any time familiar with the master's oeuvre.

31. Shrimplin-Evangelidis 1989, 58–66.

32. In his essay in this volume, Timothy Verdon also identifies the bearded figure as Nicodemus, but he discusses the statue within a strictly Catholic context (see chap. 8).

33. Shrimplin-Evangelidis 1989, 63. See also Parronchi 1981, 25–26. The epithet derives from the account in John 19:38 of the late-night visit of Nicodemus to Christ to avoid detection as a follower.

34. Shrimplin-Evangelidis 1989, 64.

35. See John 19:38.

36. Shrimplin-Evangelidis 1989, 63.

37. Ibid., 61, chooses not to examine Michelangelo's involvement with the Reform movement, taking it for granted, because, she writes, "it has been widely discussed in connection with many of his later works and in particular the Last Judgment." This is not the place to take up the question of whether Vittoria Colonna responded positively to Protestant ideas then in circulation. Should a thorough attempt be made, it would be important to consider two factors. One is Colonna's relationship with Dominican monk Fra Ambrogio Caterino, who delivered anti-Lutheran sermons in her presence when she met with Michelangelo to discuss questions of art (see chap. 1, n. 47, this volume). In 1540, Fra Ambrogio collected the sermons into a treatise entitled *Specularum haereticorum*, which he dedicated to Colonna. The second factor is Hollanda's description of Colonna's strict Catholicism in 1539: "After her husband's death she exchanged her high estate for a private humble way of life, caring but for Christ and holiness, doing much good for poor women, and showing the fruits of a true Catholic" (Hollanda 1928, 6).

38. Shrimplin-Evangelidis 1989, 64.

39. Ibid.

40. Ibid.

41. Ibid.

42. Paoletti 2000, 71, questioned Shrimplin-Evangelidis's hypothesis. See ibid., 79, n. 61, for a reasonably thorough list of bibliographical references to discussions associating Michelangelo with the religious reformers of the sixteenth century.

43. Cantimori 1970, 244. Shrimplin-Evangelidis 1989, 63, n. 48, pointed out that the epithet was known in Florence, since Calvin's *Nicodemiana* was printed there in 1548. However, a review of the published correspondence of the period seems to show that only

Protestant writers and Italian apostates living in northern countries applied the terms "Nicodemite" and "Nicodemism" to their contemporaries.

44. Ginzburg 1970, 162.

45. The letter refers to the death of Urbino. For the correct date of the letter, see n. 25 above.

46. See Gilbert 1980, 305, no. 104. The Italian text is transcribed in Barocchi and Ristori 1965–83, 5:55, no. 1219: "E di questo n'à mostro segnio Idio per la felicissima morte ch'egli à facto: e più assai che 'l morire, gli è incresciuto e' lasci[a]rmi vivo in questo mondo traditore con tanti affanni, benchè la maggior parte di me n'è ita seco, né mi rimane altro c[h]' una infinita miseria."

47. See Gilbert 1980, 306, no. 105.

48. Michelangelo may, in fact, have been referring to events that resulted from the invasion of Rome by the Spanish troops of Fernando Alvarez de Toledo, Duke of Alba, a month or so earlier, in September. For the backdrop to this interpretation, see Barocchi 1962, 4:1642, no. 664.

49. Anticipating this query, Shrimplin-Evangelidis argues that Michelangelo did not have the option to remove his features from the statue. He was then eighty years old and the great size of the *Pietà* would have placed the head of figure beyond his reach. Age, however, cannot have discouraged Michelangelo from altering the saint's features, since he was engaged in recarving the entire Rondanini *Pietà* from the moment he gave away the Florence *Pietà* and until a few days before his death at age eighty-nine. (See the letter of Daniele da Volterra to Lionardo Buonarroti, Michelangelo's nephew, announcing the master's death, in Frey 1923–30, 2:84, no. CDLII.) Furthermore, he could have reached the face of the saint by availing himself of whatever it was he used when he carved the statue.

50. Wilson 1876, 527.

51. See plate 97, nos. 1 and 2, for examples of the point chisel. Rockwell (appendix A) states that in his view Michelangelo inserted wedges in strategic locations and struck them with a hammer. Elaborating on Rockwell's idea, in the case of the right forearm of Christ, a point chisel may have been inserted into the space separating it from the head of the Magdalene (plate 34). Greater effort was certainly expended to remove Christ's upper left arm and the entire left arm of the Virgin, these being joined at the elbows as one piece. This may have necessitated the insertions of chisels at Christ's left shoulder, which has been extensively repaired with marble strips (plates 56, 92, and 104), and at the Virgin's left shoulder or the armpit (plates 3 and 59).

52. Michelangelo had earlier recarved sculptures because they had been damaged or because he changed his mind about them. For this, see Schulz 1975, 371.

53. "Returning to Michelangelo, it was necessary for him to find another marble, so that he could each day pass the time in carving; and he took up another piece of marble in which he had already roughed out a Pietà, different from that one [he broke up] and much smaller" (see appendix F, doc. 12, for the source of the English translation).

54. An iconographic change is especially noticeable in the head of the Virgin: it was formerly directed heavenward, perhaps in a manner typical of angels; now it is turned toward Christ and has the features and dress of the Madonna. For this, see Paoletti 2000, 58, who claims that the Virgin's initial identity was Nicodemus (see also n. 57, below).

55. Schulz 1975, 371. Schulz cites Michelangelo's Pitti and Taddei tondi

as examples of repeated mutations the artist made to his sculpture. He does not, however, mention the Florence *Pietà* in this regard.

56. According to Hartt 1975, 8–83, Maitani's figure influenced Michelangelo in preparing the *Pietà*. For a radically different interpretation, see Fehl 2002, 18–24.

57. Paoletti 2000, 60–61, attempts to demonstrate the interconnection between the Florence *Pietà* and the Rondanini *Pietà* by asserting that the Virgin behind Christ had formerly been a male figure representing Nicodemus. The evidence for this mutation he finds in the bared leg of the figure. However, he errs in assuming that the leg of the bearded figure in the Florence *Pietà* is also bared. In fact, a cuff at the ankle indicates that the leg is clothed in tight-fitting trousers (plate 5).

58. According to Vasari (appendix F, doc. 12).

59. The Florence *Pietà* is approximately 12½ in. (31 cm) taller and 12 in. (30 cm) wider than the Rondanini *Pietà*.

4. THE RECONSTRUCTION

1. Appendix F, doc. 12.

2. Ibid., docs. 11 and 12.

3. Ibid., doc. 14. Vasari includes this reference where he discusses Michelangelo's generosity in donating drawings and statuary to friends.

4. See chap. 5, n. 4.

5. Appendix F, doc. 3.

6. The historians are those who accept the date of 1555 for the destruction of the statue. See chap. 3, n. 24. To this list we can add Steinberg 1968, 347, and Shrimplin-Evangelidis 1989, 64.

7. Among those of this opinion are Einem 1959, 244; Russoli 1953, 61; Battisti 1989, 186; and Poeschke 1990–92, 2:120. However, even these scholars accept the 1555 dating for the destruction of the *Pietà*.

8. Appendix F, doc. 3.

9. See chap. 5 for information on Francesco Bandini, who was a Florentine banker living in Rome, and Michelangelo's friend and possible relative. See Wallace 2000, 88–91, and 96, nn. 30–33, for more recent information on Bandini. Wallace cites documents he acknowledged having received from Franca Trinchieri Camiz.

10. Appendix F, doc. 12: "Tiberio, learning of this [breaking up the statue], spoke to Bandino, who desired to have something of his, and Bandino induced Tiberio to promise Antonio two hundred gold crowns [scudi], and begged Michelangelo that if Tiberio would finish it for Bandino with the help of his models the labor should not be wasted. Michelangelo agreed, and accordingly he made them a present of it. They at once removed it." Wallace 2000, 93, hints at the possibility that Michelangelo was personally involved in restoring and finishing the statue after Francesco Bandini took possession of it. He assumes, against the evidence of Vasari, that the statue had remained in the artist's house for a long time before Bandini removed it. Steinberg also maintains that Michelangelo had participated in restoring the statue (see chap. 3, this volume).

11. We have only indirect evidence, supplied by the sixteenth-century Florentine sculptor Benvenuto Cellini, that Michelangelo had prepared models for his own use. Cellini writes that Michelangelo had made small and large models early in his career and that he finally settled on large models when carving the figures for the Medici Chapel (for this, see Vasari [ed. Brown] 1960, 94). As Peter Rockwell points out in appendix A, there is no physical evidence that Michelangelo had any model for the *Pietà*. The artist may have engaged in direct carving guided only by preparatory drawings, which have not survived. There is some support for the idea that Michelangelo had prepared models for Calcagni's use. According to O'Grody, Michelangelo made models at the suggestion of patrons so that other artists could execute his works. She includes among them the models Michelangelo gave Calcagni; see O'Grody 1999, 76. I wish to thank Louis A. Waldman for calling my attention to O'Grody's dissertation. If Michelangelo prepared the models for his own use, how might he have transferred their dimensions to the marble block? This question, too, is unanswerable. The various transfer methods that were available to Michelangelo are summarized in O'Grody 1999, 36–37. See also Vasari (ed. Brown) 1960, 151, and Wasserman 1995, 117–18. Rockwell points out in his essay that the block displays no physical evidence that Michelangelo used any transfer method.

12. According to Vasari, in addition to permitting Calcagni to repair and recarve the *Pietà*, Michelangelo asked him to complete the bust of *Brutus*, today in the Bargello, Florence. Calcagni also assisted Michelangelo in his late architectural projects. See Wallace 2000, 88–91, who introduces documents relating to Calcagni's family, youth, and upbringing. (Wallace received also these documents from Franca Trinchieri Camiz; see n. 9, above). There are no grounds for determining when Calcagni, a Florentine national, came to Rome, which Wallace speculates may have been in the late 1530s or early 1540s. Nor can we determine when he was introduced to Michelangelo, although Wallace believes this may have happened in the early 1550s. Unfortunately, Wallace found nothing that might illuminate Calcagni's training or other aspects of his professional career. There is no indication that Calcagni made independent works of sculpture, nor have any survived.

13. Appendix F, doc. 12. Evidently, Antonio preserved the pieces when he acquired the *Pietà* from Michelangelo, perhaps intending to have the statue eventually restored.

14. The workmanship and texture of the nipple are also radically different from those of the right nipple (see book frontis and plate 32).

15. The drum, moreover, was carefully measured to adjust the arm to its full length, as predetermined by the Magdalene's shoulder and the surviving fingertips of her hand at Christ's leg (plates 32 and 67).

16. See CD-ROM for a corresponding photograph of the area taken under ultraviolet light.

17. Thode 1908–13, 2:276, claimed that Calcagni made Christ's left forearm and Michelangelo the hand (Thode). De Tolnay 1945–60, 5:149–50, correctly reversed the attributions, though without comment.

18. See appendix C for a discussion of the pinwork and for the sequence Calcagni used to reassemble the pieces.

19. The head of the second pin is still visible on the surface of the marble.

20. Peter Rockwell interprets Calcagni's use of the diverse pinwork as evidence that two restorers, one superior to the other, may have been involved in repairing the statue (see appendix A). See n. 28, below, and the related discussion in the text for a document that implies that the *Pietà* may have been restored a second time in the late seventeenth century.

21. According to Schulz 1975, 370, n. 26, Michelangelo was the one who "cleaned away the stone that had been meant for Christ's left leg."

22. Might this explain Vasari's report that he saw Michelangelo changing a leg of the *Pietà* (see chap. 3 and appendix F, doc. 15), anticipating what he would do a few years later when he mutilated the statue?

23. For an illustration of the two right arms of the Rondanini *Pietà*, see Paoletti 2000, 63, fig. 11.

24. Appendix F, doc. 12: "fra l'altre cose, gli venne levato un pezzo d'un gomito della Madonna."

25. Ibid., doc. 8. Gotti 1875, 241, related a wax model of a left leg in the Victoria and Albert Museum in London to the missing one in the *Pietà*. For a discussion and illustration of the wax leg, see Pope-Hennessy 1964, 2:432 and fig. 458.

26. If, on the other hand, the knee in the Volterra inventory did belong to the Florence *Pietà*, it might have become detached when, as posited here, Calcagni removed the left leg. Calcagni was born in 1532 and died in 1565 at age 33, a year after Michelangelo and a year before Volterra; see Wallace 2000, 88–91.

27. See appendix C for a discussion of the stuccowork by the scientists of the OPD. For a discussion of the problems relating to the insertion of the left leg, see Rockwell's essay (appendix A).

28. Appendix F, doc. 25: "la statua della Pietà continente quattro statue unite rappresentanti un Christo, Simeone [*sic*] con la Madonna et una Maria in parte finita et in parte sbozzata con alcuni pezzetti . . . di mano di Michelangelo Buonarota." As we will see in chap. 5, the statue changed ownership and was moved several times while in Rome, during one of which it may have lost some of the restored pieces.

29. Two additional kinds of stucco were found. One at Christ's right elbow (red in the diagram), whose composition indicates that it was of more recent application. The other is composed of cement and is found as two insertions on the left side of the bearded figure and probably dates to the twentieth century. The cement was used to fill in holes left by a handle (possibly inserted in the statue in the eighteenth century), which was removed in the twentieth century. For a discussion of the function the handle had, see chap. 7.

30. For a chemical analysis of the stuccowork, see appendix C.

31. Rockwell (appendix A), as noted in n. 20, above, argues that the restoration was carried out by two people, one highly competent, the other less so.

32. Gotti 1875, 1:329.

33. The following scholars come to the same conclusion: Mariani 1942, 232; de Tolnay 1945–60, 151; Braunfels 1964, 64; Hartt 1975, 72; Wittkower 1977, 142; and Wilde 1978, 181.

34. Appendix F, doc. 2.

35. See plate 98, where the flat-head chisel marks are indicated in blue with diagonal striations. See appendix A for a discussion of Calcagni's use of the flat chisel and abrasives.

36. The Magdalene's head lacks the subtlety and warmth of the heads of Michelangelo's Medici *Madonna* and *Victory* (Hartt 1968, figs. 242–43 and 282–83). The Magdalene's head does not even have the cool naturalism of the heads of *Leah* and *Rachel* from the Julius tomb in San Pietro in Vincoli, Rome, whose carving is frequently—and, in my opinion, doubtfully—attributed to Michelangelo (for illustrations, see Hartt 1968, figs. 285–88). Michelangelo was probably responsible only for the design of the two figures.

37. De Tolnay 1945–60, 5:149, says only that Calcagni reworked the front side of the Magdalene with a flat chisel.

38. Ibid., 5:151 writes that "Michelangelo began Mary Madgalene with a toothed chisel: her left arm and shoulder are by him."

39. Perrig 1960, 66, n. 55, among many others, thought that Calcagni was responsible for the disproportionate size of the Magdalene. Goldscheider 1962, comment to fig. 62, claims that Calcagni shortened the Magdalene considerably, maintaining that her head was originally at the height of the Virgin's.

40. See chap. 2. Arkin 1997, 497, also attributes the Magdalene's height to Michelangelo. According to him, the length of the Magdalene's right arm determines her height. Wallace 2000, 91, and 98, n. 59, refers to the two bridges, but he learned of their existence when, with other scholars, he participated in a colloquium that Peter Rockwell and I arranged in 1998 in the presence of the statue. Yet Wallace errs when stating that the destroyed bridge extended from the side, rather than the back, of the Magdalene's head.

41. Note that in Romanino's painting the crouching Magdalene not only is diminutive, but, as in the statue, she looks away from the main event. Ippolito Scalza also made the Magdalene inconspicuous in a 1574 statue of a *Pietà* in the Cathedral of Orvieto (see Venturi 1925–37, 10:pt. 3, 978, fig. 856). Körte accounted for the Magdalene's diminutive size by pointing to a general hierarchy in scale among the four figures in the Florence *Pietà* (cited in Perrig 1960, 66, n. 55). Wallace 2000, 93, attempted to account for Michelangelo's diminutive treatment of Mary Magdalene by comparing her with his treatment of *Rachel* and *Leah* in the Julius tomb in San Pietro in Vincoli, noting that they are smaller than Moses, the main figure. The analogy seems misplaced, since Michelangelo in the Julius tomb was following a tradition in monumental tomb structure design, in which subsidiary figures in niches are often smaller than the central figures.

42. The kneeling Magdalene seems comparatively small also in a fragmentary drawing of a *Pietà* by Michelangelo in the Teylers Museum, Haarlem, inv. no. A35 verso. For an illustration, see Nagel 1996, 569, fig. 17.

43. The Magdalene's petite stature may to some extent be overstated, because it is partially fostered by a high-belted waist and by her kneeling posture. Were she to stand erect, her head would reach to about the height of the shoulder of the bearded figure. Her approximate measurements are: 47½ in. (120.7 cm) from head to knee; 21½ in. (54 cm) from heel to knee, totaling 69 in., or 5 ft. 9 in. (175.3 cm). See Symonds 1893, 2:200, who writes that the Magdalene "appears too small in proportion to the other figures; though, if she stood erect, it is probable that her height would be sufficient."

44. Schott 1962, 241.

45. Poeschke 1990–92, 120.

46. Wilde 1978, 181.

47. De Tolnay 1945–60, 5:151, attributed to Michelangelo the polished body of Christ without explanation.

48. Giorgio Vasari memorializes Michelangelo's normal working method with the famous image of a figure in a pail of water, which emerges gradually with the lowering of the water level (Vasari [ed. Milanesi] 1878–85, 7:272–73). Most historians (e.g., Wittkower 1977, 118; and Schulz 1975, 371), in fact, believe that Michelangelo had mostly carved his statues from the front face toward the rear of the statue. In my view, it is unlikely that he had adhered to this method in carving the compositionally complicated *Pietà*. He may, rather, have moved freely back and forth from the front to the two sides of the marble block. Hirst 1988, 3, pointed out, "There is plentiful

evidence that Michelangelo paid great attention to the secondary views of this statues" by making detailed preparatory drawings of all sides of his figures. Whether he extended this attention to the carving process is a question that requires further study.

49. See the CD-ROM for diagrams showing the tool marks on the other three sides of the statue.

50. For an illustration of *Brutus*, see de Tolnay 1945–60, 4: plates 88–90. According to Vasari, Calcagni was asked by Michelangelo to complete his bust of *Brutus*. Vasari wrote "Loving him (Calcagni), Michelangelo gave him the responsibility to finish the broken marble Pietà; and, in addition, a marble bust of Brutus, much larger than life size, of which the head alone had been carved with certain very small *gradine* [tooth chisels]" (appendix F, doc. 13). Vasari seems to be saying that Michelangelo had already carved the head and that Calcagni was responsible for the rest. De Tolnay 1945–60, 4:131 writes that "the hair sketched with a pointed chisel is obviously by Michelangelo himself. The face, for the most part, is made with a fine-toothed chisel and likewise by Michelangelo. A portion near the right ear and a part of the neck below this ear are worked by a rough-toothed chisel by Michelangelo. Also the chin, worked by a pointed chisel, is unfinished. The drapery, a part of the neck, and the concave back are over-worked with a flat toothed chisel, which Michelangelo did not utilize: these parts are made by Calcagni." De Tolnay was, for the most part, echoing Alois Grünwald, who first attributed to Calcagni the carving of the neck and drapery of *Brutus*. Grünwald 1914, 11–14, writes: "Und so überarbeitet er [Calcagni] die an das Gewand grenzenden Teile des Halses, die schon Michelangelo angelegt hatte, mit seinem Flacheisen, ja er rückt bis an den Haarausatz und auf die Unterseite des Kinnes vor." Hartt 1968, 278, also attributes Brutus's drapery to Calcagni: "The face and neck are brought almost to completion with the toothed chisel, and their quivering surfaces, of utmost beauty of texture, contrast sharply with the meticulous handling of the drapery, in which Calcagni used a flat chisel." Only Thode 1908–13, 3:478, and Mackowsky 1925, 301, considered the entire bust to be the work of Michelangelo.

51. See Wittkower 1977, 116, who points out that Michelangelo began to finish his statues with the most protruding part of the block, the advanced left knee in the case of *St. Matthew*.

52. For example, the *Victory* in the Palazzo Vecchio, Florence. For an illustration, see Hartt 1968, 266–67, figs. 282–83.

53. Vasari (ed. Brown) 1960, 145. Examples of this treatment of surface abound in Michelangelo mature sculptures, for example, the faces of the effigy figures in the Medici Chapel and the *Victory* in the Palazzo Vecchio, where unfinished areas cannot be seen as such from a distance. In all instances, the chisel work is faintly visible on the surfaces of the marble.

5. THE *PIETÀ* IN ROME

After the death of Franca Trinchieri Camiz, I continued her archival research and completed sections of her chapter (noted below) based on new documents I discovered. There is no doubt that, had she survived her illness, Ms. Camiz would have found these documents. My contributions are noted in related footnotes. —J.W.

1. Archivio di Stato, Rome (hereafter ASR), 30 Notai Capitolini, Uff. 7, vol. 8, notaio Aristotelis Tusculanus, fols. 118–23v, in particular

fol. 120 (21 July 1559). Francesco Bandini added a codicil to the will dated 7 February 1562. See also Archivio Giustiniani-Bandini, Rome (hereafter AGBR), vol. 1, envelope 19.

2. ASR, Notai A.C., notaio Caesar Quintilius Lottus, vol. 3920, 29 September 1562, fols. 287–89v.

3. Ibid., 1 and 26 October, 1562, fols. 297–98, 300–301, 430–33. Alessandro took this action because, having entered the Order of the Knights of Malta, he wanted to avoid turning over the requisite four-fifths of his properties to the Order. See also ibid., vol. 3924, 23 March 1564, fols. 639–40, which notes the inheritance of Francesco Bandini's estate by the three bothers and Alessandro's relinquishing of his share of the inheritance.

4. Appendix F, doc. 6. The document states that the *Pietà* had been a gift from Michelangelo to Francesco Bandini (see chap. 4 for a discussion of on the problem of how Bandini acquired the statue). Bandini's efforts to obtain ownership of the statue may have been helped by his friendship with Michelangelo and by the fact that they were related by their common lineage with the Baroncelli family.

5. Ibid., doc. 5.

6. Ibid., doc. 12. The document is translated as: "It is presently in the hands of Pierantonio Bandini, son of Francesco, in his *vigna* at Montecavallo." Pierantonio purchased the *vigna* on 14 September 1555. See AGBR, busta 1, fasc. 11, unnumbered.

7. Appendix F, doc. 17.

8. Ibid., doc. 18. The conduit brought water from the *Acqua Felice* into the northeastern corner of the garden bordering the Strada Pia. Permission to attach two small conduits to the *Acqua Felice* in order to bring water to their *vigna* was granted to Pierantonio Bandini on 5 September 1587. See Archivio Capitolino, Archivio della Camera Capitolina, Credenzone 4, vol. 93, 213, as registered in Protocolli of the Inventario Magni, 2447.

9. The loggia was destroyed in 1871, the year the garden was confiscated by the Ministero della Real Casa. For this, see Vico Fallani 1992, 184.

10. For the commission to Raguzzini to make the drawings, see Archivium Romanum Societatis Iesu, Rome (hereafter ARSI), Fondo Gesuitico 889, untitled and unbound booklet: "Richiedendo i RR. PP. Gesuiti di S. Andrea del Noviziato di Rome, che io sotto scritto architetto facessi la presente relazione su l'affare della controversia accaduta fra essi con i RR. PP. Carmelitani Scalzi di Sta. Anna della Nazione Spagnola sul Quirinale. 10 December 1739." For the purchase of the *vigna* by the Jesuits, see ASR, 30 Notai Capitolini, Uff. 36, notaio Torquato Lamperinius, 82, January 1649, fols. 30, 76–99.

11. The drawings are accompanied by a survey of the site (ARSI, Fondo Gesuitico 889, bound, unnumerated folder entitled Summarium Numero Primo, dated 10 December 1739.)

12. An engraved view of the Strada Pia by Giovanni Battista Falda of 1667–69 shows a corner of the loggia from above and behind. For an illustration, see Falda 1970, pt. 3, plate 12 (part 3 is entitled: "Il terzo libro del novo teatro delle chiese di Rome date in luce sotto il felice pontificato di nostro Signore Papa Clement X"). However, none of the maps of Rome from the sixteenth through the eighteenth century, including Falda's (plate 71), indicate the presence of the loggia. This anomaly results mostly from the viewing angle taken by the map makers.

13. The elevation drawing is inscribed on top of the page: "Prospetto del Convento delli PP. di S. Anna, e muri devisori delli Giardini

fra li mede[si]mi con li PP. Giesuiti." On bottom of the page it is inscribed "Pianta fatta dal Cav. Filippo Rauzino, architetto per l'accesso fatto nel di 10 dicembre 1739." The niche is mentioned in the following inscription: "n.o 5. Muro fatto dalli PP. Giesuiti per riquadrare il giardino, con nicchione attaccato in esso con loggia scoperta di sopra." The description of the niche with an open loggia above corresponds to the niche and loggia as described in the inventory drawn up in 1592 of Pierantonio's estate (appendix F, doc. 17).

14. ARSI, Fondo Gesuitico 889, bound, unpaginated folder entitled "Summarium Numero Primo," dated 10 December 1739: "Una nicchia... con l'arme di Clemente VIII... una porticella con l'arme d'un cardinale sopra che i Padri Gesuiti affermono esser di Bandini." [Clement VIII (r. 1592–1605) appointed Ottavio Bandini cardinal in 1596 (see Moroni 1840–79, 4:91). The cardinal's arms were above the doorway on the left. The third coat of arms is indecipherable in the drawing, but as it is surmounted by a crown and the Bandini were Florentine nationals, it may refer to the grand duke of Florence. —J.W.]

15. For the reference, see n. 11, above. The elevation of the loggia was exactly square, each side about 20 ft. or 603 cm (27 palmi), and 7 ft. 4 in. or 2.3 m (10 palmi) deep; the central niche was about 12 ft. 12 in. or 4.2 m (18 palmi) tall and about 9 ft. 6 in. or 2.9 m (13 palmi) wide: "nicchia sfondata palmi dieci con l'arme di Clemente VIII, sopra la nicchia una loggia scoperta, per cui si sale con una scaletta à lato della medessima nicchia e detta loggia è longa palmi ventisei, e un quarto." (A palmo is equal to 22.34 cm.)

16. [In an informal communication to me, Christoph Frommel tentatively dates the niche to the middle of the sixteenth century on stylistic grounds. —J.W.]

17. Appendix F, doc. 17.

18. See Ackerman 1970, 193–94.

19. The realignment of the Strada Pia for Pius IV was carried out from 1561 to 1563. For this see Coffin 1979, 191.

20. [Franca Camiz did not include the document from which she learned of Pierantonio's relation to the program. She wrote that he was its "cashier," which I changed to "treasurer." —J.W.]

21. Shortly after his death, Pius IV was praised for having converted secular public buildings to religious and sacred use. See Gamucci 1993, 16.

22. See Schiffmann 1985, 202–9.

23. Marder 1978, 294.

24. De Marco 1992, 62–64, for the idea that the *Pietà* enhances the sacredness of the garden in Titian's painting. Titian was in Rome in 1545, probably too early for him to have seen Michelangelo's marble group in person, but he may have been informed about it by El Greco, who was in Rome in 1570, when he himself was influenced by Michelangelo's statue (see Steinberg 1974, 474–77, and appendix E, nos. 11–14, for the influence of the *Pietà* on El Greco). El Greco was back in Venice by 1573, before departing for Spain, at which time he may have familiarized Titian with the details of Michelangelo's statue.

25. Another element that might support the idea that Bandini's garden had been given a Christian connotation by the *Pietà* is that decades later, in the 1580s or 1590s, one of its avenues bore the name "della Croce," which suggests that it ended in a cross or crucifix. The avenue appears in a drawing of the garden that the architect Ottaviano Mascarino made in those years (Wasserman 1966, fig.

97). On the Christian garden, see Courtright 1990, 156–62, and Gentili 1985, 218–19.

26. Another spiritually symbolic garden is the one the Jesuits had created at the end of the sixteenth century behind their church of San Vitale, on the southern side of the Bandini property. As described by Louis Richeome in 1628, the Jesuit garden displayed plants alluding to martyrdom and several religious sculptures and paintings, and a painting depicting angels adoring the cross was the focal point of an alleyway (Richeome 1628, 461).

27. Mallarmé 1929, 81–82.

28. Appendix F, doc. 17.

29. [Franca Camiz did not give a reference to this document and I have not been able to locate it. I should note, however, that the testament of Caterina di Giuseppe Giustiniani, wife of Orazio Bandini, dated 10 January 1612, does not mention the statue. She names her daughter, Girolama, her universal heir. See AGB, busta 3, envelope 42, no. 10. —J.W.]

30. Orbaan 1920, 60, 79, and 141. The reports (also for the years 1607 and 1609) are in the form of notices (*avvisi*) in letters recounting daily events taking place in Rome that were sent to the princely court of Urbino by anonymous persons possibly under control of the court (see ibid., LIII–LXIV). The *avvisi* are contained in a bound volume in the Vatican Library.

31. Appendix F, doc. 18.

32. For Cardinal Bandini's will, see Rome, Archivio Capitolino, Notai Sezione 43, vol. 40, notaio J. Olivellus, 31 July 1629, fol. 384. Cassandra was the daughter of Giovanni Bandini, who had renounced his ecclesiastical position to marry. Mallarmé 1929, 81, speculated erroneously on the statue's provenance after the death of Cardinal Bandini. Connors 1996, 46, conjectured that Pope Urban VIII (r. 1623–44) had considered purchasing the *Pietà* for the main altar in the church of Sant'Ivo, which was designed by Francesco Borromini.

33. Appendix F, doc. 19.

34. Ibid., doc. 20. The *vigna*'s ownership by the Capponi was noted four years later by Martinelli 1650, 119–20. For information on Cardinal Luigi Capponi, see Moroni 1840–79, 9:200.

35. The inventory of the cardinal's estate is dated 7 September 1629 (see ASR, Notai A.C., vol. 4698, notaio J. Olivellus, fols. 65–72v).

36. A statue of St. Onofrio, today in the Minneapolis Institute of Arts, was included in the sale of the property to Scipione Capponi (see appendix F, doc. 20).

37. Ibid., doc. 21. Scipione could not dispose of the property himself, since he was a resident of Florence. His uncle the cardinal sold the *vigna* on his behalf.

38. The cardinal acquired the palace at Montecitorio on 21 October 1649 and gave at least part of it to his nephew Scipione Capponi on 7 December 1650 (ASR, Notai A.C., notaio Sanpiero, 6632, fols. 623–25).

39. Appendix F, doc. 22. Casci also records "Still another statue, representing a *S. Paolo Primo Eremita* or a *Santo Onofrio*, was acquired by him [the cardinal]." Pietro da Cortona and Giovanni Ottinelli were unaware of the statue's transfer to Montecitorio when they wrote in their treatise of 1652 that "it is in the garden that had belonged to Cardinal Bandino at Monte Cavallo" (stà nel giardino, che fù del Sig. Cardinal Bandino à Monte Cavallo); see doc. 23.

40. See Del Piazzo 1972, 41–100.

41. The palace was in the Borgo close to St. Peter's, hence extremely convenient for the cardinal, who was librarian of the Vatican Library.

42. Cardinal Luigi Capponi named the Collegio di Propaganda Fide his universal heir in his will dated 25 June 1657. The cardinal's will is inserted among the pages of the acquisition of his estate by the Propaganda Fide (see ASR, 30 Notai Capitolini, Uff. 36, vol. 99, notaio Olimpio Ricci, 6 April 1659, fols. 450–80).

43. Appendix F, doc. 24.

44. Monsignor Torrigiani was archbishop of Ravenna (ibid., doc. 24, fols. 489r–491v); he must have lived in the palace in the Borgo from time to time.

45. Ibid., doc. 24.

46. Ibid.

47. Ibid. Because of considerable debts that came with the inheritance, the Collegio sold the cardinal's estate to Scipione Capponi on 23 September 1659 for 4,000 scudi (Rome, Archivio Storico di Propaganda Fide, Acta, 1659, vol. 28, fols. 139r–v). Scipione (who is referred to alone in the purchase document and only as Marchese Capponi) and his brother Pietro then commissioned an inventory of the cardinal's estate, which bears the date 13 April 1660 (ASR, 30 Notai Capitolini, Uff. 36, vol. 102, notaio Olimpio Ricci, 16 April 1660, fols. 387r–443v).

48. [This paragraph begins a section I wrote on the acquisition of the statue by Cosimo III, based on documents I discovered in the archives of Florence and Rome after Ms. Camiz's death. I wish to acknowledge Niccolò Capponi for his help in researching the Capponi documents in Florence. —J.W.] For the life of Scipione Capponi, see Litta, Oderici, and Passerini 1819–1911, 12: plate 15. Scipione named Piero his universal heir in a will he drew up four years earlier. See ASF, Carta Capponi, 75, cassetta 10, no. 58, 26 August 1666, *Testamento di Scipione di Piero di Francesco Capponi*. There is an attached codicil dated 8 June 1667. Scipione had three other sons, Alessandro, Luigi, and Filippo.

49. The archival documents do not mention Cosimo's reason for purchasing the *Pietà*. It may simply have been a natural desire to continue the tradition of Medici patronage.

50. Appendix F, docs. 25–27. An inventory of the grand-ducal property in Rome of 1671 does not yet include the *Pietà*. See ASF Guardaroba Medicea 779, insert 4, no. 352: Inventario generale delle robbe in Roma di S.A.S., 1671 (the precise date is not given). Paolo Falconieri was a member of an illustrious Florentine family. For information on his life, see Goldberg 1983, 85 and 184.

51. According to Goldberg 1983, 83, Montauti "was the Resident of the Tuscan Legation in Rome, combining the functions of acting ambassador, consul, majordomo and all-purpose correspondent for any errand or commission with which the Grand-ducal family might require assistance."

52. Ibid., 82.

53. Appendix F, doc. 37.

54. Ibid., doc. 28.

55. [A number of the documents relative to the transfer of the *Pietà* to Florence are discussed by Goldberg 1983, 185–89 and 353–55, nn. 10–20. However, Franca Camiz found many additional documents in the Florentine and Roman archives, permitting her to write a more complete history of the statue's voyage to Florence than he did. —J.W.]

56. [This section resumes Camiz's part of the chapter. —J.W.]

57. Appendix F, doc. 28. The English translation of the text is from Goldberg 1983, 185.

58. Appendix F, doc. 29.

59. Ibid., docs. 30–55.

60. Ibid., doc. 40. Camillo Capponi was no relation of the family that owned the *Pietà*.

61. Ibid., doc. 42.

62. Ibid., doc. 41.

63. Ibid., doc. 46. The text of the letter is very difficult to understand because of the Italian terminology and the obscure geography of the port of Pisa.

64. Bassetti's replies to Tedaldi's letter have not been found, but Tedaldi, in a number of letters, indicates that he is writing to Bassetti without naming him, in response to the grand duke's request for information (e.g., ibid., doc. 52).

65. Ibid., doc. 51. [The kilogram equivalence of the libbra was calculated differently in different cities. In Livorno it was 0.339 kg (see Zupko 1981, 133). Thus, at an estimated 14,000 libbre, the weight of the statue is equivalent to 4,746 kg, or 2,152 pounds (about a United States ton), and at an estimated 11,000 libbre, the statue is equivalent to 3,729 kg, or 1,691 pounds. To my knowledge, the *Pietà* has actually never been weighed. I thank Louis A. Waldman for the Zupko reference. —J.W.]

66. Appendix F, doc. 54.

67. Ibid., doc. 55.

6. THE *PIETÀ* IN FLORENCE

1. Appendix F, doc. 55.

2. On 3 November, four days after the canon addressed his letter, Montauti wrote to Paolo Falconieri, who had negotiated the purchase of the *Pietà*, stating that "the statue will be a suitable ornament in the church of S. Lorenzo" (ibid., doc. 56).

3. Ibid., doc. 25.

4. Ibid., doc. 57.

5. Ibid., doc. 58.

6. Ibid., doc. 59. For views of the four sides of the Medici Chapel, see de Tolnay 1945–60, 3:plates 2, 4, 5, and 6. Plate 6 shows the altar wall.

7. Appendix F, doc. 62.

8. Ibid., doc. 61.

9. A short list of those who believe that the statue was placed in the crypt includes de Tolnay 1945–60, 5:150; Bershad 1978, 226; Murray 1980, 200; Goldberg 1983, 187; Petrucci 1995, 2:191, no. 80.

10. Appendix F, doc. 64.

11. A complete list of such minor objects follows: 4 large wooden stools, 2 crates and 1 bench (both of wood), 2 sideboards of walnut and wood, 9 used lecterns with arm rests, 4 irons pots and covers, 1 iron and wooden jack, 2 pairs of scales, 4 ladles, 6 spokes and 2 iron screws, 310 bronze weights (libbre), 3 antique chairs, 2 iron poles, 2 bronze pieces weighing about six libbre, 2 used wooden cabinets, 2 copper basins and a cooper watering can, 3 small rolling pins with their handles, 40 diverse small rolling pins for cornices, 3 tiles with their handles, 3 iron hammers of various sizes, 2 iron clubs for the works (fabric of the building), 1 iron nail container, 1 blue cloth curtain to cover the shelves mentioned above, 3 stone mason's iron hammers, and 1 small bronze bell.

12. Decades later, in his 1759 edition of Vasari's *Lives*, Giovanni Bottari mentioned a storeroom that may be the one in which the *Pietà* was kept. Bottari wrote: "the Pietà was in a room of marbles that were used for the new chapel of S. Lorenzo." To be sure, there are

inconsistencies between Bottari's room of marbles and the one in which Michelangelo's statue was kept; however, those differences can be accounted for by assuming that Bottari had seen the depository some thirty years after the *Pietà* left San Lorenzo and that at this later date the depository had stored other objects. Bottari's identification of the storeroom was repeated in subsequent editions of the *Lives* well into the nineteenth century, including the famous edition by Gaetano Milanesi; see Vasari (ed. Milanesi) 1878–85, 7:192, n. 1. It entered the mainstream literature in about 1875 (a short list would include Gotti 1875, 1:330; Symonds 1893, 2:203; Lungherini 1939, 80; Paatz and Paatz 1940–54, 3:537, n. 390; Buscaroli 1957, 186). Since about the middle of the 1950s, historians have ignored Bottari's reference to a room of marbles, advocating instead a crypt as the site of the *Pietà* during its long years in San Lorenzo. Today, the crypt serves as an entrance foyer to the commemorative princely chapel above it, known as the Cappella dei Principi, and Michelangelo's New Sacristy (plate 77).

13. Appendix F, doc. 29. To be sure, Cosimo had visited Rome from 14 to 27 May 1666, when he was twenty-two years old and still crown prince (he become grand duke of Tuscany in 1670). He apparently, however, made no effort to seek out the statue; at least, he failed to mention the work in a diary he kept during the two weeks he spent in the papal city. See ASF, Mediceo del Principato, 6386, "Descrizione di viaggio del Serenissimo Principe Cosimo di Toscana 1666–1667," fols. 57r–v. As for Bassetti, he accompanied the crown prince on many of his travels (Goldberg 1983, 147), perhaps also on his trip to Rome. But, like Cosimo, he may not have sought out the *Pietà*. Bassetti was a collector (Goldberg 1983, 147, points out), but chiefly of antiquarian objects.

14. If Falconieri had the undercroft of this area in mind, he was right to have considered the ceiling too low for the *Pietà* to be properly displayed there, raised above the ground: the height of the ceiling is approximately 4 meters (as compared to the 7 ft. 3 in. or 2.3 m of the statue). For sixteenth-century elevation projects for the Cappella del Principi, see Baldini 1981, plates II and III.

15. Appendix F, doc. 63.

16. Ibid., doc. 65.

17. Richa 1754–62, 5:68. Richa noted that he got his information from an earlier, unspecified publication, which may have been an anonymous pamphlet entitled "Nota di tutte le pietre delle quali è fabbricate la Cappella di S.A.R. nominata di S. Lorenzo" (n.p., 1740), 14–15. Richa erroneously considered the *Madonna* to be a work of Michelangelo and the *St. John* that of a follower of the master. The statues have not survived, but they are recorded in drawings after the works. For illustrations, see ASF, Scrittoio delle fabbriche, fabbriche lorenesi, 1999, enclosure 851. The *Crucifix*, which Richa attributed to Giovanni Bologna, and the two statues were transferred to the high altar of San Lorenzo on 28 October 1787; see Przyborowski 1982, 2:637.

18. Appendix F, doc. 63.

19. Del Migliore 1684. The *Pietà* is not mentioned by the anonymous author of the *Ristretto delle cose più notabili della città di Firenze* of 1698 and 1719. The statue is absent from Domenico Moreni's *Memorie storiche dell'ambrosiana imperiale basilica di San Lorenzo di Firenze*, 2 vols. (Florence: Francesco Daddi, 1816–17); *Delle tre sontuose cappelle medicee situate nell'Imp. Basilica di S. Lorenzo, descrizione istorica critica* (Florence: Carli E. Comp, 1813); *Descrizione della Gran cappella delle Pietre Dure e delle sagrestia vecchia eretta da Filippo di ser Brunellesco ambedue nell'Imp. Basilica di S. Lorenzo di Firenze* (Florence: Carli E. Comp, 1813); and *Pompe funebri celebrate nell'Imp. e Real Basilica di San Lorenzo dal secolo XIII e tutto il regno mediceo* (Florence: Stamperia Magheri, 1827).

20. Tolstoj 1983, 315, wrote: "Scesi quindi sotto l'edificio dove è stata ricavata un'altra cappella. Sull'altare vidi un'immagine di Cristo Crocifisso, un'altra della Santissima Madre di Dio e un'altra ancora di S. Giovanni: scolpite nell'alabastro con una perfezione tale che si può dire unica al mondo" (I went, then, under the building where another chapel had been extracted. On the altar I saw an image of Christ crucified [obviously the Crucifix to which Richa refers], another of the most Holy Mother of God, and another still of St. John: carved in alabaster with such perfection that, one can say, is unique in the world). Comte de Caylus 1914, 307, wrote: "Il y a un souterrain fort clair dans lequel est auprès d'un Crucifix, un Magdelaine de Michel-Ange qui est belle" (There is a strongly illuminated subterranean area in which, close to a Crucifix, there is a beautiful Magdalene of Michelangelo). He evidently mistook the Virgin for the Magdalene in the same group Tolstoj mentioned.

21. Appendix F, docs. 66 and 67. The statue arrived in the Duomo on 29 August.

22. For a discussion of Bandinelli's architecture and sculpture in the Duomo, see Heikamp 1964, 32–42; Waldman 1997, 31–68; and Waldman 1999. For a nineteenth-century print showing Bandinelli's choir enclosure before it was demolished in the middle of the century, see Wasserman 2001, 294, fig. 4.

23. See Heikamp 1980, 217. For this, he cites Francesco Settimani, Memorie fiorentine, ASF, Manoscritti, 142, fol. 429: "Addì x di settembre 1721. Alcuni zelanti e scandolosi, avendo messo in considerazione al Ser.ma Granduca che le due statue di marmo rappresentanti Adamo ed Eva, per essere ignude, stessero male ne l'altar maggiore del Coro di Maria del Fiore, dopo esservi state dal 1551 in qua, nella notte di detto giorno furono levate e messe nell'Arsenale dell'Opera, donde poscia furono trasferite nel fondo del Gran Salone del Palazzo Vecchio; cosa che diede tanto da dire al pubblico che andarono attorno sopra tal novità molte belle e satiriche composizioni, delle quali reporterò un sonetto di Antonio Morosini, detto Sema." Lensi 1929, 281, first cited this document. See now also Waldman 1999, chap. 15 and app. 3, in which he discusses in detail all the circumstances relating to the removal of the *Adam* and *Eve* from behind the high altar of the Duomo.

24. Appendix F, doc. 70.

25. See Francesco Baldinucci (Santi 1980, 2:478). Foggini was born in 1625 and died in 1725. For Foggini's career, see Thieme and Becker 1907–26, 12:139.

26. For an Italian translation of the inscription by Settimani in 1722, see appendix F, doc. 70. The plaque with the inscription is preserved, but not the base, which was never included in drawings or photographs of the statue, nor can it be found among Foggini's drawings, collected in Monaci 1977. For a view of the plaque as it was later displayed in the Duomo's chapel of Santa Maria della Neve, see Schiavo 1990, 1:fig. 259. The statue's installation in this chapel is discussed below.

27. Poggi 1909, cxxl, and the rev. ed., Haines 1988, cxxi.

28. Haines 1988, cxviii.

29. Vasari (ed. Bottari) 1759–60, 2:603, n. 1.

30. Holroyd 1903, 236–37. According to Heikamp 1964, 35, the steps

ascending to the candles were already in place when *Adam* and *Eve* stood behind the high altar.

31. The stucco in-fills are difficult to detect in the illustrations. They consist of small and dark areas at side of Nicodemus, one at about hip level, the other above and slightly to the left of it. The stucco was analyzed by the Opificio delle Pietre Dure, Florence, and found to be composed of cement. See the OPD report in appendix C.

32. Holroyd 1903, 237, further notes that "wooden steps [upon which the acolytes and clumsy boy climbed] also fit so closely to the marble that they injure the lines of the group." For him, the steps had an adverse aesthetic effect upon the statue. The steps also created a tonal discoloration at their point of contact with the marble, owing to the diverse atmospheric conditions. Scientists at the OPD have told me that the discoloration can be easily removed with light cleaning.

33. Mackowsky 1925, 304, assumed that it was the statue's natural color and was mislead into referring to its "gold toned marble."

34. See appendix C. Fazzini 1989, 171–72, cites several methods of applying color to marble statues in the cinquecento, but none is applicable to the yellow patina on the *Pietà*, whose composition is indicated in the OPD report as a water-soluble, protein-based material, most likely composed of animal glue. The grayish patina adjacent to the yellow patina has the same composition.

35. See Bernardini, Calloud, and Mastrorocco 1989, 182, for an illustration of the cast and a discussion of its origins. We can detect the patina in late-nineteenth-century photographs of the *Pietà*.

36. Blühm 1996, 20. Gibson is thought to have used a solution of color mixed with hot wax. Antonio Canova anticipated Gibson by giving the surfaces of his *Hebe* of 1811 a yellowish tonality. Jayme 1994, 10, n. 20, points out that he did this in imitation of recently discovered painted antique statuary. See also Potts 2000, 43, who notes that for Canova the yellowish color made the surfaces of his sculpture a "more flesh-like tint."

37. A plaster cast of the *Pietà* produced in 1882, now in the Gipsoteca, Florence, is covered in front with a yellow patina. According to Pavlinov 1965, 120, many plaster casts were made of the *Pietà* in the nineteenth century and appear in museums around the world. One of them, in the State Museum of the Figurative Arts, Moscow, is illustrated in his fig. 37.

38. Appendix F, doc. 76.

39. Ibid., doc. 78.

40. Ibid., doc. 79.

41. Mallarmé 1929, 7–8, and Mallarmé 1930, 2. Her proposal was endorsed by, among others, Errichelli 1930, 75, and Bessone Aureli 1933, 545, who concluded, with nationalistic verve, that placing the *Pietà* on Vasari's tomb "would render honor to that insuperable genius, and also to God, because all comes from the creator, who would grant Italy, as Michelangelo himself said, 'the perfection of things.'"

42. According to Mallarmé 1930, 2, her proposal had the endorsement of Mussolini, who, she wrote, "dreams of remedying the situation" that keeps the *Pietà* from its rightful destination.

43. Mallarmé 1929, 7: "rimane confusa in un'ombra così ingrata che costa fatica solamente il trovarla."

44. Symonds 1893, 2:200. Earlier still, in 1877, Susan and Joanna Horner wrote that the statue was "unfortunately in too obscure a position to be seen, except on a very bright day; see Horner and Horner 1877, 1:75 and 78.

45. Cited in Vasari (ed. Barocchi) 1962, 3:1442. For a history on the theme of the darkness that pervades the Duomo, see chap. 7, n. 30, this volume.

46. Appendix F, doc. 80. This document notes that the resident deputy placed the Deputazione Secolare dell'Opera on record as opposing "with all its energy" (tutte le sue forze) the transfer of the *Pietà* [to which he refers as a Deposition from the Cross] to Santa Croce. He further notes that the curia concurs in moving the statue, but favors as its new site the chapel of Santa Maria della Neve. Thus, it was a foregone conclusion where the statue would be located, even as a prolonged search for a site was undertaken.

47. Ibid., doc. 94. The precise day of the installation is not forthcoming. For a plan of the Duomo in which the old and the new sites of the *Pietà* are indicated, see Pavlinov 1965, 117, fig. 4.

48. Among the scholars who expressed approval of the new site were Mariani 1942, 231, and Rivosecchi 1965, 125. For the entire documentation on the removal of the *Pietà* to the chapel of Santa Maria della Neve, see appendix F, docs. 80–94. There are references to a lifesize model on paper of an inscription that was to be attached to the base, but it is not found among the correspondence and probably was not executed. Instead, the eighteenth-century inscription followed the statue in its new home and was placed on the wall behind it (for an illustration of the eighteenth-century plaque in this new location, see Schiavo 1990, 1:fig. 259). According to Pavlinov 1965, 119, another Latin inscription, now lost, was installed in the chapel. It read "Clariore in loco locatum voluere." He translates it in Italian as "Per dare, infine, una illuminazione migliore." I would translate the Latin text as "They wanted to locate the statue in a more luminous place."

49. Baccetti 1934, 127.

50. According to Pavlinov 1965, 119, the statue was moved to the "sotterraneo" of the Duomo during the Second World War to protect it from Allied bombing, a statement for which he does not cite documentation but may have been a report in a Florentine newspaper. Pavlinov 1965, 119, also states that the *Pietà* was taken to the Accademia delle Belle Arti on 22 May 1946, for a general cleaning. For this, he cites an unspecified newspaper report and includes an illustration showing its removal from the Duomo.

51. Appendix F, doc. 95.

52. Hodson 1999, 110, seems to confuse this *Pietà* with the Vatican *Pietà* when he writes that it was moved to the museum because a sightseer attacked it in 1970.

53. Appendix F, doc. 98.

54. Ibid., doc. 99.

55. See Settesoldi 1982, 44. The statue was first cleaned and included in an exhibition held in 1980 in Santo Stefano al Ponte. See for this Paolucci 1980, 200–201. According to a report in *La Nazione* of 11 March 1980, 2, it took three hours at dawn to transport the statue to Santo Stefano.

56. See *La Nazione*, 5 June 1981, 13.

7 · CRITICAL RECEPTION

1. For an illustration of the Scalza *Pietà*, see Venturi 1925–37, 10: pt. 3, 978, 856. For a thorough discussion of the statue, see Cambareri 1998, 271–78 and 345–50. She points out that Scalza drew on Michelangelo's Florence *Pietà*—although he had not seen the statue—in conceiving his own *Pietà*, with four figures carved from a single block

of mable, with the exception of the top part of the ladder, which Scalza pieced in. Cambareri is presently preparing a monograph on Scalza, which she is coauthoring with Augusto Roca de Amicis, in which she will introduce more developed ideas about the artist's *Pietà*. I wish to thank Louis A. Waldman for the Cambareri reference and Ms. Cambareri for sending me the chapter of her dissertation in which she discusses the relationship between the Scalza and Florence *Pietà*s.

2. See appendix E, no. 36. Stefano Maderno, in 1600, made a terracotta statuette of Christ seated directly on the lap of Nicodemus/Joseph of Arimathea; see ibid., no. 37.

3. See ibid.: no. 5 for the Sabbatini painting, no. 34 for the Alberti print, and no. 6 for the Viviani painting.

4. For example, a *Pietà* possibly by Scipione Pulzone (ibid., no. 8).

5. See ibid., nos. 11–14, for copies after El Greco's lost *Entombment*.

6. Ibid., no. 31.

7. ibid., no. 38.

8. See Wittkower 1955, 55, 179, n. 4; and D'Onofrio 1967, 178–80.

9. Appendix E, no. 15.

10. Appendix F, doc. 23.

11. A relief by Massimiliano Soldani representing Christ mourned by the Virgin and angels (Bayerisches Nationalmuseum, Munich) has the motif of the inclined head in the direction of the pronated arm (illustrated in Middeldorf 1976, 37, fig. 9). However, it is impossible to say that Michelangelo's *Pietà* was Soldani's model, since Christ's figure and the composition overall differ entirely from the statue. We should not take for granted that the Florence *Pietà* is the model for every inclined head and pronated arm of a Christ.

12. See in Sgrilli 1733, xxxiii–xxxiv: "rende nondimeno una gloriosa testimonianza dell'impareggiabile suo autore." Many literary individuals do not mention the *Pietà*: Giuseppe Maria Mecatti in his history of Florence of 1755 (Mecatti 1755), Richard Duppa in his biography of Michelangelo of 1806 (Duppa 1806), Stendhal in his diary entries in Florence of 1811 (Sage 1962, 447) and 1817 (Stendhal 1968, 2:619–21). In 1811 Stendhal wrote: "All the sculptured Christs I saw yesterday and today left me cold. The copy of Michelangelo's Christ on his mother's knees inspired nothing in me but reprobation for that great man" (Sage 1962, 447). Stendhal possibly was referring to a copy of the Vatican *Pietà* in that city, rather than the one in the Duomo. Other literary individuals merely acknowledged the statue's existence without judging its artistic merits: Giuseppe Richa merely noted its presence in the Duomo in 1757 (Richa 1754–62, 6: pt. 2, 141); Charles de Brosses in two letters of 1739 stated simply that Michelangelo had left the statue unfinished because of defects in the marble (de Brosses 1957, 324, letter 24 of 4 October; 367, letter 26 of 10 October); and Leopoldo Cicognara paused briefly in his 1823–25 book on sculpture to describe its composition, devoting considerably more commentary to several of the master's other works (Cicognara 1823–25, 2:209).

13. Weatherhead 1834, 115, wrote, "This admirable group, though unfinished, does no less evince the superior genius of the artist"; Quatremère de Quincy 1835, 132, wrote, "Le groupe, d'une belle composition, dut subir le sort de quelques autres dont une sorte de fatalitè empêcha l'achèvemenet" (Beautiful as the composition is, the group had suffered the fate of some others, a sort of fatality that prevented him from finishing the work). As noted earlier, Gotti 1875, 1:329, believed that what remains of the statue "is

sufficient to give us an idea of his intention and to help us realize that beauty to which Condivi refers."

14. Burckhardt 2001, 2:538: "Es ist ein höchst unerquickliches Werk, von der rechten Seite gesehen unklar, durch die Gestalt des Nicodemus zusammengedrückt. Die Stellung der Leiche dürfte mit jener ersten Pietà in S. Peter nicht von ferne verglichen werden" (It is a highly unpleasant work, unclear on the right side, and squeezed together by the figure of Nicodemus. The placement of the deceased cannot even remotely be compared with that first Christ in the Pietà in St. Peter's).

15. Wilson 1876, 453.

16. Count Gigli bought the statuette in 1853. For this, see De Angelis 1953, 350. Parronchi 1981, 26–27, briefly discusses this incident.

17. Migliorini 1856, 4–5: "Solo possiamo soggiungere: che il marmo per le molte vicissitudini sofferte, non è finito, e Tiberio vi pose per poco la mano; dovechè la nostra cera è tutta opera del gran Maestro, vi si riconosce il suo genio, il suo modo di fare, come abbiamo osservate in altri lavori in cera da noi ammirati: ed in oggi è insieme con l'incisione l'unica depositaria della sublima idea da esso concepita" (We can only add that the statue, because of the many viscissitudes it suffered, is not finished, and Tiberio [Calcagni] worked on it briefly, so that our wax [statuette] is entirely the work of the great master. One recognizes there his genius, his method of working, as we observed in others of his admired works in wax, and it is today, together with the engraving, the only remains of the sublime idea he conceived). The engraving to which Migliorini is referring is Cherubino Alberti's well-known copy after the *Pietà* datable to the 1570s or 1580s (plate 81). According to Migliorini, one of the elements of Michelangelo's original idea that the wax statuette preserves is Christ's left leg. He wrote erroneously that Michelangelo changed its position in the statue by hiding it behind Christ's thigh and the knee of the Virgin ("Ma il nostro bozzetto di cui teniamo discorso è diverso dal marmo, e la varietà consiste nella gamba sinistra del Cristo che esce in fuori, e non rimane come nel marmo coperta dalla coscia, e dal ginocchio della madre genuflessa" [But our model, which I am discussing, is different from the marble. The difference consists in the left leg of Christ, which extends outward and is not covered by the thigh, as in the marble, and by the knee of the kneeling mother]).

18. Dupré 1873, 14: "Ho riveduto la cera che Tu [*sic*] possiedi e posso dire di esserne restato sorpreso, tanta è la bellezza di questo lavoro; l'ho confrontato col disegno levato dal gruppo in marmo che è dietro l'altar maggiore del Duomo ed ho riscontrato molte diversità negli atteggiamenti delle figure, nei sentimenti delle teste, e nell'ondeggiamento de' panneggiati, e tutti questi cambiamenti nel marmo sono tutti in peggio" (I saw again the wax you own and can say that I am surprised, such is the beauty of the work. I compared it to a drawing of the marble group that is behind the main altar of the Duomo and encountered many differences in the attitudes of the figures, in the expressions of the heads, and in the flow of the draperies, and all these changes in the marble are for the worse).

19. Ibid., 14: "nessuna forza umana e neppure a quella divina del Buonarroti era dato di conservare la prima impronta gettata là coll'entusiasmo dell'arte e della fede."

20. The commission published a report in 1873, in which Gotti 1873, 15–16, and Milanesi 1873, 17–21, both record the member's unanimous opinion that the Gigli statuette was an authentic work of Michelangelo. Gotti 1873, 16, wrote, "E perchè riuscivano le opin-

ioni di tutti concordi nel darla e predicarla opera mirabilissima e solo degna di quel divino" (All are in accord in praising and judging the statuette as a most remarkable work worthy only of the divine one). Milanesi 1873, 19, refers to "this precious joy of art," and expressed enthusiasm for the "wonderful" head and torso of Christ," concluding: "in esso modello si raccolgono le principali qualità per crederlo e riconoscerlo come cosa originale, tanto sublime è il suo concetto, bellissimo il modo, e veramente da grande artista di disporre ed aggruppare le figure, squisita ed al tempo stesso piena di forza e di sentimento la esecuzione" (In this model is concentrated the principle quality that permits us to believe and recognize it as an original thing, so sublime is its concept, very beautiful the style, and really proper of a great artist in the disposition and grouping of the figures, esquisite and, at the same time, forceful and full of feeling in the execution). Ludwig Goldscheider seems to be the only modern scholar who accepts the Gigli wax as an original model for the *Pietà* (Goldscheider 1962, commentary to fig. 62).

21. Milanesi 1873, 19–20: "Confrontando poi il modello in cera coll'opera di marmo, appariscono in questa così nel movimento delle figure, come nell'andare delle vesti, e nel sentimento delle pieghe, alcuni cambiamenti, e tutti peggiori."

22. For a history of the preparations for the centennial, see Corsi 1994, 13–30. Other sculptures by Michelangelo, but apparently not the *Pietà*, were represented with plaster casts in an exhibition the organizers of the celebration dedicated to the master's art in the Accademia delle Belle Arti. Naturally, the sculptures that were part of the Accademia collection were also excepted. Parrini 1876, 215–17, in a section of his account of the centennial entitled "Mostra Michelangiolesca," included a reference to "The Pietà, roughed out, sent from Rome" (La Pietà, abbozzo mandato da Roma). This might indicate that the *Pietà* was, in fact, included in the exhibition. However, designating the statue as sent from Rome was a curious way to refer to a work that had been in Florence for two centuries. Parrini also included in the names of the owners and locations of all the sculptures he catalogued, except the *Pietà*. Finally, the *Pietà* does not appear in the list of exhibited works cited in Corsi 1994, 19–20. If the statue was represented in the exhibition, it most likely was in the form of a photograph, since the first cast of the work dates from 1882 (Bernardini, Calloud, and Mastrorocco 1989, 181–82). We learn from Corsi 1994, 19–20, that, except for the sculptures present in the Accademia delle Belle Arti, Michelangelo's works were represented by plaster casts and photographs. It is noteworthy that Gigli's wax statuette was exhibited as an original work of Michelangelo in the Casa Buonarroti (see Fabbrichesi 1875, 20, no. 89).

23. The *Pietà* was included in two published lists of Michelangelo's oeuvre (Parrini 1876, 215; and Cavallucci 1875, 194–95). The sites visited included the Medici Chapel; the *David* in the Accademia delle Belle Arti; the Casa Buonarroti, where Michelangelo had lived; his tomb in Santa Croce; the replica of the *David* in front of the Palazzo Vecchio; a second replica of the *David* in the Piazza del Michelangelo; and even the Palazzo Medici, where Michelangelo presumably lived as a youth. For a list of the sites, see Parrini 1876, 101–74; Carocci 1875; and *La Nazione*, 4 September 1875.

24. Gotti 1875, 1:328–30.

25. Guillaume 1876, 34–118. Guillaume was born 4 July 1822 and died in Rome in 1905. A sculptor in the classical tradition, Guillaume

became director of the French Academy in Rome in 1891. See Comb 1933, 18:259.

26. Guillaume 1876, 102.

27. For all its freshness and richness of perception, the passage is an echo of what John Ruskin said about the *Pietà* in 1851 (Ruskin 1851, 2: pt. 2, 180): "the strange spectral wreath of the Florentine *Pietà*, casting its pyramidal, distorted shadow, full of pain and death, among the faint purple lights that cross and perish under the obscure dome of Sta. Maria del Fiore." What sets Guillaume apart from Ruskin, however, is that the former wrote at a crucial moment in the statue's history and he conveyed the mystery of Christ's martyrdom.

28. Symonds 1893, 2:200.

29. Ibid.

30. There is a long literary tradition on the darkness that prevails in the interior of the Duomo. Johannes Fichard in 1536 was the first to note this phenomenon, characterizing the entire interior of the cathedral as "tenebricosa" (cited in Schmarsow 1891, 379). The concern with darkness would over time focus on the *Pietà* itself. Northerners on the grand tour, including Richard Lassels in the eighteenth century (cited in Maugham 1903, 274); in the nineteenth century, William Beckford (1843, 1:182), and Susan and Joanna Horner (Horner and Horner 1877, 1:75 and 78) will view the darkness in the Duomo in negative terms. Grimm (1865, 2:357) was an exception; for him the darkness hides the statue's physical defects: "The dim light that prevails there [in the choir] suits the group [the *Pietà*], which is only finished in its general mass." See Wasserman 2001, 289–98.

31. Holroyd 1903, 236.

32. Symonds 1893, 2:200, mentions the episode of the breaking up of the statue only when discussing its history. It was not a factor in his critical judgment of the work.

33. Guillaume 1876, 106.

34. Körte 1955, 296, was among those who advocated the concept of the *non-finito*, speculating that Michelangelo considered the statue finished in the form it had when he resumed work on it under pressure by Urbino. See also Perrig 1960, 59–60. The tendency to infuse the *non-finito* with metaphysical overtones was noted by Pope-Hennessy 1970, 3:5. De Tolnay 1945–60, 5:88, is among those who are so inclined ("on the rough surfaces, the light becomes more diffused, giving the heads of Joseph of Arimathea and the Virgin an inner glow.... It seems that Michelangelo here purposely left some of the surfaces unpolished: he may have found their illuminated roughness an appropriate means to emphasize the spirituality of these figures"). Partridge 1996, 106, is the most recent scholar to give the unfinished a metaphorical interpretation. According to him, the finished and polished surfaces of Mary Magdalene convey the "supreme embodiment of earthly love and passion." Partridge continues, "the rough surface with its clear chisel marks emphasizes the hard stoniness of the marble of a work *in progress*, indicating matter becoming spirit, and spirit being that which is most solid and permanent." For a general compendium of ideas on the unfinished, see Barocchi 1962, 3:1646–59. For the unfinished in relation to Michelangelo's sculpture, see Barocchi 1962, 3:1660–68; and Schulz 1975, 366–73. Vasari's interpretation of the unfinished in Michelangelo's sculpture is more reasonable and verifiable; he states that statuary that remains undercut absorbs shading from its environment and thus seems finished when observed from a distance (see chap. 4, text, and n. 53).

35. The exact date of the discovery of the *Torso Belvedere* is not known. Michelangelo greatly admired the fragment and used it as a model for his *Ignudi* in the Sistine Ceiling. For this, see Hibbard 1974, 78, who points out that Michelangelo "was quoted as saying 'this [the *Torso Belvedere*] is the work of a man who knew more than nature.'" For a history of the ancient marble, see Wünsche 1999, 25–29.

36. See Wünsche 1999, 50–73. Imitations of ancient fragments are evident already in the seventeenth and eighteenth centuries. For this, see Schmoll 1959, 117–39, figs. 4, 36–37, 48–49.

37. As cited in Gantner 1953, 37: "Ce qu'il y a de plus beau qu'une belle chose, c'est la ruine d'une belle chose." Rodin also stated in 1914 (cited in ibid., 53): "Le beau est comme Dieux, un morceau de beau est le beau entier" (The beautiful is like God, a fragment of beauty is beauty entire). See also Elsen 1963, 174. For a discussion of the history of the fragment, see Schmoll 1959, 117–39. The sculptor Auguste Ottin made a lifesize copy of the *Torso* in 1838, and already considered it then "the most complete sculpture that exists" (cited in Wünsche 1999, 64).

38. Einem 1935, 333.

39. Indeed, many scholars today consider the statue greatly improved without Christ's left leg; Steinberg 1968, 343 and n. 1, was the first to lament this fact of modern scholarship.

40. See appendix E, no. 33.

8. MICHELANGELO AND THE BODY OF CHRIST

The Michelangelo literature is so vast and complex that I have chosen to refrain from a full annotation of every point raised in this essay, preferring simply to indicate my immediate sources and justify my own conclusions.

1. Appendix F, doc. 10: "per dilettazione e passar tempo," and doc. 11: "lavorava Michelangelo quasi ogni giorno per suo passatempo intorno a quella Pietà." For the history and *fortuna* of the Florence *Pietà*, see chap. 7; Pope-Hennessy 1970, 3:338–39; and—more extensively—de Tolnay 1945–60, 5:149–50.

2. Kristof 1989, 163–82; Shrimplin-Evangelidis 1989, 58–66 (both articles feature an extensive bibliography). See also the earlier study by Parronchi 1981, 23–33.

3. Schulz 1975, 370.

4. "Né pinger né scolpir sia più che quieti / l'anima, volta a quell'amor divino / ch'aperse, a prender noi, 'n croce le braccia." Quoted in de Tolnay 1945–60, 5:88. The sonnet, normally numbered 147, begins with the words: "Giunto è già il corso della vita mia." Cf. Frey 1897.

5. Shrimplin-Evangelidis 1989, 65.

6. Appendix F, doc. 10 (Vasari): "la dovessi servire per la sepoltura di lui, a piè di quello altare, dove e' pensava di porla." Doc. 2 (Condivi): "Fa disegno di donar questa Pietà a qualche chiesa, ed a piè dell'altare ove sia posta farsi seppellire." According to Vasari, the altar in question was to be in Santa Maria Maggiore, presumed to be in Rome; see doc. 9 and de Tolnay 1945–60, 5:150. Very serious thought has been given the *Pietà* as a tomb monument by Schütz-Rautenberg 1978, 149–62. The present "eucharistic" reading is, however, my own, neither in contradiction to Schütz-Rautenberg nor dependent upon her.

7. Giberti 1542, 37: "Quondam autem fastum detestamur, qui mira arte, et maxima cum impensa, laborata sepulchra in locis eminen-

tibus, et plerumque altaria excedentibus, super quibus unigenitus dei filius aeterno Patri quotidie pro humani generis salute victimatur collocare praesumunt." This treatise is discussed by Hiesinger 1976, 283–93 and 284. See also Vossilla 1996, 69–80.

8. Righetti 1950, 1:426.

9. Vossilla 1996, 73. Vasari says of this group that "Nicodemo è Baccio ritratto dal naturale" (Vasari [ed. Milanesi] 1878–89, 6:186).

10. Heikamp 1964, 32–42; Pope-Hennessy 1970, 3:362–63; Vossilla (ed. Verdon) 1996, 41–56; Vossilla 1996, 37–67.

11. On the theology of Bandinelli's group, see Vossilla 1996, 36–67, and esp. Verdon 1995, 113; Verdon (ed. Tarchi) 1995, 23–43; Verdon 1997, 13–24; Verdon (ed. Gheri) 1997, 193–206; Verdon (ed. Baviera) 1997, 21–31.

12. Verdon (ed. Tarchi) 1995, 29; Verdon (ed. Gheri) 1997, 197; Verdon (ed. Baviera) 1997, 24.

13. Appendix F, doc. 10: "Né si può vedere corpo morto simile a quel di Cristo, che, cascando con le membra abbandonate, fa attiture tutte differenti, non solo degli altri suoi, ma di quanti ne feciono mai: opera faticosa . . . che la dovessi servire per la spultura di lui, a piè di quello altare dove e' pensava di porla."

14. In the papal indulgence *Anima Christi*, promulgated by John XXII from Avignon. See Eisler 1969, 237. See also Lane 1975, 21–30, and—more generally—Corblet 1886, 189; and Bouyer 1968, 381–83.

15. For illustrations of the outer door and inner wall of the Asciano tabernacle, see Alessi and Martini 1994, 181, 233.

16. Lecchini Giovannoni 1996, 29–35.

17. Hood 1993, 109–11.

18. Hardison 1969, 35–79.

19. Verdon 1994, 29–46; Verdon 1997, 41–53.

20. See esp. Stechow 1964, 289–302.

21. Ibid., 300.

22. Prinz 1989, 36–39; Nepi Sciré 1990, 373–74.

23. "Treatise on the Holy Trinity," book 8, 13–16. See Migne 1865–84, 10:246–49.

24. Discourse 108. Ibid., 52: 499–500.

25. Homily 6. Migne 1857–67, 44:702–5.

26. Ibid.

27. De Tolnay 1945–60, 5:151.

28. *Expositio in Lucam* 2, 19–23. Migne 1865–84, 15:1639–42.

29. Commentary on the Gospel of St. John, book 4, 2. Migne 1857–67, 73:563–66.

30. Commentary on Psalms 60:2–3. Corpus Christianorum 1956, 39:766.

31. Commentary on Psalms 140:4–6. Corpus Christianorum 1956, 40: 2028–29.

32. Commentary on Psalms, 85, l. Corpus Christianorum 1956, 39: 1176–77.

33. Against the Heresies, book 5, 2:2–3. Sources Chrétiennes (Paris: Editions du Cerf, 1970), 153:30–38.

34. Aranci 1996, 26–27: "Communione di sancti si è il corpo el sangue di Christo. Imperò che quando le sancte persone che riceve divotamente sença peccato, Dio si unisce con loro e falle diventar una cosa sola con lui. . . . Così el corpo di Christo fa diventare la persona che prende degnamente Dio. E questo dice il psalmo: Ego dixi dij estis, et filij excelsi omnes. Dice Christo ale persone che l' prendono degnamente: io dico che vui sete facti dij e fioli del altissimo Dio."

35. Lorenzo Valla, "Sermo de mysterio Eucharistiae," cited in Trinkaus 1970, 2:637.

36. Donato Acciaiuoli, "Oratione del corpo di Cristo di Donato Acciaiuoli, e da lui nella Compagnia dei Magi recitata die xii aprilis 1468," cited in ibid., 2:645.

37. Commentary on the Gospel of St. John, book 4,2. Migne 1857–67, 73:563–66.

38. De Tolnay 1945–60, 5:151.

39. The theme of God's paternal grief derives from St. Paul, who in Romans 8:32 evokes a parallelism between Abraham and God. Abraham did not, at the last, have to sacrifice his son Isaac, whereas, Paul asserts, God "did not spare his own Son, but gave him up for us all."

40. Discourse 45, 23–24. Migne 1857–67, 36:654–55.

41. Steinberg 1968, 343–53.

42. Jacopone da Todi, *lauda* entitled, "Donna del Paradiso," in Ulivi and Savini 1994, 89–94.

43. Humfrey 1983, 127–28.

44. See Verdon 1978, 52–53, where I cite a *sacra rappresentazione* of the late fifteenth century (Biblioteca Medicea Laurenziana, Ash. 1542, 1465) in which Mary apostrophizes the tomb hewn from the rock with the words, "Sasso crudele sey tu forse Maria, sey tu sua madre che amasti tanto. . . . Pero ne rende se tu lay serrato, perché son quella io che lo lactato" (c. 86).

45. For the patristic association of Mary with the church, see Gambero 1991 (the numerous indications in the index); for Maria as bride of Christ see Gambero 1991, s.v. sposa and "talamo" in the index. For an application to the history of art, see Verdon and Luchinat 1995, 2:21.

46. See, by way of illustration, St. Ambrose's teaching on the Song of Songs, as compiled by William of Saint-Thierry in the early twelfth century: commenting on its opening words, "Osculetur me osculo oris sui" (Let him kiss me with the kisses of his mouth), Ambrose says: "with these words the text does not stir us to dishonest behavior, but rather celebrates chastity. With these words a spiritual meaning is expressed and, so to speak, a loving contemplation of the marriage union between Christ and the Church, between the uncreated Spirit and the created one, between the spirit and the flesh." See Saint-Thierry 1993, 16–17.

47. De Tolnay 1945–60, 5:148.

48. "Non è che non mi dolga, e voglia che e' si faccia del bene per l'anima sua, com'io ò fatto per l'anima di tuo padre." See letter 315 in Girardi 1976, 232 (n.d.).

49. "I' parlo a te, Signor, di ogni mia prova, Fuor del tuo sangue, non fa l'uom beato." Fragment 142 in Ceriello 1954, 151.

50. "Tuo sangue sol mie colpe lavi e tocchi, e più abbondi, quant'i'son più vecchio, di pronta aita e di perdono intero." Frey 1897, Sonnet 152, Rime, 155.

51. "Ma pur par nel tuo sangue si comprenda." Ibid., Sonnet 156, Rime, 156.

52. Ibid., Sonnet 160, Rime, 158. "gode sol l'uom ch'al battesimo rinacque."

53. Ibid., Sonnet 140, Rime, 150–51. "Manda 'l predetto lume a noi venturo, alla tua bella sposa acciò ch'io arda, il cor senz'alcun dubbio, e te sol senta."

54. "Squarcia 'l vel tu, Signor! Rompi quel muro/che con la sua durezza ne ritarda/il sol della tua luce al mondo spenta." Ibid.

II

RESOURCES

Prefaces to the Technical Studies

An essential principle of modern restoration is that interventions that materially modify a work of art (besides being carried out with obvious caution) must be preceded by a series of very complete scientific analysis. We know today that the causes of a malaise in a work of art must first be understood before the symptoms can be addressed. It is indispensable, therefore, to perform an accurate diagnosis of a work in order to ascertain its true state of conservation and the circumstances, natural and artificial, that are responsible for the malaise. Of all the sciences used in restoration, physics has been especially useful for non-destructive analysis of sculpture since its diagnostic methods do not require the removal of marble samples. Some people maintain that there is an exaggerated tendency to perform expensive analyses on works of art. However, in the case of works of extraordinary importance we must learn as much as possible about their original technique, the vicissitudes they experienced over time, and their present general state of conservation.

There is at present no plan to restore the *Pietà* of Michelangelo in the Museo dell'Opera di Santa Maria del Fiore in Florence, even if a light and careful cleaning of its marble surfaces might be worth considering for the near future. The study Jack Wasserman conceived and carried out with intelligence and new methodologies stimulated our laboratories to engage in a series of investigations of the *Pietà*. These coalesced with Wasserman's historical research and critical hypotheses to form a complete and integrated framework of knowledge about Michelangelo's great statue that is more advanced than would have been previously possible. Thanks to the investigation we conducted, the interior structure, carv-

ing, and construction techniques of this masterpiece are today better known, providing a sounder basis for various hypotheses.

The Opificio delle Pietre Dure, a National Institute of Restoration of the Ministry for Cultural Heritage and Activities, headquartered in Florence but active nationally, has in recent years become directly involved in the study and restoration of the works of Michelangelo, from *David* (which was damaged by a mentally disturbed individual) to *St. Matthew*. After the 1999 Michelangelo exhibition in Florence the *San Procolo* in San Domenico, Bologna, also came to the Opificio while it was in Florence. We are very grateful to Jack Wasserman for having invited the Opificio to collaborate in this study of the *Pietà*, a project that has been, for all of us involved, satisfying and very successful.

GIORGIO BONSANTI
Former Superintendent of the Opificio delle Pietre Dure and Laboratories of Restoration of Florence and presently Professor of History and Techniques of Restoration at the University of Turin

• • •

CONSERVATION OF WORKS OF ART in the entire complex of Santa Maria del Fiore in Florence, and their display to best advantage, are fundamental activities of the institute over which I have presided for more than three years. Therefore, I happily agreed when Professor Jack Wasserman requested permission to research the *Pietà* of Michelangelo in the Museo dell'Opera di Santa Maria del Fiore.

As the study proceeded, the results that began to emerge seemed ever more interesting and, more immediately, demonstrated the good state of health of this very important statue. For example, through a gamma-ray examination of the points of the repair Professor Wasserman verified that the metal pins on the inside of the statue showed no traces of rusting, relieving one great cause of worry.

I am proud to share in a study that has gone well beyond my initial expectations. In fact, his decision to request the help of IBM for a new and enriched method of research, one that would utilize the most innovative computer science technology, seemed to me particularly worthwhile. One can already perceive the possibilities for the future use of this technology in museology. Moreover, the reconstruction of a virtual three-dimensional image of the statue, achieved in the IBM research laboratory in New York, will be of great help in protecting the work itself.

All the material relating to this extraordinary study is included in the present volume on the *Pietà* and in the CD-ROM that IBM has prepared for the book. Moreover, all the documentation produced in connection with the research on the *Pietà* will be preserved in the archive of the Opera di Santa Maria del Fiore and will be available to scholars and to institutions of education, computer science, and restoration.

ANNA MITRANO
President of the Opera di Santa Maria del Fiore

THE CARVING TECHNIQUES
OF MICHELANGELO'S *PIETÀ*

Peter Rockwell

MICHELANGELO'S FLORENCE *PIETÀ*, in its variety and individuality, shows a fascination with the act of carving. The types of tools he used are rarely documented in the Renaissance because, it seems, few sculptors of the period felt the need to write about this aspect of their trade. In Michelangelo's lifetime, Giorgio Vasari and Benvenuto Cellini only briefly mention sculptors' tools in their treatises on sculpture, and do not even completely agree in their descriptions.[1] Cellini justified his brevity by asserting, "Gladly would I go on to describe the various kinds of point chisels, flat chisels and drills, all of which are of tempered iron or of the very finest steel; but as everybody in Italy nowadays knows all about these things it really isn't very necessary."[2] It would seem that the only accurate descriptions of tools are reliefs carved by sculptors showing carvers and their tools, of which the closest to the period is the 1506 tomb of Andrea Bregno in Santa Maria sopra Minerva in Rome.[3]

In order to shed light on this important aspect of Michelangelo's technique, I will describe individually the tools he used (plate 97), their history, and the order in which he applied them in carving of the *Pietà*.

The point chisel (*subbia*), which is mentioned by Cellini, is forged to a pencil-like point on its cutting end (plate 97, nos. 1 and 2). It was used on marble in Greek antiquity and ever since as the tool for roughing out the general form of a composition

PLATE 96
Christ, right foot

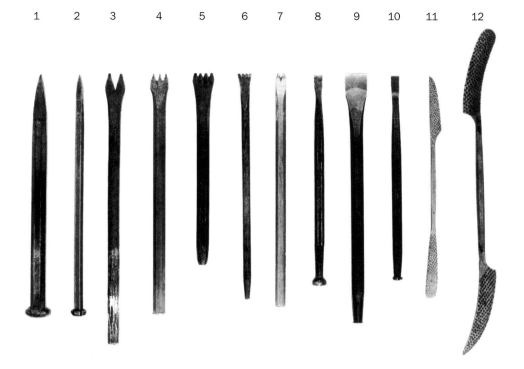

PLATE 97
Photograph of carving tools.
Nos. 1–2, point chisel; no. 3,
calcagnolo; *nos. 4–6, tooth chisel,*
or gradina; *nos. 7–8,* dente di
cane; *nos. 9–10, flat chisel, or*
scalpello; *nos. 11–12, rasp, or* raspa

from the marble block. A marble carver had to keep several on hand: the point can be blunted during the first five minutes of work on hard stone and lasts at most a couple of days. The quality of the temper of the steel, the thrust of the hammer blow, and the angle at which the tool strikes the marble also affect the life of the point. While this chisel can be sharpened during the work session, eventually it will become so blunt as to require reforging. Therefore, a carver may keep several on hand when roughing out a statue.

Michelangelo's point chisel marks are visible on the areas of the *Pietà* that are original (plate 98). These are on the base (plate 58), the bench on which the Virgin sits (plates 5 and 39), the rear of the bearded figure's garment, his garment in front (plate 83), an area between the Magdalene and Christ (plate 32), and sporadically in various minor locations. Evidence of this chisel work is absent from the repaired parts of the statue (plate 99), but Tiberio Calcagni would have used the tool where he removed the remains of the left leg: on the Virgin's lap (plate 60) and on the area of the base where the foot rested (plate 58).

Michelangelo used the point chisel with greater precision and to greater aesthetic effect than anyone before him. Earlier sculptors had used it strictly to rough out the overall shape of the figure, preferring to define the forms with tools such as the tooth chisel. Although at times Michelangelo also followed this procedure, he frequently used the point chisel to define anatomical parts and the lines of drapery. By holding the chisel at a much lower angle to the stone than was customary, he had more control over the instrument and was able to break off smaller chips from the marble, moving easily over the surfaces of the stone. The chisel he used for this method required a longer and sharper point than was usual and, therefore, would have been made of a higher grade of steel and with a more controlled tempering process. This no doubt was made possible

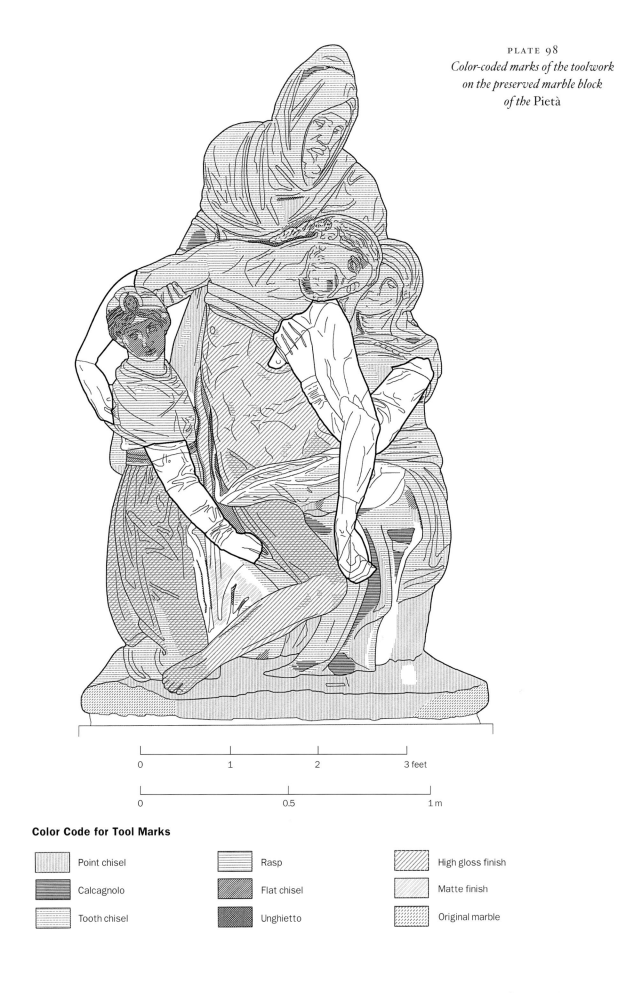

PLATE 98
*Color-coded marks of the toolwork
on the preserved marble block
of the* Pietà

0 1 2 3 feet

0 0.5 1 m

Color Code for Tool Marks

Point chisel	Rasp	High gloss finish
Calcagnolo	Flat chisel	Matte finish
Tooth chisel	Unghietto	Original marble

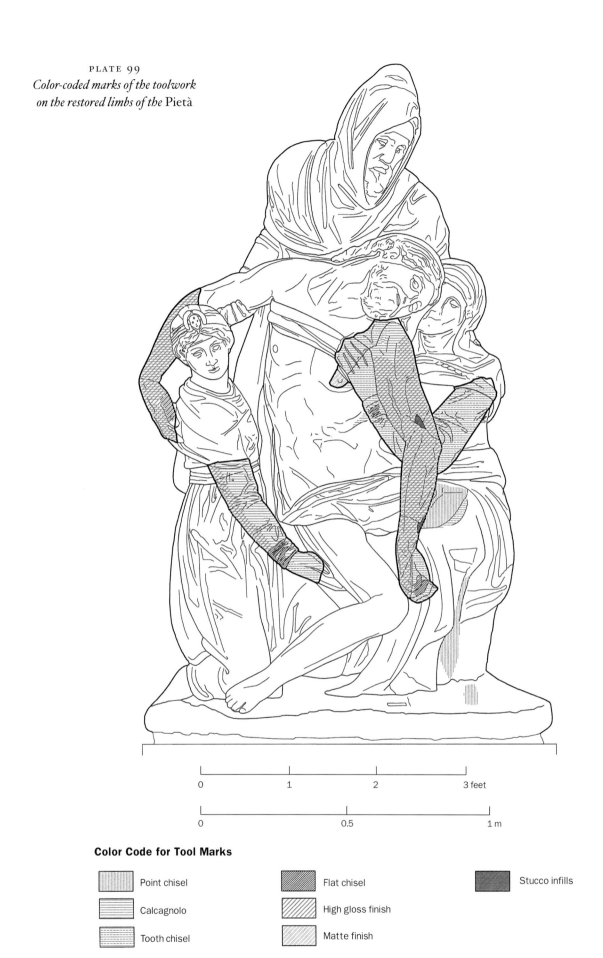

PLATE 99
Color-coded marks of the toolwork
on the restored limbs of the Pietà

0 1 2 3 feet

0 0.5 1 m

Color Code for Tool Marks

Point chisel

Calcagnolo

Tooth chisel

Flat chisel

High gloss finish

Matte finish

Stucco infills

by improved metallurgy. In any event, the point chisel as Michelangelo used it scored the marble with a series of parallel lines, resulting in a remarkable aesthetic effect.

Another important advantage to Michelangelo's technique with the point chisel is that at a lower angle, the tool is less likely to bruise the stone. A bruise, which takes the form of a white blotch, is a network of micro-fractures that may go as deep as 3⁄16 of an inch (0.5 cm) and is caused by hitting the stone too hard and too vertically with a point or tooth chisel; it is similar to what happens to ice when it is hit with a hammer. Such bruises remain visible even after the stone has been polished or finished very smoothly with abrasives, and can be erased only by carving away the fractured area. Holding the point chisel at a lower angle, as Michelangelo did, helped him to avoid bruises and simplified the polishing of the sculpture.

The *calcagnolo* (there is no useful English word) is a large-tooth chisel with two teeth, pointed or flat, often separated by a gap at least as wide as the teeth (plate 97, no. 3). Its use is first noted in the late quattrocento and was mentioned by Cellini. The tool supplements the point chisel in the second stage of the process of roughing out figures in the marble and is used to create somewhat smoother surfaces and form details.[4]

Calcagnolo marks appear mostly on the rear of the statue (plates 5 and 16) and on the side of the Virgin's left leg (plates 39 and 40).[5] They are evident on the front of the statue (plate 98), but only sporadically and to a limited extent: on the beard of Christ (plates 92 and 100), the right arm and headpiece of the bearded figure (plates 14 and 98), the left shoulder of the Virgin, the Virgin's lap, a triangular area defined in plate 101 by the arm and leg of Christ, and at the beginning of the stump of Christ's left leg (plate 60).

The tooth chisel (*gradina* in Italy; claw chisel in Great Britain) has a series of points or flat teeth across the cutting edge (plate 97, nos. 4–6). When the teeth are flat, the tool can also be described as a flat chisel with a series of notches in the cutting edge. The number of teeth can vary from two (in which case it is called in Italian either a *calcagnolo* or a *dente di cane*—dog-toothed chisel) to twelve or more. Its width can also vary greatly. The tooth chisel is usually considered to have been the invention of Greek marble carvers in the sixth or seventh century B.C. The dog-toothed chisel is one of the chisels Cellini referred to as a "flat chisel with a notch in the middle."[6] The purpose of the tooth chisel is to clarify and define forms and details while at the same time smoothing out the roughness left by the point chisel and the *calcagnolo*.

Marks made with the tooth chisel are among the most extensive on the *Pietà*, and are found on Michelangelo's surfaces as well as the parts for which Calcagni is responsible (plates 98 and 99). We see them on the entire front side of the bearded figure (plates 14 and 83); the entire figure of the Virgin (plate 2); Christ's neck and face (plates 92, 100, and 104), upper-right arm (plate 36) and hand (plate 66); the area of the upper part of Christ's missing left leg (plate 103); his right foot (plate 96); and on various parts of Mary Magdalene: her head and neck (plates 44 and 61), her body below the breasts (plate 102), her left hand (plate 17), and her right calf (plate 62).

PLATE 100

Christ, neck

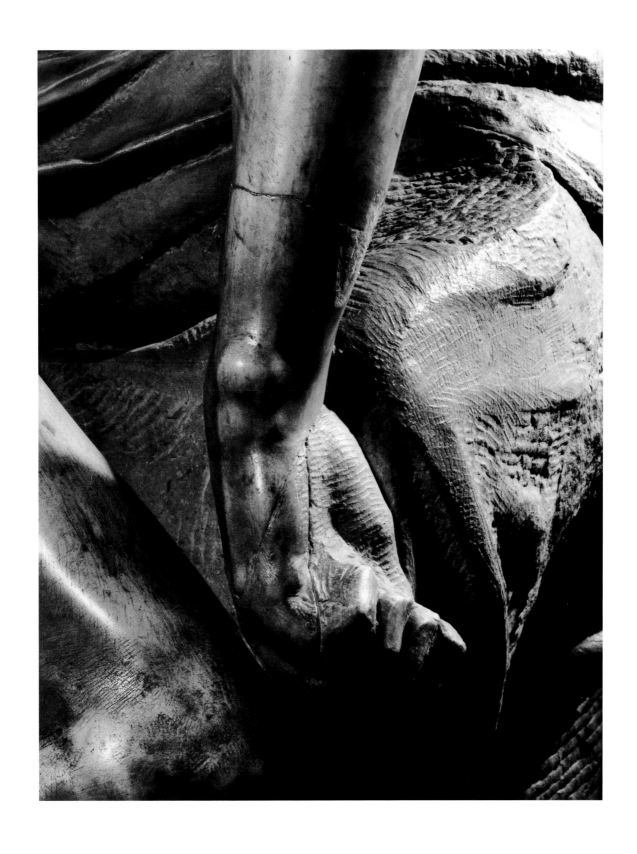

PLATE 101
Christ, left wrist and side of hand

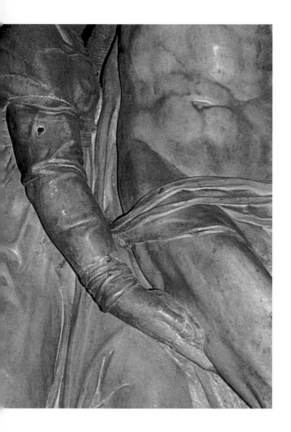

Michelangelo's technique with the tooth chisel is one of the most important criteria for identifying his hand in carving. He did not use the tool simply to erase the surface roughness left from the point chisel and to clarify the forms, as most sculptors had done since antiquity. Instead, Michelangelo repeatedly carved across the surface, changing direction each time, thereby creating a crosshatched effect (plate 100). With this use of the tooth chisel, he seems to have been seeking the form, bringing it out slowly. The method is reminiscent of Michelangelo's drawing style in both the surface effect it creates and the way the form is gradually discovered. It is important to note that in the history of stone carving, we know of no other sculptor before Michelangelo that used this technique.

Michelangelo used the tooth chisel not only on the *Pietà*, but also on other sculptures. Often, as on the face of the Madonna of the Medici Chapel, Michelangelo used the *dente di cane* (plate 97, nos. 7–8) to achieve the same effect. However, on the *Pietà* evidence of this tool is found principally on those areas probably carved by a restorer, such as the prepared stump of Christ's left leg (plates 60 and 103).

Evidence of the flat chisel (*scalpello*, or sometimes *scarpello*; plate 97, nos. 9–10) is found especially on the areas Calcagni carved: Mary Magdalene's face, hair, and headpiece (plates 49 and 61), and the beltlike drape at the waist. The flat chisel was also used—by Michelangelo—on Christ's shroud along his right side and on his right eye and head (plate 92).

This chisel has a flat cutting edge and can vary greatly in width. It has been implemented, along with the point chisel, in every stone-cutting culture that has used metal tools. It is used as an earlier finishing tool, to smooth away the tracks formed by the *calcagnolo* and/or tooth chisel. It creates sharp edges and fine details, thus defining the parts of the bodies more carefully. In sculpture, it is normally used to refine areas already formed with the tooth chisel and to add details too small to be carved with the other tools.

A channeling tool (*unghietto*) is long, narrow, and flat, with a shaft that swells in the opposite direction of the cutting edge.[7] It is primarily used for carving deep channels in marble; it can fit into a narrow crevice and be struck with a hard blow.

It was used on the *Pietà* in the area between the bodies of Christ and the Magdalene (plate 102), along Christ's neck and right shoulder (plate 104), along the underside of the Virgin's neck, and in two places on the drapery at her chest. Michelangelo rarely used this tool, but because it is found in some areas of the *Pietà* that do not show signs of restoration, its use here is probably by his own hand.

In the quattrocento the drill (*trapano*) was also used to help create channels, which are generally excavated with a channeling tool or a narrow, flat chisel.[8] Since the drill is an abrasive rather than a percussion instrument, it can make deep cuts in marble without damaging surrounding areas. Michelangelo certainly used the drill in his early work, but there are no signs of its use on his later unfinished works.[9] Drill holes appear on the *Pietà* only at the corners of the dowel hole in the trunk of Christ's missing left leg, as these pilot holes served as guides for the

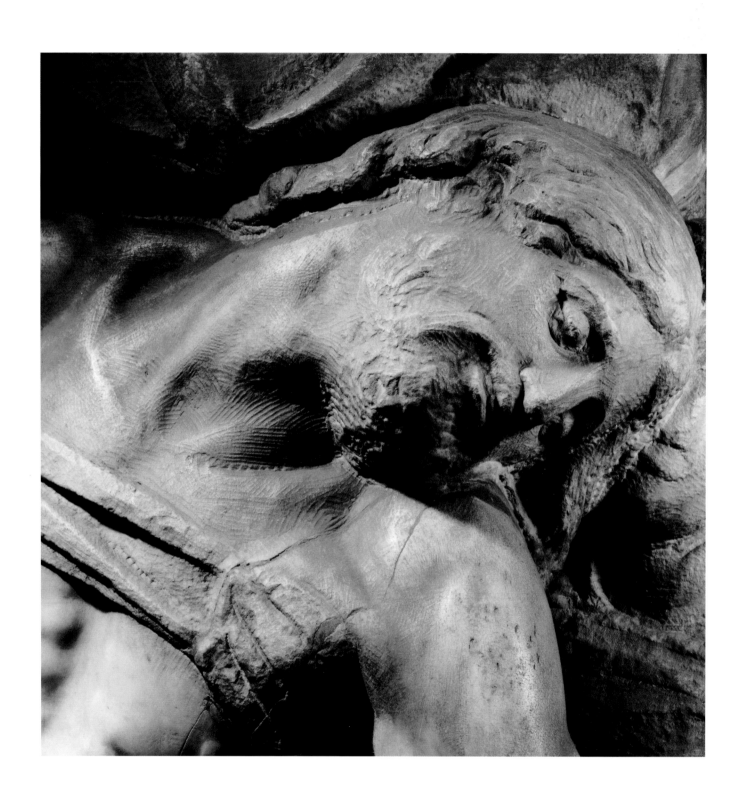

PLATE 104
Christ, neck and left shoulder

instrument that was used to dig out the dowel hole for the insertion of a new leg. Therefore, the drill work was certainly the restorer's.

The rasp (*raspa*) consists of a thin handle with a curved or straight head at each end (plate 97, nos. 11–12). It is one of a sculptor's coarser abrasives and used much as our familiar wood file. With a back-and-forth movement, it cuts and smoothes out the slightly rough surfaces left by the flat or tooth chisels. The slight scratches it creates in the stone tend not to run in parallel lines. A rasped surface can be the final finish for the marble, or it can be further polished with finer abrasives.

The rasp was used by sculptors in ancient Rome and again in Tuscany shortly before 1500 or in the early sixteenth century. I know of no examples of its use in the trecento, or even most of the quattrocento: it is not among the tools depicted on the sculptor Andrea Bregno's tomb in Santa Maria sopra Minerva. On the other hand, it does figure prominently in the writings of Cellini and Vasari in the sixteenth century. Once it became available to sculptors, it could be used after a dog-tooth chisel to give the marble a more highly polished surface.

Rasp work is extensive on the Florence *Pietà* (plate 98).[10] We must be cautious in attributing all the rasp marks to Michelangelo, because, with the exception of Christ's right shoulder (plate 36), they appear in what are probably the most heavily restored parts of the statue (plate 99). The rasping on Christ's shoulder is in a place and was done at a stage of the finishing that could correspond with Michelangelo's usual process: the areas around the shoulder are smooth enough so that the next tool would have been the rasp. Moreover, it is normal practice to start working the rasp from a high point, which in this case is the shoulder.

After the rasp, marble could be further polished with pumice, carborundum, sand, or some other natural abrasive, such as *terra di tripoli*.[11] We do not know enough about stone carving in the Renaissance to speculate on the nature of the abrasives or how many were normally used. The marks of abrasives are not clear enough to allow deductions to be made from them. A coarser abrasive can create a matte, lusterless finish (*levigato*) or a highly polished finish (*lucidato*), which would be achieved with the finest abrasives. We can see the matte finish on the garment of the Magdalene's left, inner leg (plates 6 and 98). The Magdalene's garment (from the waist down) and her restored right arm, and Christ's torso (plate 65), right leg (plate 105), and right forearm (plate 44) have all been highly polished with some form of abrasive.

There are two ways of creating a polished surface on marble. The first is accomplished by rubbing progressively finer abrasives over surfaces to erase all the marks made by metal tools and rougher abrasives. Correctly done, this process leaves the surfaces with a perfectly smooth and unblemished finish. For the finest of the abrasives, the sculptor Francesco Carradori in 1802 recommended goat's bones burned to charcoal, ground to a fine powder with a mortar and pestle and mixed with water.[12] Until recently, the abrasive composition used by stone carvers consisted of salic acid in powder form, which was rubbed across the surfaces with wet burlap. Today this is achieved with 800- or 1000-grain emery paper. According to Vasari, "lastly with points of pumice stone they rub

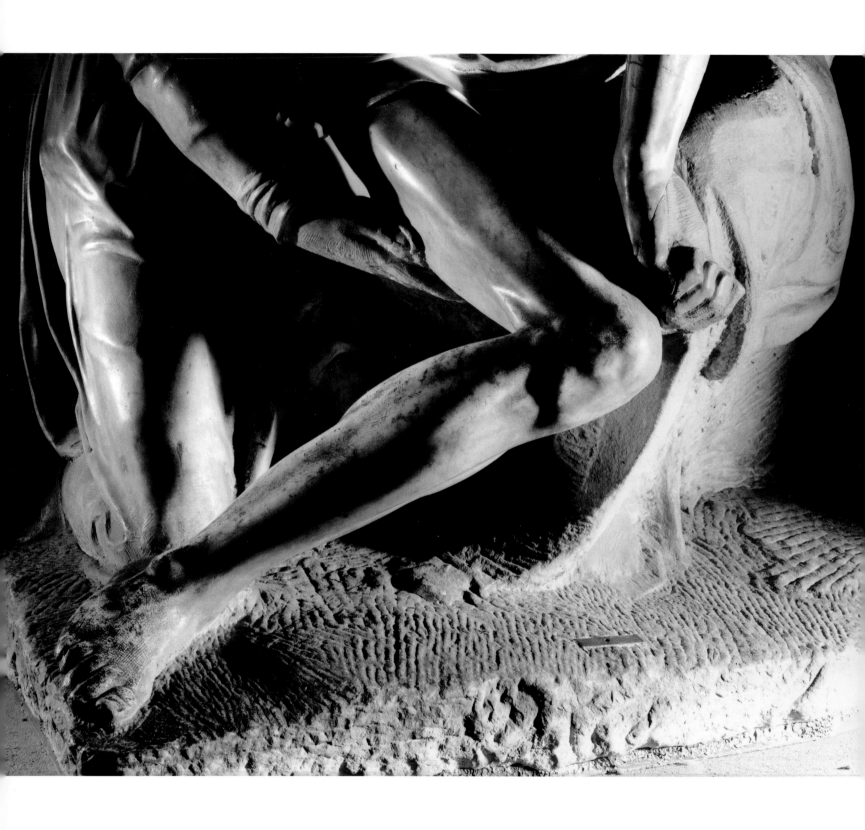

PLATE 105
Christ's right leg and base of the statue

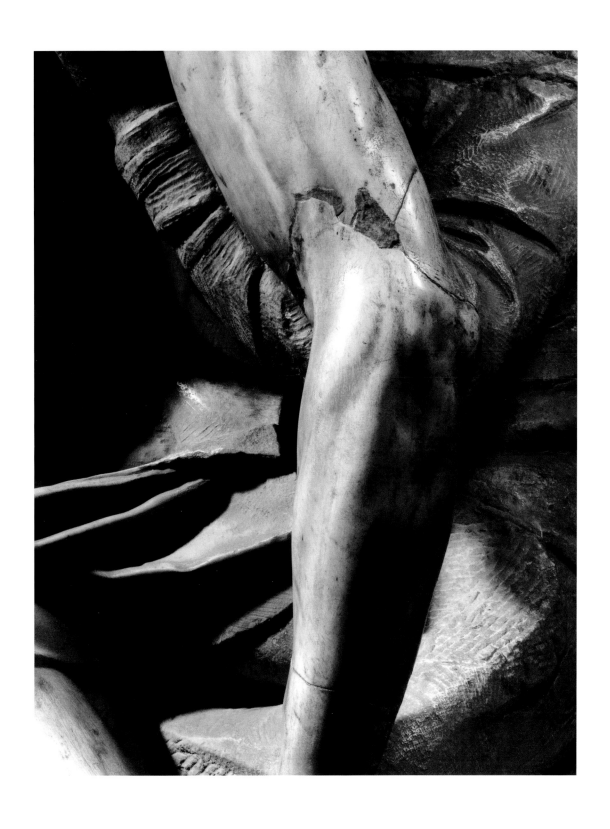

PLATE 106
Christ, left forearm and elbow

all over the figure to give that flesh-like appearance that is seen in marvelous works of sculpture. Tripoli earth is also used to make it lustrous and polished, and for the same reason it is rubbed over with straw made in bunches."[13]

The second method of polishing marble is by applying wax, oil, or animal fats. Since it is a coating applied to the marble rather than a smoothing of the stone, it does not erase the marks of previous tools. Often this treatment causes the marble to change color over time. Marble workers generally consider this sort of treatment a false polish. It is usually done when the worker is in a hurry or is seeking a polished effect without actually removing tool marks on the surface. A variation of the false polish is what occurs when many people over the years have touched or rubbed some part of a marble statue.

There are three different kinds of high polish on the *Pietà*. In the first, as evident on the Magdalene's torso and right thigh (plate 2), abrasives were used, and all the metal tool marks have been rubbed away. The second type of polish, most obvious on Christ's torso, is mostly smooth but with small areas of tooth chiseling or rasping visible beneath the sheen. This would seem to have been done with an incomplete application of abrasives followed by an application of some external polishing agent. In the third, the marks of the rasp and the tooth chisel are virtually untouched. Tooth-chisel marks remain chiefly on Christ's right foot (plate 96), which was rubbed to a high shine by the faithful during the centuries that the statue was in the Duomo.[14] Signs of the rasp are still present on the lower body and arm of the Magdalene and on the restored arms of Christ. A high-quality polish would have erased all these marks.

Finally, there is the question of whether Michelangelo used a model when carving the statue. We might assume that, had he done so, he would have used an enlarging system of some kind to transfer the dimensions and details from the model to the marble. Yet, although the *Pietà* is unfinished, there are no signs anywhere of measuring lines (incised or marked with charcoal or some other medium), points, or holes that would result from this procedure. (Certainly, he did not use a pointing system, such as a pointing machine, which invariably leaves marks on unfinished carving.)[15] Nevertheless, we cannot state unequivocally that Michelangelo did not used a model in the preparation of the statue or speculate what size it might have been. But even if he did, he would have had no means of transferring its exact measurements to the marble; therefore, a model would not have been much more helpful to him than a series of preparatory drawings.[16]

According to Vasari, Michelangelo damaged the *Pietà*. It is not easy to break up a large marble statue. If he had done it with the forceful blows of a large hammer or a sledgehammer, as some suggest, he would have had to hit the center of the part that was to be removed, rather than the joints. Therefore, had Michelangelo struck the sculpture, we would expect to find shattered, pulverized, or bruised surfaces in the areas of the breaks. For example, to break away Christ's right arm he would have had to hammer it a little above the wrist—yet there are no bruises in that area. Nor, in fact, are bruises visible anywhere on the *Pietà*.

An explanation that better fits the character of the breaks would be that Michel-angelo used a point chisel as a wedge, more surgically splitting the stone right where he wanted to dislodge the pieces. A common and effective way of breaking marble is to carve a small hole into it, insert a point chisel perpendicular to the surface, and then hammer the chisel with very strong blows. For example, to break away the right arm of Christ he would have inserted a point chisel into the finger of his right hand (plates 36 and 108, no. 3), perhaps in conjunction with another point chisel between the Magdalene's head and Christ's forearm (plates 44 and 108, no. 1). This method of dislodging parts of the statue supports Jack Wasserman's hypothesis (see chap. 3) that Michelangelo had intentionally planned to remove specific parts of the statue, not destroy the entire work in a sudden fit of passion.

The Virgin's face has been re-carved and therefore set back and made smaller (plates 47 and 107). Immediately to its left one can see the line of the previous larger outline. Because of the free technique with which the face was carved ini-tially with a tooth chisel, we may assume that the attempted revision was the work of Michelangelo.

Overall, we can divide the *Pietà* into five noticeably different areas of tool work (plate 98).[17] First, there is the back of the statue (plates 16 and 63), the front of the bearded figure, the Virgin, Christ's head and right shoulder, and the base. These areas were principally carved with the point chisel and the *calcagnolo* (plate 97, no. 3). Where the tooth chisel is used, as on Christ's head and right shoulder, the marks crisscross each other creating a crosshatch effect. These areas are so simi-lar to passages on other unfinished sculpture by Michelangelo that there can be little doubt that they were carved by him.

The second area of tool working is the body of Christ below the cloth across the chest through his right leg (plate 32). This whole area is polished, but the finish does not seem to be the result entirely of abrasives, because there are places where the finish extends over the marks of a tooth chisel. On the leg and the foot (plates 96 and 98), there are ample signs of the rasp and the tooth chisel. Even leaving aside the foot as a special case because it may have been touched so much, the evidence suggests a polish achieved by the application of wax or ani-mal fats.

The third area is the high polish on the Magdalene's body and right arm (plate 6). This seems to have been done with abrasives, since here there are no notice-able signs of tool marks.

The fourth area is the head of the Magdalene (plates 49 and 61). This area, though unfinished, was carved with a flat chisel. Since Michelangelo rarely used a flat chisel, we might presume this to be the work of another hand. However, carvers frequently experiment with different tools, especially when encounter-ing problems. It is also true that the flat chiseling is both unfinished and gives an interesting effect to the marble surface. Therefore, it does not seem possible to attribute this work definitively.

The fifth area of tool working is Christ's stump (plate 60) and the area of the leg immediately contiguous to it (plate 103), which was carved with a tooth chisel

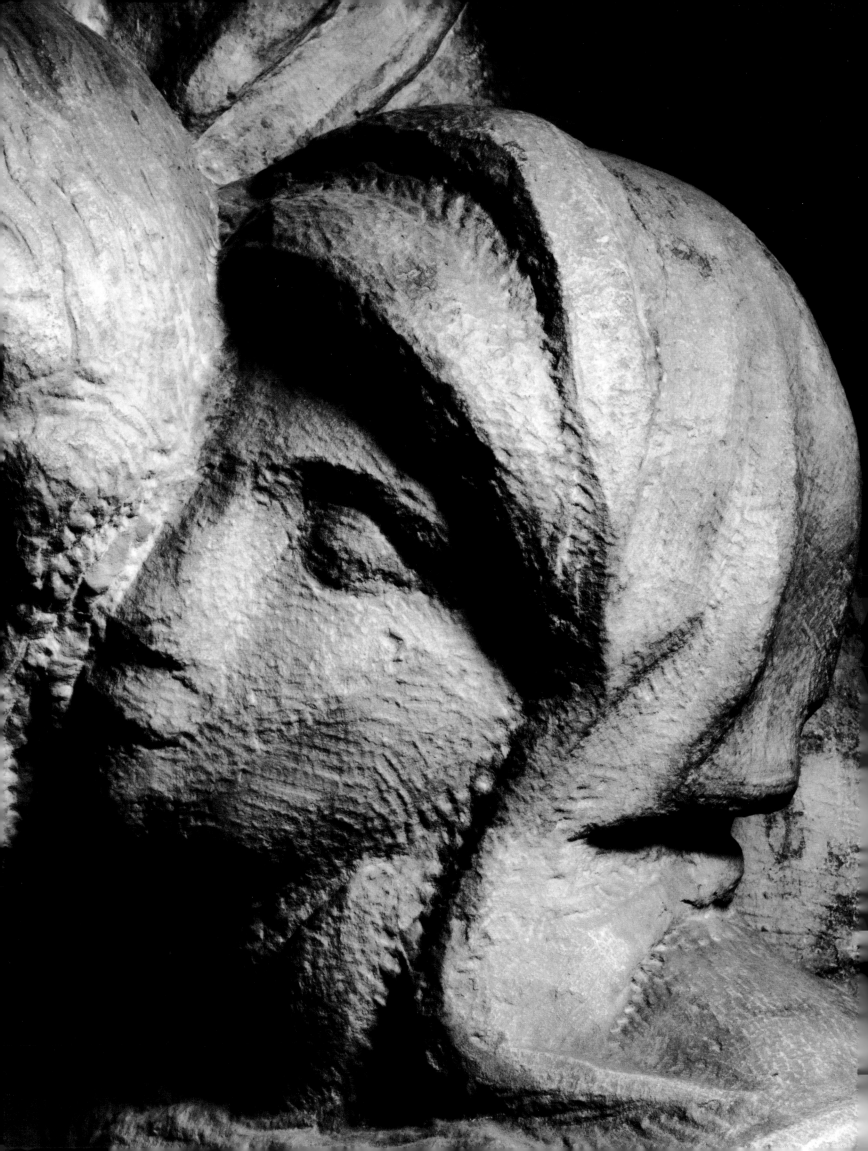

(plates 98 and 99). It is carved in a methodical way, without any signs of cross-hatching. There are marble inserts that form Christ's left hand (plate 52), the finger of his right hand (plate 36), part of the Magdalene's right arm (plate 51), and part of the fingers of Virgin's left hand where it grips Christ's body (plate 15), all of which have the same pattern of tool marks. Since the stump must have been carved by a restorer as a preparation for a new leg, it can be presumed that all these pieces were carved by the same person. This carver was meticulous, careful, and worked in an artisan-like way.

Michelangelo's innovative way of using the tooth chisel (plate 100) can be clearly distinguished from the more conventional use of the tooth chisel, evident on the stump of Christ's missing leg (plate 60), where the chisel has been moved neatly across the stone, cutting it in regular parallel lines of equal depth. Thus, the sculptor carved the piece, as traditional, from a single position and in the manner of a craftsman working in a practical way. Michelangelo, on the other hand, worked the tooth chisel in diverse directions across the marble surfaces. The Virgin's face and left arm, the bearded figure's hand on her back (plate 26), and Christ's neck all show this tendency of Michelangelo frequently to change the direction of the tool to achieve that crosshatched surface. Such an unusually free change of direction while carving with the tooth chisel suggests that he was still deciding what form the area might take. He seems to have been in a process of experimentation, carving first one way and then another. Successive passages make the form clearer, but also change it subtly.

There are five different levels of restoration evident on the *Pietà*. First are the point-chiseled areas on the drapery beneath the Virgin's thigh (plate 3) and on the base, which has roughly the shape of a foot (plate 58). Both these areas seem to show the work of a carver who is erasing what remained of Christ's leg after Michelangelo damaged it. The work in both areas was presumably preliminary, and would eventually have been finely blended with the contiguous areas. Second, Christ's leg stump and areas near it show the incomplete preparation for the addition of the missing leg (plate 60); the work with the point chisel is very careful, suggesting the carver was following a deliberate plan. But the effort to accommodate a new leg, which required more advanced carving with the tooth and flat chisels, remained incomplete. However, even if the restorer had fully prepared the area for a leg, there does not seem to be enough space without either carving more deeply into the Virgin's thigh or cutting away more of her arm. The third level of restoration is seen in several places: where Christ's right hand attaches to the Magdalene (plate 108, nos. 2 and 3), where Christ's left shoulder attaches to his arm and the Virgin's left hand (plates 56, 92, 104, and 108, nos. 7 and 9), and where Christ's left hand is repaired and attached to his knee (plates 52, 101, and 108, nos. 13 and 14) there are inserts fitted to complete each attachment. In each case, the inserts show different tool marks from those on the contiguous marble; moreover, the carving on the inserts is similar to that on Christ's stump. There are also slight differences in level between the inserts and the parts to which they attach. Presumably this, too, is an incomplete restoration, as the differences

PLATE 108
Diagram of the Pietà *with the
restored pieces numbered*

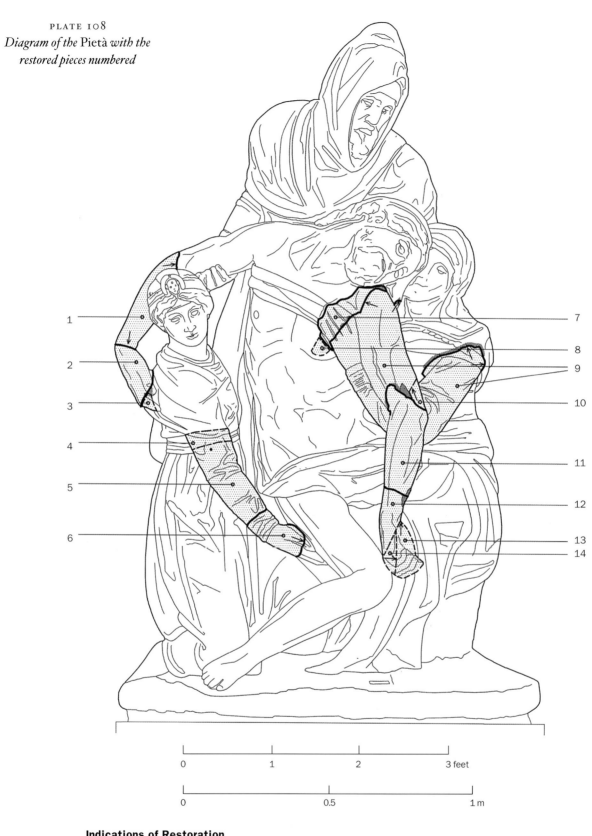

1
2
3
4
5
6

7
8
9
10
11
12
13
14

0 1 2 3 feet

0 0.5 1 m

Indications of Restoration

 Fractures Stucco infills

 Smooth fractures Diverse levels

192 APPENDIX A

between the surfaces are not masked in any way. Fourth, the restoration of the Magdalene's right arm is a careful and complete restoration (plates 32 and 108, nos. 4–6). A piece has been inserted in the upper arm using metal pins (plate 51), and the surfaces of the insert, shoulder, and arm have been smoothed to make a consistent level and finish. This is the only area of the *Pietà* that shows a completed craftsmanlike restoration. Fifth, Christ's left elbow has been restored with the use of a stucco in-fill rather than an insert (plates 54, 55, and 108, no. 11). There are also jagged lines dividing the pieces, suggesting that these are broken fragments attached without reworking or careful preparation of inserts. This technique of restoration is markedly different from that used on either the Magdalene's arm or Christ's wrist and shoulder.

Viewing the repairs, it is apparent that there were at least two restorations. One was carried out by a restorer who was a careful craftsman, who wished to make the final work look like a completed statue without discordances between the restorations and the original parts. The problem with this method is that it can contradict the unfinished character of much of the undamaged parts of the statue. The Magdalene stands out like a sore point against the rough forms of much of the rest of the statue.

The second restoration is most visible in Christ's left elbow. The restorer has simply tried to put together existing fragments. To modern sensibilities this is a much more honest, reliable restoration: there is no attempt to create an effect of a complete, undamaged sculpture. The restorer is not trying to theorize, only to repair. However, in the sixteenth century this would have been considered a careless solution. The restoration of Christ's shoulder and wrist, as well as the attachment of his hand to the Magdalene's shoulder, falls between the two types of restoration. Inserts have been prepared and put in place, but they have not been worked to match the surfaces with the marble around them. These areas suggest the work of both restorers, the first preparing the work but the second actually joining the pieces. Christ's stump looks to have been prepared by the first restorer. The leg that would have been placed there was either never prepared, never completed, or simply unavailable to the second restorer.

It is important to note that no evidence in the marble gives us any indication of the time that elapsed between the first and second restorations or who might have done them. If my analysis is correct, the second restorer, when putting together the arms, had available prepared pieces that had been carved by the first restorer.

This hypothesis for the restoration of the *Pietà* does not take into account the problems presented by the possible varieties of polish or the yellow and brown colors on the stone. A this point there is no agreement among scientists or restorers on how various polishing materials affected white marble.[18] Nor can we establish from the marble whether the polish was applied as a part of the original restoration or at a later date—and if it was later, perhaps that polish should, in fact, be considered a third restoration. There are ancient statues in the Capitoline Museum that have undergone three or more restorations since the

sixteenth century, so we should not discount the possibility of such a history of restorations also for the *Pietà*.[19]

The gamma-graphic examination of the breaks and the examination of the in-fills might point to the possibility that more than one restorer was involved in the re-piecing of the statue (see appendixes B and C). The pins are seated three ways: in one, lead is on one side and a natural resin on the other; the second uses resin on both sides of the break; while in the third, one pin is imbedded in lead on both sides. Chemical testing has shown that there are two different types of in-fills (see appendix C).

The *Pietà* is the product of Michelangelo and of others: restorers and, perhaps, assistants, the latter confining their labor to roughing out the block of stone in preparation for the detailed work to be carried out by the master. We can be certain of Michelangelo's contribution, however, in the overall composition and in the exceptional handling of the sculptor's tools in carving the heads of Christ, the bearded figure, and the Virgin. His manner of composing by discovering the forms of the heads and the sureness with which he carved the details show him to have had an amazingly versatile control over his tools. Studying the statue is like witnessing a great master in the midst of the creative act.

But Michelangelo considered the *Pietà* a failure. He mutilated it, and then abandoned it entirely. We may wonder about what would have prompted him to take such actions after such an investment in marble and labor, white statuary marble being, after all, quite expensive, and carving it being a considerable investment of time.

What was it about the statue that made Michelangelo decide to break it up? He may have complained about defects in the marble, as Vasari claims, but it is obvious from the more finished parts that the marble is of high quality. Perhaps it was posing such difficult compositional problems that he could see no way to carve his way out of them. For example, it seems that he could not give proper size to the Virgin's face, which he recarved using a free technique, initially with a tooth chisel. Therefore the outline of the face was set back and the face itself made too small to be anatomically convincing (plates 47 and 107). Still more troubling are the ill-proportioned Magdalene and the awkward imbalance of proportion between her and the other three figures. As Wasserman points out in chapter 4, these dimensions can be attributed to Michelangelo himself. Presumably, it was an unhappy result of his roughing out the statue. The evidence of Michelangelo's carving seems to be in conflict with his well-known assertion that there is only one form waiting to be discovered in a marble block. Here we see him trying something, then changing his mind—as in the carving of the Virgin's head, or most radically in the recarving of the arm of the Rondanini *Pietà* (plate 8)—or else he carefully leaves enough stone to allow for a change of mind, as in the Christ child's left hand in the *Pitti Tondo*.[20] Michelangelo worked on the Florence *Pietà* not as a carver who saw the form within the stone, but rather as an artist looking for the form as he moved into it. Indeed, much of the pleasure in looking at the *Pietà* lies in the unexpectedness of what we see. It does not follow

the ordered pattern that is traditional for marble carving, rather it allows us to follow the sculptor's thinking.

Michelangelo demonstrated a flexibility and freedom as a carver that no sculptor has ever shown; this led him down different pathways on the same piece of stone. It is probably Michelangelo's very genius as a sculptor, allowing him to work with a flexibility unknown to others, that made finishing the *Pietà* verge on the impossible.

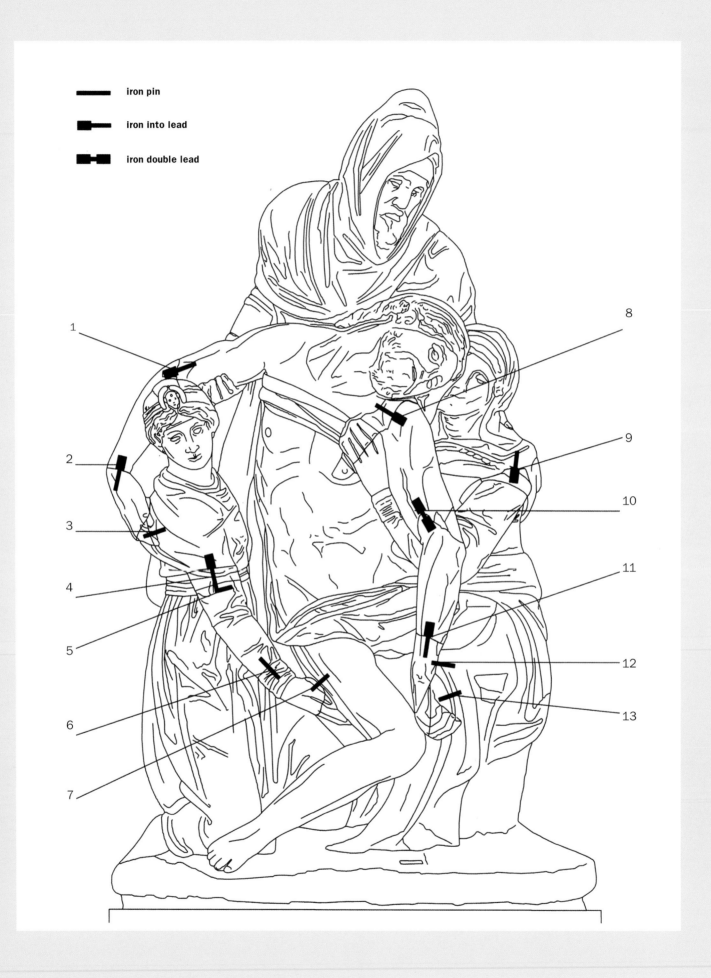

iron pin

iron into lead

iron double lead

GAMMAGRAPHIC EXAMINATION OF THE *PIETÀ*

Ente per le Nuove Tecnologie, l'Energia e l'Ambiente
Unità Salvaguardia Patrimonio Artistico (ENEA) of Rome

Pietro Moioli

THE *PIETÀ* WAS EXPOSED TO GAMMA RADIOGRAPHY EXAMINATION in order to discover the presence of reinforcing metallic pins used to repair the fractures, to locate their positions, and to determine their forms and conditions. The irradiations were performed on site, so the statue did not have to be removed from its base.

Irradiations

A gamma-ray source of cobalt[60] of an activity of about 2 curie was used to examine the distance between the source and the median surface of the particular area of the statue where the pins were likely to be present.[1] The distance was

PLATE 109
Diagram of the Pietà *indicating type
and locations of the pinwork*

kept nearly constant at 50 centimeters. The distance between the radiation and the film surface varied according to the thickness of the marble.

The distances between the source and the film, and between the film and the median surface, were measured before every irradiation. Where possible, these measurements helped to estimate the dimensions of the pins and the cavities in which they are inserted, starting with their apparent dimensions on the plate.

The length of exposure necessary to obtain good quality images was determined by the thickness of the marble in each position, based on previous laboratory experiments with marbles of different thickness under similar conditions.[2] In this regard, it is important to point out that with gamma radiography, images are generally less defined than those obtainable with normal radiography, due to the fact that the higher the energy of the electromagnetic radiation, the more the radiation itself is diffused. It is necessary to take into account that both direct and diffused radiation reaches each specific area of the film. The first is the radiation that crosses the corresponding part of the object without being absorbed and forms the image. The last one is the radiation diffused by the surrounding parts of the statue, generating halos and nuances on the image and causing a loss of definition. However, the diffused radiation is less penetrating than direct radiation and can be attenuated with suitable use of metal filters. To this end, in fact, Agfa D8-type plates were used, together with lead screens 25μm thick.

The positions of the individual plates during radiation are illustrated in the CD-ROM included with this volume. The direction of the irradiation, from source to object to film, determines the position of each plate and relate to the observer standing in front of the statue. Plate 109 provides a diagram outlining the severed parts and fractures that guided our radiography and illustrates the pinwork we discovered and their locations. The figure appears in the CD-ROM together with the gamma radiography images of each pin.

Analysis of the Images

The overall analysis of the gamma radiography examination shows the presence of pins in each of the fractures and two different methods of inserting them. In the first type, the pin is inserted in a material that is less opaque to radiation than the marble, and thus less dense than on both sides of the fracture (plate 109, nos. 3, 6, 7, 12, and 13). The second type of pin is fixed on one side of the fracture with a material (probably lead) that is highly opaque to radiation. Where the pin can be observed through the lead, it extends to the end of the cavity, and on the other side of the fracture, the pin is inserted as in the first type (plate 109, nos. 1, 2, 4, 8, 9, and 11).[3] The lead could have been fixed around the pin in two ways: either poured in a molten state (a technique in use since Roman antiquity) or hammered in as solid lead. Casting was certainly used in the break in Christ's right elbow (plate 109, no. 1); the hammering method was used in the break in Mary Magdalene's right arm (plate 109, no. 4). The images indicate that there is no sign of corrosion of the metal of the pins.

The major information deduced from each image is summarized in table B.1. The sizes of the pins and the cavities in which they are inserted are given in millimeters as follows: the thickness and length of the pins, and the width and depth of the cavities. Although these dimensions have been corrected to adjust for deformations in the images due to the distances between the object and plate, they should be considered approximate because of the surrounding haloes and the irregularity of details.

Table B.1. Dimensions (in mm) of the pins and their containers.

Location of Pin (see plate 109)	Description of Location of Pin	Pin Type	Dimensions of Pin	Cavity with Lead		Cavity in the Marble	
				side	dimensions	side	dimensions
1	Christ's right elbow	2	21 x 122	forearm	40 x 56	upper arm	31 x 67
2	Christ's right wrist	2	13 x 85	forearm	23 x 41	hand	25 x 54
3	Christ's right hand	1	15 x 27			hand into back	20 x 32
4 and 5	the Magdalene's right arm	2	15 x 148	shoulder	34 x 52	arm	34 x 112
6	the Magdalene's right wrist	1	10 x 93			both	25 x 107
8	Christ's left shoulder	2	20 x 103	arm	36 x 82	shoulder	20 x 103
9	the Virgin's shoulder	2	28 x 185	arm	47 x 86	shoulder	28 x 99
10	Christ's left elbow	2		upper arm forearm	25–40 x 80 36–45 x 49		
11	Christ's left forearm	2	14 x 37	elbow	23 x 48	wrist	14 x 37
12	Christ's left wrist	1	7 x 39			both	7 x 39
13	Christ's left hand	1	7 x 32			both	7 x 32

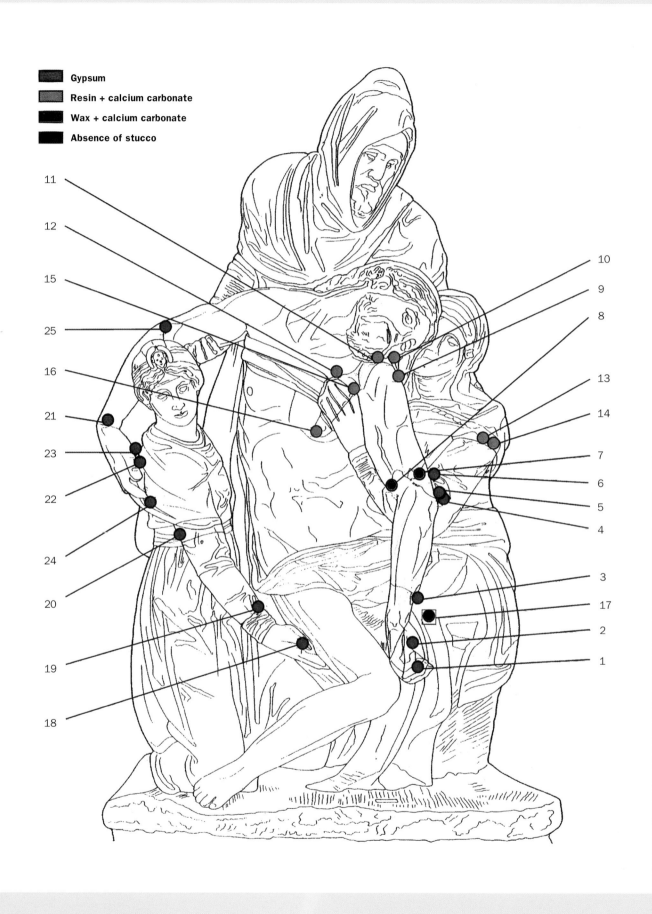

Gypsum

Resin + calcium carbonate

Wax + calcium carbonate

Absence of stucco

SCIENTIFIC EXAMINATION OF THE *PIETÀ*

Opificio delle Pietre Dure (OPD) of Florence

Alfredo Aldrovandi, Carlo Biliotti, Carlo Lalli,
Mauro Matteini, and Maria Rosa Nepoti

Problems Studied and Techniques of Investigation

The examination of the *Pietà* by the scientists of the OPD focused mainly on the areas that show clear signs of breakage and subsequent joints where the broken pieces were reattached, together with a series of stucco inserts in the missing parts. It was clearly not feasible to take samples of the marble from this masterpiece; only nondestructive techniques were considered from the outset and samples were limited to the stucco inserts. Had we been able to take samples of the marble itself, it would have been possible to analyze its isotopic composition and thereby obtain more precise information on the stone's origin and provenance.

The scientists of the laboratory of the OPD first suggested which of the various techniques of investigation would be most useful for this study. Some of these techniques were available to the OPD itself, while the collaboration of the Ente per le Nuove Tecnologie, l'Energia e l'Ambiente Unità Salvaguardia Patrimonio

PLATE 110
Color-coded diagram of the Pietà
indicating type and location of the stuccowork

Artistico (ENEA) was required to determine the presence of metal pins in the marble by gamma-ray examination. Their findings are provided in appendix B.

After a thorough inspection of the surfaces of the statue to determine the character of the finish, the shape and appearance of the fragments, and how they are connected to each other, the OPD laboratory carried out three types of examination. The first was a preliminary examination of the entire marble surface under UV (ultraviolet) radiation, in order to document the presence and distribution of materials that would be difficult to detect with the naked eye but that might generate UV fluorescence. Of particular interest was the UV optical response in the joints, in view of the stucco samples involved. The second investigation consisted of a chemical analysis of the composition of the different stucco in-fills. Thirdly, we set out to determine the composition of the surface patinas the covered parts of the statue.

Visual Examination of the Surfaces

The fragmentation affected three areas of the statue: the right forearm of Christ, the right arm of Mary Magdalene, and the left arm of Christ and left arm of the Virgin. Stucco is present in all the fragmented areas. Some of it can be recognized as adhesive material used to join marble parts (joining stucco), while other stucco served to reestablish the continuity between the marble pieces (reintegrating stucco). The appearances of the stucco in-fills are not uniform, possibly suggesting different compositions.

As for the severed parts, they cannot be recognized a priori as original fragments of the statue. It is reasonable to hypothesize that some parts had been completely destroyed and replaced with new marble pieces. The original and new fragments, whose positions are diagrammed in plate 108, are enumerated in the following list, along with references to photographs of the new and questionable pieces.

Right forearm of Christ
plate 108, no. 1: right forearm of Christ (original)
plate 108, no. 2: right hand of Christ (original)
plate 108, no. 3: fingers of right hand of Christ (partially new, plate 36)

Right arm of Mary Magdalene
plate 108, no. 4: cylindrical insert near shoulder (new, plate 51)
plate 108, no. 5: right arm of the Magdalene (original)
plate 108, no. 6: wrist and part of the right hand of the Magdalene (original)

Left arm of Christ and left arm of the Virgin
plate 108, no. 7: fingers of the left hand of the Virgin and part of the shoulder and back of Christ (original, plates 15 and 32)
plate 108, no. 8: left nipple of Christ (new, plates 15 and 32)

plate 108, no. 9: left upper arm of Christ and left arm of the Virgin (original)

plate 108, no. 10: insert on the left elbow of Christ (original, plate 55)

plate 108, no. 11: left forearm of Christ (original)

plate 108, no. 12: left wrist of Christ (original)

plate 108, no. 13: palm and fingers of the left hand of Christ (new, plates 52 and 101)

plate 108, no. 14: back of the left hand of Christ (new, plate 53)

Visual examination provided us with certain preliminary information, in particular, the configuration of the marble fragments and their edges and the continuity between the contiguous marble fragments. In terms of their configuration, several parts have geometric shapes whose edges are too regular to have been broken away from the statue. Among these are the cylindrical insert in the right arm of the Magdalene (plate 108, no. 4); the palm and fingers of the left hand of Christ (plate 108, no. 13); and the back of the left hand of Christ (plate 108, no. 14).

It is important to assess the appearance of the finished surfaces of contiguous elements with care; nonetheless, appearance alone is insufficient to demonstrate whether an element belongs to the original group. Indeed, in the course of reconstructing the statue, Tiberio Calcagni may have reworked those surfaces that Michelangelo had left unfinished and included new pieces to replace those that had been totally destroyed. The cylindrical insert in the upper part of the Magdalene's right arm is an example (plate 108, no. 4). It is likely that Calcagni inserted the new cylindrical piece in a rough state and subsequently finished it together with the adjacent parts.

A final consideration should be made concerning the patinas that are easily discernable on the marble. A dark stratification covers most of the back of the statue, except the sheltered areas. Possibly, it is the result of a spontaneous atmospheric deposit that gradually accumulated and became consolidated. A thin, yellowish, transparent film covers the entire front of the statue and ends abruptly along the two sides of the Magdalene and the Virgin. This patina seems to have been applied deliberately rather than having been caused by atmospheric conditions.

Fluorescence of the Surfaces under Ultraviolet Light

Filming Conditions and Areas Examined

The entire surface of the statue was examined under UV light using a Wood lamp, with a 365 nm wavelength. Special attention was given to the fluorescent responses near the joints and breaks, which contain the stucco in-fills.

By means of the color fluorescence, a significant grouping can be made of the different stuccoes in accordance with their compositions. This grouping can be used for sampling purposes also. Photographic documentation was carried out only where preliminary observation with the Wood lamp revealed significant differences. Filming was carried out with the use of two UV sources, each with four 18-watt Wood tubes. A reversible Fuji RHP 400 ISO film with a low nonreciprocity effect was used, together with a Schott anti-UV KV 450 barrier filter.

Table C.1 lists the eleven areas that were photographed with both UV and diffused light in order to provide a direct and immediate comparison.

Table C.1. List and position of areas examined under UV light.
(One set of diffused lighting and ultraviolet photograph is illustrated in the text with appropriate figure number, the other photographs are available on the accompanying CD-ROM and are indicated in the text with appropriate UV numbers corresponding to those found in the left-hand column below.)

UV Light	Area of Statue	Type of Exposure
UV1	right hand of Christ and back of the Magdalene	general exposure and detail of hand
UV2	left arm of Christ	general exposure and detail of arm/forearm joint
UV3	left hand of the Virgin	general exposure
UV4	right arm of the Magdalene	general exposure and detail of stucco in back of the insert
UV5	right knee of the Magdalene	general exposure
UV6	left hand of Christ	front and side exposure and from underneath
UV7	left knee of the Virgin	general exposure
UV8	left shoulder of the Virgin	general exposure and detail of the arm's point of attachment
UV9	right hand of the Magdalene	general exposure
UV10	right knee of Christ	general exposure
UV11	back of statue	exposures of the two stucco inserts on the left side of the bearded figure

Observations on the Results of the UV Fluorescence

The stuccoes at the joints can be grouped into three categories because of the different fluorescence tonalities, reflecting different compositions. Several of the stucco in-fills are virtually without fluorescence or show a very dark tonality, such as the two on the side of the bearded figure (UV11) and the joint between the hand and right arm of Christ (UV1). Other stuccoes, in particular those in the joints of Christ's left hand (UV6) and the Magdalene's right arm (UV4), have a gray-blue tonality of medium intensity.

A yellowish fluorescence was distinguished on the various stuccoes on the left shoulders of Christ (UV2) and the Virgin (UV8). These look dark under

direct observation. An intense yellow fluorescence was recorded on the reintegrating stuccoes near the elbow of Christ's left arm.[1]

The UV examination permitted us to detect the presence of other materials that otherwise would have been difficult to distinguish. Clearly visible are numerous parallel droppings with a strong white fluorescence in various locations, such as on the Magdalene's calf (UV5; plate 111) and shoulder, as well as in back of the marble group and on the heads of the Virgin and Christ. They interrupt the continuity of the yellow-brown patination that covers the front of the statue. The droppings indicate the later addition of extraneous material, possibly when casts were made of the statue.

The UV examination also revealed a series of small stains with a strong yellow fluorescence, found on the back of the Magdalene's left shoulder (UV1) and in other areas. Their shape suggests that a fluid substance was accidentally spattered on the marble surfaces. Finally, at least two or three well-circumscribed areas have a gray fluorescence that is darker than the surrounding surfaces. These are situated only in cavities of the sculpture, for instance between the Virgin's forearm and Christ's arm (UV2) and behind the armpit of the Virgin (UV8).

Study of the Compositions of the Joining and Reintegrating Stuccoes

Stucco Samples

Small samples in the form of powder were taken from the stucco in all twenty-seven areas where they appeared. In order to avoid misleading results, a thin layer was first removed from each surface so as to eliminate extraneous substances that might have been deposited from the atmosphere or applied in recent maintenance.

Table C.2 lists the samples taken, their appearance, and their locations in the statue. The photographs of the places where samples were taken are available in the CD-ROM.

Table C.2. Sample, position, and description.

Sample (see plate 110)	Position	Description
1	joining stucco between the fingers of Christ's left hand and the left knee of the Virgin	white color, chalky appearance
2	joining stucco between fragment of Christ's left hand and wrist and the Virgin's knee	light gray color, similar to sample 1, but softer in substance
3	reintegrating and joining stucco between the left wrist and forearm of Christ	white color

Sample (see plate 110)	Position	Description
4	reintegrating stucco at Christ's left elbow, between upper arm and forearm	white color
5	joining stucco between Christ's and the Virgin's left elbows	white color
6	joining and reintegrating stucco of a marble fragment applied to Christ's left elbow	white color
7	reintegrating stucco at the joining of the two rear parts of Christ's left arm	yellow-gray color; hard, translucent material
8	reintegrating stucco at the joining of the two front parts of Christ's left arm	yellow-gray color similar to sample 7; hard, translucent material
9	joining and reintegrating stucco on Christ's left shoulder blade	reddish-yellow color
10	joining and reintegrating stucco on the rear of Christ's left shoulder (separate fragment)	color as in sample 9
11	joining and reintegrating stucco on Christ's left shoulder	color as in sample 9
12	joining and reintegrating stucco at the ends of the Virgin's left-hand fingers	color as in sample 9
13	joining and reintegrating stucco where the Virgin's left arm joins her shoulder as seen from the front of the statue	color as in sample 9
14	joining and reintegrating stucco where the Virgin's left arm joins her shoulder as seen from the side of the statue	color as in sample 9
15	joining and reintegrating stucco between the fingers and back of the Virgin's left hand	color as in sample 9
16	joining and reintegrating stucco at Christ's nipple	color as in sample 9
17	sample from the rectangular dowel hole in Christ's left thigh	whitish color
18	joining and reintegrating stucco between the back and fingers of the Magdalene's right hand	white color
19	joining and reintegrating stucco at the Magdalene's right wrist	white color
20	joining stucco in the rear of the cylindrical insert in the Magdalene's right arm	white color
21	joining stucco at the wrist of Christ's right arm	white color
22	reintegrating stucco at the fold of the Magdalene's drapery in back, detached with Christ's right hand	white color
23	joining stucco between Christ's right hand and the Magdalene's shoulder	white color
24	joining and reintegrating stucco between Christ's right index finger and the back of the Magdalene	white color
25	joining stucco between Christ's right forearm and upper arm	white color

Sample (see plate 110)	Position	Description
26	reintegrating stucco on the upper-left side of the bearded figure (one of two)	grayish color
27	reintegrating stucco on the upper-left side of the bearded figure (one of two)	grayish color

Spectrometric Fourier-Transform Infrared (FT-IR) Analysis of the Stucco In-fills Grouped According to Their Compositions

After impurities were removed, the twenty-seven stucco samples were analyzed by means of FT-IR Spectrometry with the KBr pellet technique using a Perkin Elmer 1725 X Spectrophotometer. Composition and semiquantitative evaluation of each sample as analyzed by FT-IR are collected in table C.3.

Table C.3. FT-IR analysis of stucco samples. The number of plus signs indicates the approximate quantity of each substance; "tr" indicates the presence of traces of each substance; a minus sign indicates the absence of the substance.

Sample (see plate 110)	Gypsum	Calcium Carbonate (Marble)	Calcium Oxalate	Nitrates	Beeswax	Rosin (Colophony)	Silicates
1	++++	tr	tr	tr	-	-	-
2	++++	tr	-	-	-	-	-
3	++++	-	(+)	tr	-	-	-
4	++++	tr	tr	tr	-	-	-
5	++++	tr	tr	tr	-	-	-
6	++++	tr	tr	tr	-	-	-
7	-	+++	-	-	+++	-	-
8	-	+++	-	-	+++	-	-
9	-	+++	-	-	-	+++	-
10	-	+++	-	-	-	+++	-
11	-	+++	-	-	-	+++	-
12	-	+++	-	-	-	+++	-
13	-	+++	-	-	-	+++	-
14	-	++++	-	-	-	++	-
15	-	+++	-	-	-	+++	-

Sample (see plate 110)	Gypsum	Calcium Carbonate (Marble)	Calcium Oxalate	Nitrates	Beeswax	Rosin (Colophony)	Silicates
16	-	+++	-	-	-	+++	-
17	-	++++	-	-	-	-	+
18	++++	tr	-	-	-	-	-
19	++++	tr	tr	tr	-	-	-
20	++++	tr	tr	tr	-	-	-
21	++++	tr	tr	tr	-	-	-
22	++++	-	-	-	-	-	-
23	++++	-	-	-	-	-	-
24	++++	-	-	-	-	-	-
25	++++	-	-	-	-	-	-
26 (not illustrated)	tr	+++	+++	-	-	-	+++
27 (not illustrated)	tr	+++	+++	-	-	-	+++

Four types of composition were clearly distinguished:

Gypsum (14 stucco in-fills): samples 1–6, 18–25
Rosin mixed with marble powder (8 stucco in-fills): samples 9–16
Beeswax mixed with marble dust (2 stucco in-fills): samples 7, 8
Cement (2 stucco in-fills): samples 26, 27

The composition of the two cement samples (26 and 27) clearly indicates a recent intervention. Sample 17 is not stucco, but a combination of marble (scraped from inside the dowel hole in Christ's left thigh) and silicate deposits from the atmosphere. The two beeswax/marble dust samples (7 and 8) are stuccoes used to fill two small lacunae.

Our greatest problem was how to explain the use of two different compositions (gypsum and rosin/marble dust) for the joining and reintegrating stuccoes: table C.4 lists the samples grouped according to their composition and location in the statue.

Table C.4. Grouping of samples according to composition and general location (see diagram, plate 110).

Location	Gypsum	Beeswax/Marble Powder	Rosin/Marble Powder	Cement
Christ: left shoulder, arm, and hand	1, 2, 3, 4, 5, 6	7, 8	9, 10, 11, 12	
the Magdalene's right arm	18, 19, 20			
Christ's right arm and hand	21, 22, 23, 24, 25			
the Virgin's left arm			13, 14, 15	
Christ's nipple			16	
the bearded figure's left side				26, 27

Plate 113 documents one of the locations from which a sample of stucco was taken (all the sample locations are visible in the CD-ROM). Plate 112 is a graph of the FT-IR spectra of significant samples (2, 7, 10) of the three principal stucco compositions identified (gypsum, rosin/marble powder, beeswax/marble powder).

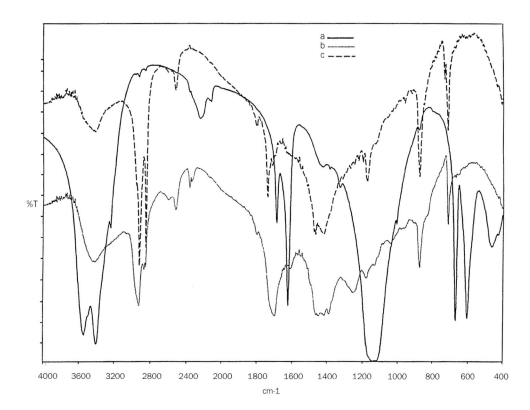

LEFT **PLATE 112**
*FT-IR spectra of samples (2, 7, 10)
of the three principal stucco
compositions (a=gypsum, b=rosin,
c=beeswax/marble dust)*

ABOVE **PLATE 113**
*Locations of the stucco samples
subjected to chemical analysis*

Characterization of the Patinas by Means of FT-IR Spectrometry

Samples of the yellow patina from the front of the statue were taken using a special technique in order to prevent contamination with marble dust. Tests were first made with distilled water, acetone, ethanol, and trichloroethylene to determine the most appropriate for this operation. Water was found to be the most effective. Ethanol worked only partially and the other two solvents had no effect at all. Therefore, a mixture of distilled water and talcum powder (an inert and insoluble substance) was applied to the surface for a time adequate to remove the patina samples. The dissolved fraction was separated from the talcum in the laboratory by centrifugation and then dried. The residue was analyzed by FT-IR.[2]

For comparison purposes, samples were taken from areas covered with the yellow patina and control samples were taken from adjacent areas. A pair of samples were taken from each of two locations: the left arm of the Virgin and the Magdalene's side. The entire back of the statue has a blackish patina, which appears quite different from the yellow one; therefore, a sample was also taken from this area (plate 4). A final sample was taken from one of the numerous small, dark stains visible primarily on the back of the statue and in several other locations. Table C.5 summarizes the results of the FT-IR analyses.

Table C.5. Composition of the patinas and other materials on the surfaces, as deduced from FT-IR analysis. The number of plus signs indicates the approximate proportion of each substance; "tr" indicates the presence of traces of each substance; a minus sign indicates the absence of the substance.

Location	Gypsum	Proteinaceous Materials	Nitrates	Silicate	Beeswax
yellowish patina from the Virgin's left arm	++	+++	+	tr	-
area without yellow patina adjacent to previous sample	+++	++	-	tr	-
yellowish patina from side of the Magdalene	+	++	++	tr	-
area without yellow patina adjacent to previous sample	+++	++	-	tr	-
back of statue, at waist level of the bearded figure	+	+++	+	-	-
dark stains on back of the statue	-	-	-	tr	+++

The most significant result regarding the composition of the yellowish patina is that it is composed of a water-soluble protein-based material (plate 114). Its most likely composition is animal glue which has IR-spectrum that is perfectly compatible with that of both samples of the yellow patina. Water-soluble proteinaceous material was also found in the grayish adjacent areas where the yellow patina is absent. Oils, soaps, fatty substances, resins, and waxes are completely absent in all the samples examined. Nitrates were found largely in the

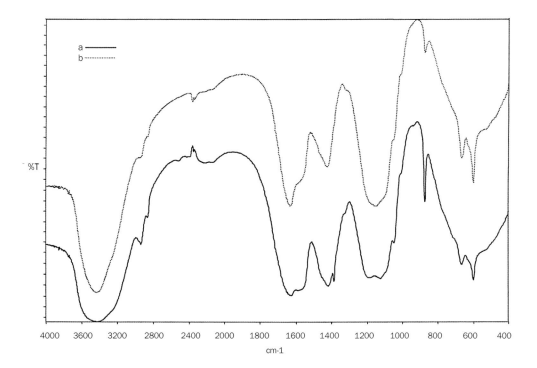

PLATE 114
*FT-IR spectra of patina samples
(a=yellow patina, b=area adjacent
to yellow patina)*

samples of the yellow patina, and this provides further confirmation of its proteinaceous nature (nitrates are well known to be the final stage in the decomposition of proteins). Gypsum is abundant in almost all the samples and is an atmospheric deposit (in contrast to the gypsum that was found in the stucco).

The yellowish patina of animal glue was probably applied in recent years, given its easy water solubility. Its color may be the result of natural aging. The dark layer on the back of the statue is mainly composed of gypsum, which is an atmospheric deposit. Its very dark appearance is due to the presence of carbon in the gypsum (plate 16). Proteins were also found in this layer. Samples from the areas adjacent to the yellow patina and from other areas of the statue contain protein and gypsum as well. This would suggest the existence of an older proteinaceous patina, which is covered in front by the yellow patina and on the back by the dark deposits. The small black stains are entirely beeswax; their color results from the presence of carbon particles.

Sequence of the Reconstruction

The gamma-ray examination by the ENEA (see appendix B) reveals the presence of metal pins joining the separate fragments, as well as lead, used to fix them in the cavities. The lead was either poured in molten form or consisted of leaves that were wrapped around the pins and hammered into shape.

Based on this information, together with direct observation, the method used to connect the fragments was analyzed and hypotheses were offered on the sequence employed to reassemble the statue. Table C.6 summarizes the conclusions that resulted from this discussion.

Fragments of Christ's Right Forearm and Neighboring Areas

Christ's right arm was reconstituted with three fragments:

Forearm
Hand and part of the Magdalene's garment
Segment of the fingers

Christ's right forearm shows two cavities at both ends into which molten lead was poured and where the metal pins are inserted (plate 109, nos. 1 and 2). A material less radio-opaque than marble and presumed to be gypsum is evident in cavities in the parts to which the fragment is attached at either end (upper arm and hand). Chemical examination confirmed that the material is indeed gypsum.

Christ's right hand, a fragment smaller than his forearm, shows a cavity without lead at its upper end. Presumably, the hand is attached to the forearm with a metal pin inserted into the cavity and fixed with gypsum (plate 109, no. 2). The lower part of the hand does not have a cavity and was presumably attached to the fingers and the Magdalene's back with gypsum (table C.6).

The segment of fingers is attached to the back of the Magdalene with a metal pin (plate 109, no. 3) and to the hand probably with gypsum (table C.6). The head of the pin is visible to the eye between the figures.

Table C.6. Christ's right forearm. Summary of joints, fragments, reunited parts, metal pins, and the presence of lead and stucco.

Reunited Parts		Metal Pins Numerated (see plate 109)	Presence of Lead	Stucco Composition (see CD-ROM for location of samples)
statue (Christ's upper-right arm)	fragment (Christ's right forearm)	1	poured, located in upper part of forearm	sample 25 (gypsum)
fragment (Christ's right forearm)	fragment (Christ's right hand)	2	poured, located in lower part of forearm	sample 21 (gypsum)
fragment (Christ's right hand)	statue (back of the Magdalene) fragment (Christ's fingers)			sample 22 (gypsum) sample 23 (gypsum)
fragment (fingers of Christ's right hand)	statue (back of the Magdalene)	3 (visible to eye)		sample 24 (gypsum)

The following is a reasonable hypothesis regarding the sequence in which the fragments were reassembled: two metal pins were inserted into the cavities of the fragments (nos. 1 and 2) and, with the marble turned in the appropriate position, were fixed with poured lead at the two ends of Christ's forearm; the hand was then joined to the forearm with a single metal pin fixed with gypsum (no. 2); the

recomposed forearm/hand was then reattached to the statue by inserting the exposed metal pin (no. 1) at its upper end into a cavity that had been drilled into Christ's upper arm and fixed with gypsum; finally, the fingers were attached to the hand with gypsum and to the Magdalene's back with a metal pin (no. 3). The pin, whose head is visible to the eye, could have been inserted externally.

Fragments of the Magdalene's Right Arm
Three fragments are relevant to the discussion (table C.7):

The small marble cylindrical insert, with regular edges, in the upper part of the Magdalene's right arm
The Magdalene's right arm
Wrist and most of the Magdalene's right hand

The cylindrical insert has a metal pin (plate 109, no. 4) that runs vertically through its center. The upper end of the pin is fixed with laminated lead in a cavity of the Magdalene's shoulder. The other end of the pin is fixed directly in a cavity in the arm. A second pin enters orthogonally into the arm and is attached to the lower end of the vertical pin (plate 109, no. 5). The head of the second pin is visible on the surface of the marble and shows signs of oxidation.

The lower end of the Magdalene's arm is attached to the wrist with a metal pin that has been fixed with stucco in both cavities (plate 109, no. 6).

The hand is attached to Christ's right leg with a metal pin, which could be recognized only with a metal detector (plate 109, no. 7). This pin is probably fixed with stucco.

Table C.7. The Magdalene's right arm. Summary of joints, fragments, reunited parts, metal pins, presence of lead, and stucco composition.

Reunited Parts		Metal Pins Numerated (see plate 109)	Presence of Lead	Stucco Composition (see CD-ROM for location of samples)
statue (the Magdalene's shoulder)	insert (the Magdalene's right arm)	4	laminated and wrapped around pin	sample 20 (gypsum)
insert (the Magdalene's right arm)	fragment (the Magdalene's right arm)	4 5		
fragment (the Magdalene's right arm)	fragment (the Magdalene's right hand)	6		sample 19 (gypsum)
fragment (the Magdalene's right wrist and hand)	statue (the Magdalene's fingertips)	7	probably none	sample 18 (gypsum)

The hypothetical sequence in which the arm was reconstructed is as follows: Metal pin (plate 109, no. 4) was fixed with laminated lead in a cavity in the Magdalene's right shoulder; three fragments comprising the Magdalene's arm (cylindrical insert, arm, and hand) were then joined to each other with metal pins; and a cavity was drilled into the upper end of the recomposed arm so that it could receive the pin that had already been inserted in the Magdalene's shoulder (plate 109, no. 4). A second cavity was then drilled into the outer surface of the Magdalene's arm as a reinforcing element (plate 109, no. 5). A third cavity was finally drilled into the Magdalene's hand for a pin (plate 109, no. 7) that would join the recomposed arm to Christ's right leg. At this point the recomposed piece, with a cavity in one end and a pin at the other, was set in place and fixed with gypsum at the Magdalene's shoulder and Christ's right leg. Finally, the external pin in the Magdalene's arm (plate 109, no. 5) was inserted for additional support.

Fragments of the Virgin's and Christ's Left Arms and the Neighboring Areas

The fragments constituting the two arms are (table C.8):

The Virgin's fingers, Christ's left shoulder, and a part of his back
Christ's left nipple, newly carved
Christ's upper arm and the Virgin's entire arm, the two constituting a single piece of marble joined at the elbow
A small remnant of Christ's left elbow
Christ's left forearm
Christ's left wrist
Palm and fingers of Christ's left hand, newly carved
Back of Christ's left hand, also newly carved

Christ's upper-left arm and the Virgin's entire left arm constitute the largest single fragment and were reattached to the statue simultaneously at his and her shoulder. A metal pin is inserted into the Virgin's arm and fixed with poured lead (plate 109, no. 9); the other end of the pin is then inserted into a cavity in her shoulder and fixed with stucco, assumed to be the same as the external reintegrating stucco (rosin mixed with marble dust). A comparable situation is evident in the method of reattaching Christ's upper arm to his shoulder (plate 109, no. 8); here a similarly configured pin arrangement is present. This time a pin is fixed in Christ's arm with poured lead. The other end of the pin passes through the fragment of his shoulder (which includes the Virgin's fingers) and enters into a cavity in Christ's shoulder, where it is probably fixed with rosin mixed with marble powder. Indeed, the external reintegrating stuccoes in this area are invariably composed of rosin.

Christ's left forearm is attached to his upper arm with a metal pin (plate 109, no. 10), both ends of which are fixed with lead. The upper end is fixed with poured lead, but there is no indication of the method used for applying the lead for the lower end. The lower end of Christ's forearm is attached to the wrist with a metal pin (plate 109, no. 11). The upper end of the pin is fixed with lead, while the lower

end is inserted into a cavity in the wrist and probably fixed with gypsum, which is the composition of the reintegrating stucco in this area.

Christ's wrist is attached to the Virgin's knee with a smaller metal pin (plate 109, no. 12), which is probably fixed with gypsum. The wrist is attached with gypsum to two separate fragments of the hand (back to front).

The two fragments that constitute the hand are probably attached to each other with gypsum, while the palm is fixed to the Virgin's leg with a metal pin (plate 109, no. 13).

There are two isolated fragments: Christ's nipple (carved separately) and the remnant of his elbow. The nipple is presumably attached with rosin mixed with marble powder. The elbow is attached with gypsum.

Two stuccoes composed of wax reintegrate Christ's elbow where the marble is missing.

Table C.8. The Virgin's and Christ's left arms. Summary of joints, fragments, reunited parts, metal pins, preserved lead, and stucco.

Reunited Parts		Metal Pins Numerated (see plate 109)	Presence of Lead	Stucco Composition (see CD-ROM for location of samples)
statue (Christ's chest)	fragment (the Virgin's fingers, Christ's left shoulder, and part of Christ's back)			sample 12 (rosin)
fragment (the Virgin's fingers, Christ's left shoulder, and part of his back)	fragment (Christ's left arm)	8	poured at end of Christ's arm	sample 11 (rosin) sample 15 (rosin) sample 9 (rosin) sample 10 (rosin)
fragment (Christ's left nipple)	statue (Christ's chest)			sample 16 (rosin)
fragment (Christ's left upper arm and the Virgin's entire arm)	fragment (Christ's left forearm)	10		sample 8 (wax) sample 4 (gypsum) sample 5 (gypsum) sample 6 (gypsum)
fragment (Christ's left elbow)	fragment (Christ's left arm and the Virgin's entire arm)			sample 7 (wax)
fragment (Christ's left elbow)	fragment (Christ's left forearm)			
fragment (Christ's left forearm)	fragment (Christ's left wrist)	11	poured in Christ's forearm	sample 3 (gypsum)
fragment (Christ's left wrist)	statue (the Virgin's left knee)	12		

Reunited Parts		Metal Pins Numerated (see plate 109)	Presence of Lead	Stucco Composition (see CD-ROM for location of samples)
fragment (Christ's left wrist)	fragment (back of Christ's left hand)			not determined
fragment (Christ's left wrist)	fragment (palm and fingers of Christ's left hand)			not determined
fragment (back of Christ's left hand)	fragment (palm and fingers of Christ's left hand)			sample 1 (gypsum)
fragment (palm and fingers of Christ's left hand)	statue (the Virgin's left knee)	13		sample 2 (gypsum)

It is more difficult to formulate hypotheses about the sequence in which the severed parts would have been reassembled in this area of the statue, because of the numerous marble fragments involved and two groupings of different stucco compositions (rosin and gypsum). Nevertheless, the following sequence is plausible:

Three metal pins were inserted into cavities and fixed with poured lead in the large fragment that includes the left arms of Christ and the Virgin (plate 109, nos. 8, 9, and 10).

Two cavities were drilled at either end of Christ's forearm, and a pin (plate 109, no. 11) was inserted in the lower end and fixed with poured lead (plate 109, no. 10).

The above two pieces were then attached to each other by inserting the pin in the upper arm (plate 109, no. 10) into the cavity of the forearm (plate 109, no. 11). The pin was fixed with poured lead.

A cavity was then drilled through the fragment of Christ's shoulder and attached to his upper arm with rosin (plate 110). The pin already present in the upper arm passed through the cavity in the fragment (plate 109, no. 8).

The reassembled piece was then attached at two points of the statue: Christ's and the Virgin's shoulders (plate 109, nos. 8 and 9), and the pins were fixed with rosin (plate 110).

Christ's nipple (plate 108, no. 8) was probably then attached with rosin (plate 110).

A metal pin was inserted into the Virgin's knee (plate 109, no. 12).

Next, two cavities were drilled into the Christ's wrist, one at the upper extremity, the other on the side (plate 109, no. 11). The wrist was then eased onto the pin in the forearm and simultaneously onto the pin on the Virgin's knee, both fixed with gypsum (plate 110).

The palm was then attached to the Virgin's leg with a metal pin (plate 109, no. 13), which was fixed with gypsum (plate 110).

Finally, the patch at Christ's elbow (plate 108, no. 10) and the back of his left hand (plate 108, no. 14) were attached with gypsum (plate 110), completing the reconstruction.

THE DEVELOPMENT OF THE VIRTUAL MODEL OF MICHELANGELO'S FLORENCE *PIETÀ*

International Business Machine Corporation (IBM)

Fausto Bernardini, Holly Rushmeier, Ioana M. Martin,
Joshua Mittleman, and Gabriel Taubin

WHEN JACK WASSERMAN PROPOSED to the IBM Foundation the idea of creating a computer model of the Florence *Pietà* in 1997, IBM was immediately interested. For the past decade, three-dimensional models have been heavily used in high-end, highly technical domains such as medicine and engineering design and inspection. In recent years, lower-cost cameras and computers and more sophisticated software have begun to make this technology feasible for a wider range of applications. We believed that the time was right to develop an inexpensive, easy-to-use system for less technical fields. IBM was eager to use its technology to help enhance people's understanding of important artistic and cultural monuments.

Wasserman believed that a three-dimensional model of the statue would allow him to study it in ways impossible by any other means. We established two main goals for our collaboration. First, we set out to scan the *Pietà* in sufficient

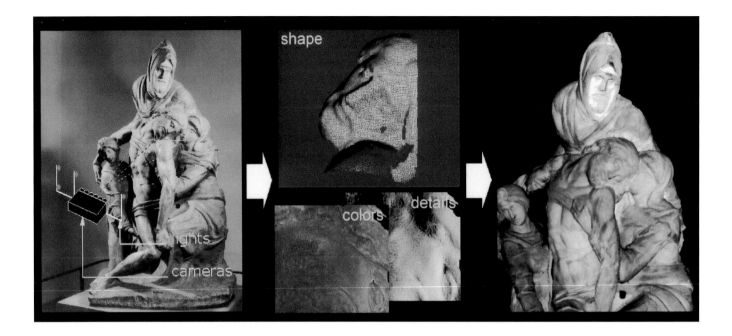

PLATE 115
*IBM digital camera system;
capturing and processing shape and
appearance measurements*

detail to produce a high-resolution model that would assist Wasserman in finding answers to several problems about the statue's history and composition. In doing so, we also tried to develop an efficient, reusable system that would be applied to other works of art in the future.

Various types of devices exist for measuring three-dimensional objects. There are low-resolution, electronic camera-based systems that can only scan very small objects. These currently cost a few thousand dollars. There are also complex, high-accuracy, custom-built, laser-based systems that are intended for high-precision industrial inspection. These can cost as much as half a million dollars. We had only a limited budget, yet we needed to measure the huge statue to a resolution better than 1 millimeter to meet Wasserman's research requirements. Balancing these considerations, we settled on the Virtuoso ShapeCamera, produced by Visual Interface Inc., and augmented it with a second system of our own design (plate 115).

The ShapeCamera projects an array of vertical lines onto the target surface and photographs it simultaneously with six black-and-white cameras. It takes an additional color photograph of the surface under normal light. Since the positions of all the cameras are known, a developer program can compute points on the surface by correlating stripes among the six black-and-white images; then the color image can be pasted onto the resulting mesh to create a realistic three-dimensional patch of the target surface. The ShapeCamera measures an average of ten thousand surface points in each patch for a resolution of about 2 millimeters, adequate for examining the statue on a large scale, but not sufficient to resolve tool marks and other fine details.

To refine these results, we added an innovative photometric system.[1] In addition to the seven photographs taken by the ShapeCamera, we took five more color pictures, each with a different light source. By comparing the illumination of each point on the surface under these known lighting conditions, we were

able to refine the approximate geometry captured by the ShapeCamera. A surface appears brighter if it directly faces the light, and dims—according to well-established formulas—as it turns away. Thus, we can use the light intensity at each point to compute the surface orientation and then factor out the orientation to compute the surface color independent of lighting. The resolution of this method is determined by the resolution of the digital color camera used. The output of this system and our developing software, therefore, is a 2 mm resolution geometric mesh, plus higher-resolution orientation and color details. The final resolution of the combined data is about 0.75 mm.

Plate 115 illustrates how we capture and process shape and appearance measurements. Each ShapeCamera photograph covers about 20 by 20 centimeters on the statue; it therefore requires hundreds of patches to create the full model. We did a preliminary scan of the statue (without the photometric system) in February 1998. We repeated the scan in June 1998 and completed it in July 1999. The final scan took about ninety hours over the course of fourteen days (including equipment setup that had to be repeated each day). We photographed about eight hundred patches. Despite various experiments with viewing positions, and using mirrors to view inaccessible areas, we found that our scanning system could not record some portions of the statue. At present, this is a limitation of all camera- and laser-based systems. Designing a scanner that can better reach into narrow crevices and small openings is an area for future research.

Transforming the raw meshes into a correct, consistent model requires considerable processing. The output of the scanner consists of a patch of geometry, unrelated to any other patch, plus a set of color pictures of the same patch of the surface. We developed and implemented new algorithms to combine this mass of data into a single three-dimensional model, with each patch smoothly joined to its neighbors, random errors filtered out, and colors corrected to compensate for variable lighting. Our data-processing pipeline, from developed patches to the completed model, requires five days of processing on a powerful workstation, so the progressive refinement of our algorithms was an extremely time-consuming task. Constructing the model proceeds in four major steps: registration, meshing, and incorporation of geometric and color details from the photometric data.

Each mesh is originally measured relative to the camera; since the camera needs to be repositioned for each set of pictures, the patches have to be assembled like a huge three-dimensional jigsaw puzzle. Measuring each camera position to sufficient precision was impractical, so we needed to deduce the correspondence between neighboring patches from features of the surface itself. To facilitate this process, we projected an array of laser dots onto the surface while we photographed it, thereby creating easily identifiable features to match from one picture to the next. But no scanning system is error-free. The ShapeCamera computes distances from the camera to the surface, and these computations have an error for which we had to compensate. The statue is covered with overlapping meshes, so we used the redundant data to derive more accurate estimates of the true surface.

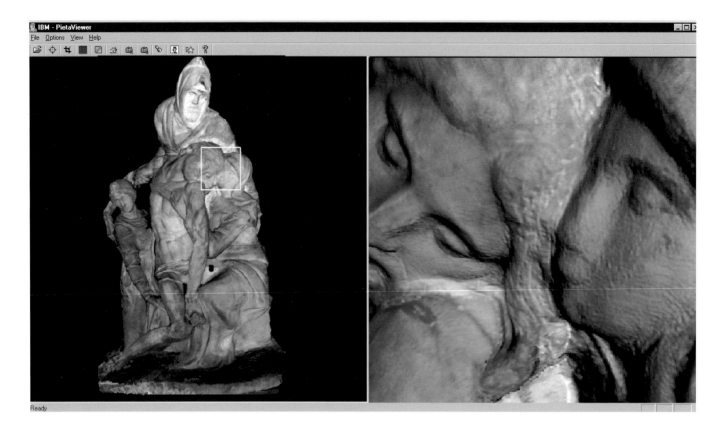

IBM - PietaViewer
File Options View Help

Ready

PLATE 116
*IBM virtual model and detail of
the Virgin's face; interactive and
detail viewer*

These first steps of processing produced a set of meshes that cover the statue, but we still needed to combine them into a single model. We developed a new meshing algorithm to construct a single triangle mesh covering the several million data points we derived from our data.[2] Our Ball-Pivoting Algorithm is a very general tool for constructing a single triangulated surface covering a set of points. It is well suited to extremely large data sets.

The second half of our processing pipeline adds the geometric and color details produced by the photometric system. For each point on each of the meshes, we compare the illumination of the point in all the photographs we took under controlled lighting conditions; then we derive a more accurate estimate of the orientation and coloration of the statue at that point. However, because each of our original picture sets was taken with the camera and lights in a different position, the lighting—and therefore the color—are inconsistent from one mesh to the next. Another of our algorithms balances these variations to provide a consistent, realistic coloring across the entire model.[3]

We further refine the mesh-to-mesh alignment with our image-based registration algorithm, which takes advantage of information in the high-resolution images to refine the geometric alignment obtained in previous steps. We use the photometric details to identify corresponding points in overlapping meshes with very high accuracy and use them to correct the registration.

The final step is to apply the processed photometric details to the geometry so that the entire model can be rendered together. We developed an algorithm to divide the unified model into new patches, each entirely visible from a single point, in order to segment the photometric data into usable units. Overlapping

photometric data are combined to compute the best estimate of the true color and fine-scale shape of the surface.

Plate 115 illustrates the concept of our system. First, our camera system collects about eight hundred picture-sets. From each, we compute a patch of geometry and corresponding fine-scale geometric and color details. All these patches are then aligned and combined into a single, consistent model.

Our primary goals for the *Pietà* project were defined by Wasserman's research questions, and our presentation of the results was shaped to fit his art historical requirements. Yet this plan could be implemented for documenting other three-dimensional works of art. It illustrates some of the potential of using computer models as powerful tools for art historical research. Such models can provide precisely defined views impossible to obtain in real life, actual measurements of a work, or complete archival representation of an object. A work of art can be embedded in virtual environments, given modifications, or be interactive with the viewer.

In order to answer certain questions about Michelangelo's composition, Wasserman needed to see the statue from points of view that were inaccessible given its size and weight. These included views from directly above the statue—to reveal details of the composition not normally visible—and from various angles below the base of the statue, to illustrate it as it would have appeared if set high, as he suspected Michelangelo originally intended. We also re-created some of the settings in which the *Pietà* stood over its history, using three-dimensional models and animations to illustrate the visual impact of the statue from these various perspectives.

Measuring the distance between points on the real statue can be difficult, as the work itself can interfere with a precise measurement. This problem does not exist in the digital world, where we can obtain the precise location of any point on our model. We can modify the statue itself to allow the historian to consider various hypotheses. For example, we removed the pieces that Calcagni reattached, illustrating the statue as it may have appeared without his efforts.

To enable Wasserman to study the statue on his own computer, we designed a viewer that could be run on a personal computer. Viewing three-dimensional scenes on computers requires trade-offs between speed and quality and between utility and flexibility. The systems that render images from three-dimensional geometry process data at a fixed speed. A more detailed and realistic model requires more data, so the time to synthesize each image inevitably increases. Navigating through a three-dimensional virtual world on a computer display is difficult. A keyboard and mouse simply aren't good tools for steering in three dimensions. If the system renders new images quickly, then the user can learn to compensate for inadequate controls, but prompt feedback may require lower-quality images, which are more difficult to understand.

Our full model of the *Pietà* is far too large for interactive display, even with today's best graphics hardware and software. On Wasserman's laptop, it was inconceivable. Therefore, we proposed a hybrid viewer that provides interactive examination of a geometrically simplified version of the model, and a detail viewer

that provides more limited interaction with a selected high-resolution image. A snapshot of this viewer appears in plate 116.

The simplified model, with only ten percent of the complexity of the full model, acts as a kind of map to the more detailed model. The user can select an area of interest, using very simple three-dimensional navigation controls to reach the desired view. To examine a region in more detail, the user frames a section of the scene and renders the desired image from a database of the full model. This step currently might take as long as ten minutes on Wasserman's laptop. The resulting two-dimensional image is enhanced to allow the lighting to be varied interactively by dragging the mouse across the window. Many details invisible with the light in one position appear when the light is moved; the user is thus able to understand fine-scale structure more clearly. We designed this technique to model a viewing practice that we observed Wasserman using on the statue as he examined its surface: he moved a small flashlight slowly back and forth across the statue to highlight small surface irregularities. The virtual light editor produces similar effects.

While it is possible to view the model adequately, the current viewer still needs much improvement to be an optional tool for art historians. Three-dimensional navigation controls in computer graphics have traditionally been designed for technical users. A great deal of work needs to be done to find intuitive methods for nontechnical users to interact with three-dimensional data, especially when viewing large data sets that must be simplified to allow interactive display. Rendering the full-detail image can take many minutes, interrupting the user's flow of thought when studying the object. Faster computers will reduce these problems in coming years, but research is also needed in improved rendering algorithms.

Examples of our results can be seen elsewhere in this book (plates 9, 10, 13, 35, 45, and 74) and the accompanying CD-ROM. The images we have produced are of lower resolution than traditional photography; however, as a trade-off, the digital model makes it possible to alter lighting, viewing position, brightness, and contrast and to dissect the geometry of the statue. But while photographs and the digital model are useful for analyzing the statue, in the end, any theory about the statue must be confirmed by reexamining the work itself, for nothing can replace the experience of viewing the statue in person.

Our team spent two years scanning on the *Pietà* project, but most of that time was devoted to developing the hardware and software tools needed for the job. Our system is not yet one that could easily be packaged for a non-expert user, but we believe we have made good progress toward that goal. Three-dimensional scanning is currently an active area of research in the graphics and computer vision communities, with new software and hardware appearing continually. Several dozen companies are marketing consumer-level scanners today. Although these are not yet accurate enough for the kind of study we undertook, they are rapidly becoming better and less expensive. We expect that these tools will become increasingly powerful and accessible over the coming years and that three-dimensional scanning and modeling will become increasingly important tools for art history, archaeology, and similar fields.

CATALOGUE OF THE DERIVATIONS OF THE FLORENCE *PIETÀ*

THIS CATALOGUE LISTS PAINTINGS, sculptures, drawings, and prints that were influenced by the *Pietà*, but it is by no means comprehensive. It is arranged by medium, and within each medium chronologically by century. A final category includes works that have been questionably related to the *Pietà*.

Two tendencies governed the process of composing copies and emulations of the *Pietà* from the cinquecento forward. One was a decisive preference for the oblique view of the statue from the left. This view focuses attention on Christ's elegant, almost decoratively composed body (plate 6).[1] Since in that view the Virgin would be only partially visible, to give her equal prominence to the other figures and for greater symmetry, painters invariably brought her figure forward from behind the body of Christ, to the same plane occupied by the figure of Mary Magdalene.[2] Cherubino Alberti's *Pietà* is an example of this tendency (plate 81).

The second tendency was to represent the *Pietà* as being in perfect condition, with its injuries glossed over and Christ's left leg replaced. Works that absorb the *Pietà* into independent compositions tend, as one might expect, to fill in the missing pieces. But drawings are exceptions in that, being more immediate responses to the statue, they at times reproduce the group without the leg (see nos. 27, 28, 32, and 33).

1. Giorgio Vasari (1511–1574), *Pietà*, c. 1560
 Accademia delle Belle Arti, Ravenna, Italy
 BIBLIOGRAPHY: Venturi 1925–37, 9, no. 6, fig. 181.

 Vasari took from Michelangelo's statue the motive of Christ's right arm surrounding a female figure, which, however, is not the Magdalene. The emblem on the Magdalene's arm with which she embraces Christ's legs is identical in shape with the one on the head of the figure in the statue, but the child's head is absent.

2. Paolo Veronese (1528–1588), *St. Barnabus Heals the Sick*, variously dated to 1556, 1560–62, and 1566
 Musée des Beaux-Arts, Rouen, France (originally San Giorgio in Braida, Verona, Italy)
 BIBLIOGRAPHY: Pignatti 1976, 1:132, no. 162, fig. 426.

 This painting is associated here with the Florence *Pietà* for the first time. There are strong similarities in posture between a sick man being cured by the saint and Michelangelo's Christ. Here, a neighboring figure places a hand on the sick man's breast, as the Virgin does to Christ in the statue.

3. Taddeo (1529–1566) or Federico Zuccari (c. 1540–1609), *Dead Christ with Angels*, before 1566 or before 1609
 Borghese Gallery, Rome
 BIBLIOGRAPHY: Della Pergola 1959, 2, no. 194; Hermann-Fiore 1992, 418–21, no. 124; Acidini Luchinat 1998, 1:216–18; illustrated on 219. Hermann-Fiore 1999, fig. 1, plate 2.

 Pergola attributes the painting to Federico Zuccari; Hermann-Fiore to Taddeo. A precise date for the painting would depend on the year Taddeo died (1566) or Federico died (1609). Christ sits on a cloth-covered bench, supported by an angel from behind, and inclines his head in the direction of his pronated right arm. In crossing his legs at the ankles, the painted Christ differs from the Christ in the statue. Four torch-bearing angels, two on each side, flank the central group. For a compositionally related sketch attributed to Federico, see no. 22.

4. Anonymous, *Dead Christ with Angels*, late sixteenth century
 Galleria Nazionale delle Marche, Palazzo Ducale, Urbino, Italy
 BIBLIOGRAPHY: Unpublished.

 Copy after no. 3.

5. Lorenzo Sabbatini (c. 1530–1576), *Pietà*, before 1576
 Vicariato, Vatican, Rome
 BIBLIOGRAPHY: Venturi 1925–37, 9, no. 6, fig. 468; de Tolnay 1945–60, 5:151.

 The painting was formerly in the sacristy of St. Peter's. The central group of four figures closely resembles Michelangelo's *Pietà*, although the emblem on the Magdalene's head is absent. The composition includes three additional figures arranged against a cross in a shallow landscape. Two ladders lean on the cross, from which a cloth hangs, and a basket in the lower-left corner includes the instruments of the Passion.

6. Antonio Viviani (1560–1620), *Pietà*, 1585
 Madonna dei Monti, Cappella Falconi (Pietà), Rome
 BIBLIOGRAPHY: Guerrieri Borsoi 1993, 231–33, no. 23a; Ottonelli and Cortona 1652, 210.

 Copy after no. 5, except that Viviani must also have looked at the statue, because he included the emblem on the Magdalene's head. This may be the painting to which Giovanni Ottonelli and Pietro da Cortona referred in 1652 as being by Taddeo Zuccari.

7. Anonymous, *Pietà*, n.d.
 Galleria Czernin, Vienna
 BIBLIOGRAPHY: Unpublished. See the photograph collection, Kunsthistorisches Institut, Florence; inv. no. 57354; print: Wolfrum, Vienna.

 Derives from no. 5, with the composition reduced to the four figures, as in the statue. Here, however, the Virgin kneels on her left knee.

8. Possibly Scipione Pulzone (1544–1598), *Pietà*, c. 1588–90
 Formerly in the collection of Lord Bagot, London
 BIBLIOGRAPHY: Zeri 1957, 78–79, fig. 80.

 The attribution and dating are Zeri's. The composition, in a landscape, is reduced to two figures: Christ seated on the lap of the Virgin. She places a cheek against Christ's and holds him on either side of his chest.

9. Anonymous, *Pietà*, late sixteenth century
 Formerly in the Galleria Nazionale di Palazzo Barberini, Rome
 BIBLIOGRAPHY: Zeri 1957, 78–79, fig. 81.

 Zeri attributes the painting to Pulzone, but it is probably a copy after no. 8, with the difference that the Virgin does not place her cheek against Christ's, but rather looks heavenward.

10. Anonymous, *Pietà*, between 1592 and 1600
 Location unknown
 BIBLIOGRAPHY: Fagiolo and Madonna 1985, fig. 21; Fehl 2002, fig. 3.

 The lost painting is recorded in the right margin of a print of Santa Maria Maggiore (center image on right) in the Istituto Nazionale per la Grafica, Rome, which Giovanni Maggi made for the jubilee year 1600. The painting represents Christ and the Virgin alone in a variation of Michelangelo's statue. Christ sits on a bench at the left and the standing Virgin places her hand on his breast and her head on his. The print is dated by the papal arms of Clement VIII (r. 1592–1605), which appear below the image.

11. Copy after El Greco (1541–1614), *Entombment*, late sixteenth century
 Formerly in the Palacio Real, Madrid
 BIBLIOGRAPHY: Steinberg 1974, 474–77, fig. 87.

 The painting evidently is a copy after a lost composition by El Greco, who was in Rome from 1570 to 1576. Several figures are depositing Christ horizontally in a sarcophagus. Steinberg mistakenly believes that in "El Greco's revision of the *Pietà* Christ is unique in respecting the one-legged state of the original." Actually, both legs of Christ are represented as parallel to each other.

12. Copy after El Greco, *Entombment*, late sixteenth century
 Collection of Mme G. Broglio, Paris
 BIBLIOGRAPHY: Steinberg 1974, 474–77, fig. 88.
 See no. 11.

13. Copy after El Greco, *Entombment*, late sixteenth century
 Collection of Condesa Viuda di Sbarra, Seville, Spain
 BIBLIOGRAPHY: Steinberg 1974, 474–77, fig. 90.
 See no. 11.

14. Copy after El Greco, *Entombment*, late sixteenth century
 Sale Christie's, London, 19 March 1963
 BIBLIOGRAPHY: Steinberg 1974, 474–77, fig. 91.
 See no. 11.

15. Guglielmo Courtois (il Borgognone) (1628–1675), *Pietà*, between 1657 and 1674
Accademia Nazionale di San Luca, Rome
BIBLIOGRAPHY: de Tolnay 1945–60, 5:151; Faldi 1974, 119 and fig. 28.

Three figures from the statue are included in a landscape; the Magdalene is missing. Christ sits on a bench beside the Virgin. He rests his right leg on his mother's lap and she places her head against his and her left hand on his chest. The bearded figure stands on a bench on which Christ sits and supports him from behind.

DRAWINGS

16. Paolo Veronese, sketch for the sick man in *St. Barnabas Heals the Sick*, variously dated to 1556, 1560–62, and 1566
Sale, Sotheby's, London, 15 June 1983
BIBLIOGRAPHY: Cocke 1984, 138–39, fig. 55.

The dating of the drawing is the same as the painting (no. 2). The posture of the figure is slightly varied. It is seated on a bench with head and gaze directed upward. The figure is a cross between the *Ignudi* from Sistine Ceiling and the Christ from the Florence *Pietà*.

17. Taddeo Zuccari, studies for a *Pietà*, before 1566
Art Institute of Chicago
BIBLIOGRAPHY: Gere 1969, 77; Mundy 1989, 88, no. 15; McCullagh and Giles 1997, 37, no. 28v; Mundy 1989, 91–92; and Acidini Luchinat 1998, 2:70

According to McCullagh and Giles, William Young Ottley may have owned this page. Ottley sketched Michelangelo's *Pietà* in 1792 (see no. 32). Mundy correctly rejects Gere's suggestion that the sketch is an early project for the *Raising of Entyclus* in the Frangipani Chapel in San Marcello al Corso, Rome. He proposes, instead, that it represents a *Lamentation* or *Deposition*. Acidini Luchinat refers to the composition as a *Pietà*. Gere dates the drawing to 1557 on the assumption that it is contemporary with the Frangipani Chapel decorations. The composition includes four figures in the approximate positions they occupy in the *Pietà* and they perform the same duties. The backward leaning posture of Christ is reminiscent of that of the sick man in Veronese's *St. Barnabus* painting (see no. 2).

18. Taddeo Zuccari, *Pietà*, c. 1562
Albertina Graphische Sammlung, Vienna
BIBLIOGRAPHY: Acidini Luchinat 1998, 1:113, fig. 18.

Acidini Luchinat, 1:115, suggests the date of around 1562 for the drawing.

19. Taddeo Zuccari, studies for a *Martyrdom of St. Lawrence*, c. 1563–66
Ashmolean Museum, Oxford
BIBLIOGRAPHY: Gere 1966, 287, fig. 2; Parker 1938–56, 2:cat. no. 764.

St. Lawrence is configured as Christ in the *Pietà*, except that he reclines in foreshortened position on a gridiron. The scene includes groups of figures and architectural structures.

20. Anonymous, *Pietà*, mid-sixteenth century
Sale, Auctiones SA, Société pour les Ventes Publiques d'Oeuvres d'Art, Basel, 1970
BIBLIOGRAPHY: Lebel 1970, no. 1.

The sale catalogue lists the drawing as of the Tuscan school and dates it to the fifteenth century. Stylistically, however, it must date to the years after the middle of the sixteenth century. The composition of two figures is possibly based on, or a copy of, a lost drawing by Michelangelo for a *Pietà* and seems a cross between the statue in Florence and Michelangelo's Colonna *Pietà* drawing (plate 19). Christ, his head and arms configured as in the statue, slips to the ground between the legs of the Virgin, as in the drawing. She holds up his right arm from behind in the manner of the bearded figure in the statue. The major difference between the two Christs is in the treatment of the legs: those in the sketch are brought together rather than splayed. An indecipherable Latin inscription is present in the upper-left corner of the verso.

21. Anonymous, *Pietà*, second half of the sixteenth century
Biblioteca Ambrosiana, Milan; codice Resta
BIBLIOGRAPHY: Bora 1976, 21, no. 24/2.

The four-figure composition is structurally related to the statue, except that the figure behind Christ is now female and the flanking figures males. The male figure on the left is almost entirely nude, Christ's left leg is held under the thigh by the figure on the right, and his arms are arranged more in the manner of the arms of Christ in the *Pietà* in St. Peter's. There is some difference of opinion as to the identity of the author of the drawing. Bora points out that John Gere attributes it to a Florentine sculptor of the 1560s; Philip Pouncey believes that the drawing technique recalls Battista Franco, a Venetian painter active in Rome between about 1549 and November of 1554. In that case, he would have seen the statue before Michelangelo mutilated it, for which there is no visual evidence in the drawing.

22. Attributed to Taddeo Zuccari, *Christ Supported by an Angel*, before 1566
National Gallery of Canada, Toronto
BIBLIOGRAPHY: Popham and Fenwick 1965, 34–35, no. 45.

The composition is similar to no. 3, above, except that the composition is formed of two figures.

23. Attributed to Federico Zuccari, *Ascension of Christ*, 1563(?)
Yale University Art Gallery, New Haven, Connecticut
BIBLIOGRAPHY: Pillsberry and Caldwell 1974, fig. 34.

A reversed version (somewhat modified) of Zuccari's *Dead Christ with Angels* in the Borghese Gallery, Rome (no. 3). The scene takes place in the midst of clouds, with a putto in each of the four corners.

24. Attributed to Taddeo Zuccari, *Pietà*, 1560s
Biblioteca Ambrosiana, Milan; codice Resta
BIBLIOGRAPHY: Bora 1976, 116.

The date depends on the year Taddeo died. The composition is a two-figure group, with Christ sitting on the lap of the Virgin. Christ's torso relates to that of Christ in the St. Peter's *Pietà*, his legs to those in the Florence *Pietà*.

25. Jacopo Nigretti (called Palma il Giovane; 1544–1628), sketch of a *Deposition*, 1568(?)
Kupferstichkabinet, Berlin; inv. no. 5139
BIBLIOGRAPHY: Unpublished. Photographic collection, Kunsthistorisches Institut, Florence; Corpus Photographicum of Drawings, no. 34324.

The dating is based on Palma's visit to Rome in 1568. A four-figure group is arranged as in Michelangelo's *Pietà*. Christ's body crumbles to the ground, his right arm extending downward, toward which he inclines his head, his left arm pronated as in the statue. Although the right leg is as in the statue, his left leg is brought down parallel to it. Christ is supported from behind by a young person (angel?); a seated veiled woman on the left embraces his right arm; another veiled woman

stands on the opposite side, her left arm raised as she looks down at Christ.

26. Jacopo Nigretti, *Christ with Nicodemus or Joseph of Arimathea*, 1568(?)
Graphische Sammlung, Munich
BIBLIOGRAPHY: Unpublished. Photographic collection, Kunsthistorisches Institut, Florence; neg. no. 96613.

The date derives from Palma's visit to Rome in 1568. A bearded figure behind Christ supports him by holding the right side of his body and his left arm. Christ sinks toward his left, his hanging right arm pronated, and his head inclined in its direction.

27. Cherubino Alberti (1553–1615), two sketches after the *Pietà* on a single sheet, c. 1580 (plate 117)
Uffizi, Gabinetto dei Disegni e delle Stampe, Florence
BIBLIOGRAPHY: Fehl 2002, fig. 4.

The left sketch reproduces Michelangelo's *Pietà* from the right side, the leg missing. The other sketch is a frontal view of the statue with the left leg inserted. The left sketch and the sketch in no. 28, below, are the earliest records of the *Pietà* with the leg missing. The sketches may have been preparatory to the print Alberti made in this same period (no. 34).

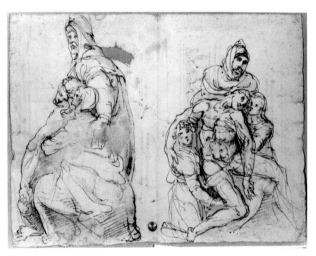

PLATE 117
Cherubino Alberti, Pietà *(sketches after the Florence* Pietà*), c. 1580.
Black chalk, 7⅛ x 9¼ in. (18 x 24.8 cm).
Uffizi, Gabinetto dei Disegni e delle Stampe, Florence*

28. Anonymous, *Pietà*, late sixteenth century
Art Institute of Chicago
BIBLIOGRAPHY: McCullagh and Giles 1997, 352, no. 548.

This northern Italian drawing is a copy after the statue with the left leg missing. As noted in the entry to no. 27, these two are the earliest records of the *Pietà* without the left leg.

29. Attributed to Giovanni Battista Naldini (c. 1537–1591), *Pietà*, before 1591
Metropolitan Museum of Art, New York
BIBLIOGRAPHY: Virch 1962, 21-22; Bean and Stampfle 1966, 77, no. 139.

Philip Pouncey attributed the drawing to Naldini, an assistant of Jacopo Pontormo, writing his opinion on the matting. Naldini's death

in 1591 is the *terminus ante quem* for dating the drawing, if it is his. Christ, sitting on a bench, is surrounded by three figures of indistinguishable sex. His torso, head, and arms are as in the statue viewed from right oblique; his legs are brought together, cross at the ankles, and incline toward the right.

30. Attributed to Giovanni de' Vecchi (1536/7–1615), *Deposition*, late sixteenth century
Philip Pouncey Collection, London
BIBLIOGRAPHY: Bunzl 1969, 42, no. 90, plate 22.

Relates to the Florence *Pietà* in a manner similar to no. 31. The grouping and general relationship between Christ and the other three figures, now all males, reinforce the connection with the statue. Several additional figures are included, with the Magdalene kneeling in the lower right corner and kissing Christ's feet, and the Virgin standing apart from the group on the right glancing toward Christ.

31. Pietro da Cortona (1596–1669), *Trinità*, 1657(?)
Location unknown
BIBLIOGRAPHY: Montagu 1989, 82, fig. 94.

The drawing is a project for Cosimo Fancelli's bronze relief representing a *Trinity* in Santa Maria della Pace in Rome (no. 38). Christ, supported by three angels, ascends toward God the Father, who prepares to receive him with outreached arms. Two additional angels below carry the cross. Christ's posture is similar to that in no. 30.

32. William Young Ottley (1771-1836), *Pietà*, signed and dated 1792 (plate 82)
Biblioteca Apostolica Vaticana, Vatican City
BIBLIOGRAPHY: Unpublished.

Ottley was in Rome between 1791 and 1801. In 1833, he became keeper of the prints in the British Museum. The drawing is in the collection of drawings and prints that had belonged to Seroux d'Agincourt. It is a careful rendering of the Florence statue on its base behind the high altar in the Duomo, but the base itself is not visible. In making his drawing, the artist seems to have sat on the ground to the left of the statue and looked upward at it. [I wish to thank Philipp Fehl for bringing this drawing to my attention.]

33. Auguste Rodin (1840–1917), *Pietà*, 1902
Munich: Bayerisches Staatsgemäldsammlungen, Neue Pinakothek
BIBLIOGRAPHY: Lenz 1999, 112, no. 9v.

Rodin must have seen the *Pietà* when he first visited Florence in 1875 and on many occasions thereafter. He reproduced the group with the left leg absent. [I thank Marco Pesavese for bringing the Lenz reference to my attention.]

PRINTS

34. Cherubino Alberti, *Pietà*, 1570s or 1580s (plate 81)
British Museum, London
BIBLIOGRAPHY: de Tolnay 1945–60, 5:151, fig. 373; Hartt 1975, 87; and Buffa 1982, fig. 141, 23 (58).

Several copies of the print exist. De Tolnay reproduces the one in the Bibliothèque Nationale, Paris. The composition of the statue is reversed. The group is present in a deep landscape, with a cave-tomb on the near left and three crosses on a distant hill. Alberti's sketch (no. 27) showing the statue without the left leg demonstrates the improbability of Hartt's premise that Alberti had made the print before Michelangelo mutilated the statue.

35. Attributed to Lorenzo Penni (n.d.), *Death of Adonis*, second half of the sixteenth century
Istituto Nazionale per la Grafica, Rome
BIBLIOGRAPHY: Massari and Rodinò 1989, 321–22, no. 118.

Antonio de Paoli was the publisher of the print. Adonis echoes Michelangelo's statue insofar as Christ's head falls toward the extended pronated arm on the right, but his body reclines toward the left and the position of the legs is slightly modified.

SCULPTURE

36. Tommaso della Porta (c. 1546–1606), *Deposition*, 1586–96 (plate 24)
San Carlo al Corso, Rome
BIBLIOGRAPHY: Panofsky 1993, 119–67; Lavin 1998, 210.

The marble statue is composed of five figures arranged in a tall and sharply vertical composition. It is similar to the *Pietà* only in one or two details, such as the hand of a female on his breast and in della Porta's expressed intention to outdo Michelangelo in creating a multi-figure statue.

37. Stefano Maderno (1575–1636), *Christ in the Lap of the Bearded Figure*, 1605
Hermitage, Leningrad
BIBLIOGRAPHY: Wardropper and Simpson 1998, 44–45.

In this terracotta statuette measuring about 12 inches (30 cm), Christ, with legs arranged as in the statue, is seated on the lap of a bearded male figure who wears boots and holds him with both hands on the sides of the body. Richardson 1722, 154, saw in the Palazzo Giustiniani, Rome, "Upon a table," a "Dead Christ in the arms of Nicodemus, or St. Joseph of Arimathea; most admirable. 'Tis in marble, small." Richardson may have been referring to the Hermitage statuette, mistaking the terracotta for marble.

38. Cosimo Fancelli (1620–1688), bronze relief of a *Trinity*, c. 1657
Santa Maria della Pace, Rome
BIBLIOGRAPHY: Montagu 1989, 82, fig. 95.

Although Fancelli made almost literal use of Cortona's drawing (no. 31), he has regularized the composition, making it more compact and two-dimensional, and he eliminated one of the two angels.

39. Anonymous, wax statuette representing a *Pietà*, eighteenth century (plate 41)
Private collection, Florence
BIBLIOGRAPHY: Parronchi 1981, 27, fig. 6.

The left leg is present. Parronchi dates the figurine to the seventeenth century. It probably dates, instead, to the eighteenth century, because it seems to have a Florentine provenance and thus could not have been made before 1722, when the *Pietà* was transferred from a storage area in San Lorenzo to the Duomo.

40. Anonymous, marble statuette representing a *Pietà*, eighteenth century
Private collection, Florence
BIBLIOGRAPHY: Parronchi 1981, 25, fig. 3.

This marble has the same dating as no. 39.

41. Anonymous, terracotta statuette representing a *Pietà*, eighteenth century
Private collection, Florence

BIBLIOGRAPHY: Parronchi 1981, 28, fig. 7.

Both arms and legs of Christ and the upper body of the Magdalene are missing. The dating is the same as no. 39.

42. Anonymous, terracotta statuette representing a *Pietà*, eighteenth century
Private collection, Florence
BIBLIOGRAPHY: Parronchi 1981, 28, fig. 8.

The dating is the same as no. 39.

43. Anonymous, terracotta statuette representing a *Pietà*, eighteenth century
State Art School, Florence
BIBLIOGRAPHY: Daurelle 1923, 824–49; Le Curieux 1924, 46–47.

The right arm was restored. The dating is the same as no. 39.

TAPESTRIES

44. Francesco Salviati (1510–1563), *Pietà*, mid-sixteenth century
Uffizi, Florence
BIBLIOGRAPHY: Viale and Viale 1952, 81, no. 74, plate 68a; Cheney 1991, 2:381.

A seated Christ is supported from behind by a bearded male, while a standing Virgin on the right clasps her hands in prayer. The tapestry was made by Giovanni Rost in Florence from on a drawing by Salviati. Dating the tapestry presents a serious problem. Viale and Viale suggest c. 1552 and Cheney 1546, both without explanation. If Cheney is right in her dating and the composition does in fact derive from the statuary group, then Michelangelo would have begun his group in 1546 or earlier. However, as only two figures are represented, it is possible that another (lost) drawing by Michelangelo was the source of the tapestry composition; for example, a fragmentary drawing of a *Pietà* in the Teylers Museum, Haarlem, Netherlands.[3]

DEBATABLE DERIVATIONS

45. Francesco Salviati, *Jonah*, 1548–50
Cancelleria, Rome
BIBLIOGRAPHY: Rubin 1987, 85; Cheney 1991, 1:225; Nagel 1996, 563–64, n. 33.

Nagel associates the figure with the Christ in the Florence *Pietà*. Cheney proposes as its source the bearded *Slave* in the Accademia delle Belle Arti, Florence. Other works in Michelangelo's oeuvre may be cited as a sources for the *Jonah*: *St. Matthew*, in the Accademia (de Tolnay 1945–60, 1: plate 63), and a figure with the left leg bent in the lower-right corner of the *Last Judgment* (de Tolnay 1945–60, 5:plate 15), which leans in an opposite direction from that of the *Jonah*.

46. Gian Lorenzo Bernini (1598–1680), *St. Sebastian*, 1623
Thyssen Bornemisza Collection, Madrid
BIBLIOGRAPHY: Wittkower 1955, 176, no. 4 and plate 5; D'Onofrio 1967, 178–80.

According to Wittkower and D'Onofrio, *St. Sebastian* has a partial parentage in the Florence *Pietà*. However, the position of Christ's torso and head may derive instead from a drawing Michelangelo made for Sebastiano del Piombo's Ubeda *Virgin and Christ* (Hartt 1970, fig. 454), and in the position of the legs from the *Moses* in San Pietro in Vincoli, Rome (de Tolnay 1945–60, 4:plate 18).

APPENDIX F

DOCUMENTS

Abbreviations

AGB	Archivio Giustiniani-Bandini, Rome (Fondazione Caetani)
AOSMF	Archivio dell'Opera di Santa Maria del Fiore
ARSI	Archivum Romanum Societatis Iesu, Rome
ASF	Archivio di Stato, Florence
ASLF	Archivio di San Lorenzo, Florence
ASR	Archivio di Stato, Rome
ASV	Archivio Segreto Vaticano, Rome
BAV	Biblioteca Apostolica Vaticana, Rome

DOCUMENT 1 • 1550

Giorgio Vasari, *Le vite de' più eccellenti architetti, pittori, et scultori italiani, da Cimabue, insino à tempi nostri*:

Cosí egli in breve tempo due figure di marmo finí, le quali in detta sepoltura pose, che mettono il Moisè in mezzo; e bozzato ancora in casa sua, quattro figure in un marmo, nelle quali è un Cristo deposto di croce; la quale opera può pensarsi, che se da lui finita al mondo restasse, ogni altra opera sua da quella superata sarebbe per la difficultà del cavar di quel sasso tante cose perfette.

BIBLIOGRAPHY: Vasari (ed. Bellosi) 1986–91, 2:910–11.
This is the first edition of Vasari's *Lives* published in Florence in 1550 by Lorenzo Torrentino.

DOCUMENT 2 • 1553

Ascanio Condivi, *Vita di Michelagnolo Buonarroti*:

Ora ha per le mani una opera di marmo, qual'egli fa a suo diletto, come quello che pieno di concetti, è forza che ogni giorno ne partorisca qualcuno. Quest'è un gruppo di quattro figure più che al naturale, cioè un Cristo deposto di croce, sostenuto così morto dalla sua Madre, la quale si vede sottentrare a quel corpo col petto, colle braccia e col ginocchio in mirabil atto, ma però aiutata di sopra da Nicodemo, che ritto e fermo in sulle gambe, lo solleva sotto le braccia, mostrando forza gagliarda, e da una delle Marie della parte sinistra. La quale ancor che molto dolente si dimostri nondimeno non manca di far quell'uffizio, che la Madre per lo estremo dolore prestar non può. Il Cristo abbandonato casca con tutte le membra relassate, ma in atto molto differente e da quel che Michelangelo fece per la Marchesana di Pescara, e da quel della Madonna della Febbre. Saria cosa impossibile narrare la bellezza e gli affetti che ne' dolenti e mesti volti si veggiono, sì di tutti gli altri, sì dell'affannata Madre; però questo basti. Vo' ben dire ch'è cosa rara, e delle faticose opere, che egli fino a qui abbia fatte; massimamente perchè tutte le figure distintamente si veggono, nè i panni dell'una si confondono co'panni dell'altre.... Fa disegno di donar questa Pietà a qualche Chiesa, ed a piè dell'altare, ove sia posta, farsi seppellire.

BIBLIOGRAPHY: Condivi 1553; Condivi (ed. Nencioni) 1998, 51–52; and an English translation in Condivi (ed. Wohl) 1976, 87–90.

DOCUMENT 3 • 21 AUGUST 1561

ASR, Archivio del Collegio dei Notai Capitolini, notaio Curtius Saccocius, vol. 1519, fol. 614r:

Indictione 4 mensis Augusti diè 21, 1561
In presentia Cum sit prout infrascripte partes asseruerunt quod Antonius Johannis Marie del francese de Castro Durante, ad presens famulus domini Michaelis Angeli Bonaroti scultoris, eidem domino Michaeli Angelo per plures annos et ultra octo inservierit et de servitiis huius-

modi prestitis et de mercede sua fuerit ab eodem domino Michaeli Angelo satisfactus.... Recognoscendo etiam veritatem erga dictum Antonium idem dominus Michael Angelus confessus fuit duas figuras marmoreas sbozzatas manu ipsius domini Michaelis Angeli et in domo existentes, de uno Christo, una con la croce, e l'altra Christo morto, esse ipsius Antonii et ad cum spectare et pertinere et propterea a quoquam nolle super eis molestari.

BIBLIOGRAPHY: Vasari (ed. Barocchi) 1962, 4:1677–78; Corbo 1965, 142, no. 108.

This is a notarized document in which Michelangelo donates a Christ carrying a cross and also a Pietà (presumed to be the Rondanini *Pietà*; plate 8) to his servant Antonio.

DOCUMENT 4 ◆ 19 FEBRUARY 1564

ASR, Archivio del Collegio dei Notai Capitolini, notaio Vitalis Galganus, vol. 752, fol. 421r:

> In una stantia a basso, coperta a tetto, dove sono: una statua principiata per uno santo Pietro sbozzata et non finito; un'altra statua principiata per uno Christo con un'altra figura di sopra, staccate insieme, sbozzate et non finite; un'altra satua piccolina per un Christo con la croce in spalla et non finita.

BIBLIOGRAPHY: Corbo 1965, 128–29, no. 70.

This document is from an inventory of Michelangelo's estate.

DOCUMENT 5 ◆ 18 MARCH 1563 [1564]

Giorgio Vasari in Florence writing to Lionardo Buonarroti in Rome:

> E venutomi consideratione che Michelagniolo, d'udita io—et che lo sa anche Daniello et m. Tomaso de' Cavalieri et molti altri suoi amici—che la Pietà delle cinque figure che gli roppe la faceva per la sepoltura sua, et vorrei ritrovare, come suo erede, in che modo l'aveva il Bandino: perché, se la ricercherete per servirvene per detta sepoltura, oltre che ella è disegniata per lui, èvvi un vecchio che egli ritrasse sé; [et] non sendo stata poi tocha da Tiberio, procurerei di averla et me ne vorrei servire per ciò.

BIBLIOGRAPHY: Daelli 1865, 55, no. 33; Frey 1923–30, 59–60, no. 186; Barocchi, Bramanti, and Ristori 1988–95, 2:179–83, no. 362 (especially p. 181).

The text of the document is transcribed from Barocchi.

DOCUMENT 6 ◆ 23 MARCH 1564

ASR, Notai Auditor Camerae, notaio Caesar Quintilius Lottus, vol. 3924, fols. 639–40:

> Die 23 Martii 1564.
> et che anchora al detto Messer Alessandro sicome dice se aspettasse et pertinesse la tertia parte de una statua grande de marmo ad uso di Pietà che fu donata da Messer Michel Angelo Bonarrota à lor padre.

BIBLIOGRAPHY: Unpublished.

The document refers to the division of the property of Francesco Bandini among his three sons on 29 September 1562 (see chap. 5).

DOCUMENT 7 ◆ 14 JULY 1564

Benedetto Varchi, *Orazione funerale fatta e recitata da lui pubblicamente nell'essequie di Michelagnolo Buonarroti*:

> Chiese Michelangelo a' Frati di Santa Croce (già sono travalicati molti anni) tanto di luogo nella loro spaziosissima Chiesa, che egli vi potesse murare una cappella, e collocarvi un sepolcro; promettendo loro (e non era punto né bugiardo né millantatore) che, oltra l'architettura, vi farebbe di sua mano tante, e tali Pitture, e Sculture, con tali, e tanti ornamenti,

che i Forestieri, che passavano per Firenze; vorrebbono andare prima in Santa Croce, per vedere quella cappella, che dietro al palazzo de' Signori, per vedere i Lioni. I Frati glele concedettero graziosamente, e di volonteroso cuore; ma gl' operai, i quali erano laici, e idioti, per mostrare che non solo erano quanto da Michelagnolo; ma potevano più di lui; da che si raro huomo era loro capitato alle mani, a dimandar grazia; dopo haverlo aggirato buona pezza, hora di giù, e ora di su; e fattolo andare piu volte, à suono di campanuzzo, dentro, e di fuori, senza allegarne altra cagione, se non che ciò loro non piaceva; gle le dinegarono. Per la qual cosa egli sdegnatosi (com'hanno in costume di fare gl'animi nobili e generosi, qual era il suo) mai piu in tutto il tempo della sua vita non mise pie in quella Chiesa; ancora che in ella avesse la sepoltura de' suoi Maggiori: nella quale lasciò alla sua morte di volere essere sepolto, e sotterrato.

BIBLIOGRAPHY: Varchi 1564, 37–38; Gotti 1875, 1:368; Vasari (ed. Barocchi) 1962, 4:2224.

The oration was delivered in the Medici patronage church of San Lorenzo, Florence.

DOCUMENT 8 ◆ 5 APRIL 1566

Archive unknown. Inventory of Daniele da Volterra's estate: Die quinta aprilis 1566. Inventarium rerum et bonorum quondam domini Daniellis Ceccarellis de Volaterris repertum in domo eius solite habitationis sita in monte Quirino.

> In una stanza da basso.... Un ginocchio di marmo della pietà di Michelangelo.

BIBLIOGRAPHY: Gasparoni 1866, 178–80, esp. 180; cited in Steinmann and Wittkower 1927, 145, no. 778. The item is referred to repeatedly in publications on the statue.

Gasparoni, who first published the document, did not indicate its archival source; nor did Steinmann and Wittkower, nor later historians. Gasparoni on p. 180, n. 11, was the first to claim that the knee came from the Florence *Pietà*.

DOCUMENT 9 ◆ 1568

Giorgio Vasari, *Le vite de' più eccellenti pittori scultori ed architettori*:

> Mentre che queste cose si andavano preparando, venne volontà a Baccio [Bandinelli] di finire quella statua di Cristo morto tenuto da Niccodemo [*sic*], il quale Clemente suo figliolo aveva tirato innanzi, perciocchè aveva inteso che a Roma il Buonarroto ne finiva uno, il quale aveva cominciato in un marmo grande, dove erano cinque figure, per metterlo in Santa Maria Maggiore alla sua sepoltura. A questa concorrenza, Baccio si messe a lavorare il suo con ogni accuratezza, e con aiuti, tanto che lo finì; ed andava cercando in questo mezzo per le chiese principali di Firenze d'un luogo, dove egli potesse collocarlo, e farvi per sè una sepoltura.

BIBLIOGRAPHY: Published in Vasari (ed. Milanesi) 1878–85, 6:188–89; English trans. in Vasari (ed. Hinds) 1927, 3:212.

"Santa Maria Maggiore" is assumed by most scholars to refer to the Roman basilica.

DOCUMENT 10 ◆ 1568

Giorgio Vasari, *Le vite de' più eccellenti pittori scultori ed architettori*:

> Non poteva lo spirito e la virtù di Michelagnolo restare senza far qualcosa; e poichè non poteva dipingnere, si messe attorno a un pezzo di marmo per cavarvi drento quattro figure tonde maggiori che 'l vivo, facendo in quello Cristo morto, per dilettazione e passar tempo, e, come egli diceva, perchè l'esercitarsi col mazzuolo lo teneva sano del corpo. Era questo Cristo, come deposto di croce, sostenuto dalla Nostra Donna, entrandoli sotto ed aiutando con atto di forza Niccodemo fermato in piede, e da una delle Marie che lo aiuta, vedendo mancato la forza nella

Madre, che vinta dal dolore non può reggere. Nè si può vedere corpo morto simile a quel di Cristo, che, cascando con le membra abbandonate, fa attiture tutte diferenti, non solo degli altri suoi, ma di quanti se ne fecion mai: opera faticosa, rara in un sasso, e veramente divina; e questa, comme si dirà di sotto, restò imperfetta, ed ebbe molte disgrazie; ancora ch' egli avessi avuto animo che la dovessi servire per la sepoltura di lui, a piè di quello altare, dove e' pensava di porla.

BIBLIOGRAPHY: Vasari (ed. Milanesi) 1878–85, 7:217–18; English trans. in Vasari (ed. Hinds) 1927, 4:145.

DOCUMENT II • 1568
Giorgio Vasari, *Le vite de' più eccellenti pittori scultori ed architettori*:

Lavorava Michelagnolo, quasi ogni giorno per suo passatempo, intorno a quella Pietà che s'è già ragionato, con le quattro figure; la quale egli spezzò in questo tempo per queste cagioni: perchè quel sasso aveva molti smerigli, ed era duro, e faceva spesso fuoco nello scarpello, o fusse pure che il giudizio di quello uomo fussi tanto grande, che non si contentava mai di cosa che e' facessi: e ce e' sia il vero, delle sue statue se ne vede poche finite nella sua virilità, che le finite affatto sono state condotte da lui nella sua gioventù; come il Bacco, la Pietà della Febre, il Gigante di Fiorenza, il Cristo della Minerva, che queste non è possibile nè crescere nè diminuire un grano di panico senza nuocere loro; l'altre del duca Giuliano e Lorenzo, Notte ed Aurora, e 'l Moisè con l'altre dua in fuori, che non arrivano tutte a undici statue; l'altre, dico, sono restate imperfette, e son molte maggiormente, come quello che usava dire, che, se s'avessi avuto a contentare di quel che faceva, n'arebbe mandate poche, anzi nessuna, fuora; vedendosi che gli era ito tanto con l'arte e col giudizio innanzi, che come gli aveva scoperto una figura, e conosciutovi un minimo che d'errore, la lasciava stare, e correva a manimettere un altro marmo, pensando non avere a venire a quel medesimo; ed egli spesso diceva essere questa la cagione che egli diceva d'aver fatto sì poche statue e pitture. Questa Pietà, come fu rotta, la donò a Francesco Bandini.

BIBLIOGRAPHY: Vasari (ed. Milanesi) 1878–85, 7:242–43; English trans. in Vasari (ed. Hinds) 1927, 4:158.
Document 12 immediately follows the last sentence of this document.

DOCUMENT 12 • 1568
Giorgio Vasari, *Le vite de' più eccellenti pittori scultori ed architettori*:

In questo tempo Tiberio Calcagni, scultore fiorentino, era divenuto molto amico di Michelagnolo per mezzo di Francesco Bandini e di messer Donato Giannotti; ed essendo un giorno in casa di Michelagnolo, dove era rotta questa Pietà, dopo lungo ragionamento li dimandò per che cagione l'avessi rotta, e guasto tante maravigliose fatiche; rispose, esserne cagione la importunità di Urbino suo servidore, che ogni dì lo sollecitava a finirla; e che, fra l'altre cose, gli venne levato un pezzo d'un gomito della Madonna, e che prima ancora se l'era recata in odio, e ci aveva avuto molte disgrazie attorno di un pelo che v'era; dove scappatogli la pazienza la roppe, e la voleva rompere affatto, se Antonio suo servitore non se gli fussi raccomandato che così com'era gliene donassi. Dove Tiberio, inteso ciò, parlò al Bandino che desiderava di avere qualcosa di mano sua; ed il Bandino operò che Tiberio promettessi a Antonio scudi 200 d'oro, e pregò Michelagnolo che se volessi che con suo aiuto di modelli Tiberio la finissi per il Bandino, saria cagione che quelle fatiche non sarebbono gettate in vano; e ne fu contento Michelagnolo: là dove ne fece loro un presente. Questa fu portata via subito, e rimessa insieme poi da Tiberio, e refatto non so che pezzi; ma rimase imperfetta per la morte del Bandino, di Michelagnolo e di Tiberio. Truovasi al presente nelle mani di Pierantonio Bandini, figliuolo di Francesco, alla sua vigna di Montecavallo. E tornando a Michelagnolo, fu necessario trovar qualcosa poi di marmo, perchè e' potessi ogni giorno passar tempo scarpellando; e fu

messo un altro pezzo di marmo dove era stato già abbozzato un'altra Pietà, varia da quella, molto minore.

BIBLIOGRAPHY: Vasari (ed. Milanesi) 1878–85, 7:243–45; English trans. in Vasari (ed. Hinds) 1927, 4:158–59.
This document follows document 11. Historians identify the "much smaller" *Pietà* to which Vasari refers in this document as the Rondanini *Pietà* in the Museo Civico, Castello Sforzesco, Milan.

DOCUMENT 13 • 1568
Giorgio Vasari, *Le vite de' più eccellenti pittori scultori ed architettori*:

Aveva seco Michelagnolo a questo parlamento Tiberio Calcagni, scultore fiorentino, giovane molto volonteroso di imparare l'arte, il quale essendo andato a Roma, s'era volto alle cose d'architettura. Amandolo Michelagnolo, gli aveva dato a finire, come s'è detto, la Pietà di marmo ch'e'roppe; ed in oltre una testa di Bruto, di marmo, col petto, maggiore assai del naturale, perchè la finisse: quale era condotta la testa sola con certe minutissime gradine.

BIBLIOGRAPHY: Vasari (ed. Milanesi) 1878–85, 7:262; English trans. in Vasari (ed. Hinds) 1927, 4:167–68.

DOCUMENT 14 • 1568
Giorgio Vasari, *Le vite de' più eccellenti pittori scultori ed architettori*:

Donò… a Antonio suo servitore, ed a Francesco Bandini, la Pietà che roppe, di marmo: nè so quel che si possa tassar d'avarizia questo uomo, avendo donato tante cose, che se ne sarebbe cavato migliaia di scudi.

BIBLIOGRAPHY: Vasari (ed. Milanesi) 1878–85, 7:277; English trans. in Vasari (ed. Hinds) 1927, 4:174.
Vasari here refers to the gift of the statue to Antonio and Bandini to demonstrate Michelangelo's generosity of donating works of art to individuals, even though he could otherwise have sold them for a considerable sum.

DOCUMENT 15 • 1568
Giorgio Vasari, *Le vite de' più eccellenti pittori scultori ed architettori*:

Il Vasari, mandato da Giulio terzo a un'ora di notte per un disegno a casa Michelagnolo, trovò che lavorava sopra la Pietà di marmo che e'ruppe. Conosciutolo Michelagnolo al picchiar della porta, si levò dal lavoro e prese in mano una lucerna dal manico; dove, esposto il Vasari quel che voleva, mandò per il disegno Urbino di sopra, e entrati in altro ragionamento, voltò intanto gli occhi il Vasari a guardare una gamba del Cristo, sopra la quale lavorava e cercava di mutarla; e per ovviare che 'l Vasari non la vedessi, si lasciò cascare la lucerna di mano, e, rimasti al buio, chiamò Urbino che recassi un lume; ed intanto uscito fuori del tavolato dove ell'era, disse: Io sono tanto vecchio, che spesso la morte mi tira per la cappa, perchè io vadia seco, e questa mia persona cascherà un dì come questa lucerna, e sarà spento il lume della vita.

BIBLIOGRAPHY: Vasari (ed. Milanesi) 1878–85, 7:281–82; English trans. in Vasari (ed. Hinds) 1927, 4:177.

DOCUMENT 16 • 1591
Francesco Bocchi, *Le bellezze della città di Fiorenza*:

Sepolcro di Michelagnolo Buonarroti, il quale oltra l'artifizio sommamente è mirabile; peroche egli tiene le ossa del più sovrano artefice; che nelle tre nobili arti già mai sia stato. Fu già pensiero del buonarroto di fare di sua mano quello, che dopo sua morte è convenuto, che altri faccia. Egli quando vivea molte volte domandò da gli Operai di S. Croce, perche gli fosse un luogo conceduto in Chiesa; ove di sua mano, con suo disegno voleva con molte figure di marmo collocare un sepolcro per se, e per li suoi: il quale dinegato da gli huomini importuni, ha privata

fiorenza d'una opera, che si aspettava maravigliosa, e rarissima; e ha mostrato, come gli huomini, che troppo usano la forza di suo magistrato, alcuna volta più tosto all'appetito, che alla ragione sodisfanno: onde hoggi tanto grande è la querela, che ne fanno gli huomini virtuosi, che, si come fu grave l'errore, sarebbe ancora grandissima l'infamia, se i nomi di quelli, che prohibirono, fossero stati a' posteri palesati. E' bellissimo tuttavia questo sepolcro, che si vede, e per l'architettura, la quale è rara, e per le figure, che sono di mirabile artifizio.

BIBLIOGRAPHY: Bocchi 1591, 156; Bocchi and Cinelli 1677, 320. Bocchi repeats what Varchi wrote in 1564 (doc. 7).

DOCUMENT 17 ◆ 10 OCTOBER 1592
ASR, Notai Auditor Camerae, notaio Petrus Catalonus, vol. 1552, fols. 753–72v:

Fol. 753: Seguono le robbe trovate a Monte Cavallo . . . nel giardino
Un [sic] statua o figura di marmo della pieta abozzata / Sopra la logetta della statua un altro tavolino di marmoro con suo sedile / Nove pili di marmoro in diversi lochi anzi intorno arco di peperino.

BIBLIOGRAPHY: Unpublished.
This document is from an inventory of the estate of Pierantonio Bandini. The document also describes the layout of the garden and notes that Pierantonio's son, the Abbot Giovanni Bandini, had inherited the property.

DOCUMENT 18 ◆ 12 APRIL 1628
AGB, Busta 7, fasc. 96:

Misure e stime de lavori di muro, et altro fatti di tutta robba da M.ro. Matteo Goroni muratore nel Casino, e Giardino dell'Illustrissimo e Reverendissimo Sig. Cardinal Bandino posto a Monte Cavallo misurati e stimati da me Francesco Peperelli per ambe le parti.
"Per haver rotto il muro nella nicchia dove è la pietà per trovar il danno del condotto e murato le legatura–30."

BIBLIOGRAPHY: Unpublished.
The niche is listed in the section of the document entitled "Gioco della Palla" in the garden.

DOCUMENT 19 ◆ 26 JUNE 1632
AGB, Busta 1, fasc. 11b:

La Marchese Cassandra del Marchese Giovanni Bandini cede al Marc. Niccolò Giugni suo marito per prezzo 18000 scudi fiorentini il Giardino di Roma posto a Monte Cavallo con patto però, che nel termino di tre o quattro anni debba averlo venduto, ad effetto, che esse cedente come erede del Cardinal Ottavio suo zio possa pagar la dote di Maria Maddalena Bandini sua sorella.

BIBLIOGRAPHY: Unpublished.

DOCUMENT 20 ◆ 15 MAY 1646
AGB, Busta 1, fasc. 11c, notaio Torquatus Sampieri:

Inventario delle robbe che sono al Giardino al Monte Cavallo. Tre statue sono nel giardino, cioè una Pietà, et una statua a canto intera d'un'imperatrice Romana, e S. Paolo prima eremita.

BIBLIOGRAPHY: Unpublished.
This is the document of the sale of the suburban villa on the Quirinal Hill by Cassandra Bandini to Scipione Capponi. The sale included "omnes statuas, lapideas, marmoreas, busta, capita statuaria et vasa florum et agrumina." Attached to the document is a plan of the property that does not include the statuary.

DOCUMENT 21 ◆ 30 JANUARY 1649
ASR, 30 Notai Capitolini, Uff. 36, vol. 82, notaio Torquato Lamperinus, fols. 87–99:

Fol. 88. Volens modo idem Em. Cardinalis Capponiis . . . nomine dicti Ill.mo Sig. Marchionis Scipionis eius nepotis preditum viridarium cum Palatio, et omnibus suis membris, omnibus . . . venditione, et donatione respective contentis, excepta tantum medietate statuarum et vasorum florum, et agruminum.

BIBLIOGRAPHY: Unpublished.
The document states that the suburban villa on the Quirinal Hill had been sold to Scipione Capponi by Cassandra Bandini and that now Cardinal Luigi Capponi is serving as his agent in the sale of the property to the Society of Jesus. The document then notes that the property was sold with all its contents, except for half the statues.

DOCUMENT 22 ◆ 1649
BAV, Barb. Lat. 4939: Memorie dello stile della corte del Em.mo Signor Card. Capponi patrone cominciato al primo dell'anno 1648, tratte da Sebastiano Casci per gli anni 1648–1649:

Fols. 277–78, 27 May 1649:
Questo giorno è arrivata la statua di marmo della Pietà, non finita di Michelangelo Buonaroti, che stava nel Giardino di Monte Cavallo, la quale è toccata al Sig. Card.le nella divisa aggiustata d'accordo con Padri Gesuiti nella vendita fatta di detto Giardino, si come ancora un'altra statua di un S. *Paolo Primo Eremita*, ò un *Santo Onofrio*, come si vuol chiamare, l'una e l'altra sono state condotte da Jacomo Santone con somma diligenza, e facilità, con spesa di venticinque scudi per essere scommoda e gelosa.
[In margin] La Pietà di Michelangelo Bonaroti condotta à Monte Citorio.

BIBLIOGRAPHY: Unpublished.
Casci seems to have been Cardinal Capponi's private secretary and kept a diary of his daily activities.

DOCUMENT 23 ◆ 1652
Giovanni Ottonelli and Pietro da Cortona, *Trattato della pittura e scultura*, 210:

Non voglio lasciar di riferire ciò, che mi disse un gran professore intorno al famosissimo Michel'Angelo, cioè che più volte lasciò in Roma l'opere abbozzate; perchè se bene erano tali, che potevano servir d'esemplari ad altri maestri, nondimeno à lui non riuscivano di perfettissima sodisfattione. Tali sono i due Gruppi di Pietà, de' quali uno fù trovato seppellito in una stanza à terreno, & hora si vede publicamente in una Officina di Roma: e l'altro stà nel giardino, che fù del Sig. Cardinal Bandino à Monte Cavallo. E queste due Bozze, oltre l'altre, che si veggono tralasciate, sono di tanta bellezza, che Tadeo Zucchero stimò bene impiegata la sua fatica in disegnarle, colorirle, e ridurle in opera: come vedesi in Roma nella Madonna de' Monti, e nella Pietà del Consolato de' Fiorentini. E da questo argomentar si può, che non è cosa insolita, ne indecente ad un consumato Artefice lasciar, ò guastar un'opera, non finita, e rifarla secondo la pienezza della sua totale sodisfattione: imperoche questo dimostra, non che l'opera sia in se molto difettosa, ma che molto perfetta, e molto eccellente sia l'idea, che nell'animo ha formato il Maestro per condurla.

BIBLIOGRAPHY: Ottonelli and Cortona 1652, 210; Mallarmé 1929, 76; cited in Steinmann and Wittkower 1927, 272, no. 425.

DOCUMENT 24 • 9 APRIL 1659
ASR, 30 Notai Capitolini, Uff. 36, vol. 99, notaio Olimpio Ricci, fols. 488–536v:

Fols. 489r–91v:
Die nona Aprilis 1659. Hoc est descriptio omnium et singulorum bonorum Ill.mo et R.mo D. Luca Torregiani Camera Apost.ca clerici et arcipiscopi Ravennaten repertorum in palazzii s. Borgi et Montii Jordani.

Fols. 492r–v:
Die 9 Aprilis 1659. Hoc est descriptio omnium singulorum bonorum Ill.mo Sig. Marchionis Scipionis Capponi et March.sa Hier.ma . . . de Capponis conviugum repertorum in palatii Burgi. Nel Palazzo di Borgo. Una Pietà di marmo bianco con 4 figure alta 12 palmi in circa non compita di mano di Michelangelo. Una statua di Sant'Onofrio di marmo simile alta circa palmi otto.

Fols. 493r–536v:
Die nono Aprilis 1659. Hoc est descriptio omnium et singulorum bonum mobilium esistentium in Palatii Burgi quam Montii Jordanii spectantium . . . ad Card.lis Capponis. On foglio 497v, under heading "sala," we read; "un piede stallo di legno sotto una statua di S. Onofrio spettante di Sig. Marchgese Capponi."

BIBLIOGRAPHY: Unpublished.
The notary compiled three separate inventories as a single document. The pedestal of the statue of St. Onofrio is included among the cardinal's possessions, but is listed as belonging to Scipione Capponi.

DOCUMENT 25 • 25 JULY 1671
ASR, 30 Notai Capitolini, Uff. 36, vol. 124, notaio Olimpio Ricci, fols. 61–62:

Venditio statue scudi pro Ill. D Paulo Falconieri.
Die 25 Lulii 1671. Ill. D Marchione Petrus Capponus filius b. m. Marchionis et Senatoris Scipionis Patrio Florentinus per me etc. cognitus sponte ac omnibus etc. vendidit ac titulo pure, mere ac irretractabilis venditionis cessit Ill. d. Paulo Falconierio filio b. m. Petri Paolo Florentino per me Pariter cognito presenti, acquirenti et acquirere declaranti pro serenissimo Magno Duce etrurie . . . pro ut dicitur, la statua della Pietà continente quattro statue unite rappresentanti un Christo, Simeone [sic] con la Madonna et una Maria in parte finita, et in parte sbozzata con alcuni pezzetti mentre ne siano in potere dell'Ill.ma sig.ra Maria Isabella Accoranboni, di mano di Michelangelo Buonarota, ad ad presens existens in palatio dicte Ill.ma Marie Isabelle Accoranbone in Burgo. . . . I Signori Alamanni e del Rosso saranno contenti di pagare all'Ill.ma Signore marchese Pietro Capponi scudi 300 moneta quali gli faccio pagare per prezzo di una statue di 4 figure rappresentanti la Pietà parte finita e parte sbozzata di mano di Michelangelo Buonarota sotto questo giorno vendutami per S. Altezza Serenissma di Toscana per istrumento rogato dal vice notaio del Consolato dei Fiorentini . . . di casa questo di 26 luglio 1671 scudi 300 moneta.

BIBLIOGRAPHY: Unpublished.
Cosimo III is referred to only as the duke of Tuscany and as His Serene Highness of Tuscany. Paolo Falconieri, who signed the document, served as Cosimo's agent in the purchase of the Pietà.

DOCUMENT 26 • 8 JUNE 1672
ASF, Carta Capponi, 76, Cassetta 11, no. 1, insert 75:

Fol. 78, no. 25: Pietà di Michelangelo al S.re Paolo Falconieri per debilità che il prezzo fosse scudi 300 di paoli dieci per scudo.
Fol. 78, no. 26: Propongo come da sudettopresso . . . li fu consegnato 300 . . . a detto Falconieri ed il prezzo negoziato in Roma.

BIBLIOGRAPHY: Unpublished.

This document refers to the sale of the Pietà as recorded in doc. 25, dated 25 July 1671.

DOCUMENT 27 • 18 JUNE 1672
ASF, Carta Capponi, 76, Cassetta 11, no. 1, insert 79, fol. 50v:

In . . . l'istromento Olimpio Ricci adi 25 luglio. 1671 circa la vendita della statua della Pietà al Sig. Paolo Falconieri per scudi 300 paoli l'uno p. no. 18.

BIBLIOGRAPHY: Unpublished.
This document refers to the sale of the Pietà as recorded in doc. 25, dated 25 July 1671.

DOCUMENT 28 • 12 JUNE 1674
ASF, Mediceo del Principato, 3941:

P.S. Dopo havere S. A. scritto a V. S. Ill.ma quanto ella vedrà nell'annessa circa la statua, è venuto stasera il nunzio a domandare in nome del papa una galera del Gran Duca per trasportare da Livorno a Genova certo contante che altra galera pontifica condurrà da Città Vecchia a Livorno, ora pare a S. A. che questa sia una buona opportunità per il trasporto della statua giudicando che costì a palazzo non haveranno difficoltà in permettere che ella sia caricata sopra la loro galera e condotta a livorno mentre esigono dall'A.S. il servizio della sudetta comodità. Onde vuole il prone [padrone] che subito ricevuta la presente, V.S. Ill.ma faccia dar mano ad incassare la statua; e nel medesimo tempo per mezzo del sig. Conte Montauti (supponendosi, che a lei tornerà farne meglio così) sia domandata a palazzo la permissione di poter caricare sopra la galera che passa a Livorno una statua che il Granduca tiene costà, senza stare ad entrare in termini di estrazione, o altro con che pare che tutto l'averebbe andare bene.

BIBLIOGRAPHY: English trans. Goldberg 1983, 352, no. 11.
This item is a postscript to a lost letter Cosimo III wrote to Paolo Falconieri ordering him to arrange the shipment of the Pietà to Florence.

DOCUMENT 29 • 16 JUNE 1674
ASF, Mediceo del Principato, 3941:

Subito avute le lettere sono andato dal Sig.re Conte Montauti, e gli ho letto il P.S. di V.S. et ho presa facultà di potere ordinare quello che bisogna p incassare la statua . . . subito ho fatto mettere mano all'opera p.che non ci sia negligenza dalla mia parte . . . p.che p. essere una macchina assai grande tra l'incassarla e trasportarla vi vorrà del tempo . . . martedi di buon ora possa partire da Ripa e restar Roma senza pietà.

BIBLIOGRAPHY: English trans. Goldberg 1983, 352, no. 12.
Paolo Falconieri in Rome writing to Apollonio Bassetti, canon of the church of San Lorenzo in Florence. The "P.S. di V.S." refers to the postscript included in doc. 28.

DOCUMENT 30 • 16 JUNE 1674
ASF, Carteggio degli artisti, vol. 19, fol. 603v (232v in new pagination):

Circa all'inviare costà le teste di marmo risarcite non si è risoluto nulla perche non ci siamo mai messi insieme ancora il camelli ed io. Mi era venuta voglia di mandarle con questa galera che viene a Livorno ma ho poi avuto paura di non dificultare l'estrazione della Pietà che ha ordinata il Ser.mo G. Duca che si mandi con chiederla nello stesso tempo per tante cose.

BIBLIOGRAPHY: English trans. Goldberg 1983, 352, no. 13.
Paolo Falconieri in Rome writing to Cardinal Leopoldo de' Medici in Florence.

DOCUMENT 31 • 16 JUNE 1674
ASF, Mediceo del Principato, 3941:

Intorno a q.to comando del Prone [Padrone] Ser.mo discorremmo hieri lungamente il sig.re Paolo et io, et havendo concertato ch'io eseguisca q.ta mattina l'ordine di chiederla comodità d'imbarcare sopr'una di q.te galere il soprad[etto] marmo, mi son fatto introdurre a tal effetto al Sig.re Card.le Altieri, che appena intesa la mia richiesta mi ha detto che deve servire al G. Duca, et che senza dilatione havrebbe ordinato l'mbarco, ma che io facessi spedir la licenza solita, al che ho replicato che mentre l'Eminenza Sua favoriva dell'imbarco consequivo con questo ogn'altra licenza. Soggiunse che era vero, et io devo dire che S. Em.a ha dimostrato gran contento in q.ta occasione di servire a S.A., al quale effetto chiamò subito Mons.re Antaldi suo auditore, et li ordinò questa licenza, che mi è stata portata fin a casa, ma per il registro, et il sigillo si sono spesi alcuni testoni. Questa notte parte la soldatesca che deve imbarcarsi sopra le galere onde dubito se possa la statua arrivare in tempo d'imbarcarsi. Ho avvisato il Sig.re Paolo di questa fretteria, et mentre sono stato tutt'oggi scrivendo, credo che lui sia stato attorno a q.ta speditione. Mi ha poi fatto dire che fin'a martedì mattina la statua non si potrà cavar dal giardino, ond'io temo che non possa arrivare in tempo di mandarsi con q.te galere, ma domatt[ina] me n'interderò meglio con esso Sig.re Paolo, con il quale ho parimente discorso circa il regalare il Sig.re Ciro et il Sig. Ercole.

BIBLIOGRAPHY: English trans. Goldberg 1983, 354, no. 15.
Torquato Montauti in Rome writing to Apollonio Bassetti in Florence.

DOCUMENT 32 • 16 JUNE 1674
ASR, Camerale diversa, vol. 5, fol. 957r:

Statue mandate fuori di Roma dal 1674 all'1683 per gli atti de' mastri de Strada 1674.
A di 16 giugno 1674 licenza di estrare da Roma a Livorno alli Ministri del Ser.mo Gran Duca di Firenze per servito di Sua Altezza Ser.ma una statua che rapresenta un principio di una Pietà di Michelangelo che nella maggior parte e solo sforzata.

BIBLIOGRAPHY: Bershad 1978, 226.
[I was unable to locate this document in the Archivio di Stato.]

DOCUMENT 33 • 16 JUNE 1674
ASR, Presidenza delle Strade, vol. 48, fol. 61:

Per tenore della presente e per l'auctorità. Del nostro officio. Di Camerlengo Concede Licenza alli ministri del Ser.mo Gran Duca di Fiorenza che possino far estraere da Roma . . . per condurre à Livorno altrove per servitio sua Altezza Ser.ma una statua che rappresenta un principio d'una Pietà di Michel Angelo che nella maggior parte e solo sbozzata dovrà però attergarsi dal ministro Cam.re consuete il solito pertanto Command.o che per da estrarle non sii dato ne molestia ne impedimento alcuno sotto pena à n.o arb.o dati li 16 Giugno 1674. Per Cardinale Altieri Camerlengo, Francesco Lauria Antaldi Auditore, Cagnatonus notus.

BIBLIOGRAPHY: Unpublished.
The grand duke receives the license to remove the *Pietà* from Rome.

DOCUMENT 34 • 16 JUNE 1674
ASV, Segretaria di Stato, vol. 159, Lettere scritte a diversi particolari 1670–76, fol. 201:

Al sig. Francesco Torre, assentista delle galere Ponteficie, C. Vecchia [. . .] sopra la galera, la quale passerà a Livorno si deve imbarcare una statua, che per servizio il G. Duca deve condursi, e lasciarsi nel sud.to Porto ai Ministri di S. A. Incarico però a VS di procurare, che cio succeda con ogni accuratezza si nel farla ben collocare nell'imbarco, si per qualunque altra diligenza, che fosse necessaria, e opportuna al trasporto

di essa, onde arrivi e si consegni ben condizionata; il che mi prometto dalla puntualità di VS.

BIBLIOGRAPHY: Unpublished.
Cardinal Altieri wrote this letter in Rome.

DOCUMENT 35 • 18 JUNE 1674
ASR, Archivio Soldatesche e Galere, vol. 404, interior volume bearing the title "Primo assento del S.re Torre, tomo primo, luglio 1670 a luglio 1674," loose sheet numbered 68r–69r:

Fol. 68v:
Nota delle staffette date da Camillo Spadone all'ill.mi Sig.ri assentisti per servitio della Rev. Camera Apostolica come appresso.

Fol. 69r:
18 giugno [1674]. Una staffetta spedita all'Emi.mo Sig.r Card. Altieri Padrone con l'aviso che le due galere di N.Sre. stavano pronte alla partenza per Livorno, e che il S.re Bolognetti voleva partire, e la statua del Gran Duca non si vedeva comparire, e che sua Em. Pardone ordinava che s'imbarcasse sopra le sudette galere, e il Sig. Bolognetti non voleva più aspettare. 4.

BIBLIOGRAPHY: Unpublished.

DOCUMENT 36 • 19 JUNE 1674
ASF, Mediceo del Principato, 3941:

In tanto posso dirle che l'A.S. e rimasta molto contenta del cortese modo con che il S.r Card.le Altieri havea voluto compiacerla anche nell'istanza fattali per il trasporto della statua à Livorno sopra la galera Pontificia, et per compimento della sodisfazione dell'A.S. Resta ora solo da sentire se l'istessa statua sarà giunta in tempo all'imbarco.

BIBLIOGRAPHY: Unpublished.
This is Apollonio Bassetti in Florence writing to Torquato Montauti in Rome. Bassetti's letter is included among Montauti's correspondence.

DOCUMENT 37 • 20 JUNE 1674
ASF, Mediceo del Principato, 3941, n.f.:

Si compiacqui il Sre Card.le Altieri di mostrar molta stima dell'occas.e ch'io li porsi di far servire al Ser.mo G. Duca n. Sig.re nell'imbarco della statua di Michel Agniolo, com'io accennai sabato a VS, di che havendo io riferito al S.r Paolo Falconieri, si prese egli il pensiero di farla diligentem.e incassare, et caricar sopra un carrettone, nel quale fù condotta à Ripa, dove imbarcata sopra il Vascello di Prone [Padrone] Galeazzi di Livorno, parti hier sera p Civitavecchia racommandata à mia instanza dal s.re March.e Patritio . . . cavata la d.a statua dalla barca, la faccia sopra di esse imbarcare p godere i favori di S. Em.a . . . che se le galere fossero già partite, o se siuscisse [?] impossibile il caricarvi q.ta macchina, la faccia condurre dall'istesso Prone Galeazzi, al quale è stata consegnata . . . Ho'anco scritto a S.r Camillo Capponi in Liv.o . . . che le galere non doveranno partire prima che arrivassi la statua. Hier sera doppo le 24 mandò il S.r Card.e uno staffiere al Palazzo di Campo Marzo à dimandare se la statua era partita, et io li feci respondere, che già era di più hore in fiumara, et che non si era potuta spedire con maggior sollecitudine.

[The letter continues, indicating that after an audience with Cardinal Altieri to thank him for his help, Montauti is reassured that the "galere non son partite, ne partiranno (from Civitavecchia) finche non si carichi la statua.]

BIBLIOGRAPHY: Partial English trans. Goldberg 1983, 354, no. 16.
This is Torquato Montauti in Rome writing to Apollonio Bassetti in Florence.

DOCUMENT 38 • 22 JUNE 1674
ASR, Archivio Soldatesche e Galere, vol. 404, interior volume bearing the title "Primo assento del S.re Torre, tomo primo, luglio 1670 a luglio 1674," loose sheet numbered 68r–69r:

Fol. 69r:
Una staffetta spedita all'Em.mo Sig.re Card.le Altieri Prone con l'aviso che la statua era arrivata, e non poteva imbracarsi sopra le galere conforme era l'ordine che sua Em.za Padrone per essere di troppo peso, ne tampoco poteva entrare nel Bocca porta della Camera di mezzo, essendo poi stata rimorchiata dalle medesime due galere.

BIBLIOGRAPHY: Unpublished.

DOCUMENT 39 • 23 JUNE 1674
ASF, Mediceo del Principato, vol. 3941:

Della continuat.ne dei favori che a conto della statua che si è inviata, ha fatto al Ser.mo G. Duca il Sig.re l'Em. Card Altieri, ne sarà gia pervenuta a VS la notitia . . . che la d.a statua era già in caminata per Civitav.a . . . La barca che conduce la statua deve haver fatto poco viaggio, et non dev'essere arrivata a Civitav.a prima di giovedi, et q.ta matt.a Mons. Marini Maggiord.o pel s.r. Card.le Altieri mi ha detto che le galere erano partite, et che p la difficultà di caricar la statua havevano risoluto di rimburchiare la barca; et che in q.ta maniera la conducevano à Livorno. Le soldatesche delle d.e galere dovev.o aspettare con impazienza, p. che stando in terra, non havevano che tre pagnotte il giorno.

BIBLIOGRAPHY: Unpublished.
This is Torquato Montauti in Rome writing to Apollonio Bassetti in Florence.

DOCUMENT 40 • 24 JUNE 1674
ASF, Mediceo del Principato, 1542, n.f.:

A ore 20½ e comparsa la galera Sri. Giulio, et galera SS. Pietro Pontificie, comondate da Sig. Commendatore Bolognetti, et Cavalier Feretti uscite di Civitavecchia venerdi, et questa mattina da Portoferraio rimburchio anco la Tartana del Padrone Galeazzo di qui, sopra della quale, si ritrova la statue divina per S. A. ma stante della l'àrtana averla condotta di Roma a Civitavecchia, e non essensi potuta stimare sopra delle galere, si come avere alquanto partite di ontanti per Genova.

BIBLIOGRAPHY: Unpublished.
This is Camillo Capponi in Livorno writing to Apollonio Bassetti in Florence. Capponi seems to have held the position of dispatcher. [Franca Trinchieri Camiz discovered this document, but I was not able to locate it.]

DOCUMENT 41 • 25 JUNE 1674
ASF, Mediceo del Principato, 1542, n.f.:

Sono giunte le dua galere di N.tro Signore quale anno rimburchiata la barca di S. Prone Galeazzo portatore della statua di S. A. S. la farò scaricare con quella dilig.a che richiede una si premurosa manifattura e ben vero che pesando questa 12: vi si rende per addesso impossibile di caricarla sopra un navicello per la scarsità dell'acqua che si ritrova nel fiume di Arno malamente porranno caricare stanotte [?] onde la terrò in buona custodia e quando verrà dellaqua ne seguirò l'ordine di S.A.S.

BIBLIOGRAPHY: Unpublished.
This is Camillo Capponi in Livorno writing to Apollonio Bassetti in Florence.

DOCUMENT 42 • 26 JUNE 1674
ASF, Mediceo del Principato, 3941:

Il giorno di San Giovanni arrivorno con prosperità le galere à Livorno . . . si che la statua è già in salvo.

BIBLIOGRAPHY: English trans. Goldberg 1983, 354, no. 17.
This is Apollonio Bassetti in Florence writing to Torquato Montauti in Rome. The passage quoted here is the first sentence of the second paragraph of the document.

DOCUMENT 43 • 26 JUNE 1674
ASF, Segretaria di Stato Firenze, vol. 59, letter no. 465:

delle due galere Pontificie che havendo inteso, che queste haveva per qualche giorno differito la loro partenza da Civitavecchia per attendere il rimorchio d'una barca, che conduceva una statua per servizio di S. A. restava con particolare obligazione al Emminenza Vostra.

BIBLIOGRAPHY: Unpublished.
This is Mons. Airoldi, Papal Nunzio in Florence, writing to the grand duke in Florence. [Franca Trinchieri Camiz discovered this document, but I was not able to locate it.]

DOCUMENT 44 • 27 JUNE 1674
ASF, Mediceo del Principato, 1542, n.f.:

io non vorrei che il Padrone Sereni.mo havesse a male che io non havessi obbedito S.A.S. in dare il rinfresco alla ciurma delle galere pontificie non l'havendo fatto perche le predd.e ciurme non havevano faticato ne in caricare ne in scaricare la statua come haveva accennato il S. Con. Montauti quale credeva che a Civitavecchia fosse seguito il trasporto dalla barcha alla galera il che non essendo seguito, mi sono fatto lecito di fare questo risparmio.

BIBLIOGRAPHY: Unpublished.
This is Camillo Capponi in Livorno writing to Apollonio Bassetti in Florence.

DOCUMENT 45 • 27 JUNE 1674
ASF, Mediceo del Principato, 1542, n.f.:

Havendo presentito che la ciurma delle galere di S. Santita non abbino travagliato in conto alcuno nella caricazione della statua non gli sono stato à dare cosa alcuna, et in quel cambio ne pagheremo il nolo al padrone Galeazzo che li ha condotta di Roma con la sua barca di dove non è stata mai mossa per la strada, et il Sig. Conte Montauti mi scrive che quando il predetto prone la conduca qui ben conditionata oltre al suo nolo gli si dia con titolo di regalo qualche contesia.

BIBLIOGRAPHY: Unpublished.
This is Camillo Capponi in Livorno writing to Apollonio Bassetti in Florence.

DOCUMENT 46 • 29 JUNE 1674
ASF, Mediceo del Principato, 1542, n.f.:

La statua di S.A.S. è stata discaricata alla rocca in luogho comodo da poterla ricaricare è ben vero che ci vorra grande aqua nel fiume prima di poterla inviare a codesta volta, essendo ancora necessario che il navicello che la carichera possa passare a Pisa sotto la cateratta per esimerla dalla soggestione della varatura perche il cavarla a Pisa del navicello sarebbe neg.o [?] pericoloso.
[In margin] quando nel fiume di Arno ci sara aqua bastante si mandera la statua sopra un navicello per mare per fuggire la varatura di Pisa.

BIBLIOGRAPHY: Unpublished.
This is Camillo Capponi in Livorno writing to Apollonio Bassetti in Florence.

DOCUMENT 47 • 3 JULY 1674
ASF, Segretaria di Stato Firenze, vol. 60:

> per la Bontà di far trattenere in Civitavecchia la partenza delle galere Pontificie, per farle attendere la statua, che venica a S.A.

BIBLIOGRAPHY: Unpublished.
This is Mons. Airoldi in Florence writing to an unknown individual in Rome. [Franca Trinchieri Camiz discovered this document, but I was not able to locate it.]

DOCUMENT 48 • 8 OCTOBER 1674
ASF, Mediceo del Principato, 1542:

> Se sara possibile si carichera la statua che impone il S.A.S.

BIBLIOGRAPHY: Unpublished.
This is Stefan Tedaldi in Livorno writing to Apollonio Bassetti in Florence. Tedaldi probably replaced Capponi as dispatcher. [Franca Trinchieri Camiz discovered this document, but I was not able to locate it.]

DOCUMENT 49 • 10 OCTOBER 1674
ASF, Mediceo del Principato, 1542:

> Circa alla statua venuta di Roma non si trova per ancora navicellaro che si arrisichi stante il gran peso, à condurla, dubitando, che l'acqua li manchi per viaggio, e che si abbi à trattenere qualche settimana per strada, se poi L'A.S. comandi; che si carichi non o stante, avvisi V.S. Ill.ma; che si fara prontam.te.

BIBLIOGRAPHY: Unpublished.
This is Stefan Tedaldi in Livorno writing to Apollonio Bassetti in Florence.

DOCUMENT 50 • 13 OCTOBER 1674
ASF, Mediceo del Principato, 1542:

> La statua accennata quanto prima vedro di spingerla à cotesta volta, acciò sua S.A.S. resti servito, ma il peso grande, è quello che fa trattenere l'Imbarco di d.a statua, perche tutti i navicelli non sono il caso, è tutti i navicelli non la possano reggere, che la prego à rappresentarlo à S.A.; accio sappi, che peraltro sarebbe o mossa molto prima.

BIBLIOGRAPHY: Unpublished.
This is Stefan Tedaldi in Livorno writing to Apollonio Bassetti in Florence.

DOCUMENT 51 • 17 OCTOBER 1674
ASF, Mediceo del Principato, 1542:

> Per avviso di V.S. Ill.ma, alla quale dico, che nell' far caricare la statua di marmo si trova molte difficultà, stante la sua gravezza, dicendosi, che pesi libbre 14000 in circa, io pero non credo più di undici mila, ma perche le navicelle che si arrisichebbeno à condurla vorrebbono fare il prezzo con me, adducendomi, che l'Opera dell' Duomo di tale peso li darebbe sc. Quaranta-; e che non si possano salvare se [?] non li da alimeno sc. 30-, tutto lo fanno che anno dubbio che in Firenze non siano sodisfatti à modo, asserendo che corrano risichio [rischio?] guastara un navicello, e pero vorrebbano sapere almeno quello possano far capitale.

BIBLIOGRAPHY: Unpublished.
This is Stefan Tedaldi in Livorno writing to Apollonio Bassetti in Florence.

DOCUMENT 52 • 22 OCTOBER 1674
ASF, Mediceo del Principato, 1542:

> In risposta alla favoritiss.ma carta di SS. Ill.mo de 20. stante le dico, che questo giorno infras.tto restera consegnato la statua di marmo à Piero Saccardi navicell.o molto praticho, alli quale assistano alla Caricazione, quale si fara col puntone ed l'assistenza del S.re Tacca accìo si aggiusti beniss:mo, è ne scrivero anco al Sig.re Provid.e Miglierotti, afine che si possi aprire la cataratta, è spero possi venire presto, accomondandosi più huomini per assistere all'alzaia; il prezzo delle nole faro che segua sc. ventitre il più, stando tirandola più che posso per servire come devo il Patron Ser.mo.

BIBLIOGRAPHY: Unpublished.
This is Stefan Tedaldi in Livorno writing to Apollonio Bassetti in Florence.

DOCUMENT 53 • 22 OCTOBER 1674
ASF, Mediceo del Principato, 1542:

> Conforme à quest'ora avverà V.S. Ill.ma sentito da altra mia, ricevera à condotta di Pietro Saccardi la statua di marmo di S.A.S; quale ricevendola bene condizionata come spero potra V.S. Ill.ma farle pagare di nolo sc ventiquattro = già non, ò possuto in nessuna maniera accordarlo con meno. Sentiro volentieri sia comparso à salvam.to, per mentre attendo l'avviso la b.a rius.a.

BIBLIOGRAPHY: Unpublished.
This is Stefan Tedaldi in Livorno writing to Apollonio Bassetti in Florence.

DOCUMENT 54 • 26 OCTOBER 1674
ASF, Mediceo del Principato, 1542:

> La mattina del di 23 di buonissima ora partì il Nav.o cola statua molto bene aggiustata, avendola fatta porre sul nav.o ed il puntone, con una facilita grand.ma, è l'accompagnaj con lettera per V.S. Ill.ma è per il Sig.re Migliorotti, Provd.e di Pisa, è se l'avvessero fatto aprire la cataratta, che non, è seguito stante l'acqua troppo alta à quello senso, egli à questo ora sarebbe comparso in Fiorenza, avendomi detto, che in quattro giorni, è forse meno voleva venire.

BIBLIOGRAPHY: Unpublished.
This is Stefan Tedaldi in Livorno writing to Apollonio Bassetti in Florence.

DOCUMENT 55 • 30 OCTOBER 1674
ASF, Mediceo del Principato, 3941:

> Due giorni fa arrivò qui felicemente la grande statua della Pietà di Michelagniolo ed oggi si è trainata alla mia chiesa di San Lorenzo dove à da collogarsi.

BIBLIOGRAPHY: English trans. Goldberg 1983, 354, no. 18.
This is Apollonio Bassetti in Florence writing to Torquato Montauti in Rome. The document establishes 28 October as the date of the statue's arrival in Florence.

DOCUMENT 56 • 3 NOVEMBER 1674
ASF, Mediceo del Principato, 3941:

> Sarà degno ornamen.to nella chiesa di S. Lorenzo la gran statua di Michelangelo, che di quà s'inviò, e non e stato poco che non sia stata negata la faccoltà di trasportarla.

BIBLIOGRAPHY: Unpublished.
This is Torquato Montauto in Rome writing to Paolo Falconieri, also in Rome.

DOCUMENT 57 • 3 NOVEMBER 1674
ASF, Mediceo del Principato, 3941:

Non ho gran pratica del sotterraneo di San Lorenzo ma per quello che io me ne ricordi: la statua della Pietà starà assai meglio di sopra con l'altre statue di medesimo autore che la giù dove non so se si possa sollevar tanto da terra che stia nella sua veduta.

BIBLIOGRAPHY: English trans. Goldberg 1983, 354, no. 19.
This is Paolo Falconieri in Rome writing to Apollonio Bassetti in Florence.

DOCUMENT 58 • 3 NOVEMBER 1674
ASF, Carteggio degli artisti, 19, fols. 641r–v:

Approvo assaissimo per la mia parte collocare la statua della Pietà fra l'altre ancor loro, si può dire, non finite di Michelagnolo perché essendone ornate tutte l'altre facce pare che vi sia necessità di metterne qualcuna nella quarta. Spero che quando V. Alt.za la vedrà, troverà una bella cosa il torso del Cristo.

BIBLIOGRAPHY: Mallarmé 1929, 82.
This is Paolo Falconieri in Rome writing to Cosimo III in Florence.

DOCUMENT 59 • 10 NOVEMBER 1674
ASF, Mediceo del Principato, 3941:

Tant'è la Pietà la vorrei nella cappella di Michelangelo come fu il primo pensiero. Quando i cadaveri dei G. Duchi si portino sorte dove anno da stare resta sbrigata la nicchia grande dove è l'altare, il quale non vorrei allora che fusse più isolto ma apoggiato al muro di sopra ne vorrei la Pietà che verebbe in faccia alla porta.

BIBLIOGRAPHY: Goldberg 1983, 354, no. 19.
This is Paolo Falconieri in Rome writing to Apollonio Bassetti in Florence. In Falconieri's day, the coffins of the grand dukes were stored in the area behind the altar of the Medici Chapel.

DOCUMENT 60 • 10 NOVEMBER 1674
ASF, Carteggio di artisti (1664–76), 19, fol. 642r:

Credo che giovedì prossimo partirà la barca del Padrone Barzzellino di Livorno, e con essa si manderanno le due teste che ai comprorno il papa. La statua della Pietà al creder mio non starà mai bene nel sotterraneo di S. Lorenzo per essere troppo basso; pure bisogna rimettersi a chi è nel luogo.

BIBLIOGRAPHY: Mallarmé 1929, 83.
This is Paolo Falconieri in Rome writing to Apollonio Bassetti in Florence.

DOCUMENT 61 • 17 NOVEMBER 1674
ASF, Mediceo del Principato, 3941:

Ell'è una gran cosa che sempre c'abbia da essere qualche disputa fra lei e me! La statua della pietà non merita di stare fra le altre opere dello stesso autore, e però si esclude dalla cappella. Io sono stracco morto di scrivere p fortuna di chi ha formata questa conclusione, e però dico in due parole sole quello che direi in molte. Q.ta statua fu fatta da Michelagnolo dopo aver fatta quella nello stesso soggetto famosiss.ma, ch'è in S. Pietro, e si pretende ch'egli volesse con questa far conoscere, che poteva far molto più di quello che aveva fatto. Ma ella mi potrebbe dire che tutto questo è una favola et io non potrei provargli, che non fosse. Ma quello, che ha detto il Bernino a me, so ch'è veriss.mo, et è questo; che il Cristo ch'è quasi finito tutto è una cosa tanta maravigliosa inestimabile, non solo per se, ma per averla fatto Michelagnolo dopo l'aver

passato l'età di 70 anni, e ch'egli uomo fatto, e consequentemente maestro, perche cominciò ad esserlo da giovanotto, vi aveva studiato se mesi e mesi continui. Ora chi possa a Firenze giudicarne meglio del Bernino, con licenza di V.S., so che non vi è. La consequenza la faccia lei.

BIBLIOGRAPHY: Mallarmé 1930, 109–10; Goldberg 1983, 355, no. 20.
This is Paolo Falconieri in Rome writing to Apollonio Bassetti in Florence.

DOCUMENT 62 • 1674–76.
ASF, Carteggio di artisti (1664–76), 19, fol. 643:

La Pietà di Michelangelo Buonarroti, ch'è situata presentemente nei sotterranei della chiesa di S. Lorenzo in Firenze fu fatta venire da Rome d'ordine di Cosimo III per mezzo del Sig.re Marchese Montauti e Sig.re Paolo Falconieri, il quale voleva in tutte le maniere che fosse collocata nella Cappella de' Depositi fra le altre opere del Medesimo autore: ma in Firenze fu risoluto di metterla dove'è presentemente. Sopra di che così scrisse il detto Falconiere al canonico Bassetti Seg.rio di Cosimo III sotto il dì 17 novembre 1674 [see doc. 61, above].

BIBLIOGRAPHY: Mallarmé 1929, 79.
This anonymous document was inserted among letters by Francesco Falconieri when the volume was compiled in 1984. Although it bears no date, it must have been written before the *Pietà* was removed from San Lorenzo in 1721, since the writer states that the statue is in the *sotterraneo* at the time he is writing. The letters with which Paolo Falconieri attempted unsuccessfully to convince the canon Bassetti to locate the statue in the Medici Chapel, cited in the document, are dated 3 and 10 November 1674 (docs. 58 and 59).

DOCUMENT 63 • 13 AUGUST 1690
ASLF, 2113, Diario della chiesa di San Lorenzo, pt. 1, fols. 49r–53:

La benedizione del sotterraneo della Cappella Granducale si face l'anno 1690 d'agosto il dì 13 in giovedì da mattina. E indiuse S. A. a santificar questo luogo, che prima era profano e teneasi a uso d'arsenale . . . Facendovi l'altare e collocandovi il crocifisso e le statue etc che prima nella stanza [space is left blank for an eventual identification of the previous location of "le statue etc."].

BIBLIOGRAPHY: Unpublished.
This is the first of a two-part reference in the same volume to the new chapel. For the second part, see doc. 65.

DOCUMENT 64 • 1692
ASF, Guardaroba medicea 509, loose sheets:

Inventario di robbe che si ritrovano di presente nella Reale Cappella di S.A.S.

No. 20 Colonna di alabastro di piu sorta che una in due pezzi
No. 4 Schafali entrovi diverse pietre cioe uno quadretto di una Sant.ma Nonziata di marmo con adorno di bargilio nove pezzi di pietre commesse altre diverse pietre
No. 1 pieta di marmo fatta da michele Agnielo bonaruoti
No. 4 Busti di gesso
No. 110 pezzi modelli di gesso di più sorte
No. 40 quadri di diverse anticaglie et disegni con sua ornamenti
No. 1 Arme di S.A.S. con dua fighure dipinte
No. 4 Sgabelloni di albero
No. 2 Casse di albero et una pancha simile
No. 2 buffetti uno di noce et uno di albero
No. 9 leggiole a braccioli usate bene
No. 4 Caldani di ferro con sua coperchi simili

No. 3 trapassi con una aste
No. 3 sete di ferro con dua suchielli
No. 1 martinello di ferro et legnio
No. 2 paia di stadere uno paio grand et et [?] uno paio piccolo et alle
 grande con bilancia di rame
No. 4 calderotti ["o romaioli" added above] uno di rame e tre di ferro
No. 6 fusi da ruota et dua vite di ferro
No. 4 Aneudine ["o vetro fassi" added above] dua grande e dua piccole
No. 3 s pianatoi di ferro da barella
No. 310 libbre di bronzi
No. 3 seggiole alla antica
No. 2 pali di ferro uno piccolo et uno grande
No. 1 spera di acciaio grande
No. 8 quarta boni di rame
No. 2 pezzi di bronzo di libb. 6 in circa
No. 2 armadia di albero usato che uno pare cipro romaiolo
No. 2 Catini di rame et uno anapiatoio [?] simile
No. 3 Spianatoi piccoli con il manico
No. 50 Spianatoi piccoli diversi per cornice
No. 3 mattonelle con sua manichi
No. 3 martelli di ferro di più grandezza
No. 1 bronzo per spianare lungo due terzi
No. 6 Ulivelle [?] di ferro per tirare su pesi
No. 2 mazze di ferro per la fabbrica
No. 2 paia di cesoie per tagliare le seghe
No. 1 paio di tanaglie di ferro
No. 1 chiodaia di ferro
No. 1 morza di ferro grande
No. 3 squadre di ferro una grande et dua piccole
No. 2 Vaglietti di ferro per vagliare la rena [in margin on left] consumato
 uno
No. 1 tenda turchina di tela con altre 4 per coprire li schafali gia notati
 di sopra
 No. tre pasa di fanoglie di ferro da fucina
 uno Mantrice da fucina grande
 No. tre Picchierelli di ferro da scarpellini
 uno Campanello piccolo di bronzo
 uno tagliolo di ferro e uno foratoio assai piccolo
 due banchi con sue ruote e ferri p lavorare pitt.re
 due pora di molle per il foco di ferro
No. 10 Cassette per ricevere smeriglio
No. 4 barelle da pulire
 uno saltatoio di rame con suo manico di ferro
 una lima grande per le seghe.

BIBLIOGRAPHY: Unpublished.

Vaccari 1997, 319, no. 1603 509, refers to this document as "un inventario della cappella reale," but without mentioning the *Pietà* or any of the inventory's contents.

DOCUMENT 65 • 21 APRIL 1694
ASLF, 2113, Diario della chiesa di San Lorenzo, pt. 2, fols. 137r–44v:

Edificatura del sotteraneo. Il sotteraneo della cappella Gand Ducale cominciò a edificarsi l'anno 1694 à di 21 d'aprile con occasione dell'osequie della ser.ma Grand.a Vittoria della Rovere. Essendo stato benedetto 4 anni avanti dal nostro S.re Piore come in q.sta a [fol.] 49.

BIBLIOGRAPHY: Unpublished.

This is the second of a two-part document. See doc. 63 for the first part.

DOCUMENT 66 • 24 AUGUST 1721
AOSMF, II, 2, 26, fols. 269–70:

[In margin] Le figure di marmo rappresentanti una *Pietà* si collochino dietro al Cora della Metropolitana in luogo ove sono le statue d'Adamo et Eva.

[Text] Item, sentito l'originale, anzi l'ordine di Sua Altezza Reale, trasmesso con lettere del clarissimo signore gran priore fra Tommaso del Bene maestro di camera della prefata Altezza Reale de' 24 agosto prossimo scorso all'illustrissimo e clarissimo signor senatore Giovanni Battista Nelli provveditore di quest'Opera lor collega del sequente tenore.
Illustrissimo signore e padrone colendissimo. Lo zelo che sempre da Sua Altezza Reale si è avuto per la maggior divozione e decoro di codesta Metropolitana ha mosso l'animo Suo a voler che resti collocato un Suo gruppo di figure in marmo rappresentanti una Pietà di mano di Michelagnolo Buonarroti, dietro al coro della medesima Metropolitana, dove appunto sono le due statue d'Adamo e d'Eva scolpite da Baccio Bandinelli. Quando dunque che dal signore Francesco Ambrogi provveditore della Galleria della Reale Altezza Sua, in seguito dell'ordine avutone, riceverà V.S. il detto gruppo, vedrà che rimanga questo situato in detto luogo, e che siano consegnate all'istesso signore provveditore Ambrogi le due statue suddette a suo comodo. E con tal congiuntura rassegnandomele, resto con farle devotissima reverenza. Di casa, 24 agosto 1721. Devotissimo et obbligatissimo servitore vostro fra Tommaso del Bene illustrissimo signore Giovanni Battista Nelli provveditore dell'Opera.
La qual lettera si conserva nella filza di Memoriali XX no. 60. Onde considerato, asservato, ottenuto deliberarono e deliberando commessero darsi pronta esecuzione a quanto piace a Sua Altezza Reale e farsi delle sopranominate figure e statue di marmo quanto e ciò che vien ordinato con dette lettere. Mandantes etc.

BIBLIOGRAPHY: partially cited without archival reference in Mallarmé 1929, 83.

This document is transcribed from the deliberations of the councils of the Arte della Lana and of the Operai di Santa Maria del Fiore, 15 September 1721. For the original document, see AOSMF, III, 1, 21, fasc. 60, c. 183.

DOCUMENT 67 • 26 AUGUST 1721
ASF, Manoscritti, 142, Francesco Settimani, Memorie fiorentine, fol. 426v:

Addì 29 di agosto 1721. Venerdì. Fu cavata dallo scrittoio della Cappella di San Lorenzo una figura di marmo che rappresenta Cristo morto in braccio di Nicomedo [*sic*], la quale fu fatta, ma non del tutto finita, da Michelagnolo Buonarroti, e fu collocata dentro al Coro di Santa Maria del Fiore avanti Adamo, ed Eva pur di marmo di mano di Baccio Bandinelli.

BIBLIOGRAPHY: Mallarmé 1929, 87.

The *scrittoio* was an administrative office responsible for building and maintaining the grand-ducal chapel.

DOCUMENT 68 • 11 JULY 1722
AOSMF, IV, 2, 93, Negozi del Provveditor, fasc. 84:

L'Opera del Duomo deve dare per la fattura d'un cartello di marmo collocato sotto l'imbasamento della Pietà di Michelangiolo fatto di gran relievo et e lungo braccia due scudi venti s. 20. E più per due legature di giallo di carrara attorno al medesimo: con quello di mio scudi sei s. 6. E più per le mostre [?] di due modiglioni di mistio di Saravezza con voluta e listelli d'intaglio con mistio di mio. scudi seidici s. 16. E più per la testate de' medesimi modignioni di mistio di mio scudi cinque s. 5, scudi 47, lire tara 10, al netto 37. A di 9 Sett. fatto il mandato a fabbrica conto dell'Opera del Duomo con Gio: Battista Foggini scultore.

BIBLIOGRAPHY: Unpublished.

Postremum Michaelis Angeli Bonarotae Opus/Quamvis ab Artifice ob Vitium Marmoris Neglectum/Eximium Tamen Artis Canona/Cosmus III Mag. Dux Etrur/Roma iam Advectum hic P.I. Anno MDCCXXII.

BIBLIOGRAPHY: Follini and Rastrelli 1790, 2:281; Harford 1857, 2:63; Vasari (ed. Barocchi) 1962, 4:1671.

The inscription was composed by Francesco Buonarroti, a descendent of Michelangelo, and was placed on the base of the *Pietà* designed by Giovanni Battista Foggini (see doc. 68). The inscription was translated into Italian in the eighteenth century by Francesco Settimani (see doc. 70). See chap. 4 for an English translation of the inscription.

DOCUMENT 70 • 13 JULY 1722
ASF, Manoscritti, 142, Settimani, Francesco, Memorie fiorentine, fol. 492v:

Addì 13 di luglio 1722. Lunedì. Fu messa dietro al Coro del Duomo, sopra una nuova base di marmi misti, una Pietà fatta per mano di Michel Angelo Buonarroti, condottavi fino sotto dì 29 agosto 1721, in luogo di Adamo, ed Eva, colla sequente iscrizione: Cosimo Terzo, Granduca di Toscana, in quest'anno 1722—comandò, che fosse posta qui l'opera di Michelangelo Buonarroti, più tempo fa portata di Roma, che quantunque sia disprezzata dall'artefice per vizio del marmo, nondimeno è un'eccellente opera dell'arte.

BIBLIOGRAPHY: Waldman 1999, app. 1, doc. 278.

For the Latin text, see doc. 69. I thank Louis A. Waldman for bringing Settimani's manuscript to my attention.

DOCUMENT 71 • 10 DECEMBER 1739
ARSI, Fondo Gesuito 889, unnumbered and untitled folder:

Item 6. In oltre ancora riferisco come havendo fatti a quel tempo I PP. Gesuiti p. riguardare il loro giardino et anche per darle maggiore semetria un altro muro annesso et accostol'antico più alto in dove accade la differenze, etc. Per cause d'attendere alla quadratura di d.o giardino e per detto effetto viene a farsi intercapedine, e riattacca col nicchione posto nel prospetto etc.

BIBLIOGRAPHY: Unpublished.

The report was written by the architect Filippo Raguzzini (signed Rauzino or Ranzino in the document). The report was accompanied by two watercolor drawings, one a plan of the garden (plate 72), the other an elevation of the "nicchione" and a building in the neighboring property (plate 73).

DOCUMENT 72 • 1739
ARSI, Fondo Gesuito 889, bound, unnumbered volume:

Summarium Numero Primo Foglio. Accanto à detta intercapedine e proposamente nel muro del convento de Padri Scalzi si vede una porta murata, a cui si saliva con tre scalini, et una porticella con l'arme d'un cardinale sopra che i Padri Gesuiti asserivono esser di Bandini, e per la quale porticella murata pretesero ch'il sud.o Cardinal Bandini prima e successivamente Capponi annesse l'ingresso nella chiesa di S. Anna de Padri Scalzi. Accanto della porticella si vede una Nicchia sfondata palmi dieci coll'arme di Clemente VIII nel mezzo sopra la quale nicchia vi è una loggia scoperta per cui si sala con una scaletta al lato della medessima nicchia, e detta loggia e longa palmi ventisei e un quarto e larga palmi dodici e alta da terra palmi ventisette e mezzo, sopra detta loggia per tutta l'altezza del muro del convento de Padri scalzi non vi sono finestre di sorte alcuna, come si accorda fra le Parti impegnandosi bensi da Padri Scalzi la pretesa [?] servitu, che anessero li sud.o nominati Cardinali nella Chiesa, o sia convento di S. Anna per detta pretessa porticella murata.

La prima fenestra aperta de Padri Scalzi, e di già descritta, si accorda fra le parti essere distante dalla detta loggia de Padri Gesuiti palmi nove. Dalla detta loggia sino al muro della controversia e longo palmi settantacinque, il muro fatto de Padri Gesuiti per rinquadrare il loro giardino e continua al muro per longhezzo sino a i cipressi altri palmi centose, l'altezza del muro, dove stanno li luoghi commune de Padri Scalzi, e che resta staccato dall'altro muro fatto per rinquadrare il giardino, dal pian del giardino, osia dall'intercapedine di sopra descritta è di palmi ventuno e tre quarti.

BIBLIOGRAPHY: Unpublished.

DOCUMENT 73 • 1754
Giuseppe Richa, *Notizie istoriche delle chiese fiorentine*:

In luogo poi di Adamo e d'Eva, che furono trasferiti nel Salone del Palazzo di Piazza, vi è sostituita una Pietà fatta, ma non finita, dal Buonarroti, come dice la Cartella di marmo appiè della Statua.

BIBLIOGRAPHY: Richa 1754–62, 6:141.

The inscription on the base of the statue, recorded in doc. 69, follows immediately.

DOCUMENT 74 • 1759–60
Giorgio Vasari, *Le vite de' più eccellenti pittori, scultori e architetti*:

Questo gruppo, che Michelagnolo non lasciò totalmente finito, fuori che il Cristo, figura principale, stette lungamente nella stanza de' marmi, che servivano per la nuova cappella di S. Lorenzo, ma poi fu trasportato dietro all'altar maggiore della Metropolitana Fiorentina, e postovi sotto quest'inscrizione fatta dal Senator Buonarroti.

BIBLIOGRAPHY: Vasari (ed. Bottari) 1759–60, 3:261, n. 2.

Bottari concludes this passage by transcribing the Latin inscription, as in doc. 69.

DOCUMENT 75 • 1759–60
Giorgio Vasari, *Le vite de' più eccellenti pittori, scultori e architetti*:

Queste due statue furono levate nel 1722 perchè erano nude, e poste nella gran sala descritta qui sopra, e in luogo loro collocatovi un gruppo d'un Cristo morto abbozzato, e tirato molto avanti dal Bonarroti, che fu l'ultima sua fatica. Questa mutazione guastò stranamente il pensiero di Baccio, che avendo nella parte di dietro rappresentato il delitto d'Adamo, nella parte davanti rappresentava il rimedio di esso, che fu la morte di Cristo, e l'assoluzione, che per esso dava Dio al genere umano. Dove ora davanti, e di dietro all'altare si rappresenta la morte di Cristo.

BIBLIOGRAPHY: Vasari (ed. Bottari) 1759–60, 2:603, n. 1.

The two nude statues in question are Bandinelli's *Adam* and *Eve*, which the sculptor installed behind the high altar in the middle of the sixteenth century. For a discussion of Bottari's comment on the changed iconography resulting from the mutation, see Wasserman 2001, 289–98.

DOCUMENT 76 • 9 FEBRUARY 1918
AOSMF, XI-1-4, fols. 97v–98r: A dì 9 febbraio 1918:

[In margin] Cantoria inamovibile a tergo dell'altare nella cattedrale.

[Text] In merito alla proposta fatta con nobilissima lettera da S. E. Reverend.ma il cardinale arcivescovo di supplire alla informe cantoria amovibile usata nella cattedrale in questi ultimi tempi e che è stata oggetto di censure acerbe e causa di incidenti spiacevoli con una cantoria, del pari posticcia ma una inamovibile, da adattarsi a tergo dell'altare maggiore, quando si fosse provveduto a una più conveniente sistemazione del gruppo "La Deposizione" di Michelangiolo, la Deputazione, che riconosce la necessità del provvedimento, dappoi che l'angustia delle attuali can-

torie sopra le porte delle due sagrestie impedirebbe la ricostituzione di una cappella decorosa e numerosa, qual è nell'animo di S.E. Rd.ma per il maggior decoro del tempio e delle funzioni solenni, che si ci celebrano, seconda di buon grado la iniziativa presa e delibera di promuovere presso il ministero delle istruzione, nei modi più efficaci le debite autorizzazioni.

BIBLIOGRAPHY: Unpublished.

DOCUMENT 77 ◆ 13 JULY 1918
AOSMF, XI-1-4, fol. 100v:

[In margin] Cantoria a tergo dell'altare maggiore nella Cattedrale.

[Text] Dà notizia, di poi, che sul progetto di costruire una cantoria a tergo dell'altare maggiore della cattedrale previa remozione da quello del gruppo "La Deposizione" di Michelangiolo, il Ministero prima di decidere ha chiesto il parere della Commissione Provinciale Conservatrice dei Monumenti.

BIBLIOGRAPHY: Unpublished.

DOCUMENT 78 ◆ 8 NOVEMBER 1918
AOSMF, XI-1-4, fol. 107v:

[In margin] Cantoria a tergo dell'altare maggiorenella Cattedrale.

[Text] In ordine alla proposta di S.E. il Cardinale Arcivescovo di costruire una cantoria amovibile di legname a tergo dell'altare maggiore della cattedrale, la Deputazione prende atto della communicazione fattale dalla R. Soprintendenza ai Monumenti della decisione del Ministero della pubblica Istruzione favorevole alla proposta ed al conseguente trasferimento del gruppo 'La Deposizione' di Michelangelo in altra parte della chiesa: e si riserva di riprendere in esame il progetto di concerto con S. E. l'arcivescovo, allorchè si stia per dargli esecuzione.

BIBLIOGRAPHY: Unpublished.

DOCUMENT 79 ◆ 6 MARCH 1923
AOSMF, XI-1-4, fols. 117r–v:

[In margin] Diverse intenzione proposta per il gruppo la Pietà di Michelangiolo.

[Text] (Don Filippo Corsini, deputato residente) In secondo luogo informa la Deputazione della richiesta fatta a S. E. il Generale Da Marchi, Presidente del Comitato Provvisorio per il monumento alla Madre Italiana, di trasferire in Santa Croce, per farne simulacro espiatorio in una cappella votiva, il gruppo della "Deposizione" di Michelangelo, ora mal collocato a tergo dell'altare maggiore della Cattedrale: e legge la lettera nella quale tale richiesta è formulata. Ricorda a questo proposito che fino dal 1919 è sorta l'idea, suffragata dal parere favorevole della Commissione provinciale per la conservazione dei monumenti e dalla autorizzazione del Ministero della Pubblica Istruzione, di collocare in miglior vista nel Duomo quel gruppo, e che se ne sta anzi studiando la nuova ubicazione in relazione al desiderio di S. E. il Cardinale Arcivescovo di istituire appunto a tergo del Coro una cantoria di legname per dare maggiore solennità a speciali funzioni liturgiche. E sottopone la domanda del Comitato alla risoluzione della Deputazione.

Il Comm. Socini si manifesta non favorevole all'accoglimento immediato della domanda, sia quale rappresentante del Corpo Accademico, sia quale membro dell'Amministrazione dell'Opera: espone le ragioni per le quali egli stima non provvida cosa destinare antiche opere d'arte di fama ormai consacrata a perpetuare la memoria di fatti attuali, le contingenze dei quali possono ispirare a degne rappresentazioni aritsti valenti, con auspicato incremento dell'arte: e si indugia a considerare, nel caso presente, se il gruppo famoso, destinato ad un collocamento degno di sé nella Cattedrale fiorentina, non presenterebbe forse nell'augustia di una cappella scarsamente illuminata i pregi artistici che il sommo artista vi ha

trasfusi: all'infuori di ogni ragione di convenienza, che dovrebbe essere ben ponderata, sulla opportunità di privare la Cattedrale di così insigne opera d'arte:

Il Sig. Sindaco, adducendo la replicata esperienza di recenti concorsi artistici è favorevole agli intendimenti del Comitato, in quanto è di parere che nessuna opera meglio di quella designata valga in questo caso alle alte finalità che si vogliono celebrare e che la destinazione in Santa Croce di quell'opera, non legata intimamente alla storia di S. Maria del Fiore, non toccherebbe minimamente i suoi pregi intrinseci. In ogni modo egli stimerebbe che la Deputazione dovesse entrare nel concetto di non respingere senz'altro la domanda che le viene rivolta.

Tale concetto è fatto proprio dal Sig. Deputato residente, il quale pur riservando gli eventuali diritti della Cattedrale sul gruppo di Michelangelo ed accennando alla necessità di un profondo studio della questione sotto tutti gli aspetti di convenienza e di arte, da parte degli organi competenti costituiti, accenna alla possibilità in ultima analisi che la "Deposizione" sia dedicata al fine prestabilito pur rimanendo nella Cattedrale fiorentina, che è pure uno dei maggiori templi della Cristianità, e nella sua nuova ubicazione, in luogo amplissimo e di insuperato decoro, nel quale è possibile di celebrare in ogni occasione con le maggiori solennità di rito l'apoteosi del sacrificio delle Madri italiane per il compimento dei destini della Patria.

La Deputazione si trova concorde nelle considerazioni del Deputato residente e delibera di rispondere alla richiesta del Comitato nel senso espresso da Lui.

BIBLIOGRAPHY: Unpublished.

DOCUMENT 80 ◆ 26 OCTOBER 1931.
AOSMF, XI-1-4, fols. 141r–v:

[In margin] Deposizione dalla Croce di Michelangelo.

[Text] Il Deputato Residente, a proposito della recente polemica sui giornali circa la infelice collocazione attuale della Deposizione dalla Croce di Michelangelo e la proposta di trasferirla a S. Croce significa alla Deputazione che, mentre è d'accordo che ora il bel Monumento è collocato in modo che non può essere ammirato come si conviene, ritiene che la Deputazione si debba opporre, con tutte le sue forze, a che l'insigne opera sia tolta dalla Cattedrale. Se la Deputazione consente, chiede l'autorizzazione di iniziare degli studi per trovare nella Cattedrale stessa un luogo più adatto e più degno dell'attuale. A questo proposito osserva che la Curia è d'accordo sia per l'opposizione al trasporto del Monumento in altra Chiesa, sia per il suo spostamento. Fra i diversi progetti ve ne sarebbe uno al quale aderisce anche la Curia e cioè di collocarlo nella tribuna della S. Croce e precisamente nella Cappella della Madonna della Neve, dove, non essendovi vetri istoriati, la luce sembra debba essere adatta. Ad ogni modo saranno fatti gli opportuni studi d'accordo con la R. Soprintendenza all'Arte Medioevale e Moderna, collocandovi, in via provvisoria, il calco del gruppo che la R. Scuola d'Arte concede gentilmente. La Deputazione è pienamente d'accordo col Deputato Residente e lo autorizza a fare eseguire gli opportuni studi al riguardo.

BIBLIOGRAPHY: Unpublished.

DOCUMENT 81 ◆ 11 JANUARY 1932
AOSMF, XI-2-93, anno 1932, folder no. 8:

Oggetto: Firenze, Duomo - Trasferimento della Pietà di Michelangiolo. Il Direttore del Regio Istituto d'Arte mi comunica che è lieto di concedere in prestito a codesta Deputazione un calco in gesso della Pietà Michelangiolesca del Duomo, a condizione che la Deputazione provveda al trasporto e alla restituzione in sede del gesso a suo carico ed a sua cura. Il calco potrà essere ritirato in qualunque giorno non festivo, con un semplice tempestivo preavviso.

Faccio viva premura alla S. V. perchè l'Opera voglia sollecitamente provvedere in proposito, essendo ormai urgente prendere una determinazione definitiva nei riguardi della collocazione di quella insigne opera d'arte.

BIBLIOGRAPHY: Unpublished.

This is Prof. Giovanni Poggi, Soprintendente all'Arte Medioevale e Moderna della Toscana, writing to Marchese Roberto Ginori-Venturi, Deputato Residente dell'Opera Secolare di Santa Maria del Fiore.

DOCUMENT 82 • 14 JANUARY 1932
AOSMF, XI-2-93, anno 1932, envelope no. 8:

Eccellenza, Questa Deputazione Secolare, in seguito agli articoli apparsi sui Giornali in merito alla proposta di trasportare nella chiesa di S. Croce la Pietà di Michelangiolo, deliberò di opporsi a qualsiasi proposta del genere, ma in pari tempo di fare gli opportuni studi per collocare l'insigne monumento in luogo più adatto alla sua visibilità di quello che non sia l'attuale.

Presi gli opportuni accordi con la R. Soprintendenza ai Monumenti, fu stabilito di approfittare di un calco del gruppo stesso, che trovasi nella Gipsoteca dell'Istituto d'Arte, per studiare quale possa essere il luogo più favorevole per il collocamento di cui trattasi.

Nell'informare di ciò V.E. Rev.ma La prego, a nome della Deputazione, di volere acconsentire che il calco, posto su di un carrello, possa essere portato in S. Maria del Fiore perchè possano essere fatte le opportune prove.

Assicuro che le prove stesse saranno fatte durante il tempo che il Duomo rimane chiuso e che non dureranno che pochi giorni.

BIBLIOGRAPHY: Unpublished.

It is not clear to whom this letter was addressed. Possibly it was to the archbishop of Florence.

DOCUMENT 83 • 16 JANUARY 1932
AOSMF, XI-2-93, anno 1932, envelope no. 8:

In risposta alla Sua lettera del 14 Gennaio corrente, udite anche il Rev:mo Capitolo Metropolitano, do ben volentieri il mio consenso a ciò che Ella richiede e nei termini da Lei esposti. La prego però a voler invitare a far parte della Commissione esaminatrice anche uno dei Canonici componenti la Deputazione ecclesiastica.

Le fo notare inoltre che, dovendosi nella collocazione del monumento tener conto, oltre che delle ragioni estetiche, anche, e in particolar modo, di quelle liturgiche, per venire ad una decisione definitiva occorrerà procedere di comune accordo con l'Autorità ecclesiastica.

BIBLIOGRAPHY: Unpublished.

Mons. Giovacchino Bonardi writing on behalf of the Curia Arcivescovile to Marchese Roberto Ginori-Venturi, Deputato Residente dell'Opera Secolare di Santa Maria del Fiore.

DOCUMENT 84 • 27 JANUARY 1932
AOSMF, XI-2-93, anno 1932, envelope no. 8:

Carissimo Professore. In seguito a verbali accordi col prof. Poggi è stato stabilito che avanti di fare il sopraluogo in Duomo per la studio del migliore collocamento della Pietà di Michelangiolo, sia portato il calco del Monumento nella Cappella della Madonna della Neve e collocato davanti l'altare, togliendo, se necessario, il gradino di legno. Sarebbe bene che la visita fosse fatta nei primi giorni della prossima settimana, per cui la prego di farmi sapere in tempo il giorno in cui sarà a posto.

BIBLIOGRAPHY: Unpublished.

This unsigned letter was probably written by Marchese Roberto Ginori-Venturi to the architect of the project, Giuseppe Castellucci, referred to in the letter as "Carissimo Professore."

DOCUMENT 85 • 8 FEBRUARY 1932
AOSMF, XI-2-93, anno 1932, envelope no. 8:

In seguito al desiderio espresso dall'E.V. Rev.ma con la lettera del 16 gennaio u.s. di procedere cioè di comune accordo al nuovo collocamento della Pietà di Michelangelo, pregiomi informa La che Giovedi II alle ore 10 e ¾ ci riuniremo in Duomo per studiare il posto più adatto al collocamento stesso. Prego pertanto l'E.V. di voler Lei incaricare qualcuno dei Rev.mi Canonici della Deputazione Ecclesiastica di intervenire a questa riunione, alla quale spero possa prender parte anche il Segretario della Commissione stessa Mons. Giulio Bonardi.

BIBLIOGRAPHY: Unpublished.

Marchese Roberto Ginori-Venturi, Deputato Residente dell'Opera Secolare di Santa Maria del Fiore, writing to Mons. Giovacchino Bonardi.

DOCUMENT 86 • 25 AUGUST 1932
AOSMF, XI-2-93, anno 1932, envelope no. 8:

In seguito agli accordi presi col Comm. Poggi Soprintendente all'Arte Medioevale e Moderna, mi faccio un dovere di remettere alla S.V. ill.ma un nuovo progetto di sistemazione del gruppo della Pietà di Michelangelo, per gli opportuni provvedimenti.

BIBLIOGRAPHY: Unpublished.

Architect Giuseppe Castellucci writing to Marchese Roberto Ginori-Venturi.

DOCUMENT 87 • 31 AUGUST 1932
AOSMF, XI-2-93, anno 1932, envelope no. 8:

Ho ricevuto giorni fa il disegno della base della Pietà e la ringrazio. Ne ho parlato anche col Comm. Poggi, il quale fra breve mi farà avere una lettera ufficiale di approvazione. Sarà mia cura informarla per l'inizio dei lavori. Sarebbe pertanto bene, per guadagnare tempo, id preparare il materiale occorrente.

BIBLIOGRAPHY: Unpublished.

Presumably Marchese Roberto Ginori-Venturi writing to the architect of the project, Giuseppe Castellucci.

DOCUMENT 88 • 23 SEPTEMBER 1932
AOSMF, XI-2-93, anno 1932, envelope no. 8:

Oggetto: Inizio di lavori—Sistemazione della Pietà di Michelangiolo—Allegati 2 disegni—Questa Soprintendenza autorizza codesta Spettabile Opera a dare inizio ai lavori per la sistemazione della Pietà di Michelangiolo nella prima Cappella a destra della Tribuna delle Reliquie in conformità del voto espresso dalla Commissione Provinciale di Belle Arti e del disegno preparato dall'Arch. Giuseppe Castellucci di cui si trasmette copia.

BIBLIOGRAPHY: Unpublished.

Giovanni Poggi writing to Marchese Ginori-Venturi.

DOCUMENT 89 • 6 OCTOBER 1932
AOSMF, XI-1-4, fol. 144:

[In margin] Nuova collocazione della Deposizione di Michelangelo.

[Text] Il deputato residente ricorda che nell'adunanza precedente la Deputazione lo autorizzò a fare eseguire studi per una nuova collocazione della Deposizione di Michelangelo nella cattedrale. In seguito a ciò, presi accordi con la R. Soprintendenza all'Arte Medioevale e Moderna, fu collocato il calco del monumento, concesso dalla R. Scuola d'Arte, sull'Altare della Cappella della Madonna della Neve. Invitata la Commissione Provinciale per la conservationze dei Monumenti ad esprimere il suo guidizio su tale collocamento, la Commissione l'approvò all'unanimità.

Chiede quindi alla Deputazione l'autorizzazione ad iniziare: lavori, che saranno eseguiti col personale dell'Opera, ma che certamente porteranno ad una spesa non indifferente per l'acquisto del materiale (marmo, laterizi etc.) che si prevede possa aggirarsi sulle 3000 lire.

BIBLIOGRAPHY: Unpublished.

DOCUMENT 90 ◆ 14 JUNE 1933
AOSMF, XI-2-93, anni 1933–34, fasc. 8:

Le rimetto il modello in carta alla grandezza naturale della iscrizione da apporsi sotto il Monumento della Deposizione di Michelangelo, con preghiera di esaminarlo e restituirmelo con la sua approvazione o indicando le modificazioni che ritenesse apportarvi.

BIBLIOGRAPHY: Unpublished.
Marchese Ginori-Venturi writing to Giovanni Poggi.

DOCUMENT 91 ◆ 17 JUNE 1933
AOSMF, XI-2-93, anni 1933–34, fasc. 8:

Questa Soprintendenza manifesta la sua piena approvazione al modello rimessole della iscrizione da apporre sotto il gruppo della Pietà di Michelangiolo trasferito in una delle cappelle della crociera di sinistra. Il disegno al naturale è stato restituito direttamente, per brevità, all'architetto Castellucci.

BIBLIOGRAPHY: Unpublished.
Giovanni Poggi writing to Marchese Ginori-Venturi.

DOCUMENT 92 ◆ 2 AUGUST 1933
AOSMF, XI-2-93, anni 1933–34, fasc. 8:

La cappella della Madonna della Neve, che dovrà accogliere il monumento della Deposizione, è pressoché sistemata. Occorre intanto incominciare a sostituire il palco per sollevare il gruppo e questo lavoro occuperà qualche giorno I nostri lavoranti, ma sarà fatto dalle 12 alle 16½, cioè durante la chiusura della Cattedrale. Ritengo che questa operazione, non disturbando le Funzioni Religiose, non troverà ostacolo da parte dell'Eminenza Vostra, ad ogni modo gradirò un cenno di benestare con qualche cortese sollecitudine.

BIBLIOGRAPHY: Unpublished.
Marchese Ginori-Venturi writing to the Cardinal Elia Dalla Costa, archbishop of Florence.

DOCUMENT 93 ◆ 3 AUGUST 1933
AOSMF, XI-2-93, anni 1933–34, fasc. 8:

Ho ricevuto la deferente comunicazione relativa ai lavori da eseguirsi in S. Maria del Fiore al noto scopo. Detti lavori, avendo luogo a Cattedrale chiusa, non recheranno disturbo di sorta.

BIBLIOGRAPHY: Unpublished.
Cardinal Elia Dalla Costa writing to Marchese Ginori-Venturi.

DOCUMENT 94 ◆ 5 SEPTEMBER 1933, NO. 132.
AOSMF, XI-2-93, anni 1933–34, fasc. 8:

Gentillissimo Professore. Ho visto la Deposizione a posto e mi compiaccio sempre più del nuovo collocamento. Monsignor Bonardi, e ritengo abbia ragione, insiste perchè siano tolti i due armadi della Cappella e cercherà di persuadere i suoi colleghi della Commissione Ecclesiastica perchè sia adottato un braciere, da mettersi in luogo sicuro, vicino alla ritirata, incaricando uno dei Chierici di portare il fuoco acceso da casa sua. È una soluzione economica per noi e spero sarà adottata. Mi sento intanto in obbligo di rivolgere a Lei, gentilissimo professore, i miei ringraz-

iamenti per la sua assidua ed intelligente opera prestata per la remozione e la nuova collocazione del Gruppo.

BIBLIOGRAPHY: Unpublished.
The letter is unsigned and its recipient unnamed. It was probably written by Marchese Ginori-Venturi to the architect of the project, Giovanni Castellucci.

DOCUMENT 95 ◆ 23 DECEMBER 1960
AOSMF, Carteggio miscellaneo (1940–89): Pratica spostamento della Pietà:

Eccellenza, Ella è a conoscenza come da lungo tempo l'afflusso dei visitatori, specialmente stranieri, disturbi in sommo grado la tranquillità del tempio, nel recarsi alla Cappella ove è situata l'opera d'arte "La Pietà di Michelangiolo," che è a fianco al piccolo coro dei Rev. di Canonici. Non ostante le disposizioni impartite e la sorveglianza più attiva per impedire il chiacchierio profano sia dei visitatori che delle guide che li accompagnano, l'inconveniente permane e continuerebbe anche se tale statua fosse trasportata in altro punto della Cattedrale. Avendo avuto sull'argomento dei colloqui particolari con il Pof. Filippo Rossi, Sovrintendente delle Gallerie e Musei, questi si sarebbe manifestato propenso al trasferimento dell'opera d'arte nel nostro museo ove è possibile collocarla, date i recenti lavori di trasformazione operati, in una vasta sala adettissima allo scopo.

BIBLIOGRAPHY: Unpublished.
Rodolfo Francioni, president of the Opera di Santa Maria del Fiore, writing to the adjunct archbishop of Florence.

DOCUMENT 96 ◆ 24 DECEMBER 1960
AOSMF, Carteggio miscellaneo (1940–89): Pratica spostamento della Pietà:

. . . mi permetto rimetterLe copia della lettera inviata a S. Ecc. Mons. Florit, in merito al trasferimento della statua della Pietà. Conto molto sulla Sua autorevole e saggia parola di "Capo del Capitolo" perchè la cosa desiderata da anni vada a buon fine a maggior decoro del culto e della nostra incomparabile Cattedrale.

BIBLIOGRAPHY: Unpublished.
A copy of the above letter by Rodolfo Francioni to Mons. Gino Josia of the Capitolo della Metropolitana Fiorentina.

DOCUMENT 97 ◆ 31 DECEMBER 1960
AOSMF, Carteggio miscellaneo (1940–89): Pratica spostamento della Pietà:

Con riferimento alla Sua recente lettera, considerati gli inconvenienti per il culto verificatisi in seguito all'attuale ubicazione della "Pietà" di Michelangelo nella cappella a destra del piccolo coro dei canonici, NULLA OSTA da parte di questo Ordinariato al trasferimento dell'opera d'arte nei locali del Museo dell'Opera di Santa Maria del Fiore.

BIBLIOGRAPHY: Unpublished.
The adjunct archbishop of Florence writing to Rodolfo Francioni.

DOCUMENT 98 ◆ 9 JANUARY 1961
AOSMF, Carteggio miscellaneo (1940–89): Pratica spostamento della Pietà:

. . . quella sera io mi limitai a eccepire l'inopportunità di sistemare la Pietà in sale basse e anguste come quelle del piano terreno, e a manifestare quindi il parere che, eventualmente, sarebbero state più adatte le sale del primo piano.

BIBLIOGRAPHY: Unpublished.

Soprintendente of the Soprintendenza alle Gallerie per la provincie di Fiorenze, Arezzo e Pistoia writing to an undesignated person.

DOCUMENT 99 ◆ 8 APRIL 1961
AOSMF, Carteggio miscellaneo (1940–89): Pratica spostamento della Pietà:

> Estratto del verbale della adunanza: No. II—La Commissione esprime decisamente ed all'unanimità il suo parere sfavorevole e contrario a che sia rimossa dal Duomo la Pietà di Michelangelo, privando così come purtroppo si è fatto nel passato, per altri capolavori, la Cattedrale di una insigne opera. La Commissione apprezza che si sia bellamente riordinato il Museo dell'Opera del Duomo, ma disapprova che per arricchirlo si tolgano questi tesori di arte a S. Maria del Fiore, nella sicurezza che la cosa susciterebbe anche commenti sfavorevoli nella stampa cittadina. È giustissimo e doveroso che si provveda ad eliminare il disordine ed il disturbo alle Sacre Funzioni, causato da certe comitive turistiche, ma questo inconveniente non si eliminerebbe certo col solo togliere la Pietà di Michelangelo per la quale del resto si potrebbe anche studiare diversa collocazione. Piuttosto allo scopo di evitare tali irriverenze, si propone: a) che alle porte del Duomo e delle altre chiese artisticamente importanti, come del resto si fa in tante cattedrali e perfino in luogo di culto portestante, ebraico ed anche musulmano, siano affissi cartelli in varie lingue, decorosi e ben visibili, con la scritta: Funzione sacra—sono vietate le visite turistiche organizzate con guida, nei giorni feriali sino alle ore 10 nei giorni festivi per tutta la mattina, b) La guardia del Duomo faccia severamente osservare tale disposizione, c) Di tale disposizione sembra conveniente dare comunicazione all'Ente per il Turismo ed alla Azienda del turismo perchè le guide autorizzate ne siano informate. La Commissione incarica il Presidente di presentare a S. E. il Card. Arcivescovo, a S. E. l'Arcivescovo Coadiutore ed al Presidente dell'Opera del Duomo Dott. Rodolfo Francioni tale voto.

BIBLIOGRAPHY: Unpublished.
Commissione Diocesana per l'Arte Sacra, Florence, writing to Cardinal Elia Dalla Costa, Monsignor Ermenegildo Florit, and Dr. Rodolfo Francioni.

NOTES TO THE APPENDIXES

APPENDIX A. THE CARVING TECHNIQUES OF MICHELANGELO'S *PIETÀ*

1. Vasari (ed. Brown) 1960, 152, and Cellini 1967, 136–37. Cellini describes the tools and their use (136): "With this chisel, *subbia*, you approach to within at least half a finger of what is called the 'penultima pelle,' the last skin but one; then you take a chisel (*scarpello*) with a notch in the middle of it, and carry on the work further till it be ready for the file, *lima*, and this file again is called the *lima raspa*, or roughing file, or occasionally *scuffina*." However, according to Vasari a carver would "begin by roughing out the figures with a kind of tool they call '*subbia*,' . . . then with other tools called '*calcagnuoli*' which have a notch in the middle and are short . . . till they come to use a flat tool more slender than the *calcagnuolo*, which has two notches and is called '*gradina*.' . . . This done, they remove the tooth marks with a smooth chisel . . . they work off with curved files all traces of the *gradina*. They proceed in the same way with slender files and straight rasps, to complete the smoothing process." In fact neither of these descriptions fits exactly the evidence of unfinished works. This suggests that Cellini and Vasari were not writing from personal or prolonged experience.

2. Cellini 1967, 136–37.

3. The relief on Bregno's tomb is attributed to Luigi Capponi (illustrated in Butters 1996, 2: fig. 141). For more information on carving tools as well as illustrations, see Rockwell 1993, 31–68 and 254–62.

4. I am following Cellini in distinguishing the *calcagnolo* from other tooth chisels.

5. See the CD-ROM for color-coded diagrams showing the locations of these Calcagnolo marks.

6. Cellini 1967, 136. The chisel was used as a near-to-finishing tool, and evidence of its use can be found on many works of the cinquecento, for example, the right arm of Isaiah by Lorenzetto in the Chigi Chapel, Santa Maria del Popolo, Rome.

7. For an illustration of a channeling tool, see Rockwell 1983, 59, drawing 5, no. 7.

8. For an illustration of the drill, see Rockwell 1983, 64, drawing 10, nos. 3, 8, and 9.

9. There is an interesting discussion of Michelangelo and the drill in Wittkower 1977, 102–13. It should be noted, with regards to the words Michelangelo wrote on a preparatory drawing for the bronze *David*, "David with his sling and I with my bow Michelangelo" (quoted in ibid., 102), that the drill used in his day was not a bow drill (*violino*) but a pump drill (*trapano ad asta*). All the evidence we have shows that the bow drill was a carpenter's drill, which was seldom, if ever, used on stone. Examples of the pump drill are seen on Nanni di Banco's relief under the niche of the *Quattro Santi Coronati* at Or San Michele, Florence (see Paniscig 1946, fig. 32, for an illustration) and on the tomb of Andrea Bregno in Santa Maria sopra Minerva, Rome (see Butters 1996, 2: fig. 141, for an illustration). Irving Lavin speculated that Michelangelo's use of the term "bow" in his inscription refers to a bowed caliper (Lavin 1993, 33).

10. In the finishing process, sculptors commonly used the rasp immediately following the dog-tooth chisel. Although only dog-tooth chisel work is found on Michelangelo's completed sculptures, he probably used the rasp on them as well.

11. See Vasari (ed. Brown) 1960, 153. Butters 1996, 2:395–96, no. 12, published a sixteenth-century manuscript on the method of sawing marble—*Primo libro del capitano Francesco De Marchi da Bologna, cittadino romano*—in which mention is made of the use of *pietra Tripolina* powder as an abrasive for polishing marble. When I wrote this essay, I was unaware of this treatise, which also discusses several kinds of abrasives used in the cinquecento. I wish to thank Louis A. Waldman for bringing the manuscript to my attention.

12. Carradori 1979, XXVI.

13. Vasari (ed. Brown) 1960, 153.

14. Christ's left arm seems also to have been rubbed to a high shine, this time by the hands of boys who used the arm as a railing when they mounted the rear of the high altar to light candles (see chap. 6, text, and n. 32).

15. For a discussion and illustration of the pointing machine, see Baudry 1978, 170–84. The pointing machine, *la macchinetta* in Italian, is really more an apparatus than a machine. How it got its name is a mystery. For more complete descriptions including illustrations of both this device and its predecessors of the eighteenth and nineteenth centuries, see Rockwell 1983, 121–23. To my knowledge, the earliest carvings since antiquity that show these points are the marble carvings by four different sculptors who executed the Trevi Fountain between 1758 and 1762. The earliest models showing equivalent points are by Antonio Canova, many of which can be seen in the Gipsoteca di Possagno, Italy. (For examples of Canova's use of pointing marks, see Mellini 1999, illustrations on pp. 248–49.) The earliest illustrations of the technique are in the *Encyclopédie* of Diderot and d'Alembert (for an illustration, see Vasari (ed. Brown) 1960, plate 10, A). The best illustrations of the early period of the technique, before the pointing machine, are in Carradori's nineteenth-century handbook on sculpture (Carradori 1979, plates 8 and 9). No examples of measuring points on any of the many areas of unfinish on Bernini's sculptures have been discovered during the recent restoration. Lavin 1967, 93–101, argued in favor of Michelangelo's use of a some sort of pointing system and Schulz 1975, 371–72 and n. 36, asserted that Michelangelo or his assistants used the pointing machine. There is no evidence on Michelangelo's unfinished carvings to support these views.

16. The transfer methods discussed by Leon Battista Alberti, Vasari, and Cellini all rely on approximate measurements and seem awkward and impractical for transferring compositions from a model to a marble block from which a statue is to be carved. For Wasserman's discussion of Michelangelo's use of a model, see chap. 4.

17. See the CD-ROM for color-coded diagrams with the tool marks on the rear and sides of the statue.

18. No one knows for sure the cause of these tan and brown colorings on white marble. Recently Louis A. Waldman has directed us to Fazzini 1988/89, 171–72, in which several different methods of coloring antique statuary in the cinquecento is cited. Some inconclusive tests have been made, for example, on the *Virgin and Child with St. Anne* by Andrea Sansovino in San Agostino in Rome, but no one is exactly sure how the color came about. There is consensus among restorers in Rome that it is the product of some material put on the stone. I have discussed the problem with the restoration scientists George Wheeler, Lorenzo Lazzarini, and Duane Chartier, and I am inclined to conclude that the coloring was caused by rubbing animal fat into the marble as a quick and cheap polish. Kristina Hermann-Fiore has proposed that the very light coloring found on parts of Bernini's *Apollo and Daphne* in the Borghese Gallery, Rome, is an intentional patina used by the artist. The one thing that everyone agrees on is that the varieties of tan to brown coloring found on many white marble sculptures are all products of human intervention.

19. This statement is based on unpublished studies carried out by Roberto Nardi's restoration team during the cleaning of the marble carvings on the ground floor of the museum, in which I participated, as well as studies carried out with the Conservazione Beni Culturali (CBC) on reliefs in the stairway of the Palazzo Conservatori. Medieval statues were also subject to multiple restorations. Arnolfo di Cambio's tomb of Cardinal Bray in San Domenico in Orvieto has at least three documented restorations.

20. For an illustration, see Hartt 1968, plate 124.

APPENDIX B. GAMMAGRAPHIC EXAMINATION OF THE *PIETÀ*

1. The curie is the unit of measurement of the activity of a radioactive material and corresponds to 3.7×10^{10} disintegrations per second.

2. Good quality images are obtained if the photographic density is acceptable. The density is defined as the logarithm of the ratio between the intensity of the incident light and that of the transmitted light.

3. Plate 109, no. 10, is an elaboration of the type-2 pin, since it has both sides of the pin set into lead containers.

APPENDIX C. SCIENTIFIC EXAMINATION OF THE *PIETÀ*

1. See CD-ROM: UV3.

2. The authors of this report wish to thank Dr. Maria Rizzi of the OPD and Dr. Angelita Mairani, a fellow at the OPD, for their collaboration in the analysis of the surface patinas with FT-IR.

APPENDIX D. THE DEVELOPMENT OF THE VIRTUAL MODEL OF MICHELANGELO'S FLORENCE *PIETÀ*

1. Fausto Bernardini et al., "Acquiring Input for Rendering at Appropriate Level of Detail: Digitizing a Pietà," in *Proceedings of the 9th Eurographics Workshop on Rendering, June 29–July 1, 1998* (Vienna: Springer-Verlag, 1998), 81–92.

2. Fausto Bernardini et al., "The Ball-Pivoting Algorithm for Surface Reconstruction," *IEEE Transactions on Visualization and Computer Graphics* 5, no. 4 (October–December 1999): 349–59.

3. Fausto Bernardini and Holly Rushmeier, "Computing Consistent Normals and Colors from Photometric Data," in *Proceedings of 3DIM 99, Second International Conference on 3D Digital Imaging and Modeling*, Ottawa, Canada: IEEE (October 4–8, 1999): 99–108.

APPENDIX E. CATALOGUE OF THE DERIVATIONS OF THE FLORENCE *PIETÀ*

1. This view is perhaps implicit in Paolo Falconieri's comment to Cosimo III, to the effect that he "will find the torso of Christ a beautiful thing" (appendix F, doc. 58).

2. For example, Cherubino Alberti's *Pietà* (plate 117).

3. For an illustration, see Nagel 1996, 569, fig. 17.

ACKNOWLEDGMENTS

Preparing this book on Michelangelo's Florence *Pietà* was a labor of love. It was an exhilarating and challenging experience alternating with moments of anxiety, despair, and doubt. The love and the labor were sustained, and the negative indications mitigated, by several individuals and institutions.

Above all there is David Lenefsky, to whom I am deeply, deeply grateful. I do not exaggerate when I say that without his tireless efforts to find most of the necessary financial resources, his friendship and enthusiasm, and his repeated commands to "get back to work," this book could not have been written.

A scholar—especially a retired scholar—cannot spend four years traveling to Italy for long periods to work in the libraries, archives, and museums, and acquiring photographs with which to illustrate a book without subsidies from foundations. I am very grateful, therefore, for the financial assistance I received from the Samuel S. Kress Foundation (which, among other things, made possible Aurelio Amendola's magnificent photographs of the *Pietà*), the Robert Lehman Foundation, the Adam Sender Charitable Trust, the Norman and Rosita Winston Foundation, and the Edgar and Elissa Cullman Foundation.

I thank collectively the personnel of the libraries and archives in which I did my researches. The libraries include the Hertziana in Rome, the Kunsthistorisches Institut in Florence, the Biblioteca Nazionale in Florence, the American Academy in Rome, and those in the Vatican, the University of Pennsylvania, and Temple University in Philadelphia. I especially salute the individuals who make Temple University's interlibrary loan service function so efficiently. The identities of the archives in which I was well served are noted in the section of documents and in the body of the book.

I am greatly beholden to Anna Mitrano, President; Paolo Bianchini, Geometra; Patrizio Osticresi, Administrative Secretary; and the security personnel of the Opera di Santa Maria del Fiore, Florence, for having facilitated my repeated and lengthy examinations of the *Pietà* in the Opera museum. Lorenzo Fabbri, Director of the Opera archives, also deserves my grateful acknowledgment for having patiently guided my research in his archives and reviewed the section of documents pertaining to the statue's presence in the Cathedral of Florence and in the Opera museum.

I convey gratitude to Giorgio Bonsanti, former Soprintendente of the Opificio delle Pietre Dure in Florence, and his colleague Anna Maria Giusti, as well as the personnel of Ente per le Nuove Tecnologie, l'Energia e l'Ambiente Unità

Salvaguardia Patrimonio Artistico, for agreeing to execute scientific examinations of the *Pietà*. I wish also to acknowledge Cynthia Rockwell, who did a preliminary translation of the reports by the ENEA and the OPD (appendixes B and C) from Italian into English.

I express appreciation to several colleagues and friends for the conception and outcome of the book: to the late Philipp Fehl, because the idea for the book was formulated during a discussion we had about problems relating to the *Pietà*; to the individual and institutional contributors to this book, whose essays have so enriched it; and to those who undertook the thankless task of reading the manuscript in its various versions: David A. Wilkins, Timothy Wardell, Patricia Fidler, Louis A. Waldman, and Leonard Boasberg. They made excellent suggestions for improving the flow of the text, and they corrected many errors of fact, grammar, and spelling. Raina Fehl, Barbara Steindl, and Lucia Monaci Moran were helpful in finding facts I had neglected to include in my research notes, for which they have my thanks.

I am deeply indebted to Stanley Litow, president of the IBM International Foundation, and Paula Baker, vice president of the IBM International Foundation, for having agreed to IBM's participation in the book and for their confidence in my ability to execute it. I wish also to acknowledge debts to Maurizio Saracini of Editech s.r.l., Florence, who brought the new technology to my attention, and to Massimo Caroni, who one day said to me: "Why not IBM?"

Several individuals at, and engaged by, the Princeton University Press—Nancy Grubb, Mary Christian, Devra K. Nelson, Kate Zanzucchi, Ken Wong, Sarah Henry, Laura Lindgren, Celia Fuller, Alison Rooney, Andrew Frisardi, and Cathy Dorsey—applied their admirable individual skills in transforming my manuscript into a book. They did exceptional work in structural and copy editing, in production, in design, and in indexing, for which I extend to them my heartfelt thanks.

Anyone who has devoted years to writing a book knows how essential it is to have a loved one at one's side who can tolerate absences at research facilities and at the computer. So, I conclude these acknowledgements with many, many hugs and kisses for my beloved wife, Ambra Amati Wasserman.

JACK WASSERMAN

CONTRIBUTORS' BIOGRAPHIES

FRANCA TRINCHIERI CAMIZ was educated at Wellesley, Radcliffe, and Harvard. She taught for many programs in Rome, including Trinity College, Temple University, Rhode Island School of Design, and Elderhostel Italy. Widely published in the fields of Italian Renaissance and Baroque art, she was perhaps best-known for her work on Caravaggio, particularly his "quadri musicali" and his *Martyrdom of Saint Matthew* in San Luigi dei Francesi. Her interest in early music has led to numerous publications, including articles on Augustinian musical education in fifteenth-century Naples, the iconography of St. Cecilia, the castrato singer, female singers, and musical instruments in Seicento Roman villas and palaces. A book she had been preparing, *The Mute Lyre: Viewing Music in Seventeenth Century Rome*, remained unfinished at her death.

MONSIGNOR TIMOTHY VERDON took his doctoral degree in art history at Yale University and has taught for Syracuse University, Florida State University, Georgetown University, and Stanford University, mainly in Florence, Italy. In addition to art history, Verdon studied theology in Washington, D.C. and Florence. He was ordained as a Roman Catholic priest in 1994, and is a canon of Florence Cathedral. Monsignor Verdon is also a member of the Board of Directors of the Cathedral Foundation and Museum (Opera di Santa Maria del Fiore), an Advisor to the Vatican Commission on the Cultural Heritage of the Church, and Director of the Diocesan Office for Catechesis through Art. He has published on the Florence Cathedral complex, on Renaissance sculpture and painting, and on the religious content of Renaissance Art.

PETER ROCKWELL, a sculptor in stone and a student of the history of stone carving techniques, studied at Haverford College and the Pennsylvania Academy of Fine Arts before moving to Rome, Italy, where he has lived since 1962. Rockwell exhibits in American and Italian art galleries and has executed fountains, gargoyles, and other monsters for parks and churches in the United States and Italy. He has participated, as consultant, in conservation projects involving the sculptures of the Cathedral of Orvieto, the Baptistry of Parma, the Column of Trajan, the Trevi Fountain, and the Ponte Sant'Angelo, as well as in archaeological excavations at Aphrodisias in Turkey. Rockwell has published widely on stone-carving techniques, including a book, *Lavorare la pietra* (translated into English as *The Art of Stoneworking: A Reference Guide*), and he has taught at the Italian Central

Restoration Institute, the International Centre for the Study of the Preservation and Restoration of Cultural Property (ICCROM) in Rome, and Temple University in Rome.

PIETRO MOIOLI completed his degree in nuclear physics in 1968. He has held the position of researcher at CNEN (Italian Commission for Nuclear Energy) and ENEA (Italian Agency for New Technology, Energy, and the Environment), with a special interest in experimental techniques as applied to the neutron characterization of nuclear reactors. Since 1986, he has devoted himself, at ENEA, to the investigation of nuclear techniques as applied to archaeological objects and works of Art.

ALFREDO ALDROVANDI received an undergraduate degree in physics at the Università degli Studi of Modena in 1979 and post-graduate degrees successively in physics and chemistry at the same institution in 1980 and 1981. Since 1983 he has been director of physics at the Opificio delle Pietre Dure e Laboratori di Restauro di Firenze, a subsidiary of the Ministero dei Beni e le Attività Culturali. Aldrovandi teaches courses in the physical structure of materials and methods of scientific research at the school of the Opificio and has published extensively in area of his specialization.

CARLO LALLI received a degree in biological sciences at the Università degli Studi di Firenze. Since 1982 he has been associated with the Opificio delle Pietre Dure e Laboratori di Restauro di Firenze, where he performs diagnostic investigations on works of painting and sculpture. He specializes in stratigraphic analyses of samples in cross-section. Among the various works he has analyzed are works by Caravaggio, Rubens, Donatello, Giotto, Benvenuto Cellini, Verrocchio, Masaccio, and Michelangelo. Lalli also teaches at the school of the Opificio and at various universities, where he offers courses in, among other subjects, the chemistry of materials and environmental physics. Lalli has published widely on problems of atmospheric polution and its effects on works of art.

CARLO BILIOTTI studied at the Istituto d'Arte di Firenze and has been associated with Opificio delle Pietre Dure in Florence since 1981. He has been involved in the restoration of numerous mosaics and marbles by, among other artists, Donatello and Jacopo della Quercia. He teaches courses on restoration at the school of the Opificio and has participated in many national and international conferences devoted to restoration.

MAURO MATTEINI received a degree in chemistry in 1968 at the University of Florence. His association with the Opificio delle Pietre Dure began in 1975, where he is director of the scientific laboratory. Matteini is involved in diagnostic investigations and research in the conservation of international artistic patrimony, including murals and paintings on panel and canvas, bronzes, tapestries and works on paper, painted facades, and sculptures in stone and marble, espe-

cially those exposed to the weather. He has contributed notably to the development of the laser technique in conserving and cleaning works of art, and has used the technique in restoring works of art, most notably by Raphael, Michelangelo, Donatello, Benvenuto Cellini, and Jacopo della Quercia. He teaches the chemistry of restoration at the school of the Opificio and at the University of Bologna. Matteini has published numerous articles in specialized jounals and three books on the chemistry of restoration and on the methods of investigating works of art.

MARIA ROSA NEPOTI received degrees in biology and political science at the Università degli Studi of Florence. Following the flood in Florence in 1966, Nepoti participated in salvaging works of art and books at the Biblioteca Nazionale Centrale. In 1982 she became associated with the Laboratorio Scientifico dell'Opificio delle Pietre Dure di Firenze, where she specializes in Spectrometric Fourier-Transform Infrared (FT-IR) analysis of works of art. Nepoti has taught courses at the school of the Opificio delle Pietre Dure on techniques and methods of scientific and chemical examination of physical properties of materials, paper, and pergamon. She has collaborated in the restoration of many works of art, including those by Jacopo della Quercia, Ghiberti, Verrocchio, Raphael, Donatello, and Caravaggio, and has published numerous articles in scienific journals.

FAUSTO BERNARDINI received a degree in electrical engineering from the University of Rome (La Sapienza) in 1990 and a Ph.D. in computer science from Purdue University in 1996. He is presently a research staff member and manager of the Visual and Geometric Computing group at the IBM Thomas J. Watson Research Center in New York. His research interests include three-dimensional scanning and reconstruction, interactive 3-D graphics, and geometric modeling. Bernardini has published extensively in his field of specialization.

HOLLY RUSHMEIER received her doctorate in mechanical engineering from Cornell University in 1988. She is presently a research staff member at the IBM Thomas J. Watson Research Center, with interests that include data visualization, rendering algorithms, and acquisition of input data for computer graphics image synthesis. In 1990, Rushmeier was selected as a U.S. National Science Foundation Presidential Young Investigator. She has chaired and cochaired sessions for the ACM Siggraph conference, the IEEE Visualization conference, and the Eurographics Rendering Workshop. From 1996 to 1999, she was editor in chief of ACM Transactions on Graphics and has published several articles in specialized journals.

IOANA M. MARTIN received a Ph.D. in computer science from Purdue University in 1996 and is presently a research staff member in the Visual Technologies Department at the IBM Thomas J. Watson Research Center in New York. Martin's research interests include interactive computer graphics, visualization, and image processing. Since she has joined IBM, she has worked on several projects including adaptive delivery of 3-D models over networks, three-dimensional data

compression, and model reconstruction. Her most recent line of research focuses on modeling with subdivision surfaces.

JOSHUA MITTLEMAN has a master's degree in computer science from Rutgers University. He is presently a programmer at the IBM Thomas J. Watson Research Center in New York, specializing in simplification, level-of-detail control, and other algorithms applied to rendering complex models.

GABRIEL TAUBIN earned a doctorate in electrical engineering from Brown University and a Licenciado en Ciencias Matematicas degree from the University of Buenos Aires, Argentina. Taubin joined the IBM Thomas J. Watson Research Center in New York in 1990, where, from 1996 to 2000, he was manager of the Visual and Geometric Computing Group. During the 2000–2001 academic year he was on sabbatical at the California Institute of Technology as a visiting professor of electrical engineering. He has been named IEEE Fellow for his contributions to the development of three-dimensional geometry compression technology and multimedia standards. His main research interests fall into the following disciplines: applied computational geometry, computer graphics, geometric modeling, three-dimensional photography, and computer vision. He made significant contributions to three-dimensional capturing and surface reconstruction, modeling, compression, progressive transmission, and display of polygonal meshes. The geometry compression technology he developed is now part of the MPEG-4 standard and the IBM HotMedia product.

SELECTED BIBLIOGRAPHY

ACIDINI LUCHINAT 1998. Acidini Luchinat, Cristina. *Taddeo e Federico Zuccari fratelli pittori del Cinquecento*. 2 vols. Rome: Jandi Sapi Editori, 1998.

ACKERMAN 1970. Ackerman, James S. *The Architecture of Michelangelo*. Harmondsworth, U.K.: Penguin Books Ltd., 1970.

ALESSI AND MARTINI 1994. Alessi, Cecilia, and Laura Martini, eds. *Panis vivus. Arredi e testimonianze figurative del culto eucaristico dal VI al XIX secolo*. Exh. cat. Siena, Italy: Curia Arcivescovile di Siena, Soprintendenza Beni Artistici e Storici, 1994.

ANDRES, HUNISAK, AND TURNER 1988. Andres, Glenn, John M. Hunisak, A. Richard Turner. *The Art of Florence*. 2 vols. New York: Abbeville Press, 1988.

ANDERSON 1969. Anderson, Marvin W. "Luther's Sola Fide in Italy: 1542–1551." *Church History* 38, no. 1 (March 1969): 25–42.

ARANCI 1996. Aranci, Gilberto, ed. *Libretto della Dottrina Cristiana, attribuito a Sant'Antonino, Arcivescovo di Firenze*. Florence: Angelo Pontecorboli, 1996.

ARKIN 1997. Arkin, Moshe. "'One of the Marys...': An Interdisciplinary Analysis of Michelangelo's Florentine Pietà." *Art Bulletin* 79, no. 3 (September 1997): 493–517.

BACCETTI 1934. Baccetti, Nello. *Spiriti e figure*. Milan: Editrice Ancora, 1934.

BAINTON 1969. Bainton, Roland H. *Erasmus of Christendom*. New York: Charles Scribner's Sons, 1969.

BALDINI 1981. Baldini, Umberto. *The Sculpture of Michelangelo*. New York: Rizzoli, 1981.

BALDRIGA 2000. Baldriga, Irene. "The First Version of Michelangelo's Christ for S. Maria sopra Minerva." *Burlington Magazine* 142, no. 1173 (December 2000): 740–45.

BAROCCHI 1962. Barocchi, Paola, ed. *Giorgio Vasari, Le Vite di Michelangelo nelle redazioni dal 1550 e del 1568*. 5 vols. Milan: Riccardo Ricciardi Editore, 1962.

BAROCCHI AND RISTORI 1965–83. Barocchi, Paola, and Renzo Ristori, eds. *Il carteggio di Michelangelo, Edizioni postuma di Giovanni Poggi*. 5 vols. Florence: S.P.E.S., 1965–83.

BAROCCHI AND CIULICH 1970. Barocchi, Paola, and Lucilla Bardeschi Ciulich, eds. *I ricordi di Michelangelo*. Florence: Sansoni, 1970.

BAROCCHI, BRAMANTI, AND RISTORI 1988–95. Barocchi, Paola, Kathleen Loach Bramanti, and Renzo Ristori, eds. *Il carteggio indiretto di Michelangelo*. 2 vols. Florence: S.P.E.S., 1988–95.

BAROCCHI ET AL. 1994. Barocchi, Paola, et al., eds. *Giorgio Vasari. Le Vite de' più eccellenti pittori scultori e architettori nelle redazioni del 1550 e 1568. Indice di frequenza*. 2 vols. Pisa, Italy: Scuola Normale Superiore and Accademia della Crusca, 1994.

BAROLSKY 1979. Barolsky, Paul. *Daniele da Volterra: A Catalogue Raisonné*. New York and London: Garland Publishers, 1979.

BATTISTI 1964. Battisti, Eugenio, ed. *Michelangelo scultore*. Rome: Armando Curcio Editore, 1964.

BATTISTI 1989. Battisti, Eugenio. *Michelangelo scultore*. Naples: Guida Editori, 1989.

BAUDRY 1978. Baudry, Marie-Thérèse. *La sculpture, méthode et vocabolaire, principes d'analyse scientifique*. Paris: Imprimerie Nationale, 1978.

BEAN AND STAMPFLE 1966. Bean, Jacob, and Felice Stampfle. *The Italian Renaissance*. Exh. cat. New York: Metropolitan Museum of Art and Pierpont Morgan Library, 1966.

BECK 1996. Beck, James. "Is Michelangelo's *Entombment* in the National Gallery, Michelangelo's?" *Gazette des Beaux-Arts* 127 (May–June 1996): 181–98.

BECKFORD 1843. Beckford, William. *Italy; with Sketches of Spain and Portugal*. 2 vols. London: Richard Bentley, 1843.

BERENSON 1970. Berenson, Bernard. *The Drawings of the Florentine Painters*. 3 vols. Chicago: University of Chicago Press, 1970.

BERNARDINI, CALLOUD, AND MASTROROCCO 1989. Bernardini, Luisella, Annarita Caputo Calloud, and Mila Mastrorocco, eds. *La scultura italiana del XV al XX secolo nei calchi della gipsoteca*. Florence: Cassa di Risparmio, 1989.

BERSHAD 1978. Bershad, David L. "Recent Archival Discoveries Concerning Michelangelo's 'Deposition' in the Florentine Cathedral and a Hitherto Undocumented Work of Giuseppe Mazzuoli (1644–1725)." *Burlington Magazine* 120, no. 901 (April 1978): 225–26.

BERTARELLI 1937. Bertarelli, Luigi V. *Firenze e dintorni*. Milan: Touring Club Italiano, 1937.

BERTLING 1992. Bertling, Claudia. *Die Darstellung der Kreuzabnahm und der Beweinung Christi in der erste Hälfte des 16. Jahrhunderts*. New York: Georg Olms Verlag, 1992.

BESSONE AURELI 1933. Bessone Aureli, A. M. "Per il cambiamento della tomba di Michelangelo." *Illustrazione Vaticana* 4, no. 14 (16–31 July 1933): 545–47.

BLÜHM 1996. Blühm, Andreas. *The Colour of Sculpture, 1840–1910*. Ed. Andreas Blühm. Zwolle, Netherlands: Waanders Uitgevers, 1996.

BOCCHI 1591. Bocchi, Francesco. *Le bellezze della città di Fiorenza*. 1591. Reprint, with an introduction by John Shearman, Farnborough, U.K.: Gregg International Publishers Ltd., 1971.

BOCCHI AND CINELLI 1677. Bocchi, Francesco, and Giovanni Cinelli. *Le bellezze della città di Firenze dove a piano di pittura, di scultura di sacri templi, di palazzi, i più notabili artifizi, e più preziosi si contengono*. Florence: Gugliantini, 1677.

BORA 1976. Bora, Giulio, ed. *I disegni del codice Resta*. Bologna, Italy: Credito Italiano—Impaginazione Emmerre Studio, 1976.

BORGHINI 1994. Borghini, Raffaello. "Modi da dar colore al marmo acciò sia simile all'antico." In *La tecnica della scultura nei trattati del rinascimento*, ed. Simona Rinaldi. Rome: Lithos Editrice, 1994, 135–39.

BOUYER 1968. Bouyer, Louis. *Eucharistic Theology and Spirituality of the Eucharistic Prayer*. Notre Dame, Ind.: University of Notre Dame Press, 1968.

BRANDES 1924. Brandes, Georg. *Michelangelo Buonarroti: His Life, His Times, His Era*. Trans. Heinz Norden. 1924. Reprint, London: Constable and Company Ltd., 1963.

BRAUNFELS 1964. Braunfels, Wolfgang. *Der Dom von Florenz*. Lausanne, Switzerland: Urs Graf-Verlag, 1964.

BRUNI 1940. Bruni, Bruno. "La prima sepoltura di Michelangelo." In *Atti e memorie della Reale Accademia Petrarca* 28–29 (1940): 247–54.

BUFFA 1982. Buffa, Sebastian, ed. *The Illustrated Bartsch: Italian Artists of the Sixteenth Century*. Vol. 34. New York: Abaris Books, 1982.

BUNZL 1969. Bunzl, Tan, ed. *Italian Sixteenth Century Drawings from British Private Collections*. Exh. cat. Edinburgh: Edinburgh Festival Society Ltd., 1969.

BURCKHARDT 2001. Burckhardt, Jacob. *Der Cicerone, Eine Anleitung zum Genuss der Kunstwerke Italiens, Architektur und Skulptur*. Ed. Bernd Roeck, Christine Tauber, and Martin Warnke. 2 vols. Munich: C. H. Beck; Basel: Schwabe & Co. AG., 2001.

BUSCAROLI 1957. Buscaroli, Rezio. *Michelangelo, la vita, la teorica sull'arte, le opere*. Bologna, Italy: Tamari Editori, 1957.

BUTTERS 1996. Butters, Susanne B. *The Triumph of Vulcan: Sculptors' Tools, Porphery, and the Prince in Ducal Florence*. 2 vols. Florence: Leo S. Olschke, 1996.

CAMBARERI 1998. Cambareri, Marietta. *Ippolito Scalza and the Sixteenth-Century Renovation Projects at Orvieto Cathedral*. Ph.D. diss., Institute of Fine Arts, New York University, 1998.

CAMPI 1997. Campi, Emidio. "Kruzifixus und Pietà Michelangelos für Vittoria Colonna. Versuch einer theologischen Interpretazion." In *Vittoria Colonna: Dichterin und Muse Michelangelos*, ed. Sylvia Ferino-Pagden. Exh. cat. Milan: Skira Editore, 1997, 408–11.

CANTIMORI 1970. Cantimori, Delio. "Submission and Conformity: 'Nicodemism' and the Expectations of the Conciliar Solution to the Religious Question." In *The Late Italian Renaissance, 1525–1630*, ed. Eric Cochrane. London: MacMillan and Co., 1970.

CAROCCI 1875. Carocci, G. "Le Feste Michelangiolesche." *Illustrazione universale* 2, no. 57 (14 September 1875): 450–51.

CARRADORI 1979. Carradori, Francesco. *Istruzione elementare per gli studiosi della scultura (1802)*. Ed. Gianni Carlo Sciolla. Treviso, Italy: Libreria Editrice Canova, 1979.

CASADEI MUGNAI 1973. Casadei Mugnai, Giovanna. "Tiberio Calcagni." In *Dizionario biografico degli italiani*. Vol. 16. Rome: Istituto della Enciclopedia Italiana, 1973, 489–90.

CAVALLUCCI 1875. Cavallucci, Camillo J. "Guida alle opere di Michelangiolo in Firenze." In *Michelangiolo Buonarroti, Ricordo al popolo italiano*. Florence: G. C. Sansoni, Editore, 1875, 194–95.

CELLINI 1967. Cellini, Benvenuto. *The Treatises of Benvenuto Cellini on Goldsmithing and Sculpture*. Ed. and trans. Charles R. Ashbee. New York: Dover Publications, 1967.

CERIELLO 1954. Ceriello, G. R., ed. *Rime di Michelangelo Buonarroti*. Milan: Rizzoli, 1954.

CHENEY 1991. Cheney, Iris H. *Francesco Salviati (1510–1563)*. 2 vols. Ph.D. diss. (1963), Ann Arbor, Mich.: University Microfilms International, 1991.

CICOGNARA 1823–25. Cicognara, Leopoldo. *Storia della scultura del suo risorgimento in Italia fino al secolo di Cavona*. 3 vols. Prato, Italy: Fratelli Giachetti, 1823–25.

CLEMENTS 1966. Clements, Robert J. *The Poetry of Michelangelo*. London: Peter Owen, 1966.

CLEMENTS 1968. Clements, Robert J., ed. *Michelangelo: A Self-Portrait*. New York: New York University Press, 1968.

COCKE 1984. Cocke, Richard. *Veronese's Drawings: A Catalogue Raisonné*. London: Philip Wilson Publishers, 1984.

COFFIN 1979. Coffin, David R. *The Villa in the Life of Renaissance Rome*. Princeton, N.J.: Princeton University Press, 1979.

COFFIN 1982. Coffin, David R. "The Lex 'Hortorum' and Access to Gardens in Latium." *Journal of Garden History* 2, no. 3 (July–September 1982): 201–32.

COLONNA 1889. Colonna, Vittoria. *Carteggio di Vittoria Colonna*. Ed. Ermanno Ferrero and Giuseppe Müller. Turin, Italy: Ermanno Loescher, 1889.

COMB 1933. Comb, Jacques. "Guillaume, Eugène." In *Enciclopedia italiana*. Edizioni Istituto G. Treccani. Vol. 18. Milan: Rizzoli and Co., 1933.

COMTE DE CAYLUS 1914. Comte de Caylus. *Voyage d'Italie 1714–1715*. Paris: Librairie Fischbacker, 1914.

CONDIVI 1553. Condivi, Ascanio. *Vita di Michelagnolo*. Rome: Blado, 1553.

CONDIVI (ED. WOHL) 1976. Condivi, Ascanio. *The Life of Michelangelo*. Ed. Hellmut Wohl. Oxford: Oxford University Press, 1976.

CONDIVI (ED. NENCIONI) 1998. Condivi, Ascano. *Vita di Michelagnolo Buonarroti*. Ed. Giovanni Nencioni. Florence: S.P.E.S., 1998.

CONNORS 1996. Connors, Joseph. "S. Ivo alla Sapienza: The First Three Minutes." *Journal of Society of Architectural Historians* 55, no. 1 (March 1996): 38–57.

CORBLET 1886. Corblet, Jules. *Histoire dogmatique, liturgique et archéologique du Sacrèment de l'Eucharistie*. Paris: Société Generale de Librairie Catholique, 1886.

CORBO 1965. Corbo, Anna M. "Documenti romani su Michelangelo." *Commentari* 16, nos. 1–2 (January–June 1965): 98–151.

CORPUS CHRISTIANORUM 1956. Corpus Christianorum, Series Latina. Vols. 39 and 40, ed. D. Eligius Dekkers and Iohannes Fraipont. Turnhout: Typographi Brepols Editores Pontificii, 1956.

CORSI 1994. Corsi, Stefano. "Cronaca di un centenario." In *Michelangelo nell'ottocento. Il centenario del 1875*, ed. Stefano Corsi. Exh. cat. Milan: Edizione Charta, 1994, 13–30.

CORTI 1937. Corti, Guido. *Galleria Colonna*. Rome: Editore Sallustiana, 1937.

COSSA AND ROBERTI 1974. Cossa, Francesco, and Ercole de' Roberti. *Cosmè Tura*. Milan: Rizzoli Editore, 1974.

COURTRIGHT 1990. Courtright, Nicole. *Gregory XIII's Tower of the Winds in the Vatican*. Ann Arbor: University of Michigan, 1990.

COX-REARICK 1989. Cox-Rearick, Janet. "From Bandinelli to Bronzino." *Mitteilungen des Kunsthistorischen Institutes in Florenz* 33 (1989): 37–83.

DACOS 1986. Dacos, Nicole. *Le Logge di Raffaello*. 2nd ed. Rome: Istituto Poligrafico e Zecca dello Stato, Libreria dello Stato, 1986.

DAELLI 1865. Daelli, Giovanni. *Carte michelangiolesche inedito*. Milan: Daelli, 1865.

DARR 1980. Darr, Alan P. *Pietro Torrigiano and His Sculpture for the Henry VIII Chapel, Westminster Abbey*. 3 vols. Ph.D. diss., New York University, 1980.

DAURELLE 1923. Daurelle, Jacques. "Sur une maquette originale de Michel-Ange." *Mercure de France* 147 (1923): 824–49.

DAVIES 1909. Davies, Gerald S. *Michelangelo*. London: Methuen, 1909.

DE ANGELIS 1953. Angelis, Alberto De. "Ottavio Gigli collezionista, letterato e patriota." *Capitolium* 28 (1953): 347–52.

DE BENEDICTIS 1996. De Benedictis, Cristina, ed. *Altari e committenza*. Exh. cat. Florence: Angelo Pontecorboli Editore, 1996.

DE BROSSES 1957. De Brosses, Charles. *Viaggio in Italia. Lettere familiari*. Eds. Carlo Levi and Glanco Natoli. Milan: Editore Parenti, 1957.

DELACROIX 1948. Delacroix, Eugéne. *The Journal of Eugéne Delacroix*. Trans. Walter Pach. New York: Crown Publishers, 1948.

DEL BRAVO 1964. Del Bravo, Carlo. "Per Giovan Francesco Caroto." *Paragone* 15, no. 173 (May 1964): 3–16.

DEL BRUNO 1698. Del Bruno, Raffaello. *Ristretto delle cose più notabili della città di Firenze*. 2nd ed. Florence: Carlieri, 1698.

DELLA PERGOLA 1959. Della Pergola, Paola. *Galleria Borghese. I dipinti*. 2 vols. Rome: Istituto Poligrafico e Zecca dello Stato, Libreria dello Stato, 1959.

DEL MIGLIORE 1684. Del Migliore, Ferdinando L. *Firenze. Città nobilissima illustrata*. Florence: Stampa della Stella, 1684.

DEL PIAZZO 1972. Del Piazzo, Marcello. "Il Palazzo di Montecitorio. Ragguagli documentari." In *Montecitorio. Ricerche di storia urbana*, ed. Franco Borsi. Rome: Officina Edizioni, 1972, 41–100.

DE MAIO 1986. De Maio, Romeo. "Il mito della Maddalena nella controriforma." In *La Maddalena tra sacro e profano*, ed. Marilena Mosco. Milan: Arnoldo Mondadori Editore, 1986, 82–83.

DE MARCO 1992. De Marco, Nicholas. "Titian's 'Pietà': The Living Stone." *Venezia Cinquecento* 2, no. 4 (July–December 1992): 55–92.

DESWARTE-ROSA 1997. Deswarte-Rosa, Sylvie. "Vittoria Colonna und Michelangelo in San Silvestro al Quirinale nach den Gesprächen des Francisco de Holanda." In *Vittoria Colonna: Dichterin und Muse Michelangelos*, ed. Sylvia Ferino-Pagden. Exh. cat. Milan: Skira Editore, 1997, 349–73.

DE TOLNAY 1945–60. De Tolnay, Charles. *Michelangelo*. 5 vols. Princeton, N.J.: Princeton University Press, 1945–60.

DE TOLNAY 1975. De Tolnay, Charles. *Michelangelo: Sculptor, Painter, Architect*. Princeton, N.J.: Princeton University Press, 1975.

DE TOLNAY 1975–80. De Tolnay, Charles. *Corpus dei disegni di Michelangelo*. 4 vols. Novara, Italy: Istituto Geografico De Agostini, 1975–80.

DETZEL 1894. Detzel, Heinrich. *Christliche Ikonographie*. 2 vols. Freiburg, Germany: Herden'sche Verlagshandlung, 1894.

DIXON 1994. Dixon, John W. *The Christ of Michelangelo: An Essay on Carnal Spirituality*. Atlanta, Ga.: Scholar's Press, 1994.

D'ONOFRIO 1967. D'Onofrio, Cesare. *Roma vista da Roma*. Rome: Edizioni "Liber," 1967.

DUPPA 1806. Duppa, Richard. T*he Life and Literary Works of Michel Angelo Buonarroti*. London: Murray, 1806.

DUPRÉ 1873. Dupré, Giovanni. "Lettera dell'illustre Prof. Giovanni Dupré." In *Documenti relative al bozzetto in cera della Pietà di Michelangelo Buonarroti che ne provano l'autenticità posseduto dal Cav. Ottavio Gigli*, ed. Aurelio Gotti. Florence: Stabilimento di G. Pellas, 1873, 14.

DUSSLER 1964. Dussler, Liutpold. "Die Spätwerke des Michelangelo." In *Michelangelo Buonarroti*. Würzburg, Germany: Leo Leonhardt Verlag, 1964, 115–39.

EINEM 1935. Einem, Herbert von. "Der Torso als Theme der bildenden Kunst." *Zeitschrift für Ästhetik und allgemeine Kunstwissenschaft* 29 (1935): 331–34.

EINEM 1940. Einem, Herbert von. "Bemerkungen zum Florentiner Pietà Michelangelos." *Jahrbuch der Preussischen Kunstsammlungen* 61 (1940): 77–99.

EINEM 1956. Einem, Herbert von. *Michelangelo. Die Pietà in Dom zu Florenz*. Stuttgart, Germany: Reclam-Verlag, 1956.

EINEM 1959. Einem, Herbert von. *Michelangelo*. Trans. Ronald Taylor. London: Methuen, 1959.

EINEM 1973. Einem, Herbert von. *Michelangelo, Bildhauer, Maler, Baumeister*. Berlin: Gebr. Mann Verlag, 1973.

EIRE 1979. Eire, Carlos M. N. "Calvin and Nicodemus: a Reappraisal." *Sixteenth Century Journal* 10, no. 1 (spring 1979): 45–69.

EISLER 1969. Eisler, Colin. "The Golden Christ of Cortona and the Man of Sorrows in Italy." *Art Bulletin* 51 (September 1969): 107–18 and 233–46.

ELAM 1998. Elam, Caroline. " 'Che ultima mano?': Tiberio Calcagni's *postille* to Condivi's Life of Michelangelo." In *Ascanio Condivi. Vita di Michelagnolo Buonarroti*, ed. Giovanni Nencioni. Florence: S.P.E.S., 1998, XXIII–XLVI.

ELLINGTON 1995. Ellington, Donna S. "Impassioned Mother or Passion Icon: The Virgin's Role in the Late Medieval and Early Modern Passion Sermons." *Renaissance Quarterly* 48, no. 2 (summer 1995): 227–61.

ELSEN 1963. Elsen, Albert E. *Rodin*. New York: Museum of Modern Art, 1963.

ERRICHELLI 1930. Errichelli, Alfonso. *Michelangelo*. Città di Castello: "Il Solco"–Casa Editrice, 1930.

EVANS 1835. Evans, George W. D. *The Classic and Connoisseur in Italy and Sicily*. 3 vols. London: Longman, Rees, Orme, Brown, Green, and Longman, 1835.

FABBRICHESI 1875. Fabbrichesi, Angiolo. *Guida della Galleria Buonarroti*. Florence: Tipografia Cenniniana nelle Murate, 1875.

FAGIOLO AND MADONNA 1985. Fagiolo, Marcello, and Maria L. Madonna. *Roma sancta. La città delle basiliche*. Rome: Gangemi Editore, 1985.

FALDA 1931. Falda, Giovanni Battista. *Roma al tempo di Clemente X. La pianta di Roma di Giambattista Falda del 1676*. Ed. Francesco Ehrle. Rome: Danesi, 1931.

FALDA 1970. Falda, Giovanni B. *Vedute di Roma e dintorni. 1667–1668*. Rome: Ente Provinciale per il Turismo di Roma, 1970.

FALDI 1974. Faldi, Italo. "Dipinti di figure del rinascimento al neoclassicismo." In *Accademia Nazionale di San Luca*. Rome: Stefano de Luca, 1974, 81–170.

FARA 1988. Fara, Amelio. *Bernardo Buontalenti, l'architettura, la guerra e l'elemento geometrico*. Genoa, Italy: Sagep, 1988.

FAZZINI 1988/89. Fazzini, Antonio. *"Statue, pitture et anticaglie" nel palazzo di Jacopo Salviati. Una collezione fiorentina del Cinquecento*. Thesis, Università degli Studi di Firenze, 1988/89.

FEHL 2002. Fehl, Phillip. "Michelangelo's Tomb in Rome: Observations on the *Pietà* in Florence and the Rondanini *Pietà*." *Artibus et Historiae* 45, no. 23 (2002): 9–27.

FERGONZI 1997. Fergonzi, Flavio. "The Discovery of Michelangelo: Some Thoughts on Rodin's Week in Florence and Its Consequences." In *Rodin and Michelangelo: A Study in Artistic Inspiration*, ed. George H. Marcus and Curtis R. Scott. Exh. cat. Philadelphia: Philadelphia Museum of Art, 1997, 51–67.

FERINO-PAGDEN 1997. Ferino-Pagden, Sylvia. "Zu Michelangelos Zeichnungen für Vittoria." In *Vittoria Colonna: Dichterin und Muse Michelangelos*, ed. Sylvia Ferino-Pagden. Exh. cat. Milan: Skira Editore, 1997, 445–57.

FERRARI 1961. Ferrari, Luisa. *Il Romanino*. Milan: Bramante Editore, 1961.

FIORELLI MALESCI 1986. Fiorelli Malesci, Francesca. *La Chiesa di Santa Felicita a Firenze*. Florence: Cassa di Risparmio di Firenze, 1986.

FOLLINI AND RASTRELLI 1790. Follini, Vincenzo, and Modesto Rastrelli. *Firenze antica e moderna*. 2 vols. Florence: Pietro Allegrini, 1790.

FREEDBERG 1979. Freedberg, Sidney J., *Painting in Italy, 1500 to 1600*. Reprint. New York: Penguin Books Ltd., 1979.

FREEDBERG 1972. Freedberg, Sidney J. *Painting of the High Renaissance in Rome and Florence*. 2 vols. New York: Harper & Row, 1972.

FREY 1897. Frey, Carl, ed. *Die Dichtungen des Michelagniolo Buonarroti*. Berlin: G. Grote'sche Verlagsbuchhandlung, 1897.

FREY 1923–30. Frey, Karl, ed. *Der literarische Nachlass Giorgio Vasaris*. 2 vols. Munich: Georg Müller, 1923–30.

FRIENDLÄNDER 1964. Friendländer, Walter. "Early to Full Baroque: Cigoli and Rubens." In *Studien zur toskanischen Kunst. Festschrift für Ludwig Heinrich Heydenreich*. Munich: Prestel-Verlag, 1964.

FRUTAZ 1962. Frutaz, Amato P., ed. *Le piante di Roma*. Vol. 3, no. 1. Rome: Isituto di Studi Romani, 1962.

GAMBERO 1991. Gambero, Luigi. *Maria nel pensiero dei Padri della Chiesa*. Milan: Edizioni Paoline s.r.l., 1991.

GAMUCCI 1993. Gamucci, Bernardo. *Le antichità della città di Roma, raccolta sotto brevità da diversi antichi e moderni scrittori*. Rome: Centro Editoriale Internazionale, 1993.

GANTNER 1953. Gantner, Joseph. *Rodin und Michelangelo*. Vienna: Anton Schroll & Co., 1953.

GARGANO 1929. Gargano, Giuseppe S. "L'ultima tragedia e la sepoltura di Michelangelo." *Il Marzocco* 34 (8 December 1929): 2–3.

GARTH 1949. Garth, Helen M. *Saint Mary Magdalene in Mediaeval Literature*. Baltimore: Johns Hopkins Press, 1949.

GASPARONI 1866. Gasparoni, Benvenuto. "La Casa di Michelagelo Buonarroti." *Il Buonarroti* 1 (1866): 158–64, 177–80, 204–7.

GAYE 1839–40. Gaye, Giovanni. *Carteggio inedito d'artisti dei secoli xiv, xv, xvi*. 3 vols. Florence: Molini, 1839–40.

GENTILI 1985. Gentili, Augusto. *I giardini di contemplazione Lorenzo Lotto 1503/1512*. Roma: Bulzoni, 1985.

GERE 1966. Gere, John A. "Two of Taddeo Zuccaro's Last Commissions, Completed by Federico Zuccaro. I. The Pucci Chapel in S. Trinità dei Monti." *Burlington Magazine* 108 (June 1966): 286–93.

GERE 1969. Gere, John A. *Taddeo Zuccaro: His Development Studied in His Drawings*. London: Faber, 1969.

GIBERTI 1542. Giberti, Gian M. *De nemine sepeliendo*. Verona: n.p., 1542.

GILBERT 1980. Gilbert, Creighton, trans., and Robert N. Linscott, ed. *Complete Poems and Selected Letters of Michelangelo*. Princeton, N.J.: Princeton University Press, 1980.

GINZBURG 1970. Ginzburg, Carlo. *Il Nicodemismo. Simulazione e dissimulazione religiosa nell'Europa del '500*. Turin, Italy: Giulio Einaudi Editore, 1970.

GIRARDI 1976. Girardi, Enzo Noè, ed. *Michelangelo Buonarroti: Lettere*. Arezzo, Italy: Ente Provinciale per il Turismo, 1976.

GOLDBERG 1983. Goldberg, Edward. *Patterns in Late Medici Art Patronage*. Princeton, N.J.: Princeton University Press, 1983.

GOLDFARB 1997. Goldfarb, Hilliard. "Michelangelo Buonarroti (Caprese 1475–Rome 1564) Pietà." In *Vittoria Colonna: Dichterin und Muse Michelangelos*, ed. Sylvia Ferino-Pagden. Exh. cat. Milan: Skira Editore, 1997, 426–28, no. 4.36.

GOLDSCHEIDER 1955. Goldscheider, Ludwig. *The Left Arm of Michelangelo's 'Notte.'* Milan: Annali, 1955.

GOLDSCHEIDER 1962. Goldscheider, Ludwig. *A Survey of Michelangelo's Models in Wax and Clay*. London: Phaidon, 1962.

GOLDSCHEIDER 1967. Goldscheider, Ludwig. *Michelangelo: Paintings, Sculptures, Architecture*. London: Phaidon, 1967.

GOTTI 1873. Gotti, Aurelio. "Relazione degli Amministratori dell'Ente morale Buonarroti al Municipio di Firenze e primo voto della R. Commissione di Belle Arti." In *Documenti relativi al bozzetto in cera della Pietà di Michelangelo Buonarroti che ne provono l'autenticità posseduto dal Cav. Ottavio Gigli*, ed. Aurelio Gotti. Florence: Stabilimento di G. Pellas, 1873, 15–16.

GOTTI 1875. Gotti, Aurelio. *Vita di Michelangelo Buonarroti narrata con l'aiuto di nuovi documenti*. 2 vols. Florence: Tipografia della Gazzetta d'Italia Editrice, 1875. Trans. Charles Heath Wilson under the title *Life and Works of Michelangelo Buonarroti* (London: John Murray, 1876).

GOTTSCHEWSKI 1908. Gottschewski, Adolf. "Zu Michelangiolos Schaffenprozess." *Monatshefte für Kunstwissenschaft* 1, no. 2 (1908): 853–67.

GOTTSCHEWSKI N.D. Gottschewski, Adolf. *Michelangelo: die Skulptoren*. Stuttgart, Germany: Spemann, n.d.

GRIFI 1899. Grifi, Elvira. *Saunterings in Florence*. Florence: R. Bemporad & Figlio, 1899.

GRIMM 1865. Grimm, Herman. *Life of Michael Angelo*. Trans. Fanny Elizabeth Bunnett. 2 vols. London: Smith, Elder and Co., 1865.

GRÜNWALD 1914. Grünwald, Alois. *Florentiner Studien*. Prague: Kunstanstalt Stengel & Co., 1914.

GUASTI 1863. Guasti, Cesare, ed. *Le rime di Michelagelo Buonarroti*. Florence: Felice Le Monnier, 1863.

GUERRIERI BORSOI 1993. Guerrieri Borsoi, Maria B. "S. Maria dei Monti. Cappella Falconi (della Pietà)." In *Roma di Sisto V*, ed. Maria Luisa Madonna. Rome: Edizioni de Luca, 1993.

GUILLAUME 1876. Guillaume, Eugène. "Michel-Ange sculpteur." *Gazette des Beaux Arts* 13 (1876): 34–118.

HAINES 1988. Haines, Margaret. *Duomo di Firenze, documenti sulla decorazione della chiesa e del campanile tratti dall'archivio dell'Opera per cura di Giovanni Poggi*. Florence: Edizioni Medicea, 1988.

HARDISON 1969. Hardison, Osborne B., Jr. *Christian Rite and Christian Drama in the Middle Ages*. Baltimore: Johns Hopkins Press, 1969.

HARFORD 1857. Harford, John S. *The Life of Michel Angelo Buonarroti*. 2 vols. London: Longman, Brown, Green, Longmans, and Roberts, 1857.

HARTT 1968. Hartt, Frederick. *Michelangelo: The Complete Sculpture*. New York: Harry N. Abrams, Inc., 1968.

HARTT 1970. Hartt, Frederick. *The Drawings of Michelangelo*. New York: Harry N. Abrams, Inc., 1970.

HARTT 1975. Hartt, Frederick. *Michelangelo's Three Pietàs*. New York: Harry N. Abrams, Inc., 1975.

HEIKAMP 1964. Heikamp, Detlef. "Baccio Bandinelli nel Duomo di Firenze." *Paragone* 15, no. 175 (July 1964): 32–42.

HEIKAMP 1980. Heikamp, Detlef. "Scultura e politica. Le statue della Sala Grande di Palazzo Vecchio." In *Le arti del principato Mediceo*. Florence: S.P.E.S, 1980, 201–54.

HERMANN-FIORE 1992. Hermann-Fiore, Kristina. "Taddeo Zuccari. Pietà with Angels." In *The Genius of the Sculptor in Michelangelo's Work*, ed. Pietro C. Marani. Exh. cat. Montreal: The Museum of Fine Arts, 1992.

HERMANN-FIORE 1997. Hermann-Fiore, Kristina. "Apollo e Dafne del Bernini al tempo del cardinale Scipione Borghese." In *Apollo e Dafne del Bernini nella Galleria Borghese*, ed. Kristina Hermann-Fiore. Cinisello Balsamo (Milan): Silvana Editoreale, 1997, 71–110.

HERMANN-FIORE 1999. Hermann-Fiore, Kristina. "La Pietà nell'opera di Federico e Taddeo Zuccaro." In *Der Maler Federico Zuccari. Ein römischer Virtuoso von europäischen Ruhm*. Munich: Hirmer Verlag, 1999, 185–205.

HIBBARD 1974. Hibbard, Howard. *Michelangelo*. New York: Harper & Row, 1974.

HIESINGER 1976. Hiesinger, K. B. "The Fregoso Monument: A Study in Sixteenth-Century Tomb Monuments and Catholic Reform." *Burlington Magazine* 118, no. 878 (May 1976): 283–93.

HIRN 1912. Hirn, Yrjö. *The Sacred Shrine*. London: Macmillan and Co., Ltd., 1912.

HIRST 1967. Hirst, Michael, "Daniele da Volterra and the Orsini chapel–1." *Burlington Magazine* 109, no. 774 (January–December 1967): 498–509.

HIRST 1988. Hirst, Michael. *Michelangelo and His Drawings*. New Haven, Conn., and London: Yale University Press, 1988.

HIRST AND DUNKERTON 1994. Hirst, Michael, and Jill Dunkerton. *The Young Michelangelo: The Artist in Rome 1496–1501*. London: National Gallery Publications, 1994.

HIRST 1997. Hirst, Michael. "Der tote Christus von trauernden Figuren gestützt." In *Vittoria Colonna: Dichterin und Muse Michelangelos*, ed. Sylvia Ferino-Pagden. Exh. cat. Milan: Skira Editore, 1997, 452.

HODSON 1999. Hodson, Rupert. *Michelangelo Sculptor*. Florence: Summerfield Press; and London: Philip Wilson Publishers, 1999.

HOLLANDA 1928. Hollanda, Francesco De. *Four Dialogues on Painting*. Trans. Aubrey F. G. Bell. London: Humphrey Milford, 1928.

HOLROYD 1903. Holroyd, Charles. *Michael Angelo Buonarroti*. London: Druckworth and Co., 1903.

HOOD 1993. Hood, William. *Fra Angelico at San Marco*. New Haven, Conn., and London: Yale University Press, 1993.

HORNER AND HORNER 1877. Horner, Susan, and Joanna Horner. *Walks in Florence*. 2 vols. London: Henry S. King & Co., 1877.

HUMFREY 1983. Peter Humfrey. *Cima da Conegliano*. Cambridge: Cambridge University Press, 1983.

ISERMEYER 1965. Isermeyer, Christian A. "Das Michelangelo-Jahr 1964 und die Forschungen zu Michelangelo als Maler und Bildhauer von 1959 bis 1965." *Zeitschrift für Kunstgeschichte* 28 (1965): 307–52.

JAMESON 1857. Jameson, Anna B. *Legends of the Madonna as Represented in the Fine Arts*. 2nd ed. London: Longman, Brown, Green, Longmans, and Robert, 1857.

JAYME 1994. Jayme, Erik. *Antonio Canova (1757–1822) als Künstler und Diplomat*. Heidelberg, Germany: Heidelberger Universitätsbibliothek, 1994.

JOANNIDES 1996. Joannides, Paul. *Michelangelo and His Influence: Drawings from Windsor Castle*. Exh. cat. London: Lund Humphries Publishers, 1996.

KELLER 1976. Keller, Harald. *Michelangelo*. Frankfurt: Fischer, 1976.

KNAPP 1910. Knapp, Fritz. *Michelangelo*. Stuttgart: Deutsche Verlagsanstalt, 1910.

KÖRTE 1955. Körte, Werner. "Das Problem des Nonfinito bei Michelangelo." *Römisches Jahrbuch für Kunstwissenschaft* 7 (1955): 293–302.

KRISTOF 1989. Kristof, Jane. "Michelangelo as Nicodemus: The Florence Pietà." *Sixteenth Century Journal* 20, no. 2 (summer 1989): 163–82.

KÜNSTLE 1928. Künstle, Karl. *Ikonographie der christlichen Kunst*. Freiburg: Herder and Co., 1928.

LANE 1975. Lane, Barbara, " 'Depositio et Elevatio': The Symbolism of the Seilern Triptych." *Art Bulletin* 57, no. 1 (March 1975): 21–30.

LAVIN 1967. Lavin, Irving. "Bozzetti and Modelli: Notes on Sculptural Procedure from the Early Renaissance through Bernini." *Stil und Überlieferung in der Kunst des Abendlandes. Akten des 21 Internationalen Kongresses für Kunstgeschichte in Bonn 1964*. Vol. 3. Berlin: Velag Gebr. Mann, 1967, 93–104.

LAVIN 1978. Lavin, Irving. "The Sculptor's Last Will and Testament." *Bulletin. Allen Memorial Art Museum* 35, nos. 1–2 (1978): 4–39.

LAVIN 1993. Lavin, Irving. "David's Sling and Michelangelo's Bow: A Sign of Freedom." In *Past-Present: Essays on Historicism in Art from Donatello to Picasso*. Berkeley and Los Angeles: University of California Press, 1993, 29–61.

LAVIN 1998. Lavin, Irving. "Ex Uno Lapide: The Renaissance Sculptor's *Tour de Force*." In *Il Cortile delle Statue: Der Statuenhof des Belvedere im Vatikan. Akten des internationalen Kongresses zu Ehren von Richard Krautheimer. Rome, 21–23 Oktober 1992*, ed. Matthias Winner, Bernard Andreae, and Carlo Pietrangeli. Mainz, Germany: Verlag Philipp von Zabern, 1998, 191–210.

LAVIN 2001. Lavin, Marilyn A. "The *Stella Altarpiece*: Magnum Opus of the Cesi Master." *Artibus et historiae* 22, no. 44 (2001): 9–22.

LEBEL 1970. Lebel, Robert, ed. *Dessins et aquarelles importants provenant de trois collections (Bedeutende Zeichnungen und Aquarelle aus drei Sammlungen)*. Auction cat., 26 September 1970. Basel, Switzerland: Auctiones SA, Société pour les Ventes Publiques d'Oeuvres d'Art, 1970.

LECCHINI GIOVANNONI 1996. Lecchini Giovannoni, Simona. "Il Corpus Christi e la mensa d'altare in alcuni dipinti fiorentini del Cinquecento." In *Altari e committenza*, ed. Cristina De Benedictis. Exh. cat. Florence: Angelo Pontecorboli Editore, 1996, 29–35.

LE CURIEUX 1924. Le Curieux. "Une maquette originele de Michel-Ange." *Renaissance de l'art Français et des Industries de Luxe* 7 (January 1924): 46–47.

LENSI 1929. Lensi, Alfredo. *Palazzo Vecchio*. Milan: Bestetti and Tumminelli, 1929.

LENZ 1999. Lenz, Christian. *Rodin und Helene von Nostitz*. Exh. cat. Munich: Bayerische Staatsgemäldesammlungen Neue Pinakothek, 1999.

LEONARDI 1995. Leonardi, Corrado. *Michelangelo, l'Urbino il Taruga*. Città di Castello, Italy: Petruzzi Editore, 1995.

LEVI 1932. Levi, Doro. "La tomba della Pellegrina a Chiusi." *Rivista del R. Istituto d'archeologia e storia dell'arte* 4 (1932): 7–60.

LIGHTBOWN 1983. Lightbown, Ronald. *Sandro Botticelli*. Milan: Fabbri Editore, 1983.

LITTA, ODERICI, AND PASSERINI 1819–1911. Litta, Pompeo, Federico Oderici, and Luigi Passerini. *Famiglie celebri di Italia*. 16 vols. Milan: Luciano Basadonna, 1819–1911.

LOTTI 1975. Lotti, Luigi. "Le quattro Pietà di Michelangelo." *Alma Roma* 16 (1975): 65–72.

LUNGHERINI 1939. Lungherini, Sante. "Le Quattro 'Pietà' di Michelangelo. Il Gruppo di Palestrina donato dal Duce a Firenze." *Firenze. Rassegna mensile del comune* 8 (March 1939): 77–81.

MACKOWSKY 1925. Mackowsky, Hans. *Michelangelo*. Berlin: Bruno Cassirer Verlag, 1925.

MAGHERINI GRAZIANI 1875. Magherini Graziani, Giovanni. *Michelangelo Buonarroti*. Florence: Barbera, 1875.

MALLARMÉ 1929. Mallarmé, Camille. *L'ultima tragedia di Michelagnelo*. Rome: Casa Editrice Optima, 1929.

MALLARMÉ 1930. Mallarmé, Camille. *Un Drame Ignoré de Michel-Ange*. Paris: Firmin-Didot et c.ie, 1930.

MARDER 1978. Marder, Tod. "Sixtus V and the Quirinal." *Journal of the Society of Architectural Historians* 37, no. 4 (December 1978): 283–94.

MARIANI 1942. Mariani, Valerio. *Michelangelo*. Turin, Italy: Unione Tip. Ed. Torinese, 1942.

MARTINELLI 1650. Martinelli, Fioravanti. *Roma ricercata*. Rome: Biagio Deversin, 1650.

MASSARI AND RODINÒ 1989. Massari, Stefani, and Simonetta P. V. Rodinò. *Tra mito e allegoria. Immagini a stampa nel '500 e '600*. Rome: Istituto Nazionale per la Grafica, Sistemi Informazioni S.r.a., 1989.

MAUGHAM 1903. Maugham, H. Neville. *The Book of Italian Travel*. London: Grant Richards, and New York: E. P. Dutton and Co., 1903.

MCCULLAGH AND GILES 1997. McCullagh, Susanne F., and Laura M. Giles. I*talian Drawings before 1600 in the Art Institute of Chicago: A Catalogue of the Collection*. Chicago: The Art Institute of Chicago, in association with Princeton University Press, 1997.

MCMAHON 1956. McMahon, A. Philip, trans. *Treatise on Painting by Leonardo da Vinci*. 2 vols. Princeton, N.J.: Princeton University Press, 1956.

MECATTI 1755. Mecatti, Giuseppe M. *Storia cronologica della città di Firenze*. 2 vols. Naples: Stamperia Simoniana, 1755.

MELLINI 1999. Mellini, Gian Lorenzo. *Canova. Saggi di filologia e di ermeneutica*. Milan: Skira Editore, 1999.

MENDELSOHN 1982. Mendelsohn, Leatrice. *Paragoni. Benedetto Varchi's Due Lezzioni and Cinquecento Art Theory*. Ann Arbor, Mich.: University Microfilms International Research Press, 1982.

MIDDELDORF 1976. Middeldorf, Ulrich. " 'Vestire gli Ignudi.' Un disegno del Soldani." In *Kunst des Barock in der Toskana*. Munich: Bruckmann, 1976, 33–38.

MIGLIORINI 1856. Migliorini, Arcangelo M. "Notizie storiche intorno a un bozzetto in cera di Michelangelo Buonarroti, rappresentante una Pietà." *Le arti del disegni* 3, no. 1 (5 January 1856): 3–5.

MIGNE 1857–67. Migne, Jacques Paul, ed. *Patrologiae Cursus Completus, Series Graeca*. 242 vols. Paris: Migne, 1857–67.

MIGNE 1865–84. Migne, Jacques Paul, ed. *Patrologiae Cursus Completus, Series Latina*. 221 vols. Paris: Migne, 1865–84.

MILANESI 1873. Milanesi, Gaetano. "Seconda relazione della R. commissione di Belle Arti, riunita per ordine del Ministro con la sezione archeologica." In *Documenti relativi al Bozzetto in Cera della Pietà di Michelangelo Buonarroti che ne provano l'autenticità posseduto dal Cav. Ottavio Gigli*, ed. Aurelio Gotti. Florence: Stabilimento di G. Pellas, 1873, 17–21.

MOLAJOLI 1974. Molajoli, Rosemarie. *L'opera completa di Cosmè Tura*. Milan: Rizzoli Editore, 1974.

MONACI 1977. Monaci, Lucia. *Disegni di Giovan Battista Foggini (1652–1725), Gabinetto disegni e stampe degli Uffizi*. Florence: Leo S. Olschki Editore, 1977.

MONBEIG GOGUEL 1998. Monbeig Goguel, Catherine, ed. *Francesco Salviati (1510–1563) o la Bella Maniera*. Exh. cat. Milan: Electa, 1998.

MONTAGU 1989. Montagu, Jennifer. *Roman Baroque Sculpture*. New Haven, Conn, and London: Yale University Press, 1989.

MONTANELLI 1970. Montanelli, Indro, ed. *Piazza Navona*. Rome: Franco Spinosi Editore, 1970.

MORENI 1816–17. Moreni, Domenico. *Continuazione delle memorie istoriche dell'ambrosiana imperiale basilica di S. Lorenzo di Firenze*. 2 vols. Florence: Francesco Daddi, 1816–17.

MORONI 1840–79. Moroni, Gaetano. *Dizionario di erudizione storico-ecclesiastica*. 108 vols. Venice: Tipografia Emiliana, 1840–79.

MORTARI 1992. Mortari, Luisa. *Francesco Salviati*. Rome: Leonardo-DeLuca Editori, 1992.

MOSCO 1986. Mosco, Marilena, ed. *La Maddalena tra sacro e profano*. Milan: Arnoldo Mondadori Editore, 1986.

MUGNAI 1973. Mugnai, G. Casadei. "Tiberio Calcagni." In *Dizionario biografico degli italiani*. Vol. 16. Rome: Istituto della Enciclopedia Italiana, 1973, 489–90.

MÜNTZ 1895. Müntz, Eugène. *Histoire de l'art pendant la Renaissance*. 3 vols. Paris: Hachette, 1895.

MUNDY 1989. Mundy, James E., ed. *Renaissance into Baroque: Italian Drawings by the Zuccari, 1550–1600*. Exh. cat. Milwaukee: Milwaukee Art Museum, 1989.

MURRAY 1980. Murray, Linda. *Michelangelo*. London: Thames and Hudson, 1980.

NAGEL 1993. Nagel, Alexander. *Michelangelo, Raphael, and the Altarpiece Tradition*. Ann Arbor, Mich.: Universal Microfilms International, 1993.

NAGEL 1994. Nagel, Alexander. "Michelangelo's London 'Entombment' and the Church of S. Agostino in Rome." *Burlington Magazine* 136 (March 1994): 164–67.

NAGEL 1996. Nagel, Alexander. "Observations on Michelangelo's Late *Pietà* Drawings and Sculptures." *Zeitschrift für Kunstgeschichte* 59, no. 4 (1996): 548–72.

NAGEL 1997. Nagel, Alexander. "Gifts for Michelangelo and Vittoria Colonna." *Art Bulletin* 79, no. 5 (December 1997): 655–61.

NAGEL 2000. Nagel, Alexander. *Michelangelo and the Reform of Art*. Cambridge: Cambridge University Press, 2000.

NEPI SCIRÉ 1990. Nepi Sciré, Giovanna. "La Pietà." In *Tiziano*, ed. Susanna Biadene. Exh. cat. Venice: Marsilio Editori, 1990, 373–74.

NIKÉ N.D. Niké, Marcel. *Florence historique, monumentale artistique*. Paris: Librerie de Paris, n.d.

O'GRODY 1999. O'Grody, Jeannine A. *"Un semplice modello": Michelangelo and His Three-Dimensional Preparatory Works*. Ph.D. diss., Ann Arbor, Mich.: Universal Microfilms International, 1999.

OLSON 1992. Olson, Roberta J. M. *Italian Renaissance Sculpture*. London: Thames and Hudson, 1992.

ORBAAN 1920. Orbaan, Johannes A. F. *Documenti sul barocco in Roma*. Rome: Società Romana di Storia Patria, 1920.

OSTROW 1996. Ostrow, Steven F. *Art and Spirituality in Counter-Reformation Rome*. Cambridge: Cambridge University Press, 1996.

OTTONELLI AND BERRETTINI 1973. Ottonelli, Giovanni D., and Pietro Berrettini. *Trattato della pittura e scultura: Uso e abuso loro (1652)*, ed. Vittorio Casale. Treviso: Libreria editrice Canova, 1973.

OTTONELLI AND CORTONA 1652. Ottonelli, Giovanni D., and Pietro da Cortona. *Trattato della pittura e scultura*. Florence: Gio. Antonio Bonardi, 1652

PAATZ AND PAATZ 1940–54. Paatz, Walter, and Elisabeth Paatz. *Die Kirchen von Florenz*. 6 vols. Frankfurt am Main: V. Klostermann, 1940–54.

PANISCIG 1946. Paniscig, Leo. *Nanni di Banco*. Florence: Arnaud Editore, 1946.

PANOFSKY 1927. Panofsky, Erwin. " 'Imago Pietatis.' Ein Beitrag zur Typengeschichte des 'Schmerzensmanns' und der 'Maria Mediatrix.' " In *Festschrift für Max J. Friedländer, zum 60. Geburtstage*. Leipzig: E. A. Seemann, 1927, 261–308.

PANOFSKY 1962. Panofsky, Erwin. *Studies in Iconology*. New York: Harper Torchbooks, 1962.

PANOFSKY 1993. Panofsky, Gerda. "Tommaso della Porta's 'Castles in the Air.'" *Journal of the Warburg and Courtauld Institutes* 56 (1993): 119–67.

PAOLETTI 2000. Paoletti, John T. "The Rondanini *Pietà*: Ambiguity Maintained through the Palimpsest." *Artibus et historiae* 42 (2000): 53–80.

PAOLUCCI 1980. Paolucci, Antonio. "Le opere d'arte." In *Firenze e la Toscana dei Medici nell'Europa del cinquecento. La comunità cristiana fiorentina e toscana nella dialettica religiosa del cinquecento*, ed. Arnaldo d'Addario. Exh. cat. Florence: Saverio Becocci, 1980, 197–262.

PAOLUCCI 1993. Paolucci, Antonio. "Tesori d'arte dentro Santa Maria del Fiore." In *Alla riscoperta di Piazza del Duomo in Firenze. La Cattedrale di Santa Maria del Fiore*, ed. Timothy Verdon. Vol. 2. Florence: Centro Di, 1993, 89–109.

PAOLUCCI 1997. Paolucci, Antonio. *Michelangelo: Le Pietà*. Photo. Aurelio Amendola. Milan: Skira Editore, 1997.

PAPINI 1949. Papini, Giovanni. *Vita di Michelangiolo nella vita del suo tempo*. Milan: Garzanti, 1949.

PARKER 1938–56. Parker, Karl T. *Catalogue of the Collection of Drawings in the Ashmolean Museum*. Italian Schools. 2 vols. Oxford: Clarendon Press, 1938–56.

PARRINI 1876. Parrini, Cesare, ed. *Relazione del centenario di Michelangelo Buonarroti sul settembre del 1875 in Firenze*. Florence: Giuseppe Civelli, 1876.

PARRONCHI 1981. Parronchi, Alessandro. "Sulla Pietà fiorentina di Michelangelo." *Storia dell'arte* 10, nos. 36–37 (1981): 23–33.

PARRONCHI 1996. Parronchi, Alessandro. *Opere giovanili di Michelangelo Revisioni e aggiornamenti*. 3 vols. Florence: Leo S. Olschki Editore, 1996.

PARTNER 1976. Partner, Peter. *Renaissance Rome, 1550–1559*. Berkeley and Los Angeles: University of California Press, 1976.

PARTRIDGE 1996. Partridge, Loren. *The Renaissance in Rome, 1400–1600*. New York: Harry N. Abrams, Inc., 1996.

PASTOR 1923–53. Pastor, Ludwig. *The History of the Popes*. 40 vols. London: Kegan Paul, Trench, Trubner & Co. Ltd., 1923–53.

PATRIZI 1982. Patrizi, Giorgio. "Colonna, Vittoria." In *Dizionario biograifico degli italiani*. Vol. 27. Rome: Istituto della Enciclopedia Italiana, 1982, 448–57.

PAVLINOV 1965. Pavlinov, Pavel. "La sistemazione della Pietà di S. Maria del Fiore e il metodo creativo di Michelangelo, studi in onore di Giusta Nicco Fasola." *Arte Lombarda* 10 (1965): 115–42.

PENNY 1993. Penny, Nicholas. *The Materials of Sculpture*. New Haven, Conn., and London: Yale University Press, 1993.

PERRIG 1960. Perrig, Alexander. *Michelangelo Buonarrotis letzte Pietà-Idee*. Bern: Francke Verlag, 1960.

PETRUCCI 1995. Petrucci, Francesca. "Le sculture dell'interno." In *La Cattedrale di Santa Maria del Fiore a Firenze*, ed. Cristina Acidini Luchinat. 2 vols. Florence: Cassa di Risparmio, 1995, 157–92.

PIGNATTI 1976. Pignatti, Terisio. *Veronese*. Venice: Alfieri Edizione d'Arte, 1976.

PILLSBERRY AND CALDWELL 1974. Pillsberry, Edmund P., and John Caldwell. *Sixteenth Century Italian Drawings: Form and Function: Yale University Art Gallery*. New Haven, Conn., and London: Yale University Art Gallery, 1974.

PITSCHNEIDER 1997. Pitschneider, Stefania. "Biographische Daten zu Michelangelo Buonarroti." In *Vittoria Colonna: Dichterin und Muse Michelangelos*, ed. Sylvia Ferino-Pagden. Exh. cat. Milan: Skira Editore, 1997, 311–34.

POESCHKE 1990–92. Poeschke, Joachim. *Die Skulptur der Renaissance in Italien, Michelangelo und seine Zeit*. 2 vols. Munich: Hirmer Verlag, 1990–92.

POESCHKE 1996. Poeschke, Joachim. *Michelangelo and His World*. Trans. Russell Stockman. New York: Harry N. Abrams, Inc., 1996.

POGGI 1909. Poggi, Giovanni. *Il Duomo di Firenze*. 1909. Rev. ed. edited by Margaret Haines. Florence: Edizione Medicea, 1988.

POLVERINI FOSSI 1991. Polverini Fossi, Irene. "Pietà, devozione e politica: due confraternite fiorentine nella Roma del rinascimento." *Archivio storico italiano* 149 (1991): 119–61.

POPE-HENNESSY 1964. Pope-Hennessy, John. *Catalogue of Italian Sculpture in the the Victoria and Albert Museum*. 3 vols. London: Her Majesty's Stationary Office, 1964.

POPE-HENNESSY (KONGRESS) 1964. Pope-Hennessy, John. "The Palestrina Pietà." In *Stil und Überlieferung in der Kunst des Abendlandes. Akten des 21. Internationalen Kongress für Kunstgeschichte in Bonn*. Vol. 2. Bonn, Germany: Arbo Druck, H. Reinhartz, 1964, 105–14.

POPE-HENNESSY 1970. Pope-Hennessy, John. *Italian High Renaissance and Baroque Sculpture*. 3 vols. 2nd ed. New York: Phaidon, 1970.

POPE-HENNESSY 1974. Pope-Hennessy, John. *Fra Angelico*. 2nd ed. London: Phaidon, 1974.

POPHAM AND FENWICK 1965. Popham, Arthur E., and Kathleen M. Fenwick. *European Drawings in the Collection of the National Gallery of Canada*. Toronto: University of Toronto Press, 1965.

POPHAM 1971. Popham, Arthur E. *Catalogue of the Drawings of Parmigianino*. 2 vols. New Haven, Conn., and London: Yale University Press, 1971.

POTTS 2000. Potts, Alex. *The Sculptural Imagination, Figurative, Modernist, Minimalist*. New Haven, Conn., and London: Yale University Press, 2000.

PRINZ 1989. Prinz, Wolfram. "L'autoritratto di Donatello." *Antichità viva* 28, no. 4 (1989): 36–39.

PRZYBOROWSKI 1982. Przyborowski, Claudia. *Die Ausstattung der Fürstenkapelle an der Basilika von San Lorenzo in Florenz*. 2 vols. Berlin: Fröhlich and Kaufmann, 1982.

QUATREMÈRE 1835. Quatremère de Quincy, Antoine C. *Histoire de la vie et des ouvrages de Michel-Ange*. Paris: Firmin Didot Frères, Libraires, 1835.

RAMSDEN 1963. Ramsden, E. H. *The Letters of Michelangelo*. 2 vols., London: Peter Owen Ltd., 1963.

RICCI 1895. Ricci, Alessandro. *Manuale del marmista*. Milan: Hoepli, 1895.

RICHA 1754–62. Richa, Giuseppe. *Notizie istoriche delle chiese fiorentine divise ne' suoi quartieri*. 10 vols. Florence: Pietro Gaetani Viviani, 1754–62.

RICHARDSON 1722. Richardson, Jonathan. *An Account of Some of the Statues, Bas-Reliefs, Drawings, and Pictures in Italy*. London: J. Knapton, 1722.

RICHEOME 1628. Richeome, Louis. *La Peinture Spirituelle*. Vol. 2, pt. 6, *Des Jardins*. Paris: Sebastien Cramoisy, 1628, 461.

RICHTER 1970. Richter, Jean P., ed. *The Literary Works of Leonardo da Vinci*. 2 vols. 3rd ed. New York: Phaidon, 1970.

RIDDERBOS 1998. Ridderbos, Bernhard. "The Man of Sorrows: Pictorial Images and Metaphorical Statements." In *The Broken Body: Passion Devotion in Late-Medieval Culture*, ed. A. A. MacDonald, H. N. B. Ridderbos, and R. M. Schusemann. Groningen, Netherlands: Egbert Forsten, 1998, 145–81.

RIGHETTI 1950–53. Righetti, Mario. *Manuale di storia liturgica.* 4 vols. Milan: Editrice Ancora, 1950–53.

RIOPELLE 1997. Riopelle, Christopher. "Rodin Confronts Michelangelo." In *Rodin and Michelangelo: A Study in Artistic Inspiration,* ed. George H. Marcus and Curtis R. Scott. Exh. cat. Philadelphia: Philadelphia Museum of Art, 1997, 35–49.

RIVOSECCHI 1965. Rivosecchi, Mario. *Michelangelo e Roma.* Bologna, Italy: Cappelli, 1965.

ROCKWELL 1993. Rockwell, Peter. *The Art of Stoneworking.* Cambridge: Cambridge University Press, 1993.

RODIN 1912. Rodin, Auguste. *L'Art.* Interview by Paul Gsell. Paris: Bernard Grasset, Editions, 1912.

ROSELLI 1978. Roselli, Orfeo. *Osservazioni della scultura antica dai manoscritti Corsini e Doria e altri scritti.* Ed. Phoebe Dent Weil. Florence: Edizioni S.P.E.S., 1978.

ROSENBLUM AND JANSON 1984. Rosenblum, Robert, and Horst W. Janson. *Art of the Nineteenth Century: Painting and Sculpture.* London: Thames and Hudson, 1984.

RUBIN 1987. Rubin, Patricia L. "The Private Chapel of Cardinal Alessandro Farnese in the Cancelleria, Rome." *Journal of the Warburg and Courtauld Institutes* 50 (1987): 82–112.

RUBIN 1995. Rubin, Patricia L. *Giorgio Vasari: Art and History.* New Haven, Conn., and London: Yale University Press, 1995.

RUHMER 1958. Ruhmer, Eberhard. *Cosmé Tura: Paintings and Drawings.* London: Phaidon Press, 1958.

RUSKIN 1851. Ruskin, John. *Modern Painters.* 5 vols. London: Smith, Elder, and Co., 1851.

RUSSOLI 1963. Russoli, Franco. *Tutta le scultura di Michelangelo.* Milan: Rizzoli, 1953. Trans. Paul Colacicchi under the title *All the Sculpture of Michelangelo.* (New York: Hawthorn Books, Inc., 1963).

SAGE 1962. Sage, Robert, ed. *The Private Diaries of Stendhal.* New York: Norton, 1962.

SAINT-THIERRY 1993. Saint-Thierry, Guglielmo di. *Commento ambrosiano al cantico dei cantici.* Trans. Gabriele Banterle. Milan: Biblioteca Ambrosiana, 1993.

SALVINI 1977. Salvini, Roberto. *Michelangelo.* Milan: Arnoldo Mondadori Editore, 1977.

SANDBERG-VAVALÀ 1929. Sandberg-Vavalà, Evelyn. *La croce dipinta italiana.* Verona, Italy: Casa Editrice Apollo, 1929.

SANMINIATELLI 1965. Sanminiatelli, Bino. *Vita di Michelangelo.* Rome: Ente Nazionale per le Biblioteche Popolari e Scholastiche, 1965.

SANTI 1980. Santi, Bruno, ed. *Zibaldone Baldinucciano.* 2 vols. Florence: Edizioni S.P.E.S., 1980.

SATOLLI 1993. Satolli, Alberto. *Per Ippolito Scalza.* Rimini: Gattei Stampa & Stampa Euroarte, 1993.

SCARTABELLI 1856. Scartabelli, Cesare. *Discorso in Commemorazioni di Michelangelo Buonarroti letto il dì 28 settembre 1856.* Florence: Tipografia di F. Bencini, 1856.

SCHIAVO 1990. Schiavo, Armando. *Michelangelo nel complesso delle sue opere.* 2 vols. Rome: Istituto Poligrafico e Zecca dello Stato, Libreria dello Stato, 1990.

SCHIFFMANN 1985. Schiffmann, René. *Roma Felix. Aspekte der Städtebaulichen Gestaltung Roms unter Papst Sixtus V.* Bern: Peter Lang, 1985.

SCHILLER 1971–72. Schiller, Gertrud. *Iconography of Christian Art.* Trans. Janet Seligman. 2 vols. Greenwich, Conn.: New York Graphic Society Ltd., 1971–72.

SCHLEIF 1993. Schleif, Corine. "Nicodemus and Sculptors: Self-Reflexivity in Works of Adam Kraft and Tilman Riemenschneider." *Art Bulletin* 75, no. 4 (December 1993): 599–626.

SCHMARSOW 1891. Schmarsow, August. "Excerpte aus Joh. Fischard's 'Italia' von 1536." *Repertorium für Kunstwissenschaft* 14 (1891): 130–39.

SCHMOLL 1959. Schmoll gen. Eisenwerth, J. A. "Zur Genesis des Torso-Motivs und zur deutung des Fragmentarischen Stils bei Rodin." In *Das Unvollendete als künstlerische Form,* ed. J. A. Schmoll. Bern: Francke Verlag, 1959, 117–39.

SCHOTT 1962. Schott, Rolf. *Michelangelo.* New York: Harry N. Abrams, Inc., 1962.

SCHULZ 1975. Schulz, Juergen. "Michelangelo's Unfinished Works." *Art Bulletin* 57, no. 3 (September 1975): 366–73.

SCHÜTZ-RAUTENBERG 1978. Schütz-Rautenberg, Gesa. *Künstlergrabmäler des 15 und 16 jahrhunderts in Italien.* Cologne, Germany: Bölav, 1978.

SESTIERI 1952. Sestieri, Ettore. *L'ultima Pietà di Michelangelo.* Rome: Grimaldi and Mercandetti, 1952.

SETTESOLDI 1982. Settesoldi, Ettore. *The Museum of the Opera del Duomo of Florence.* Florence: Editrice Arte e Natura, 1982.

SGRILLI 1733. Sgrilli, Bernardo. *Descrizione e studi dell'insigne fabbrica di S. Maria del Fiore.* Florence: Bernardo Paperini, 1733.

SHEARMAN 1971. Shearman, John. *Pontormo's Altarpiece in S. Felicita,* Newcastle upon Tyne, U.K.: University of Newcastle upon Tyne, 1971.

SHEARMAN 1992. Shearman, John. *Only Connect.* Princeton, N.J.: Princeton University Press, 1992.

SHRIMPLIN-EVANGELIDIS 1989. Shrimplin-Evangelidis, Valerie. "Michelangelo and Nicodemism: The Florentine Pietà." *Art Bulletin* 71, no. 1 (March 1989): 58–66.

SIMONCELLI 1979. Simoncelli, Paolo. *Evangelismo italiano del Cinquecento.* Rome: Istituto Storico Italiano per l'Età Moderna e Contemporanea, 1979.

SMICK-MCINTIRE 1988. Smick-McIntire, Rebekah. "Michelangelo e il concetto di 'Pietà' nel tema rinascimentale dell'amore e della morte." *Atti del xii convegno dell'associazione internazionale per gli studi di lingua e letteratura italiana.* Vol. 2. Florence: Leo S. Olshkin, 1988, 485–92.

STECHOW 1964. Stechow, Wolfgang. "Joseph of Arimathea or Nicodemus." In *Studien zur toskanischen Kunst, Festschrift für Ludwig Heinrich Heydenreich,* ed. Wolfgang Lotz and Lisa Lotte Möller. Munich: Prestal-Verlag, 1964, 289–302.

STEINBERG 1968. Steinberg, Leo. "Michelangelo's Florentine Pietà: The Missing Leg." *Art Bulletin* 50, no. 1 (December 1968): 343–53.

STEINBERG 1970. Steinberg, Leo. "The Metaphors of Love and Birth in Michelangelo's Pietàs." In *Studies in Erotic Art,* ed. Theodore Bowie and Cornelia Christenson. New York: Basic Books, 1970, 232–335.

STEINBERG 1974. Steinberg, Leo. "An El Greco 'Entombment' Eyed Awry." *Burlington Magazine* 116, no. 857 (August 1974): 474–77.

STEINBERG 1985. Steinberg, Leo. "The Case of the Wayward Shroud." In *Tribute to Lotte Brand Philip,* ed. William K. Clark and Colin Eisler. New York: Abaris, 1985, 185–92.

STEINBERG 1989. Steinberg, Leo. "Animadversions. Michelangelo's Florentine *Pietà*: The Missing Leg Twenty Years After." *Art Bulletin* 71, no. 3 (September 1989): 480–505.

STEINMANN AND WITTKOWER 1927. Steinmann, Ernest, and Rudolf Wittkower. *Michelangelo Bibliographie. 1510–1926.* Leipzig: Klinkhardt and Biermann, 1927.

STENDHAL 1968. Stendhal, *Oeuvres Complètes: Rome, Naples, et Florence*. Ed. Daniel Muller. 2 vols. Geneva: Edito-Service, 1968.

STRINATI 1992. Strinati, Claudio. "La scultura a Roma nel cinquecento." In *L'arte in Roma nel secolo XVI. Istituto Nazionle di Studi Romani*, ed. Daniela Gallavolti Cavallero, Fabrizio D'Amico, and Claudio Strinati. Vol. 2. Bologna, Italy: Nuova Casa Editrice Cappelli di Gem s.r.l., 1992, 301–428.

SUIDA 1953. Suida, William E. *The Samuel H. Kress Collection at the Museum of Fine Arts of Houston*. Houston: Museum of Fine Arts, 1953.

SUMMERS 1972. Summers, David. "*Maniera* and Movement: The *Figura Serpentinata*." *Art Quarterly* 35, no. 3 (autumn 1972): 269–301.

SUMMERS 1981. Summers, David. *Michelangelo and the Language of Art*. Princeton, N.J.: Princeton University Press, 1981.

SUTHERLAND GOWER 1903. Sutherland Gower, Ronald. *Michael Angelo Buonarroti*. London: Bell, 1903.

SYMONDS 1893. Symonds, John A. *The Life of Michelangelo Buonarroti*. 2 vols. London: John Nimmo, 1893.

TACHA SPEAR 1969. Tacha Spear, Athena. "Letter to the Editor." *Art Bulletin* 51, no. 4 (December 1969): 410–12.

TAMPIERI 1997. Tampieri, Roberta, ed. *La Biblioteca dell'Istituto. Carte Poggi*. Florence: Leo S. Olschki, 1997.

TANCOCK 1976. Tancock, John L. *The Sculpture of Auguste Rodin*. Philadelphia: Philadelphia Museum of Art, 1976.

THIEME AND BECKER 1907–26. Thieme, Ulrich, and Felix Becker. *Allgemeines Lexikon der Bildendes Künstler*. 36 vols. Leipzig: E. A. Seemans, 1907–26.

THODE 1908–13. Thode, Henry. *Michelangelo. Kritische Untersuchungen über seine Werke*. 3 vols. Berlin: G. Grote'sche Verlangsbuchhandlung, 1908–13.

TOLSTOJ 1983. Tolstoj, Petr A. *Il viaggio in Italia (1697–1699)*. Trans. Claudia Piovene Cevese. Geneva: Slatkine, 1983 (originally published in *Russkij Archiv*, 1888).

TRINKAUS 1970. Trinkaus, Charles. *In Our Image and Likeness: Humanity and Divinity in Italian Humanist Thought*. 2 vols. Chicago: University of Chicago Press, 1970.

TROLLOPE 1842. Trollope, Frances. *A Visit to Italy*. 2 vols. London: Richard Bentley, 1842.

ULIVI AND SAVINI 1994. Ulivi, Ferruccio, and Marta Savini, eds. *Poesia religiosa italiana dalle origini al Novecento*. Casale Monferrato, Italy: Piemme, 1994.

VACCARI 1997. Vaccari, Maria Grazia, ed. *La guardaroba medicee dell'Archivio di Stato di Firenze*. Florence: Regione Toscana Giunta Regionale, 1997.

VANNUGLI 1991. Vannugli, Antonio. "La 'Pietà' di Jacopino del Conte per S. Maria del Popolo: dall'identificazione del quadro al riesame dell'autore." *Storia dell'Arte*, no. 71 (January–April 1991): 59–93.

VARCHI 1564. Varchi, Benedetto. *Orazione funerale di messer Benedetto Varchi, fatta e recitata da lui pubblicamente nell'essequie di Michelagnolo Buonarroti in Firenze, nella chiesa di San Lorenzo*. Florence: I. Giunti, 1564.

VASARI 1550. Vasari, Giorgio. *Le vite de' più eccellenti architetti, pittori, et scultori italiani, da Cimabue, insino a' tempi nostri*. Florence: Lorenzo Torrentino, 1550.

VASARI 1568. Vasari, Giorgio. *Le vite de' più eccellenti pittori, scultori, ed architettori*. Florence: Giuntina, 1568.

VASARI (ED. BOTTARI) 1759–60. Vasari, Giorgio. *Vite de' più eccellenti pittori, scultori e architetti*. Ed. Giovanni G. Bottari. 3 vols. Rome: Niccolò and Marco Pagliarini, 1759–60.

VASARI (ED. MILANESI) 1878–85. Vasari, Giorgio. *Le vite de' più eccellenti pittori, scultori, ed architettori*. Ed. Gaetano Milanesi. 9 vols. Florence: G. C. Sansone, Editor, 1878–85.

VASARI (ED. BROWN) 1960. Vasari, Giorgio. *Vasari on Technique*. Ed. G. Baldwin Brown; trans. Louisa S. Maclehose. London, J. M. Dent and Co., 1960.

VASARI (ED. HINDS) 1927. Vasari, Giorgio. *The Lives of the Painters, Sculptors, and Architects*. Ed. Ernest Rhys. Trans. A. B. Hinds. 4 vols. London: J. M. Dent and Sons Ltd.; New York: E. P. Dutton and Co., Inc., 1927.

VASARI (ED. BAROCCHI) 1962. Vasari, Giorgio. *La vita di Michelangelo*. Ed. Paola Barocchi. 5 vols. Milan: Ricciardi, 1962.

VASARI (ED. BAROCCHI) 1966–87. Vasari, Giorgio. *Le vite de' più eccellenti pittori, scultori e architettori nelle redazioni del 1550 e 1568*. Ed. Paola Barocchi and Rosanna Bettarini. 8 vols. Florence: Sansoni, 1966–87.

VASARI (ED. BELLOSI) 1986–91. Vasari, Giorgio. *Le vite de' più eccellenti architetti, pittori, et scultori italiani da Cimabue insino a' tempi nostri. Nell'edizione per i tipi di Lorenzo Torrentino, Firenze 1550*. Ed. Luciano Bellosi and Aldo Rossi. 2 vols. Turin, Italy: Giulio Einaudi, 1986–91.

VASARI (ED. BAROCCHI) 1994. Vasari, Giorgio. *Le vite di più eccellenti pittori, scultori, e architetti, indice di frequenze*. Ed. Paola Barocchi and Sonia Maffei. 2 vols. Pisa, Italy: Scuola Normale Superiore and Accademia della Crusca, 1994.

VENTURI 1900. Venturi, Adolfo. *La Madonna*. Milan: Ulrico Hoepli, 1900.

VENTURI 1925–37. Venturi, Adolfo. *Storia dell'arte*. Vol. 9, pts. 1–7; Vol. 10, pts. 1–3. Milan: Ulrich Hoepli, 1925–37.

VERDON 1978. Verdon, Timothy. *The Art of Guido Mazzoni*. New York: Garland Publishers, 1978.

VERDON 1994. Verdon, Timothy. "Il 'pane vivo': la teologia, le immagini, il percorso." In *Panis vivus. Arredi e testimonianze figurative del culto eucaristico dal VI al XIX secolo*. Ed. Cecilia Alessi and Laura Martini. Exh. cat. Siena, Italy: Curia Arcivescovile di Siena, Soprintendenza Beni Artistici e Storici, 1994.

VERDON 1995. Verdon, Timothy. "'Ecce homo': spazio sacro e la vittoria dell'uomo." In *Alla Riscoperta di Piazza del Duomo in Firenze. La Cupola di Santa Maria del Fiore*. Vol. 4. Ed. Timothy Verdon. Florence: Centro Dì, 1995, 89–113.

VERDON 1996. Verdon, Timothy. "L'uomo in cielo: teologia, antropologia, arte." *Vivens homo. Rivista teologica fiorentina* 7, no. 1 (January–June 1996): 13–24.

VERDON (ED. BAVIERA) 1997. Verdon, Timothy. "Il mistero dell'Eucaristia nell'arte dalla Controriforma al Settecento." In *Mistero e immagine l'eucaristia nell'arte del XVI al XVIII secolo*, ed. Salvatore Baviera and Francesca Pirazzoli. Exh. cat. Milan: Electa, 1997, 41–53.

VERDON (ED. DE BENEDICTIS) 1996. Verdon, Timothy. "L'altar maggiore di Santa Maria del Fiore di Baccio Bandinelli." In *Altari e committenza*, ed. Cristina De Benedictis. Florence: Angelo Pontecorboli Editore, 1996, 37–67.

VERDON 1997. Verdon, Timothy. "Sotto il cielo della cupola." In *Sotto il cielo della cupola. Il coro di Santa Maria del Fiore dal rinascimento al 2000*, ed. Timothy Verdon. Exh. cat. Milan: Electa, 1997, 21–31.

VERDON (ED. GHERI) 1997. Verdon, Timothy. "Immagini della Controriforma. L'iconografia dell'area liturgica di Santa Maria del Fiore." In *La Cupola di Santa Maria del Fiore: storia, restauro,*

immagine, ed. Franco Gheri and Vanna Gelli. Florence: Ordo Equestris Sancti Sepulchri Hierosolymitani, 1997, 193–206.

VERDON (ED. LUCHINAT) 1995. Timothy Verdon, "Spiritualità e arti figurative." In *La Cattedrale di Santa Maria del Fiore a Firenze*, ed. Cristina Acidini Luchinat. 2 vols. Florence: Cassa di Risparmio, 1995, 19–30.

VERDON (ED. TARCHI) 1995. Verdon, Timothy. "'Ecce homo': contesto e senso degli affreschi della cupola." In *Il Giudizio ritrovato: il restauro degli affreschi della cupola di Santa Maria del Fiore*, ed. Rossella Tarchi. Florence: Cooperativa Firenze 2000, 1995, 23–43.

VICO FALLANI 1992. Vico Fallani, Massimo de. *Storia dei giardini pubblici di Roma*. Rome: Newton Compton, 1992.

VIALE AND VIALE 1952. Viale, Mercedes, and Vittorio Viale. *Arazzi e tapeti antichi*. Turin, Italy: Industria Libraria Tipografica Editrice, 1952.

VIRCH 1962. Virch, Claus. *Master Drawings in the Collection of Walter C. Baker*. Exh. cat. New York: Metropolitan Museum of Art, 1962, 21–22.

VISONÀ 1990. Visonà, Mara. *Carlo Marcellini Accademico "spiantato" nella cultura fiorentina tardo-barocca*. Pisa: Pacini Editore, 1990.

VORAGINE 1993. Voragine, Jacobus de. *The Golden Legend*. Trans. William G. Ryan. 2 vols. Princeton, N.J.: Princeton University Press, 1993.

VOSSILLA 1996. Vossilla, Francesco. "Da scalpellino a cavaliere. L'altare-sepolcro di Baccio Bandinelli all'Annunziata." In *Altari e committenza. Episodi a Firenze nell'età della Controriforma*, ed. Cristina De Benedictis. Florence: Angelo Pontecorboli, 1996.

VOSSILLA (ED. VERDON) 1996. Vossilla, Francesco. "Dal coro alla cupola. Linee del mecenatismo di Cosimo I in Santa Maria del Fiore nell'epoca del Concilio di Trento." In *L'Uomo in cielo: il programma pittorico della cupola di Santa Maria del Fiore: teologia ed iconografia a confronto*, ed. Timothy Verdon. Bologna, Italy: Edizioni Dehoniane, 1996, 41–56.

WALDMAN 1997. Waldman, Louis A. "From the Middle Ages to the Counter-Reformation: The Choirs of S. Maria del Fiore." *Sotto il cielo della cupola*, ed. Timothy Verdon. Milan: Electa, 1997, 37–68.

WALDMAN 1999. Waldman, Louis A. *The Choir of Florence: Transformations of Sacred Space, 1334–1572*. 2 vols. Ph.D. diss., New York University, 1999.

WALLACE 1992. Wallace, William E. "Michelangelo's Rome *Pietà*: Altarpiece or Grave Memorial?" In *Verrocchio and Late Quattrocento Italian Sculpture*, ed. Steven Bule, Alan P. Darr and Fiorella S. Gioffredi. Florence: Casa Editorice Le Lettere, 1992, 243–55.

WALLACE 1997. Wallace William E. "Michelangelo's Risen Christ." *Sixteenth Century Journal* 228, no. 4 (winter 1997): 1251–80.

WALLACE 1998. Wallace, William E. *Michelangelo: The Complete Sculpture, Painting, Architecture*. Southport, Conn.: Harry Lauter Levin Associates, Inc., 1998.

WALLACE 2000. Wallace, William E. "Michelangelo, Tiberio Calcagni, and the Florentine *Pietà*." *Artibus et historiae* 42 (2000): 81–100.

WARDROPPER AND SIMPSON 1998. Wardropper, Ian, organizer, and Fronia Simpson, ed. *From the Sculptor's Hand: Italian Baroque Terra-*

cottas from the State Hermitage Museum. Exh. cat. Chicago: Art Institute of Chicago, 1998.

WASSERMAN 1966. Wasserman, Jack. *Ottaviano Mascarino*. Published under the auspices of the Accademia Nazionale di San Luca, Rome. Rome: Tipografia della Pace, 1966.

WASSERMAN 1995. Wasserman, Jack. "Traditional Sculpture and the Place of Contemporary Replication." In *Leonardo da Vinci's Sforza Monument Horse: The Art and the Engineering*, ed. Diane Cole Ahl. Bethlehem, Pa.: Lehigh University Press; London: Associated University Presses, 1995, 111–27.

WASSERMAN 2001. Wasserman, Jack. "Michelangelo's Pietà in Florence: Transformation of Place and Intent." In *Santa Maria del Fiore: The Cathedral and Its Sculpture*, ed. Margaret Haines. Florence: Edizioni Cadmo, 2001, 289–98.

WEATHERHEAD 1834. Weatherhead, G. Hume. *A Pedestrian Tour through France and Italy*. London: Simpkin and Marshall, 1834.

WEIL-GARRIS 1981. Weil-Garris, Kathleen. "Bandinelli and Michelangelo: A Problem of Artistic Identity." In *Art, the Ape of Nature: Studies in Honor of H. W. Janson*, ed. Moshe Barasch and Lucy Freeman. New York: Harry N. Abrams, Inc., 1981, 223–51.

WEIL-GARRIS BRANDT 1987. Weil-Garris Brandt, Kathleen. "Michelangelo's *Pietà* for the Cappella del Re di Francia." In *"Il se rendit en Italie." Etudes offertes à André Chastel*," Jean-Pierre Babelon et al., organizing committee. Paris: Edizioni dell'Elefante–Flammarion, 1987, 77–116.

WEISZ 1981. Weisz, Jean S. "Daniele da Volterra and the Oratory of S. Giovanni Decollato." *Burlington Magazine* 123, no. 939 (June 1981): 355–56.

WILDE 1978. Wilde, Johannes. *Michelangelo: Six Lectures*. Oxford: Clarendon Press, 1978.

WILSON 1876. Wilson, Charles Heath. *Life and Works of Michelangelo*. London: Murray, 1876.

WIND 1989. Wind, Geraldine Dunphy. "Once More, Michelangelo and Nicodemism." *Art Bulletin* 71, no. 4 (December 1989): 693–94.

WITTKOWER 1955. Wittkower, Rudolf. *Gian Lorenzo Bernini*. London: Phaidon Press, 1955.

WITTKOWER 1977. Wittkower, Rudolf. *Sculpture: Processes and Principles*. New York: Lane, 1977.

WITTKOWER AND WITTKOWER 1964. Wittkower, Rudolf, and Margot Wittkower. *The Divine Michelangelo: The Florentine Academy's Homage in His Death in 1564*. London: Phaidon Press, 1964.

WÜNSCHE 1999. Wünsche, Raimund. *Der Torso. Ruhm und Rätsel*. Munich: Lithos Krammer Media-Data GmbH, 1999.

YOUNG 1911. Young, George F. *The Medici*. 2 vols. London: John Murray, 1911.

ZERI 1957. Zeri, Federico. *Pittura e controriforma. L'arte senza tempo di Scipione da Gaeta*. Milan: Giulio Einaudi Editore, 1957.

ZEIGLER 1985. Zeigler, J. E. *The Word Becomes Flesh: Cantor Art Gallery, College of the Holy Cross*. Exh. cat. Worcester, Mass.: Cantor Art Gallery, 1985.

ZUPKO 1981. Zupko, Ronald E. *Italian Weights and Measures from the Middle Ages to the Nineteenth Century*. Philadelphia: American Philosophical Society, 1981.

INDEX

Florence *Pietà* (Michelangelo) *(continued)*

catalogue of derivations of, 223–27; centrality of Christ's corpse in, 51, 130–34, 155n.63; Christ's missing left leg in, 34, 51, *58*, 60–66, *61*, *62*, 68, 70, 79–84, *85–87*, 88, 97, 125, 128, 157nn. 12–17, 19, 21, 22, and 27, 158n.30, 159n.21, 160nn. 22, 25, and 26, 166n.17, 168n.39, 176, 182–85, *183*, 189–91, 193; chronology of, 29–31, 60–63, 64, 75–76, 151n.31, 157n.24; compositional problems posed in, 45–46, 157n.12, 194; composition of, 39–49, 153–55nn. 31–54; critical reception of, 119–25, 165–68nn. 1–40; dynamic narrative in, 18, 34, 35, 49, 132, 154n.40; eighteenth-century wax replica of, 43, 60, *63*, 227 no. 39; eucharistic reading of, 51, 116, 127–48; Florentine provenance of, 75–76, 109–17, 163–65nn. 1–56; formalist preoccupations and, 128; identity of bearded figure in, 17, 19, 34, 57, 66–67, 134, 141, 156nn. 75 and 77; identity of two women in, 153n.20; illusion, distortion, and abbreviation in, 45–49; inception of work on, 29–31, 151n.31; intended viewpoint of, 27, 34, 49, 130–31, 137, 150nn. 10 and 11; the Magdalene's diminutive size in, 20, 91, 149n.9, 157n.12, 160nn. 39–43, 194; the Magdalene's spiritual role in, 51–57, 155n.65; marble block for, 17, 45–46, 59, 63, 70, 154nn. 44 and 45, 156n.6, 157n.9, 194, 201; meanings attached to, 49–57, 116, 127–48, 155–56nn. 56–77; Michelangelo's conjectured iconographic transformation of, 70–73, 83–84, 158n.54; Michelangelo's dismantling of, 19, 20, 21, 59–73, 79, 84, 123, 127, 128, 154n.50, 156–59nn. 1–59, 160n.22, 188–89, 194; Michelangelo's late paintings related to, 44–46, 154nn. 40 and 51; Michelangelo's motivations for creation of, 18–19, 25, 45, 127–28; Michelangelo's own features represented on face of bearded figure in, 18, 34, 57, 66, 67, 124, 128, 137–40, 149n.8, 153n.12, 158n.49; Michelangelo's spiritual state of mind and, 66–67, 128, 140–41, 147–48, 158n.37; Michelangelo's supposed dissatisfaction with, 59–60, 128, 154n.50, 157n.12; model use and, 76, 121–23, 159nn. 10 and 11, 188; as monument for Michelangelo's own tomb, 19, 20, 25–29, 34, 127–29, 157n.11, 168n.6; multiple-view feature of, 49, 155n.54; "museum piece" interpretation of, 127, 128; origin and function of, 18–19, 25–31, 150–52nn. 1–50; overall views of, *8*, *12–16*, *50*, *52*, *91*, *108*, *114*; patinas on, 115, 165nn. 33–37, 193, 203, 205, 210–11, *211*, 244n.18; photographs of (*see* Florence *Pietà*, photographs of); plaster cast of, 115, 165n.37; questions heretofore not satisfactorily explored about, 19–20; recarving hypothesis and, 68–73, 158nn. 51, 52, and 55; reconstruction of, 75–97 (*see also* reconstruction of *Pietà*); Roman provenance of, 99–107, 160n.28, 161–63nn. 1–67; scientific examination of, 21, 172–73, 197–216 (*see also* scientific examination of *Pietà*); size of, 17, 149n.1; size of Virgin's face in, 194; "slung leg" motif and, 63–66, 144–46, 157nn. 21, 22, 27, and 29, 158n.30; succession of ownership of, 75–76, 98–99, 103–5; sweet calm of Christ's facial expression in, 132–34; technical studies of, 21, 172–222 (*see also* carving tools and techniques; scientific examination of *Pietà*; virtual model of *Pietà*); title and subject matter of, 33–35, 152–53nn. 1–18; Virgin's spiritual role in, 49–51, 144–46, 155nn. 56–62; virtual model of, 217–22 (*see also* virtual model of *Pietà*); visual and iconographic sources for, 39–41; weight of, 107, 163n.65

Florence *Pietà*, photographs of, 11, 124, 130; on altar in Santa Maria della Neve Chapel, Duomo, Florence, *108*; base of statue, with remains of pedestal on which Christ's foot rested, *85*; bearded figure's head from front, slightly oblique view, *32*; bearded figure's left hand on back of Virgin, *47*; Christ, back of left hand, *79*; Christ, band at chest and neck, *96*; Christ, lap and stump of missing left leg, *58*; Christ, left forearm and elbow, *187*; Christ, left shoulder and back, *82*; Christ, left wrist and palm of hand, *78*; Christ, left wrist

and side of hand, *181*; Christ, loincloth at lap, *72*; Christ, neck, *180*; Christ, neck and left shoulder, *184*; Christ, patch on left elbow, *81*; Christ, right arm held up by bearded figure, view of back, *83*; Christ, right foot, *174*; Christ, upper left arm and elbow, *80*; Christ's head, full face, *136*; Christ's right arm, encircling the Magdalene, view of back, *69*; Christ's right hand on the Magdalene's back, *118*; Christ's right leg and base of statue, *186*; Christ's torso, *frontispiece*, *93*; Christ's torso and the Magdalene's right arm, *182*; head of the bearded figure, full face, *56*; head of the Magdalene, view from above, *53*; heads of Christ, the Virgin, and the bearded figure, *126*; heads of Christ and the Virgin, *71*; Magdalene, encircled by Christ's right arm, *55*; Magdalene, full face, *74*; Magdalene, full figure from left, *8*; Magdalene, hand on Christ's right leg, *95*; Magdalene, left hand on leg of bearded figure, *37*; Magdalene, left shoulder, and Christ's right hand, *94*; Magdalene, lower part of figure from right, *90*; Magdalene, right profile, *89*; Magdalene, upper right arm, *77*; marble bridge under Christ's left hand, *76*; shroud between Christ and the Magdalene, *52*, *53*; three-quarter view from right, behind high altar of Duomo, Florence, *50*; view from left, and steps to back of high altar, Duomo, Florence, *114*; view from oblique left, *16*, *50*; view from oblique left, with shroud between Christ and the Magdalene, *52*; view from right, *13*; view of back, *91*; view of back, from left, *15*; view of back, from right, *14*; view of front, *12*, *50*; view of lower back, *38*; Virgin, back of left arm, *86*; Virgin, left hand, above Christ's left nipple, *36*; Virgin, lower part of figure, view from right, *61*; Virgin, right hand, *48*; Virgin's arm and area above stump of Christ's missing left leg, *183*; Virgin's head, full face, *190*; Virgin's lap, with stump of Christ's missing left leg, *87*; Virgin's thigh and stump of Christ's missing left leg, *62*. *See also* virtual model of *Pietà*

"Florentine Catechism," 141

fluorescence of surfaces under ultraviolet (UV) light, 202, 203–5, *205*

Foggini, Giovanni Battista, new base for *Pietà* by, 112

Foglietta, Catervo, 103

Fourier-Transform Infrared (FT-IR) analysis of *Pietà*: patinas and, 210–11, *211*; stuccowork and, 207–9, *209*

fragment, aesthetic of, 124–25, 168n.36

Francioni, Rodolfo, 116

Franco, Battista, 225 no. 21

Frangipani Chapel, San Marcello al Corso, Rome, 225 no. 17

Frey, Karl, 150n.15

Frommel, Christoph, 162n.16

FT-IR analysis. *See* Fourier-Transform Infrared analysis of *Pietà*

Galatians, St. Paul's letter to, 139

gammagraphic examination of *Pietà*, 76, 150n.15, 173, 194, 197–99, 202, 211

Genesis, St. Paul's interpretation of, 144

Gere, John, 225 nos. 17 and 21

Gerson, Jean de (Jean Charlier), 49, 155n.58

Gianotti, M. Donato, 59

Giberti, Gian Matteo, 129, 134

Gibson, John, 115, 165n.36

Gigli, Count Ottavio, wax statuette of *Pietà* owned by, 121–23, 166nn. 16–20, 167n.22

Ginori-Venturi, Marchese Roberto, 116, 165n.46

PHOTOGRAPHY CREDITS

New photography by Aurelio Amendola: frontispiece; plates 1–6, 14–17, 26, 27, 29, 30, 32, 36–40, 44, 47–49, 51, 52, 54–62, 66–68, 80, 83, 92, 96, 100, 101, 103–7

Permission to reproduce illustrations is provided by the owners or sources as listed in the captions. Additional photography credits are as follows (numerals refer to plates):

Agence photographique de la Réunion des musées nationaux, Paris (20, 85, 94)

Alinari, Florence and Rome (7, 8, 11, 18, 31, 42, 43, 64, 75, 79, 86, 90, 91, 95)

Umberto Bandini, Anna Maria Giusti, and Annapaola Pompalini Mantell, *La Cappella dei Principi e le pietre Dure a Firenze* (Milan: Electa Editrice, 1979), fig. 211 (77)

Giovanni Battista Falda, *Roma al tempo di Clemente X. La pianta di Roma di Giambattista Falda del 1676*, ed. Francesco Ehrle. (Rome: Danesi, 1931), n.p. (71)

© Biblioteca Apostolica Vaticana, Vatican City (82)

Kunsthistorisches Institut, Florence (12, 25, 87, 89)

International Business Machine Corporation (IBM), Armonk, New York (115, 116)

All rights reserved, The Metropolitan Museum of Art, New York (93)

Ministero per i Bene Culturali e Ambientali, Istituto Centrale per il Catalogo e la Documentazione, Rome (24, 28, 46)

Opificio delle Pietre Dure (OPD), Florence (50, 111–14)

Alessandro Parronchi, "Sulla Pietà fiorentina di Michelangelo," *Storia dell'arte* 10, nos. 36–37 (1981): fig. 69 (41)

Peter Rockwell (97)

Soprintendenza alle Gallerie, Gabinetto Fotografico, Florence (22, 63, 69, 76, 78, 84, 117)

Jack Wasserman (33, 34, 53, 65, 102)

MICHELANGELO'S FLORENCE PIETÀ

Designed and composed by Lindgren/Fuller Design, New York City

Composed in Hoefler Text with display lines in Cresci

Printed on 135gsm GardaMatt Art Paper

Separations, printing, and binding by Graphicom, Inc., Verona, Italy